essential skills digital imaging

third edition

mark galer
les horvat

ELSEVIER

AMSTERDAM • BOSTON • HEIDELBERG • LONDON • NEW YORK • OXFORD
PARIS • SAN DIEGO • SAN FRANCISCO • SINGAPORE • SYDNEY • TOKYO
Focal Press is an imprint of Elsevier

Focal
Press

Focal Press
An imprint of Elsevier
Linacre House, Jordan Hill, Oxford OX2 8DP
30 Corporate Drive, Burlington MA 01803

First published 2001
Reprinted 2002
Second edition 2003
Third edition 2005

British Library Cataloguing in Publication Data
A catalogue record for this book is available from the British Library

Library of Congress Cataloguing in Publication Data
A catalogue record for this book is available from the Library of Congress

ISBN 0 240 51971 X

For more information on all Focal Press publications visit our website at:
www.focalpress.com

Printed and bound in Italy

Working together to grow
libraries in developing countries

www.elsevier.com | www.bookaid.org | www.sabre.org

ELSEVIER BOOK AID
 International Sabre Foundation

Acknowledgements

Among the many people who helped make this book possible,
we wish to express our gratitude to the following:

The staff and students of RMIT University, Melbourne, for their support,
friendship and illustrative input.

To our respective families:

Dorothy, Matthew and Teagan;
Sue, Nikki, Cameron and Dannika;

for their love, endless support and understanding.

Picture Credits

Paul Allister; Lizette Bell; Andrew Boyle; Saville Coble; Catherine Dorsen; Andrew Elliot; Tamas Elliot; Sam Everton; Seok-Jin Lee; Justin Ridler; Raphael Ruz; Fabio Sarraff; Amber Williams; Stuart Wilson.

All other images and illustrations by the authors.

Chapter Credits

Mark Galer: Foundations, Image Adjustments, Digital Negatives,
Image Enhancements, Post-production, Presentations.

Les Horvat: Digital Capture, Platforms and Output Devices,
Color Management, Managed Workflows, Printing and Pre-press,
Capture Workflows, File Handling Workflows

Contents

Introduction viii
Essential information x

foundation module

Foundations I
Introduction 2
Channels and modes 3
Levels 4
Hue, saturation and brightness 5
Color and light overview 7
Bit depth and mode 10
File size 11
File formats 12
Resolution 14
Understanding resolution 15
Image size 17

Digital Capture 23
Introduction 24
Image formation 27
Image sensor characteristics 29
Image sensor types 30
How a sensor creates an image 31
Types of digital camera 32
Choosing a digital camera 40

Digital Negatives 53
Introduction 54
Processing RAW data 55
Processing activity 55
White balance - Step 1 55
Tonal adjustments - Step 2 56
Noise reduction and sharpening - Step 3 58
Choosing a bit depth - Step 4 59
Choosing a color space - Step 5 61
Additional information 62

Platforms and Output Devices 67

Introduction 68
External storage 71
Mobile storage devices 74
Scanners as input devices 75
Workings of a flatbed scanner 76
Printers as output devices 78

Color Management 83

Introduction 84
What is a color space? 85
Color gamuts 88
How does RGB relate to CMYK? 89
Color concepts in practice 91
Applying color management 93
Hardware calibration 97

Image Adjustments 99

Introduction 100
First steps 101
Image capture - Step 1 101
Cropping an image - Step 2 102
Tonal adjustments - Step 3 104
Color adjustments - Step 4 108
Cleaning an image - Step 5 110
Sharpening an image - Step 6 111
Saving a modified file - Step 7 112
Experimenting with levels 115

Contents

application module

Image Enhancements 119
Introduction 120
Advanced cropping and sizing techniques - Project 1 121
Advanced levels control - Project 2 127
Target values - Project 3 137
Shadows and highlights - Project 4 143
Advanced sharpening techniques - Project 5 148

Post-production 157
Black and white - Project 6 158
Toning - Project 7 163
Creative depth of field - Project 8 169
Tonal contraction - Project 9 175
Digital montage - Project 10 180

Presentations 187
Introduction 188
Contact sheet 189
Picture Package - Project 11 190
Screen presentations 192
Creating a slide background - Project 12 198
Creating a web photo gallery - Project 13 206
Creating a panorama using Photomerge - Project 14 211

workflows module

Capture Workflows 215
Introduction 216
Digital camera controls 217
File format 218
Camera noise 221
White balance 225
Setting up the camera - Project 15 226
Creative use of sharpening - Project 16 231
Remote camera software 237
Capture workflow decisions 238

File Handling Workflows 241

Introduction 242
Image browsing 243
Metadata 246
Archiving captured images - Project 17 249
Applying workflow actions to folders - Project 18 251

Managed Workflows 255

Introduction 256
Setting up a closed-loop workflow - Project 19 257
Using profiles in a managed workflow 259
How to set up an ICC profile based system 264
Color settings for Photoshop 265
Color management for Elements 266
Color management policies for Photoshop 267
Creating a target image - Project 20 270

Printing and Pre-press 273

Introduction 274
Closed loop printing to an RGB device - Project 21 278
Managed printing to an RGB device - Project 22 279
Managed printing to a CMYK device 282

Glossary 289

Keyboard shortcuts 299

Web links 301

Supporting CD 302

CD content 304

Index 305

Introduction

Digital imaging has revolutionized photography. Most of what we now see in print has been created using digital technologies. Digital involvement extends from at one level, image capture using a fixed lens digital camera and basic image adjustments, to image capture using a medium or large format digital back and extensively enhanced and manipulated post-production image editing adjustments in Photoshop. This book is intended for photographers who wish to use the 'digital darkroom' rather than the traditional darkroom for creative illustration. The information, activities and projects contained within provide the essential skills necessary. The subject guides offer a comprehensive and progressive learning approach, giving support and guidance. An emphasis on useful (essential) practical advice maximizes the opportunities for creative image production enabling the user to place the skills and techniques in context with their own imaging needs.

Paul Allister

Acquisition of skills

The book first focusses its attention on the basic principles of digital imaging. Emphasis is placed on the essential techniques and foundation skills required for high quality digital capture and production. The book is designed to build competence to deal with potentially confusing areas such as suitable capture systems, platforms, resolution and the control over tonality and color. Adobe Photoshop Elements and CS2 are primarily referred to as these dominate post-production image editing practice.

However, this is not an Adobe manual. The activities and projects focus on the entire imaging chain from capture to print. Terminology is kept as simple as possible using only those terms in common usage by practising professionals.

Application of skills

The subsequent chapters are devoted to the practical application of the digital skills and concepts addressed in the first half. A series of progressive projects explore and build upon the image adjustment skills to further enhance digital images in a more controlled way. This is followed by projects on image post-production techniques to extend the skill base for image creation. The book concludes with projects designed to help you present your images professionally with the minimum of fuss.

Independent learning

The chapters contained in this book offer an independent learning resource that will give the user a framework for the techniques and skills required for professional digital imaging as well as the essential skills for personal creativity and communication.

The skills

To acquire the essential skills to capture, adjust, enhance and output commercial quality digital images takes a little time and practice. If the skills are practised repeatedly they will eventually become 'second-nature' rather than just a basic understanding. Try to become comfortable with the skills introduced in one chapter and then apply them to each of the following chapters wherever appropriate.

The CD associated with this book has movie tutorials and supporting images

CD and web site

A companion CD complete with QuickTime movie tutorials and images supports many of the imaging tasks undertaken in this book. A dedicated web site has also been set up where it is possible to download copies of these images required to complete the activities within the study guides. The address for the Internet web site is: **http://www.photographyessentialskills.com**

Useful links

It is possible to maximize your full technical and creative potential by looking at information and images from a variety of different sources. The CD and supporting web site provide a range of links to extend your knowledge data base and provide a source for creative inspiration.

DIGITAL IMAGING `>>>`

essential skills `>>>`

Essential information

The basic equipment required to complete this course is access to a computer with Adobe Elements 3 or Photoshop CS2 (versions 7 and CS would also suffice for most of the activities contained in the book). The photographic and design industries traditionally use Apple Macintosh computers but many people choose Windows based PCs as a more cost effective alternative. When Photoshop is open there are minor differences in the interface, but all of the features and tools in the main image editing interface are identical. It is possible to use this book with either Windows based PCs or Apple Macintosh computers.

Storage

Due to the large file sizes involved with digital imaging it is advisable that you have a high capacity, removable storage device attached to the computer or use a CD writer to archive your images. Avoid bringing magnetic disks such as Zip disks into close contact with other magnetic devices such as can be found in mobile phones and portable music players - or even the speakers attached to your computer.

Commands

Computer commands which allow the user to modify digital files can be accessed via menus and submenus. The commands used in the study guides are listed as a hierarchy, with the main menu indicated first and the submenu or command second, e.g. Main menu > Command or Submenu > Command. For example, the command for opening the Image Size dialog box would be indicated as follows: Edit > Image Adjustments > Image Size.

Keyboard shortcuts

Many commands that can be accessed via the menus and submenus can also be accessed via keyboard '**shortcuts**'. A shortcut is the action of pressing two or more keys on the keyboard to carry out a command (rather than clicking a command or option in a menu). Shortcuts speed up digital image processing enormously and it is worth learning the examples given in the study guides. If in doubt use the menu (the shortcut will be indicated next to the command) until you become more familiar with the key combinations. See page 299 and 300 (Keyboard shortcuts) for a list of the most frequently used shortcuts.

Note > **The keyboard shortcuts indicate both the Mac and PC equivalents.**

Example: The shortcut for pasting objects and text in most applications uses the key combination Command/Ctrl + V. The Macintosh requires the Command key (next to the spacebar) and the V key to be pressed in sequence whilst a PC requires the Control key (Ctrl) and the V key to be pressed.

essential skills

digital foundations

Sam Everton

essential skills

~ Gain a working knowledge of digital image structure.

~ Understand file size, bit depth, image modes, channels, file format and resolution.

~ Understand color theory and color perception.

Introduction

Digital imaging is now revolutionizing not only the process of photography but also the way we view photography as a visual communications medium. This new photographic medium affords the individual greater scope for creative expression, image enhancement and manipulation.

Before we rush into making changes to our digital files in order to create great art, or turn a warty old frog into a handsome prince, it makes sense to slow down and take time out to understand the structure of the digital image file. In this way the technical terms used to identify, quantify and specify the digital file as a whole, or the component parts of the digital file, serve to clarify rather than bamboozle our overloaded gray matter.

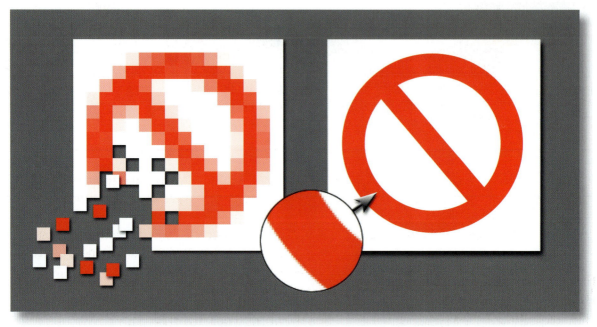

Anti-aliasing and small pixels ensure that a staircase of pixels is rendered as a smooth arc

Pixels

The basic building block of the digital image is the humble pixel (picture element). Pixels are rectangular and positioned in rows horizontally and vertically to form a grid or mosaic. Each pixel in the grid is the same size and is uniform in color and brightness, i.e. the color does not vary from one side of the pixel to the other. If we fully zoom in on the pixels of a digital image, using image-editing software, we will see how smooth flowing shapes can be convincingly constructed out of rectangular building blocks (with not a curved pixel in sight). There are two processes used to create the illusion of curved lines in our photographs. The first is a process called anti-aliasing where some of the edge pixels adopt a transitional (in-between) color to help create a smoother join between two different adjacent colors or tones. This process helps camouflage the staircase or 'shark's teeth' that may become noticeable. The most convincing way to render a smooth flowing line, however, is to simply display the pixels so small that we cannot make them out to be square using the naked eye.

Channels and modes

All the colors of the rainbow when mixed together create white light (a prism is often used to split white light into its component colors to demonstrate the connection between light and color). All the colors of the rainbow can be created by mixing just three of these colors – **Red**, **Green** and **Blue** light (called the **primary** colors of light) – in differing amounts. Using these simple scientific principles all the variations of color in our multicolored world can be captured and stored in three separate component parts of our digital image file. These component parts are called the Red, Green and Blue 'Channels'. An image that uses this process to store the color data is called an RGB image. RGB is one type of 'Image Mode'.

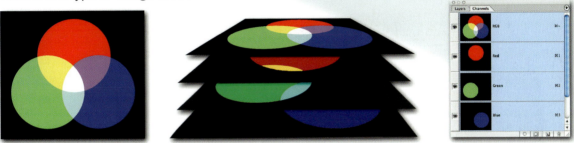

The primary colors of light (stored in three separate channels) create the secondary colors when mixed

In Adobe Photoshop and Elements the colored channels are working behind the scenes to create multicolored images by providing three sets of information regarding color, i.e. the amount of red, green and blue present in each pixel location. When the color from only one channel is present a primary color is created in the image window. When information from two channels is present a secondary color is displayed. These secondary colors (created by mixing two primaries) are called Cyan, Magenta and Yellow. When there is an absence of any color from the three channels the pixel location appears black (no illumination). Mixing all three channels together creates white light or gray if the brightness value from each of the three channels is lowered (see 'Levels, page 4'). Color information about the image can also be stored using the secondary colors (mixing two secondary colors creates a primary) plus black. Images using this system or **Mode** are called **CMYK** images. Photoshop users can view the information stored in the component channels whilst Elements users must just be content to know that it exists, but that you don't have access to view it.

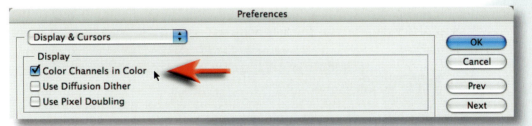

Note > Photoshop users can view the information in each channel with or without color (Preferences > Display & Cursors). It is usually beneficial to view the information in the channels without color when conducting advanced post-production editing but for the purposes of understanding what is actually happening, color is a distinct advantage.

Levels

We have seen how mixing primary colors of light can create the secondary colors. In the previous illustration, where three colored circles were overlapped, the color in each of the three channels is either 'on' or 'off'. In this way six colors are created from three channels. The three channels can, however, house a greater range of information about color than simply 'yes' (fully on) or 'no' (fully off) in any one pixel location. The capture devices are capable of measuring '**how much**' color is present in any one given location. In a standard RGB image, 256 different levels of color can be assigned to each pixel location. The channels operate very much like a mixing desk, mixing varying amounts of color from each of the three color channels to create the full color spectrum.

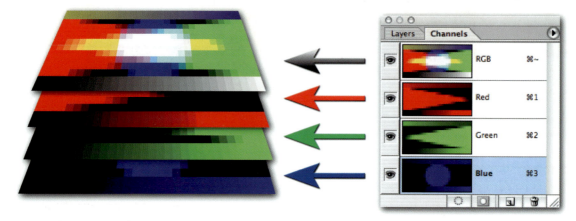

In a standard RGB digital image each pixel can be assigned one of 256 different '**levels**' of color from each of the three color channels, from 0 (no color in that pixel location) to 255 (full color present in that pixel location). If the three channels are mixed in equal proportions what we see is a series of tonal steps from black (0 in all three channels) to white (255 in all channels).

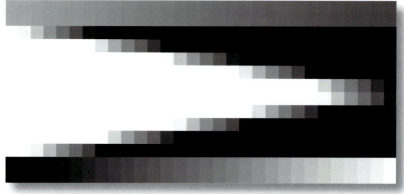

256 levels of tone are reduced to 30 so the steps can be clearly seen

256 separate tones are sufficient to create a smooth transition from dark to light with no visible steps. If the pixels are sufficiently small when printed out, the viewer of the image cannot see either the individual pixels or the steps in tone, and the illusion of '**continuous tone**' or '**photographic quality**' is achieved.

Hue, saturation and brightness

Equally high levels in each of the three color channels create not only a bright or light toned pixel but may also indicate a bright level of illumination in the scene that has been captured. This can be attributed to the pixel being a record of a bright light, or the reflected light off a brightly illuminated subject, but it may alternatively be due to possible overexposure during the capture process, i.e. the sensor being exposed to the light source for too long.

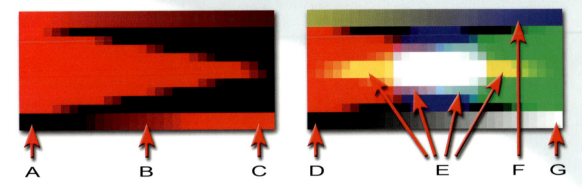

The illustration above shows the enormous variety of tones that can be achieved by combining 256 levels of information from the three color channels. Given that each channel can vary its level of information, independently of the other two, it is possible to create a single pixel with one of a possible 16.7 million different values (256 x 256 x 256). To describe the nature of a particular color value without resorting to numbers, Adobe has adopted a system where the characteristics of the color can be described in three ways. These descriptive categories are:

Hue - as dictated by the dominant primary or secondary color, e.g. red, yellow, blue, etc.
Saturation - the strength of the color, e.g. when one or two of the channels registers 0 the resulting color is fully saturated, i.e. no level of gray or white is weakening the purity of the color.
Brightness - from 0 (black - all channels 0) to 255 (at least one channel registering 255).

Using a common language of hue, saturation and brightness (HSB) we can identify the colors indicated by letters in the illustration above, in terms that can be readily understood by the broader community that are neither mathematicians nor Photoshop nerds.

A to **C** are levels of brightness from black to fully saturated bright red. The levels from the other two channels are not influencing the overall color or brightness of any of the pixels (all green and blue values are set to level 0).

D and **G** are levels of brightness from black to white. When all channels read the same level the resulting tones are fully desaturated.

E indicates fully saturated secondary colors created by mixing two primary channels at level 255.

F indicates colors of lower saturation as information from the three channels is unequal (therefore creating a gray component to the color's characteristic).

DIGITAL IMAGING >>>

>>> essential skills >>>

Color Picker

As we have discussed previously it is essential when describing and analyzing color in the digital domain to use the appropriate terminology. A greater understanding of the characteristics of Hue, Saturation and Brightness (HSB) can be gained by viewing colors in the Adobe Color Picker. Click on the foreground swatch in the Tools palette to open the Color Picker.

> **Hue** - All colors can be assigned a location and a number (a degree between 0° and 360°). A vertical colored bar in the Color Picker allows the user to click anywhere on the bar to view the range of colors associated with that particular hue. Note the number in the top field next to the 'H' radio button. Each of the six primary and secondary colors is positioned 60° apart, e.g. Red at 0°, Yellow at 60°, Green at 120°, etc.

> **Saturation and Brightness** - Click in the large square box to the left of the bar to choose a saturation and brightness value for the selected Hue. Saturation increases when the selection circle is moved to the right side of the box and decreases when moved to the left. Brightness increases towards the top of the box and decreases towards the bottom of the box.

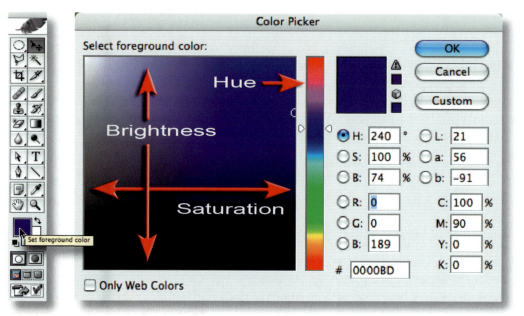

The 'foreground swatch' and 'Color Picker (CS version)'

Creating and sampling color from an image

If the mouse cursor is moved out of the Color Picker dialog box and into the image window the mouse cursor icon turns into the eyedropper icon, regardless of what tool was selected in the Tools palette when the Color Picker was opened. Pressing the Caps Lock key on the keyboard turns this icon into a target for precise selection of a color or tone. Clicking in an area of the image window will sample the color and reveal its characteristics in the Color Picker dialog box. The sample size can be changed from a single pixel to a '3 by 3 Average' or '5 by 5 Average' by right-clicking (PC) or Control-clicking (Mac) in the image window to reveal the context menu for the eyedropper tool.

Color and light overview

Additive color

The additive primary colors of light are Red, Green and Blue or RGB. Mixing any two of these primary colors creates one of the three secondary colors Magenta, Cyan or Yellow.

Note > Mixing all three primary colors of light in equal proportions creates white light.

Subtractive color

The three subtractive secondary colors are Cyan, Magenta and Yellow or CMY. Mixing any two of these secondary colors creates one of the three primary colors Red, Green or Blue. Mixing all three secondary colors in equal proportions in a CMYK file creates black or an absence of light (CS only).

ACTIVITY 1

Open the files RGB.jpg and CMYK.jpg (CS users only) from the supporting CD and look at the channels to see how they were created using Photoshop. Use the information palette to measure the color values.

Note > Choose 'don't Color Manage' when opening these files in your Adobe software.

Hue, Saturation and Brightness

Although most of the digital images are captured in RGB it is sometimes a difficult or awkward color model for some aspects of color editing. Photoshop and Elements allows the color information of a digital image to be edited using the HSB model. Hue, Saturation and Brightness or HSB is an alternative model for image editing which allows the user to edit either the Hue, Saturation or Brightness independently of the other two.

ACTIVITY 2

Open the image Hue.jpg, Saturation.jpg and Brightness.jpg. Use the Color Picker to analyze the color values of each bar.

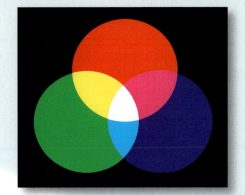

RGB - additive color

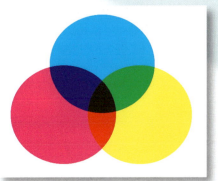

CMY - subtractive color

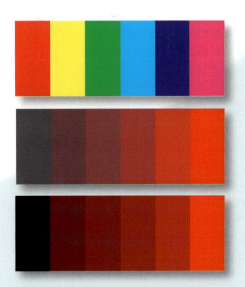

HSB - Hue, Saturation and Brightness

Color perception

Our perception of color changes and is dependent on many factors. We perceive color differently when viewing conditions change. Depending on the tones that surround the tone we are assessing, we may see it darker or lighter. Our perception of a particular hue is also dependent on both the lighting conditions and the colors or tones that are adjacent to the color we are assessing.

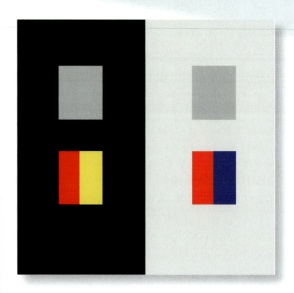

Color perception

ACTIVITY 3

Evaluate the tones and colors in the image opposite. Describe the gray squares at the top of the image in terms of tonality. Describe the red bars at the bottom of the image in terms of hue, saturation and brightness. Open the supporting file and check the differences in tone and color.

Color gamut

Color gamut varies, depending on the quality of paper and colorants used (inks, toners and dyes, etc.). Printed images have a smaller color gamut than transparency film or monitors and this needs to be considered when printing. In the image opposite the out of gamut colors are masked by a gray tone (CS/CS2 only). These colors are not able to be printed using the default Photoshop CMYK ink values.

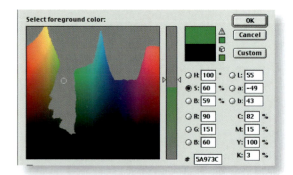

Out of gamut colors

Color management issues

The issue of obtaining consistent color - from original, to its display on a monitor, through to its reproduction in print - is considerable. The variety of devices and materials used to capture, display and reproduce color in print all have a profound effect on the end result (see Color Management).

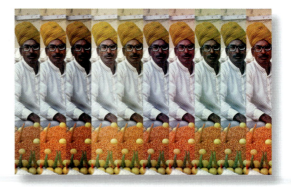

Color management ensures consistent colors

ACTIVITY 4

1. Double-click the Hand Tool in the Tools palette to resize the image to fit the monitor.

2. Click on the '**Zoom Tool**' in the tools palette to select the tool (double-clicking the Zoom tool in the tools palette will set the image at 100% magnification).

3. Click on an area within the image window containing detail that you wish to magnify. Keep clicking to increase the magnification (note the current magnification both in the title bar of the image window and in the bottom left-hand corner of the image window.

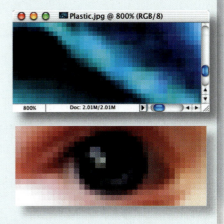

4. At a magnification of 400% you should be able to see the pixel structure of the image. Increase the magnification to 1200% (to decrease the magnification you should click the image with the Zoom Tool whilst holding down the Option/Alt key on the keyboard).

5. Click on the hand in the tools palette and then drag inside the image window to move the image to an area of interest (pixel variety).

6. Open the Info palette from the Windows menu in your Adobe image-editing software. From the Palette Options choose 'HSB Color' as the 'Second Color Readout'.

7. Click on the eyedropper in the Tools palette to sample the color information (note how the color of the selected pixel is displayed in the foreground swatch in the Tools palette).

8. View the color information in the Information palette in terms of its RGB numbers and its hue, saturation and brightness values. Try to find the brightest, darkest, most saturated, least saturated areas within your selected image.

Bit depth and mode

As discussed earlier in 'Levels' each pixel in a single channel of a standard RGB image is described in one of a possible 256 tones or levels. The computer memory required to calculate and store this color data is '8 bits', a bit (binary digit) being the basic unit of the computer's memory. The amount of bits dedicated to describing and recording tonal or color variations is called the '**bit depth**'. If only tonal information is required (no color) a single channel 8-bit image is sufficient to create a good quality black and white image, reproducing all of the tonal variations needed to produce 'continuous tone'. An 8-bit image that handles only tonal variations is more commonly referred to as a **Grayscale** image.

When 8 bits are needed for each of the three channels of an RGB image this results in what is often referred to as a 24-bit image (3 x 8). Adobe, however, does not refer to an RGB image as a 24-bit image but rather as an RGB Color and lists the bit depth of each channel rather than the entire image, e.g. 8 Bits/Channel. Images with a higher '**bit depth**' have a greater potential for color or tonal accuracy although this sometimes cannot be viewed because of the limitations of the output device. Images with a higher bit depth however, require more data or memory to be stored in the image file (Grayscale images are a third of the size of RGB images with the same pixel dimensions and print size). Adobe offers support for 16 Bits/Channel images.

RGB image, 256 levels per channel (24-bit)　　　　　　　　　　　　　　　　　*256 levels (8-bit)*

Capturing and editing at bit depths exceeding 8 bits per channel

Sophisticated 'prosumer' digital cameras and digital SLRs (DSLRs) are able to export files in the 'RAW' format in bit depths higher than 8 bits per channel to the computer. Higher quality scanners are able to scan and export files at 16 bits per channel (48-bit). In Photoshop and Elements 3 it is possible to edit an image using 16 bits per channel or 8 bits per channel. The file size of the 16-bit per channel image is double that of an 8-bit per channel file of the same pixel dimensions. Image editing in this mode is used by professionals for high quality retouching. When extensive tonal or color corrections are required it is recommended to work in 16 bits per channel whenever possible. It is, however, important to note that not all of the Adobe editing tools function in 16-bit mode.

File size

Digital images are data hungry (this data being required to record the extensive variations in color and/or tone of the original image or subject). The simple binary language of computers and the visual complexities of a photographic image lead to large '**file sizes**'. This data can require large amounts of computer memory to display, print or store the image. The text file for this entire book would only be a small fraction of the memory required for the cover image (10 megabytes).

Units of memory

8 bits	=	1 byte
1024 bytes	=	1 kilobyte
1024 kilobytes	=	1 megabyte
1024 megabytes	=	1 gigabyte

Storage capacity of disks and drives

Flash/USB pen	=	64 megabytes-1 gigabyte
CD	=	700-800 megabytes
DVD	=	4.7-gigabytes
iPod	=	512 megabytes to 60 gigabytes

Fortunately files can be '**compressed**' (reduced in memory size) when closing the file for storage or uploading over the Internet. Portable hard drives (such as Apple's 'iPod' or the smaller 'USB' or 'Flash' drives) are now commonly used for storing and transferring large image files conveniently and quickly. A 5 megapixel digital image can be saved as a 10 megabyte RAW file or a 1 megabyte JPEG file using a high quality compression setting in the camera. The same file opens up to a 14.1 megabyte file in Photoshop. When talking about file size it helps to know whether you are talking about an open or closed file and whether any image compression has been used.

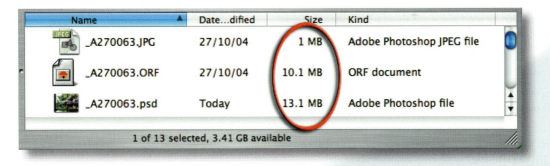

ACTIVITY 5

Find one digital image file and identify its file size when the image is closed. Open the same digital image using image editing software and identify its file size when open (go to the 'document sizes' underneath the image window or choose 'Image Size' from the 'Image' menu (Resize submenu in Elements).

File formats

When an image is captured by a camera or scanning device it has to be '**saved**' or memorized in a '**file format**'. If the binary information is seen as the communication, the file format can be likened to the language or vehicle for this communication. The information can only be read and understood if the software recognizes the format. Images can be stored in numerous different formats. The four dominant formats in most common usage are:

* RAW (.dng) - Camera RAW or Digital Negative
* JPEG (.jpg, jpf and jpx) - Joint Photographic Experts Group
* TIFF (.tif) - Tagged Image File Format
* Photoshop (.psd) - Photoshop Document

Camera RAW or Digital Negative - Unlike the other file formats, RAW is not an acronym for a much longer name. Selecting the RAW format in the camera instead of JPEG or TIFF stops the camera from processing the color data collected from the sensor. The RAW data is what the sensor 'saw' before the camera processes the image, and many photographers have started to refer to this file as the 'digital negative'. The unprocessed RAW has to be converted into a usable image file format using image editing software supplied by the camera manufacturer or built into software packages such as Adobe Photoshop CS or Elements 3.

A close-up detail of an image file that has been compressed using maximum image quality in the JPEG options box

A close-up detail of an image file that has been compressed using low image quality in the JPEG options box. Notice the artifacts that appear as blocks

JPEG (Joint Photographic Experts Group) - Industry standard for compressing continuous tone photographic images destined for the World Wide Web (www) or for storage when space is limited. JPEG compression uses a 'lossy compression' (image data and quality are sacrificed for smaller file sizes when the image files are closed). The user is able to control the amount of compression. A high level of compression leads to a lower quality image and a smaller file size. A low level of compression results in a higher quality image but a larger file size. It is recommended that you only use the JPEG file format after you have completed your image editing and always keep a master Photoshop document for archival purposes.

File formats

Format	Compression	Color modes	Layers	Transparency	Uses
RAW	No	Unprocessed	No	No	Master file (unmodified)
JPEG	Yes	RGB, CMYK, Grayscale	No	No	Internet and camera format (compressed)
JPEG2000	Yes	RGB, CMYK, Grayscale	No	No	Internet and archival
Photoshop	No	RGB, CMYK, Grayscale, Indexed color	Yes	Yes	Master file (modified)
TIFF	Yes	RGB, CMYK, Grayscale	Yes	Yes	Commercial printing and generic camera format (lossless)
GIF	Yes	Indexed color	No	Yes	Internet graphics and animations

JPEG2000 - This latest version of the JPEG file format supports higher bit depths and alpha channels. It produces less image artifacts than the standard JPEG compression but uses a more complex list of saving options than the standard JPEG format. Photoshop and Elements 3 support the file format but it is not available as part of the 'Save for Web' options.

PSD (Photoshop Document) - This is the default format used by the Adobe image-editing software. A Photoshop document is usually kept as the master file from which all other files are produced depending on the requirements of the output device.

TIFF (Tagged Image File Format) - This has been the industry standard for images destined for publishing (magazines and books, etc.). TIFF uses a 'lossless' compression (no loss of image data or quality) called '**LZW compression**'. Although preserving the quality of the image, LZW compression is only capable of compressing images by a small amount. TIFF files now support layers and transparency that can be read by other Adobe software products such as InDesign.

GIF (Graphics Interchange Format) - This format is used for logos and images with a small number of colors and is very popular with web professionals. It is capable of storing up to 256 colors, animation and areas of transparency. It is not generally used for photographic images.

Lossy and lossless compression

The important thing to note when choosing a compression method is the difference between lossy and lossless compression methods. Each compression method enables you to squeeze large image files into smaller spaces (closed file size). Lossless compression does this with no loss of picture quality, whereas lossy compression enables greater space savings with the price of losing some of your image's detail.

Resolution

Resolution is a term that is used to specify the size of a pixel, a dot of colored light on a monitor or a dot of ink on the printed page. There are usually two resolutions at play at any one time – the resolution of the digital file and that of the output device. We can talk about capture size, image resolution, monitor resolution and printer resolution. They are all different, but they all come into play when handling a single digital image that is to be printed. Various resolutions can be quoted as we move through the chain of processes involved in creating a digital print (in the example below the total number of pixels remains constant throughout the chain of events).

Image sensor

The sensor to the right creates an image file with 5 million pixels or 5 megapixels (2560 × 1920 pixels). The resolution assigned to the image file by the capture device may be a print or monitor resolution. Either way it has no bearing on the file size, which is determined by the total number of pixels.

Digital file displayed on screen

The monitor resolution (the size of its display pixels) is defined by its resolution setting (approximately 100 pixels for every linear inch or 10,000 pixels for every square inch in a high definition TFT display). The image pixels (different to the display pixels) can be viewed in a variety of sizes by zooming in and out of the image using image-editing software.

Digital file adjusted in Photoshop

The resolution of the digital file is adjusted to 256 pixels per inch (ppi). Each pixel is allocated a size of 1/256th of an inch. Because the digital file is 2560 pixels wide this will create a print that is 10 inches wide if printed (256 × 10 = 2560).

Note > Increasing the document size further will start to lower the resolution below the level which is recommended by commercial output devices (the pixels will be large enough to see with the naked eye).

The image is printed

The image is printed on an inkjet printer using a printing resolution of 1440 dots per inch. Many colored dots of ink are used to render a single image pixel.

Overview

The image is captured at a resolution of over 3000ppi and displayed at 100ppi on a high resolution monitor. Using image-editing software the image resolution is lowered to 256ppi (the pixel dimensions remain the same). The image is then printed using an inkjet printer with a printer resolution of 1440dpi. The different resolutions associated with this chain of events are:

Capture size > Display resolution > Image resolution > Output device resolution

Understanding resolution

Resolution is perhaps the most important, and the most confusing, subject in digital imaging. It is important because it is linked to quality. It is confusing because the term '**resolution**' is used to describe at what quality the image is captured, displayed or output through various devices.

10 pixels per inch *20 pixels per inch* *40 pixels per inch*

Resolution determines image quality and size

Increasing the total number of pixels in an image at the capture or scanning stage increases both the quality of the image and its file size. It is '**resolution**' that determines how large or small the pixels appear in the final printed image. The greater the image resolution the smaller the pixels, and the greater the apparent sharpness of the image. Resolution is stated in '**pixels per inch**' or '**ppi**'.

Note > With the USA dominating digital photography, measurements in inches rather than centimeters are commonly used - 1 inch equals exactly 2.54 centimeters.

The images to the right have the same pixel dimensions (300 x 300) but different resolutions. The large image has a resolution half that of the small one. A digital image can be made to appear bigger or smaller without changing the total number of pixels, e.g. a small print or a big poster. This is because a pixel has no fixed size. The pixel size can be modified by the image-editing software to change the document size. Increasing the resolution of the image file decreases the size of the pixels and therefore the output size of the file.

Note > When talking about the 'size' of a digital image it is important to clarify whether it is the pixel dimensions or the document size (measured in inches or centimeters) that is being referred to.

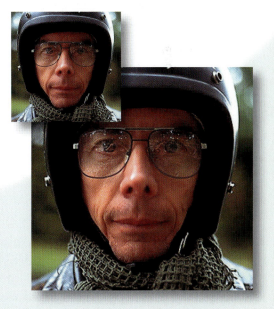

Dpi and ppi

If manufacturers of software and hardware were to agree that dots were round and pixels were square it might help users differentiate between the various resolutions that are often quoted. If this was the case the resolution of a digital image file would always be quoted in 'pixels per inch', but this is not the case.

At the scanning stage some manufacturers use the term dpi instead of 'ppi'. When scanning, 'ppi' and 'dpi' are essentially the same and the terms are interchangeable, e.g. if you scan at 300dpi you get an image that is 300ppi.

When working in Photoshop and Elements image resolution is always stated in ppi. You will usually only encounter dpi again when discussing the monitor or printer resolution. The resolutions used to capture, display or print the image are usually different to the image resolution itself.

Note > Just in case you thought this differentiation between ppi and dpi is entirely logical - it isn't. The industry uses the two terms to describe resolution, 'pixels per inch' (ppi) and 'dots per inch' (dpi), indiscriminately. Sometimes even the manufacturers of the software and hardware can't make up their minds which of the two they should be using, e.g. Adobe refer to image resolution as ppi in Photoshop and dpi in InDesign – such is the non-standardized nomenclature that remains in digital imaging.

File size and resolution

When we use the measurement 'ppi' or 'pixels per inch' we are referring to a linear inch, not a square inch (ignore the surface area and look at the length).

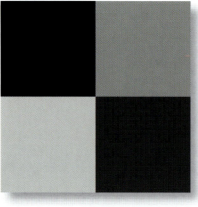

2 inch × 2inch file @ 1 ppi = 4 pixels *2 inch × 2 inch file @ 2 ppi = 16 pixels*

File size, however, is directly linked to the **total** number of pixels covering the entire surface area of the digital image. Doubling the image output dimensions or image resolution quadruples the total number of pixels and the associated file size in kilobytes or megabytes.

Note > Handling files with excessive pixel dimensions for your output needs will slow down every stage of your digital image process including scanning, saving, opening, editing and printing. Extra pixels above and beyond what your output device needs will not lead to extra quality. Quality is limited or 'capped' by the capability of the output device.

Image size

Before you adjust the size of the image you have to know how to determine the size you need. Six and eight megapixel digital cameras are currently the affordable 'end' of professional digital capture. The image resolution produced by these digital cameras is not directly comparable to 35mm film capture but the images produced can satisfy most of the requirements associated with professional 35mm image capture. DSLRs using full frame sensors can match medium format film cameras for quality.

Six megapixel cameras capture images with pixel dimensions of around 3000 x 2000 (6 million pixels or 6 'megapixels'). The resulting file size of around 17MB (1 megapixel translates to nearly 3 megabytes of data) is suitable for commercial print quality (300ppi) to illustrate a single page in a magazine. Digital capture is now an affordable reality for all professional photographers.

USEFUL SPECIFICATIONS TO REMEMBER

- Typical high-resolution monitor: 1024 x 768 pixels
- Typical full-page magazine illustration: 3000 × 2000 (6 million pixels)
- High-resolution TFT monitor: 100ppi
- High quality inkjet print: 240ppi
- Magazine quality printing requirements: 300ppi
- Full-screen image: 2.25MB (1024 × 768)
- Postcard-sized inkjet print: 4MB
- 10 x 8 inch inkjet print: 13.2MB
- Full-page magazine image at commercial resolution: 20MB

Note > Remember to double the above file sizes if you intend to edit in 16 bit per channel mode.

A 20MB file will usually suffice if you are not sure of the intended use of the digital file. 35mm film scanned with a scanning resolution of **2300** will produce a 20.3MB file (2173 pixels x 3260 pixels).

Calculating a suitable file size and scanning resolution

Scanning resolution is rarely the same as the resolution you require to print out your image. If you are going to create a print larger than the original you are scanning, the scanning resolution will be greater than the output resolution, e.g. a 35mm negative would have to be scanned at 1200ppi if a 6 × 4 inch commerical print is required. If the print you require is smaller than the original the scanning resolution will be smaller than the output resolution.

The smaller the original the higher the scanning resolution.

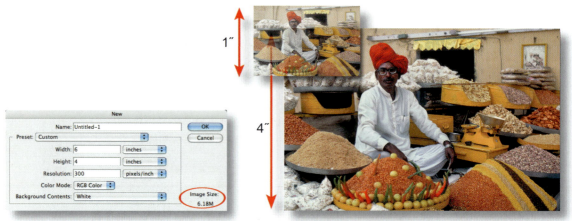

Magnification × output resolution = scanning resolution
scanning resolution = 4 × 300ppi = 1200ppi

To calculate the correct file size and scanning resolution for the job in hand you can:

1. Go to 'File > New' in Photoshop, type in the document size, resolution and mode you require and then make a note of the number of megabytes you require from the scanning process. Then adjust the scanning resolution until the required number of megabytes is captured.

2. Multiply the magnification factor (original size to output size) by the output resolution (as dictated by the output device) to find the scanning resolution (not so difficult as it sounds!).

Size & mode	Output device resolution		
	100ppi screen	240ppi inkjet	300ppi commercial
8 × 10 RGB	2.29MB	13.20MB	20.60MB
8 × 10 Grayscale	781K	4.39MB	6.87MB
5 × 7 RGB	1.00MB	5.77MB	9.01MB
5 × 7 Grayscale	342K	1.92MB	3.00MB
4 × 6 RGB	703K	3.96MB	6.18MB
4 × 6 Grayscale	234K	1.32MB	2.06MB

File size

Pixel dimensions, document size and resolution

Before retouching and enhancement take place the '**image size**' should be scaled for the intended output (the capture resolution will probably require changing to output resolution). Choose Image > Image Size in Photoshop or Image > Resize > Image Size in Elements. This will ensure that optimum image quality and computer operating speed is maintained. Image size is described in three ways:

• Pixel dimensions (the number of pixels determines the file size in terms of kilobytes).
• Print size (output dimensions in inches or centimeters).
• Resolution (measured in pixels per inch or ppi).

If one is altered it will affect or impact on one or both of the others, e.g. increasing the print size must either lower the resolution or increase the pixel dimensions and file size. The image size is usually changed for the following reasons:

• Resolution is changed to match the requirements of the print output device.
• Print output dimensions are changed to match display requirements.

```
                          Image Size

   ┌ Pixel Dimensions:  6.20M (was 2.01M) ─────┐      ┌─────────────┐
   │                                            │      │     OK      │
   │   Width:  1800        pixels      ▲▼  ┐    │      └─────────────┘
   │                                        ]⊗  │      ┌─────────────┐
   │   Height: 1204        pixels      ▲▼  ┘    │      │   Cancel    │
   └────────────────────────────────────────────┘     └─────────────┘
   ┌ Document Size: ────────────────────────────┐      ┌─────────────┐
   │                                            │      │   Auto...   │
   │   Width:  6           inches      ▲▼  ┐    │      └─────────────┘
   │                                        ]⊗  │
   │   Height: 4.014       inches      ▲▼  ┘    │
   │                                            │
   │   Resolution: 300     pixels/inch ▲▼       │
   └────────── Set the document resolution ─────┘
     ☑ Scale Styles
     ☑ Constrain Proportions
     ☑ Resample Image:  Bicubic        ▲▼
```

Image size options

When changing an image's size a decision can be made to retain the proportions of the image and/or the pixel dimensions. These are controlled by the following:

• If '**Constrain Proportions**' is selected the proportional dimensions between image width and image height are linked. If either one is altered the other is adjusted automatically and proportionally. If this is not selected the width or height can be adjusted independently of the other and may lead to a distorted image.

• If '**Resample Image**' is selected adjusting the dimensions or resolution of the image will allow the file size to be increased or decreased to accommodate the changes. Pixels are either removed or added. If deselected the print size and resolution are linked. Changing width, height or resolution will change the other two. Pixel dimensions and file size remain constant.

Resampling

An image is 'resampled' when its pixel dimensions (and resulting file size) are changed. It is possible to change the output size or resolution without affecting the pixel dimensions (see 'Understanding resolution'). Resampling usually takes place when the pixel dimensions of the original capture or scan do not precisely match the requirements for output (size and resolution). Downsampling decreases the number of pixels and information is deleted from the image. Increasing the total number of pixels or resampling up requires new pixels to be added to the file. The new pixels use information based on color values of the existing pixels in the image file.

Image scanned at correct resolution *Effects of excessive resampling*

Excessive resampling up can result in poor image quality (the image will start to appear blurry). Avoid the need for resampling to enlarge the file size, if at all possible, by capturing at a high enough resolution or by limiting the output size. If you have to resample due to the limitations of your capture device (not enough megapixels) then files that resample best are those that have been captured from a digital camera using a low ISO setting and have not previously been sharpened.

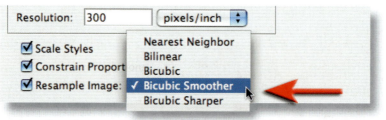

Interpolation methods

When resampling an image to create a larger file, choose the 'Bicubic Smoother' from the Interpolation options in the Image Size dialog box. Use 'Bicubic Sharper' when decreasing the size of the file. Bilinear and Nearest Neighbor are used for hard-edged graphics and are rarely used for the Interpolation of photographs. If you have already sharpened your image prior to resampling (best avoided) you will need to reapply the Unsharp Mask to regain the sharp quality of the image.

Sam Everton

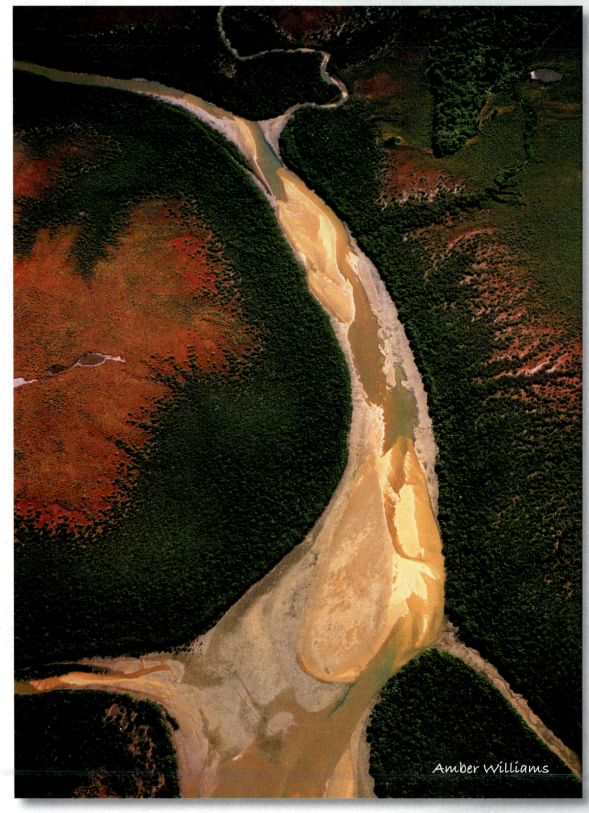

Amber Williams

digital capture

Les Horvat

essential skills

~ Know the choices available in digital capture devices, including:

- high end cameras
- prosumer cameras
- DSLRs
- point and shoot cameras

~ Understand the principles behind the mechanisms of digital capture.

~ Create a resource for objective comparisons between digital cameras.

~ Appreciate when digital is the preferred choice for image capture.

Introduction

The ability to perform any digital manipulation requires image data to be 'captured' and then entered into a computer system. This can be achieved by using either of the following:

~ A digital camera for initial capture with the data then transferred onto a computer, via direct link or storage card.
~ A traditional camera using film, then at some later stage scanning the image and transferring the data onto a computer.

Whilst both methods result in a similar data file which can be said to represent the image as 'seen' by the camera and indeed the photographer, they actually produce data that have important differences. To understand these differences, let us first examine the processes involved.

Traditional camera and scanned image as capture device

Any image taken on film will exhibit the general characteristics of that particular film emulsion, namely:

grain, tonality, color and sharpness.

When this image is scanned, these particular characteristics are overlaid with any characteristics (or limitations) that belong to the particular scanning hardware or software. The image file will then be a combination of all these particular attributes, resulting in 'noise', artifacts or 'non-imaging' data being an integral part of the information. The degree or significance of this non-imaging data will vary with the particular devices (film, camera and scanner) actually utilized, but may have a clearly visible influence on the final appearance.

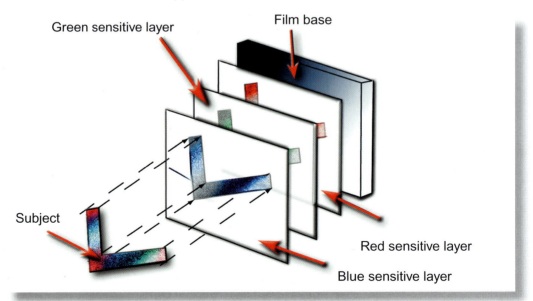

Film capture showing silver halide formation on dye sensitive layers

Digital cameras as capture devices

An image file created with a digital camera bypasses the film stage and as a result of this single stage process, potentially produces a more accurate data file. Whilst digital cameras have their own problems, particularly with regard to resolution (see 'Image sensor types', page 30) and tonal range, such data files potentially do contain 'cleaner' information.

>>> DIGITAL IMAGING

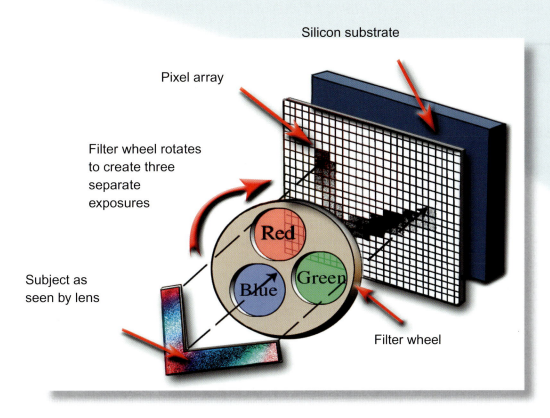

Silicon substrate

Pixel array

Filter wheel rotates to create three separate exposures

Red

Green

Blue

Subject as seen by lens

Filter wheel

Digital capture showing image formation within a pixel array (see 'Multi shot matrix')

>>> essential skills >>>

Digital technology is moving at breakneck speed, with today's digital cameras offering single shot exposures onto ever increasing sensor resolutions, at a rapidly reducing cost and with a dynamic range that in many cases is greater than film.

The transition from film based capture to digital capture is relentless. Although many photographers come from a practice based on a film paradigm, the digital revolution is very nearly complete.

Dynamic Range of scene capable of being captured	
Color slide film:	4-5 stops
Color negative film:	7-8 stops
Black & White film:	9-10 stops
Human eye:	more than 12 stops
Canon 1D/1Ds sensor:	8-9 stops

Digital versus traditional

Whether as a photographer you come from a film based tradition, or whether your experience is mainly digital, the method used to create the image is worth considering - at what point does one form of capture become superior to another? Is the convenience of shooting digitally the most realistic, and accessible option, or is film a better mode of capture?

At this point in our evolution of silicon versus silver, the debate is no longer based on image quality. No longer is film considered to produce a superior result. However, whilst digital capture can definitely produce a more pure, cleaner file, it is essential to remember that shooting film still can retain certain advantages. Apart from a possible price premium (cost of the digital camera plus batteries, storage devices etc., compared to an equivalent quality film based camera), the ability of film to act as both an inexpensive and convenient archival storage medium has also to be considered. Digital files need to be archived and although the cost of this process has dropped rapidly (particularly with the advent of inexpensive CD and DVD media and burners and external storage devices), the long term storage and permanence of digital files can involve time consuming processes and handling. On the other hand, the archival permanence and ease of storage of film has a long, proven pedigree. In addition, the ease with which a new roll of film can be inserted into a camera, as the previous roll is dropped casually into a pocket, needs to be compared with the necessity and inconvenience of downloading files from a digital camera - or at the very least, maintaining a collection of somewhat expensive storage cards for later download.

Against this traditional workflow, is the ability for instant gratification via a digitally captured image. This itself can be so profound an experience as to render this debate, in many peoples' view, a non starter. Not only is it possible to immediately view the image for a technical check, but it is possible to show the image immediately and conveniently to others - be they the subject of the shot, a client, a model or just an interested companion. The advantage that this offers can be immense. Added to this is the ability to alter the ISO setting at will when shooting digitally (admittedly with an increase in noise somewhat like increased grain) rather than having to make a film choice that needs to be maintained for the entire roll. As well, there is no need to deal with issues of color temperature if shooting RAW (see 'The Digital Negative', pg 53) and the use of correction filters for color compensation is not required. These are just some of the important considerations that need to be addressed in any comparison of film versus digital capture but today more than ever, the decision will most likely be based on preferred workflow and historical background.

Image formation

To help understand the differences between digital capture and film (analog) capture, together with the implications of those differences with regard to quality, we need to examine the ways in which the image is formed through each method.

Conventional cameras (using film)

In a traditional camera, light passes through the lens and falls onto a film emulsion, with exposure adjusted by the aperture or shutter of the camera. Color film itself is composed of a series of sensitive '**layers**' each containing crystals of '**silver halide**'. Exposure to light gives rise to a stimulation and subsequent movement of charged particles, resulting in the formation of a '**latent image**' in the form of '**metallic silver**' clumps. In color films, these clumps are amplified and made visible by development with the metallic silver being replaced with color '**dyes**' - resulting in color '**film grain**'. During exposure, each film layer responds to only one of the red, green and blue portions of the spectrum that combine to make white light. When the resultant image is viewed, it is the combination of color dye specks or 'grains' within each layer that results in a 'full color' image. The characteristics of the final image are to a great extent controlled by the film. A change in film type will result in not only a possible change in sensitivity (or film speed), but also a change in color, tonality, grain and so on.

With a traditional camera, the same unit can be used to record images with very different characteristics, simply by altering the film.

Film with coarse grain

Fine grain film with smooth tones

Digital cameras (using image sensors)

Just as in traditional cameras, a digital camera uses a lens to focus the light, and an aperture and shutter to control exposure. Instead of film however, the light falls onto an image sensor composed of a series of light sensitive areas, usually referred to as 'pixels'. Each 'pixel' is connected electronically to a processor, which can measure the electrical stimulation the 'pixel' has received. These 'pixels', just like the 'silver halides' in films, only record light intensity - not color. Color is created by selectively allocating, or alternately sequencing pixels to record the red, green or blue components of white light.

The nature of the image sensor, unlike a camera using film, is integral to the construction of the camera. That is to say, all of the characteristics the sensor imparts to the image are fixed and unable to be changed, unless the camera is replaced. Thus the tonality, color rendition and sharpness are a fixed signature of the device itself. This important difference is true for all but the most high end (or expensive) cameras, where interchangeable digital or film backs would offer, in theory anyway, some flexibility. However, with the greater acceptability of use of the camera RAW format by digital cameras, many of these characterisitics can now be altered after capture.

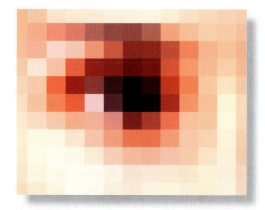

Varying light intensity captured by pixels - hold the book at a distance to make out the image

Note > Unlike film based cameras, the characteristics of the recorded image are determined by the sensors used and are part of the camera.

As a pixel is exposed to light of increasing intensity, it produces a corresponding linear increase in electrical charge. This charge is amplified, measured and a corresponding gray tone or '**level**' is produced. This level is itself represented by a unique number, which can then be stored as digital information and subsequently easily manipulated on a computer.

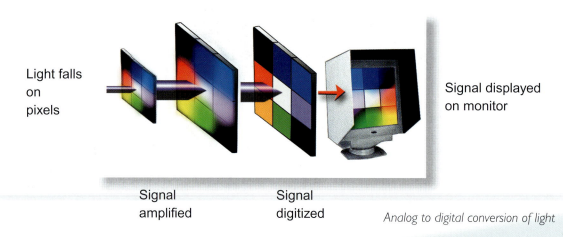

Light falls on pixels

Signal displayed on monitor

Signal amplified

Signal digitized

Analog to digital conversion of light

Image sensor characteristics

Regardless of the type of image sensor used in a camera, they tend to have the following characteristics:

~ The sensor sites within them are regular in shape.
~ The sensor sites are laid out in a grid pattern.
~ The pixels in standard sensors (see 'Color sensors', page 31) register only brightness, not color.
~ The size of the array is often smaller than the equivalent film format.

Due to these characteristics, images formed by the sensors mostly have these attributes:

~ Sensor sites in most cases do not overlap (as they might with dye specks in the various layers within films), so the pixel generated image does not '**waste**' any information.
~ The regular pixel shape within an organized array is more '**efficient**' than the random nature of film grain.
~ Three sensor sites are required to produce a unique color, therefore the number of sites must be divided by three, when determining the actual pixel resolution of a sensor.
~ As the array is often smaller than the equivalent film format and although a digital camera may appear similar to a 35mm system, it is likely that the angle of view, or magnification of the lenses, will not be equivalent. This difference can be indicated by the measure of '**aspect ratio**'.

To calculate the aspect ratio of a camera, simply divide the pixel width by the pixel height. For example the Canon PowerShot S10 has a resolution of 1600x1200 pixels. This results in an aspect ratio of 1.33:1, as compared to 8"x10" photographic paper which has a ratio of 1.25:1. The image at right shows the cropping effect that can result

The difference in aspect ratio (when compared to that of conventional film) may result in the need to crop the image when printing. To understand this, consider what aspect ratio means - the ratio of the image height to the width.

For example a square has an aspect ratio of 1:1, whilst 35mm film has an aspect ratio of 1.5:1 (1.5 times wider than it is high). Most sensors fall somewhere between the two, and so it is often necessary to choose between cropping part of the image or reducing the image size of the printout to fit the paper.

Image sensor types

Whether within a camera or a scanner, most image sensors are made from either '**charge-coupled devices**' - '**CCD**s', or '**complementary metal oxide semiconductor**' - **CMOS**, chips, although more recently the direct image Foveon chip is also being used as an image sensor.

An image captured using a CCD sensor in a Kodak digital SLR camera

Battle of the sensors

For nearly thirty years, the relatively mature technology of CCD sensors has dominated the image sensor market, first within video camcorders and more recently as the imaging chip within still cameras, but the high cost of their very specialized production process has inhibited their acceptance. The newer CMOS imaging chip offers the advantage of being much cheaper to produce, due to a simpler means of production as well as economies of scale which result from the fact that a form of CMOS chip is the backbone of most desktop computer systems.

A further advantage of CMOS sensors is the ability of the chip to be designed in such a way as to also control other aspects of the camera itself, such as the internal clock, shutter, or exposure. This results in a much simpler and potentially cheaper camera with fewer chips required for its functionality. On the debit side, the CMOS chip suffers from more noise than CCDs and requires sophisticated mechanisms to reduce this problem to acceptable levels, which can become a problem in low light situations.

How a sensor creates an image

Regardless of the type of sensor, the silicon pixels that make up the light sensitive array record the amount of light falling onto it by accumulating an electrical charge, which is then measured and converted to digital information in the form of a number. **The higher the number, the greater the amount of light falling onto the pixel.**

Color sensors

Until recently, image sensors could only 'see' in black and white - that is, they were not able to differentiate color. However Foveon, a company who has been at the forefront of sensor chip technology, has begun production of the X3 Direct Image, 3.43 million pixel sensor; a sensor currently available in cameras produced by Sigma and Polaroid which is able to differentiate between colors in its capture. This means that in reality it is comparable in function to existing sensors with more than 10 million pixels, since it has 3.43+3.43+3.43 effective pixels.

The major difference between this sensor and other types of image sensor is that each pixel is designed to receive all three basic colors of light, instead of only one. In other words rather than break images into separate colors and allocate them in some way to separate pixels, this sensor captures the different wavelengths of light by measuring how deeply photons of light actually penetrate the surface of the pixel.

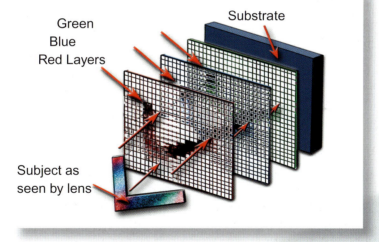

Foveon's X3 digital color sensor

This is achieved by stacking three photodetecters within each pixel, each designed to capture a separate color - one dedicated to red wavelengths, one dedicated to blue wavelengths and one dedicated to green wavelengths of light. This is rather similar to the way that conventional film records color and therefore it is the first digital capture process to successfully mimic film. As a result, not only is there a need for fewer pixels for any given resolution, but there is also a smaller light loss and fewer artifacts - thereby enabling successful capture with less noise within low lighting conditions.

Types of digital camera

Now that we have examined the ways that a digital image can be created, let us consider the various types of digital camera available. The simplest method of categorizing digital cameras is by cost - modestly expensive, expensive and hideously expensive! However with the improvements in technology and the speed at which these improvements are arriving, there is no doubt that over the past few years prices of all types of digital cameras are coming down and coming down dramatically. It makes more sense therefore to discuss digital camera in terms of their features and the uses to which they can be put.

High end digital cameras

This group of cameras falls into two categories. Those that are mainly designed as camera backs which fit onto existing medium or large format camera systems (see discussion on 'Image sensor types', page 30) and those that are complete cameras in themselves. The camera back style is most often used by professional photographers where quality of image is the most important criterion. These units are extremely expensive, but in a busy studio the cost can be offset by the flexibility, the immediacy and the savings in film and processing.

Removable digital backs

Until recently, most digital camera backs used a linear array or multi-shot matrix system to achieve quality that was comparable to that which could be gained from film. However, the most recent generation of film backs are of the single shot variety (or offer single shot modes) and are able to produce images with up to 25 megapixel resolution. An example of this type of camera back is the Leaf Valeo 22, suitable for medium format cameras and able to produce a 126MB file in 16-bit mode with one instantaneous exposure on its 48mm x 36mm CCD sensor. This type of digital back sets the benchmark in the pursuit of high end digital capture, although at a significant price.

Leaf Valeo Pro Back

Medium and large format camera systems

As discussed in the previous section, many high end digital cameras involve the use of removable backs adapted to existing camera systems. They are not however the only possibilities available. Sinar, the makers of large format cameras, have produced a totally modular digital camera which enables it to be used either on its own or together with components from their other camera systems.

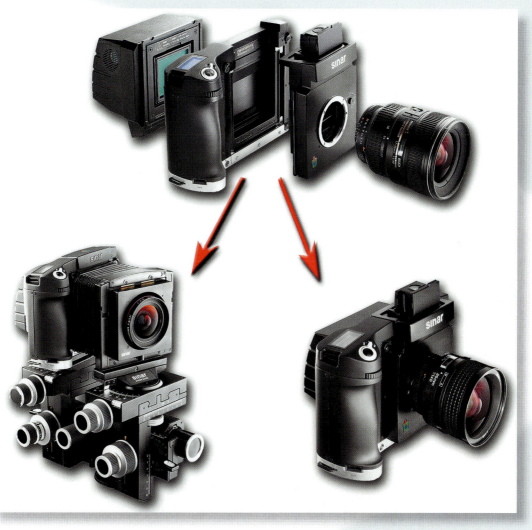

Sinar m modular camera system in combination with Sinar p3 view camera

This camera, the Sinar m, contains a lens panel with optional viewfinders which can adapt to a huge range of lenses, together with a shutter panel which can be used on its own or with the Sinar p3 view camera. Such high end type camera systems enable a complete modular set-up, which can be tailored to operate with a range of digital backs. Depending on the requirements of the photographer, studio based imaging complete with view camera movements, as well as location based single shot, portable capture systems, can be readily utilized.

Image sensor advances

An exciting development for digital cameras is the introduction of the high resolution CMOS sensor. As discussed earlier in this chapter (see 'Battle of the sensors', page 30), although CMOS sensors had been expected to reduce the price of digital cameras due to their inherent cheaper production processes, the image quality produced with these sensors has not until recently been able to match the CCD chip.

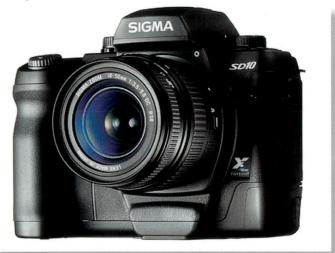

Sigma SD10 which is the latest camera to use the Foveon X3 chip

However, three companies have made important developments in their CMOS chip designs - Canon, Kodak and Foveon. All three have taken different approaches to their sensor design and manufacture, with Canon developing their latest 8 megapixel sensor completely in house, Kodak joining together with third parties to develop their new 13.7 megapixel full-frame offering and Foveon introducing its revolutionary 3.4 megapixel (effective 10.2 megapixel) X3 sensor which is capable of capturing color within all of its cells.

All three approaches to sensor technology have been incorporated into the latest cameras available from the main camera manufacturers (Foveon using the Sigma camera) and have raised the bar for quality and value. Although still with more noise issues in shadow areas than CCD chips, it is expected that CMOS chips will continue to increase market share as these problems are overcome.

Sensors in mobile phones

An area where CMOS chips have proliferated rapidly is in the introduction of mobile phones incorporating cameras. These devices are rapidly becoming the 'point and shoot' option of choice for the casual user with some able to take images up to 3 megapixels in size.

SLR style digital cameras

This group of digital cameras has in the past most often been designed around existing 35mm camera bodies, which are then adapted to accommodate the image sensor, the LCD screen and the associated hardware. However, digital SLR cameras (often referred to as DSLRs) are now usually designed 'from the ground up', although they still tend to conform to the usual film based camera control layouts. Menu driven digital options are however usually selected through buttons on the rear of the camera body, which usually incorporate camera set-up, image set-up and hardware controls as well as previews of the images captured on the card. One other extremely useful feature is the ability to view the tonal histogram of the image, which gives information as to the exposure and tonality of the captured shot. In addition it is usually possible to zoom into the image to determine sharpness and detail, although this can be difficult when working in brightly lit areas.

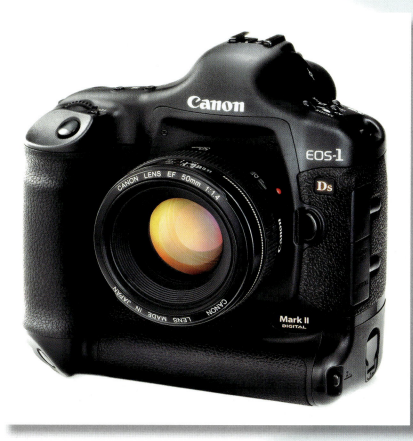

Canon EOS 1Ds Mark II

One camera that is defining the standards for this group, and in fact challenging many previously held ideas of camera formats and image quality, is the Canon 1Ds Mark II. This camera uses a full-frame CMOS sensor to capture a 16.7 megapixel image at up to 4 frames per second for 32 continuous shots.

An example of a high quality camera that is somewhat less expensive and more suitable for capturing fast action, is the similarly named Canon EOS 1D MkII. With an 8.4 megapixel CMOS sensor, this unit - one of the fastest available - can shoot at 8.5 frames per second for 20 frames in RAW capture mode. The speed of image capture that this camera is able to process, ensures it is well suited for shooting fast moving action. The 28.7mm x 19.1mm size sensor is approximately one quarter smaller than 35mm film, thereby resulting in an approximate 25% increase in the effective focal length of existing Canon lenses when used with this camera - good for telephoto usage, but not for wide angle views.

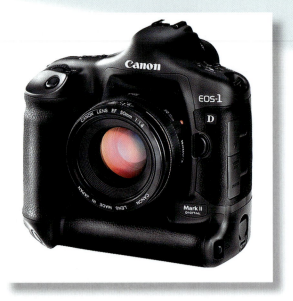

Canon EOS 1D MkII

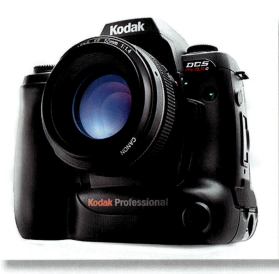

Kodak Pro SLR/C

By way of comparison, the Kodak Pro SLR/n uses a full frame 13.9 megapixel CMOS sensor and requires no adjustment to the effective focal length of existing lenses as it covers the entire 24mm x 36mm image area of 35mm film. The camera body can utilize all Nikon 'F' mount lenses whilst the SLR/C variant is designed to accommodate Canon lenses. Although this camera is not able to sustain rapid shooting to the extent of the Canon model (since it only delivers 5 frames per second for a maximum of 18 frames) the ability to effectively use wide angle lenses at their original focal length is a distinct advantage for the type of photographer who requires ultra-wide lens formats. At this stage, apart from the Canon EOS 1Ds MkII and the Kodak Pro SLR, most other cameras use a smaller than full-frame sensor.

One major advantage of these types of camera is the creative image control that is possible, since most camera features work similarly to their film based counterparts. With removable lenses and optical viewfinders, they are capable of producing photographic quality images with the same application of creativity and selection as is possible with any SLR style camera - with the added advantage of instantly being able to view the results. They can be used as stand alone units capturing fast action on location, as well as being equally at home under studio conditions shooting while tethered directly to a computer, to enable easy review and creative control.

Prosumer cameras

Not so long ago, digital cameras were most suitably categorized by the size of their sensors. However it is more appropriate these days to group cameras in terms of their general functionality, rather than just pixel size. An important category that has recently developed is the highly featured prosumer camera, which is typically easy to use, often including zoom lenses as well as programmed exposure control, and produces quality images via its multi-megapixel sensors.

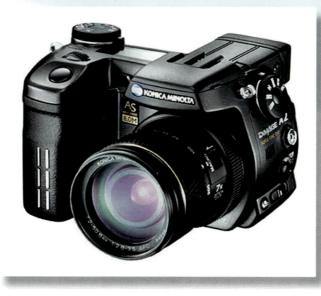

Minolta Dimage A2

These 3-8 megapixel cameras are finding a ready market with keen photographers wishing to embrace the digital age. Despite rapidly becoming more affordable, these mid priced cameras still cost more than their similarly featured, film based cousins. However, due to the huge competition in this sector of the market, their feature to cost ratio is increasing rapidly. Examples include the Olympus C-8080, Minolta Dimage A2, Fuji Finepix S20 Pro and the Canon PowerShot S1 - although new models are being released almost daily, each with more features and at a lower price-point.

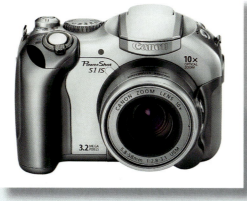

Canon PowerShot S1

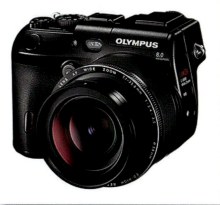

Olympus Camedia C-8080

Compact digital cameras

The most crowded area of digital camera development, this is the group of cameras that is changing the nature of popular photography. These cameras are usually fully automatic, with fixed or limited zoom lenses and resolutions of between three to five megapixels. Even though this group of digital cameras is usually more expensive than the equivalent film based versions, they are very affordable and becoming more so by the day.

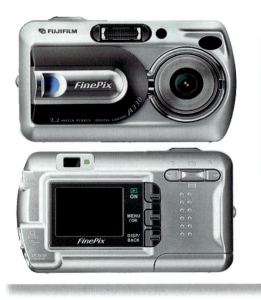

The convenience of being able to transmit pictures electronically, or at the very least see the results immediately, plus the ease of being able to print the images from on-line or in-store kiosks, or in the home; are encouraging the rapid acceptance of this technology as the new de-facto standard for domestic photography. Coupled with the fact that on-going costs for film, development and processing are removed, this technology is changing the way snapshooters are recording family, social and other significant moments in our lives. The ability to review - and of course delete - images has empowered a new generation of picture takers and is encouraging them to use photography more and more in their daily lives.

Fuji FinePix A330

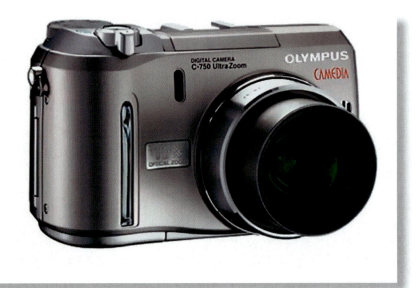

Olympus Camedia C–750

DIGITAL IMAGING >>> >>> essential skills >>>

Digital video cameras

Although we think of video and still photography as two very different and unrelated areas, technology is encouraging a blurring of that delineation, to the point where the same camera is able to capture both types of image. The latest digital video cameras already digitize each frame as it is captured, hence it is possible to select individual frames and use them as still photographic images. Given that video cameras shoot at 25 or 30 frames per second, you can imagine the range you have to choose from - a de-facto 'motorwind' for capturing fast action! The debit side is that the resolution of each frame is generally lower than the resolutions achievable with a dedicated still camera. You can however also record sound, for notes or narration, to help keep track of your shots.

Software, such as Pinnacle's Studio 9, offers easy editing of the video capture and enables transformation of video into still images ideal for web page use - as single images, 360 degree panoramas or even animated GIFs. To complicate matters further, many digital cameras can capture short bursts of video in addition to still images. Add to this the ability to also capture sound and the multi-function digital camera is a technology whose time has definitely come.

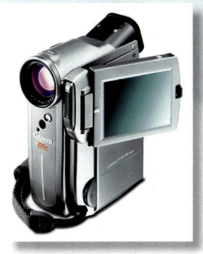

Canon Optura 300 digital video camera

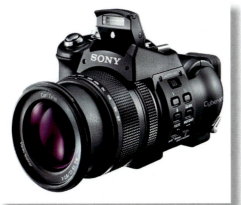

Current examples of this 'all in one' camera are the Sony Cybershot DCS range, but the list is growing rapidly and most prosumer digital camera manufacturers have similar offerings. Without doubt however, as the technology improves, the ease of use and flexibility of such cameras will no doubt ensure that these hybrids become more and more popular.

Sony Cybershot DCS F 828

ACTIVITY 1

Make a list of various digital cameras you are able to find information about, and decide into which category they would belong.
Consider under what circumstances (or type of use) each digital camera may be most appropriate. Make a list of possible photographic activities and categorise each camera as being suitable or unsuitable. In addition, determine the cost of each camera and decide which is the most cost effective option.

Choosing a digital camera

So far in our discussion we have examined one of the more important aspects of digital cameras (apart from price), namely the image sensor and construction. But what other features are important when comparing digital cameras? As new cameras are released, the specifications and feature list seem to grow - without always giving the consumer information that can be readily understood or easily compared. What then are the really important aspects to look for in a digital camera? Starting with image quality and resolution issues, let us examine the important features.

Pixel count

This critical aspect of any digital camera does not rely exclusively on the number of pixels within the sensor, but also on the way the color image is created (see 'Color sensors', page 31). Generally speaking the more pixels, the higher the resolution of the image and the larger the print that can be made from the image. However, the situation is complicated by some manufacturers who have produced more complex chip designs with multiple photo sites designed to better capture the image information. In this regard when comparing resolution it is important to note the 'true resolution' of pixels rather than an 'interpolated or effective resolution'. An interpolated figure can be disputable, as it relies on the creation of pixel data by algorithms within the camera's hardware - and is therefore open to debate when comparing specifications.

An example of this type of camera is the Fuji FinePix S3 Pro, which has a 6.17 megapixel CCD sensor and utilizes Nikon F mount lenses. This particular camera uses a specially constructed pixel array that instead of being rectangular, is octagonal in shape. Within each pixel are two photosites designed to capture different parts of the brightness range of the scene, which are then combined to produce the final image. This leads to Fuji claiming that images captured with this camera are crisp, highly detailed image files of 12.3 megapixels resolution. Whilst the quality claim may be so, an 'apples with apples' comparison with other traditional types of sensor would be more consistent with a claim of 6.17 megapixel resolution.

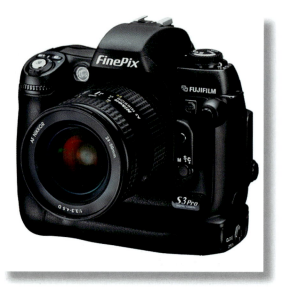

Fuji FinePix S3 Pro

The same issue is also relevant but in the opposite way, when considering the Sigma SD10 which uses the Foveon X3 sensor. This sensor has a resolution of 3.4 megapixels, but it can be claimed that due to the ability of the sensor to capture color information with each pixel (rather than using three pixels to create color as occurs with most conventional chips) it has a true resolution for comparison purposes of 10.2 megapixels. (Note also that the edge pixels in an array are not usually used in the final image and if counted in the camera's specifications can give a slightly inflated figure.)

Bit depth

In addition to the pixel resolution, the 'bit depth' of each pixel is a measure of how many shades of gray each pixel is able to discern. An 8-bit depth is equivalent to 256 different shades (or tones) and is the norm for full color imaging, but a higher figure (10 or even 12-bit) will lead to an increase in image quality. This bit depth allows for losses sustained in any processing or later manipulation of the data.

Note > A full color image is created by the addition of the red, green and blue components of light and so an 8-bit color depth creates a 24 bit (8 x 3) color image.

Sensor size and aspect ratio

As mentioned earlier in this chapter, most digital cameras have sensors that are smaller than 35mm film. These vary in size and have various aspect ratios, although some manufacturers have standardized on a 4:3 ratio. This is sometimes referred to as a 4/3 type sensor.

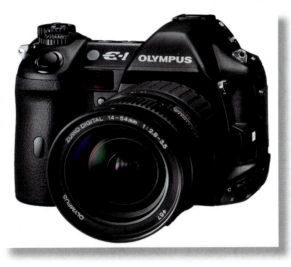

Olympus E1

It may at first appear that there is not any real disadvantage to having a smaller sensor, as the image will be magnified to the limits of its resolution anyway. However, one issue with a smaller sensor chip is that it has to use very small photo-diode sensor sites, which themselves tend to generate more noise. In addition, if the sensor has to produce a live preview, that is the camera does not have an optical viewfinder for viewing purposes and relies on a digitally created image on the LCD, this too tends to create more noise - as well as greater drain on the battery. However, one advantage for cameras with these types of sensor, is that they are also able to capture short bursts of video - a common feature in the more consumer oriented sector of the market. Small sensors also mean that shorter focal length lenses are needed to give the same field of view as cameras with larger sensors or for 35mm film. This results in a larger depth of field, which means that more of the image is in focus. This may not seem to be a problem at first, but can be contrary to the creative requirements of the shot.

Note > A further disadvantage of a smaller sensor size is the larger magnification required for any given image size, which increases the necessity for a high quality, sharp lens.

Lens design

Whilst some digital cameras come equipped with the same lenses as film based cameras, the sometimes novel design of the camera body allows for other innovations such as swivelling or rotatable lenses. Many digital cameras also come equipped with a zoom lens. These zoom lenses have had to seriously shrink in order for them to be incorporated into the body of the camera. The important aspect of any zoom lens however, is the optical rather than the digital zoom range, as a digital zoom is nothing more than an enlargement of a section of the frame - something that can be achieved with any editing program. DSLRs have interchangeable lenses and so offer a wide range of both fixed and zoom focal lengths. A trend that is becoming prevalent is the production of specially designed lenses specifically made for DSLRs.

Olympus 11-22mm f 2.8 zoom lens

One issue that can affect lens performance with digital cameras is that of sharpness - especially at the edges of the frame. This occurs because the light is not falling at right angles to all parts of the sensor due to the lens bending the rays of light at an angle in order to achieve coverage. Digital lenses are designed to ensure that light strikes the sensor directly, resulting in a sharper, brighter image, even at the edges. Such lenses are also designed specifically with the smaller sensor sizes in mind and thus cover only the reduced area of the chip. Of further importance is the trend of incorporating an image stabilizer within the lens itself. A stabilizer contains two small solid-state gyro sensors that are installed in the lens elements. Unlike old fashioned gyros that were large, heavy, externally mounted devices, today's image stabilizers fit into the lens and are powered by the camera. They become fully functional within a second or so of activation.

Pentax 16-45mm f 4.0 zoom lens

Camera buffer

The buffer in a digital camera acts as a random access memory (RAM) and stores the image before it is written to the storage card. This improves the efficiency of the camera and allows for a series of images to be taken in rapid succession, without having an annoying wait after each frame has been taken - as occurred in many earlier digital cameras. The buffer can be incorporated within the camera either before or after processing. If before processing, the unprocessed data is held until it is full, or until the camera is not taking any further images at which time the processing occurs and the data written to the memory card. If after processing, the captured data is processed and held until the buffer is full or until the camera stops taking images, at which time it is written to the card.

Note > An after processing buffer will hold more pictures if a lower image quality is selected, thus enabling the camera to perform longer in burst mode.

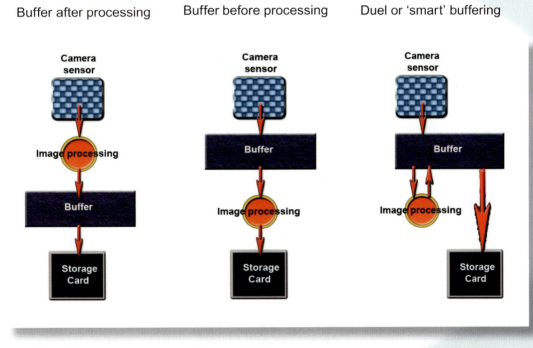

Diagram showing the three common forms of buffer usage in digital cameras

A recent innovation found in some cameras is the use of a larger buffer, to both store the data before processing as well as after processing. This avoids the necessity to immediately write the image data to the card, which is the slowest of the camera's functions, thus shortening the response time of the camera.

Note > Larger buffers allow writing to the card in parallel with further processing, thereby allowing the camera to continue functioning and taking further pictures.

Response times and shutter lag

One aspect of digital cameras that can be a disadvantage is their inability to respond quickly. Some cameras require quite a few seconds after start-up before they are in a ready state, so that a picture can actually be taken. This can sometimes mean the difference between getting the shot or missing out completely. Equally problematic can be the time taken from the moment of pressing the shutter button, to the camera actually taking the picture. This time delay, known as shutter lag can have a number of causes:

~ A small on-board buffer (see previous section) which fills readily resulting in the data having to be processed, written to the memory card, or both.
~ A slow on-board computer within the camera's electronics.
~ The time taken for the auto focus mechanism to activate and focus.
~ The time taken for the camera computer to 'wipe' the previous image from the sensor.

Any of these factors can result in an irritating delay between the intention of taking a picture and the camera actually responding. The loss of 'decisive moment' can even in some cases extend to the loss of the shot completely! This effect is generally more noticeable in lower priced compact digital cameras and generally within acceptable limits in most DSLRs. However, it always pays to test drive any digital camera before purchase, to ensure that any delays are not excessive and the camera responds as expected.

File formats and compression

The greater compression applied to an image, the greater the number of images that can be stored in the camera buffer or on the memory card. However, lossy style compression (as found with JPGs) will degrade the image to some degree - the more compression, the more degradation. In fact, as discussed in later chapters, saving the file in RAW format (also sometimes referred to as DNG or other similar proprietary acronyms) can result in rather large files even though a certain amount of lossless compression usually occurs when saving. Generally, the following types of file formats are used by digital cameras, each with their own advantages and disadvantages:

File type	Lossy compression	Lossless compression	No compression	Quality	File size
Low quality JPG	Yes			Low	Smallest
Medium quality JPG	Yes			Medium	Small
High quality JPG	Yes			High	Medium
RAW		Yes		Highest	Largest
Uncompressed TIFF			Yes	Highest	Large

Table showing benefits associated with various digital file formats

From the above table, it is clear that the quality trade-off between larger files, and smaller, more compressed files, needs to be considered not only in light of how many images can be stored on a memory card, but also on the end usage and purpose of the images.

Memory cards

The buffer storage capacity of the camera is not sufficient to hold all the images that may be taken in a normal session of image capture. This problem is solved by digital cameras incorporating removable internal memory cards.Think of these as similar to rolls of film, which can be removed and replaced by another when full. There are many different types of card available and it is important to consider what type of card a camera uses, as they are not interchangeable. Although memory cards are reusable, they don't have a limitless capacity so it is important to have a number available - and of sufficiently large capacity.

> The memory card supplied with most digital cameras is usually too small in capacity to be of any great use, although the camera won't operate without one. It is generally necessary to purchase extra cards, preferably with a larger capacity.

There is a large number of cards available on the market today, with varying capacity and varying write speeds. The following is a breakdown of the main types:

CompactFlash cards

CompactFlash is one of the most common types of digital camera memory. Most prosumer digital cameras, and all digital DSLRs are CompactFlash compatible. There are two physical sizes of CompactFlash - Type I and Type II. Type II is thicker and of a higher capacity, but some cameras will not accept them. The main benefit of CompactFlash, besides availability, is that it has a controller chip in the card which allows for higher transfer speeds. Some cameras however are not set up to take advantage of this extra speed, although cameras with larger internal buffers, usually DSLRs and some prosumer models, do take advantage of this feature. CompactFlash is relatively inexpensive, readily available, quite robust and fits many digital cameras. As a result, although they will eventually wear out with use, they are one of the most desirable types of digital camera memory.

CompactFlash cards are manufactured by many companies, as are inexpensive USB card readers

essential skills >>> >>> DIGITAL IMAGING >>>

MicroDrives

The MicroDrive card is actually a miniature hard drive housed in a Type II CompactFlash body and so is compatible with CompactFlash. Although flash memory has now bypassed the MicroDrive in capacity, the MicroDrive is still the best value, large capacity storage card available. However, they do have a reputation for being delicate and prone to failure, since they have moving parts that can wear, or be damaged if dropped. Because of these mechanical parts, MicroDrives use more battery power than flash memory and compared to new, high-speed CompactFlash cards, MicroDrive transfer times can be fairly slow.

MicroDrive with reader

MultiMedia and SD cards

Amongst the smaller memory cards currently available, MultiMedia and Secure Digital memory are designed for compact cameras and are often used in PDAs, organizers, phones, and MP3 players. As a result of their lower capacity, they are generally not used in larger prosumer or DSLR type cameras. The main difference between these two memory types is that Secure Digital cards have a write-protect switch and encryption capabilities for added data security. This has implications for devices as diverse as home security and in-car navigation systems.

Secure Digital memory card

Sony Memory Stick

Memory Stick

The Memory Stick was developed by Sony for their CyberShot digital camera range as well as other Sony electronic devices. Unfortunately, the Memory Stick is only compatible with Sony digital cameras, which means that if you decide to purchase another brand of camera, the Memory Stick cards you own are not likely to be of any use. Sony MP3 players and PDAs also accept Memory Sticks however, so they may be of use in those devices.

xD-Picture Cards

The xD-Picture Card is the most recent memory card format and the smallest, with a size of 20mm x 25mm by 1.7mm thick. With a size that enables it to be used in ultra compact cameras, it can also be used in CompactFlash compatible devices with an available adapter. This format was developed and introduced together by Olympus and Fuji, so most current compact digital cameras from those manufacturers use xD-Picture Card media.

Olympus xD-Picture Card

SmartMedia

SmartMedia used to be one of the most common types of digital camera storage media. They were used in most Olympus and Fuji digital cameras until the introduction the xD-Picture Card and although is being phased out, should still be available for some time. These cards are thinner than CompactFlash cards, but despite their smart name, they lack any on-card memory controller chip and so require more complex camera electronics.

120Mb SmartMedia Card

The Sandisk ImageMate 8 in 1 Card reader

The type of storage media is frequently often determined by the camera - although it may be smarter to choose the camera depending on the media it accepts! The most common (and at this stage the largest capacity) available, are CompactFlash cards. Unless you wish to share cards with other devices or other compact cameras, this would usually be the card media of choice. To transfer the data from the card to the computer requires some form of card reader unless the data is transferred directly via firewire cable or docking station. Some computers - especially laptops - have card readers built in, but if needed an external device can be easily connected to any computer via a USB port. The most convenient of these devices are able to read multiple card formats and are able to deal with any memory cards that may be in use.

Computer interface

Aside from using the portable memory card within the camera, the ease with which files can be transferred to the computer via a direct link is also of paramount importance - particularly for larger image files. The interface itself will control the speed of the file transfer and must be compatible with the computer operating system. These days the main interface types are:

~ USB II port: fast transfer, widely available on newer computers - Mac and PC
~ USB I port: USB interface often found in older computers, but much slower than USB II
~ Firewire port: fastest transfer but only found on some systems.

The speed and flexibility of file transfer is a major consideration as far as workflow is concerned, as the number of images and hence the size of files can grow very rapidly. Whereas film itself is a natural storage medium, to archive digital images usually requires downloading the files, some form of digital 'album' style organization for ease of review and later access, as well as subsequent burning onto CD or other storage media. New interface options, such as the docking station mentioned previously, are being developed to make this process easier and more automated. Some digital cameras have connections for displaying images via a television set, whilst camera/ printer combinations allow printing without the need for a computer, with the storage card being able to be placed directly into the printer.

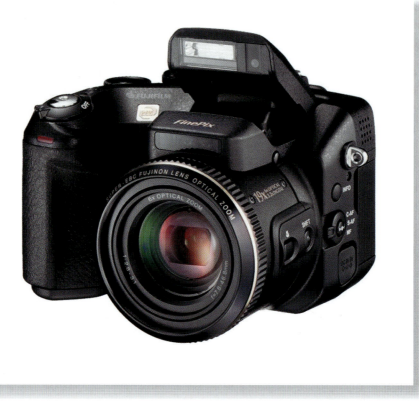

Fuji FinePix S7000

Sensitivity

Unlike with a film based camera, where it is simple to change the type of film to deal with various lighting situations, a digital camera only has one sensor. The sensor therefore needs to be adaptable and be able to function at various ISO equivalents. However, small sensors do not deal well with higher ISO values, as they are much more prone to noise due to the size and proximity of the sensor sites on the chip. Whilst most entry level cameras have an ISO range of at least 100-400 ISO, the more expensive DSLRs and even some prosumer cameras, will have ratings as high as 3200 or even 6400 ISO. Of course the higher the ISO, the more 'gain' is applied by the electronics amplifying the signal, which also has the effect of amplifying the noise. In an attempt to make life easier, some cameras even take the decision away from the photographer by automatically choosing the optimum ISO setting depending on the lighting conditions and the exposure mode selected.

> Higher ISOs effectively mean more noise, especially in shadow areas of the image - a trade off that is familiar to photographers shooting film.

Viewfinder

One important difference between digital cameras is whether they have an optical viewfinder, rely on a 'live' LCD screen, or perhaps even use an electronic viewfinder (similar to a video camera) for viewing and framing purposes. An optical viewfinder on a DSLR is the same as on an SLR film camera. It uses a prism and mirror mechanism to allow viewing of exactly the same scene as the lens can see. However, other optical viewfinders on smaller digital cameras tend to suffer from parallax error - especially at close distances. This is because the positioning of the viewfinder on the camera is at a different point to that of the lens. As a result, some cameras have an LCD screen with 'live preview', however these can be difficult to see in bright sunlight and tend to consume considerable battery power.

There can also be a time lag associated with these displays, since the image has to constantly re-draw as the camera is moved, which can make shooting moving subjects almost impossible. Resolution can also be a problem, especially for fine detail, when compared to an optical viewfinder. One advantage they do have however, is that they can be swivelled and rotated away from the camera body to enable the camera to be used in very difficult and restricted situations.

Canon PowerShot with LCD viewfinder

An alternative to the LCD is the electronic viewfinder found on more expensive prosumer cameras. Although quicker to respond, and sometimes sharper than LCDs, they still do not compare to the true optical viewfinders found in DSLRs.

49

Power source

Modern day digital cameras have at their heart a power usage that is insatiable. Although camera power management and consumption vary greatly depending on factors such as autofocus mechanisms, LCD displays, shutter mechanisms and even temperature, there is no doubt that long battery life and quick battery recharge are essential ingredients for all digital cameras.

Alkaline batteries are quite inexpensive, but can be consumed extremely rapidly and are not rechargeable. As a result, a camera that relies on this type of power source can become expensive and inconvenient in the longer term. Rechargeable batteries vary from the memory prone 'NiCd', the better performing 'NiMH', the newer, longer lasting but more expensive 'LiOn', as well as 'MnLi'. Fortunately battery technology is constantly improving, as is the ability of digital cameras to consume less power.

Nikon SQ with recharging docking station

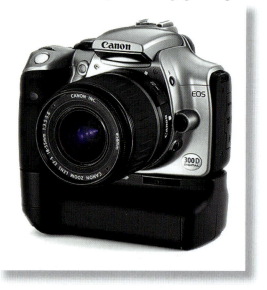

An AC adapter that allows mains power usage when the batteries are dead is also important, even though the unit then becomes tethered - at least the camera is still able to operate. Also convenient are cameras that can sit in a cradle or docking station while they recharge, or as a minimum are able to accommodate the removable batteries from the camera. Be sure to check the camera comes with a spare battery, otherwise its purchase will have to be factored into the price, as at least one spare is essential.

Battery grip on Canon EOS digital camera

Bundled software

All digital cameras come with some kind of software bundle to get you started. Almost always, these are very limited, basic programs or pared down 'special' editions of more powerful software that is available. As a minimum however, software to control the taking, preview and storage of the images will be included. However, some cameras also include a download utility, an album style management system, a panoramic stitching type program, or even manipulation software such as Photoshop Elements. At the higher end, the camera or digital back should come with software to control its operation, manage the created files, as well as a RAW format editor. Whether you actually end up using this software or not, it is a good idea to factor in and compare the cost of this extra software in relation to the overall camera price.

Size and weight

The features that a photographer would want from a camera depend very much on the purpose to which that camera will be put. If you are a fashion photographer you may prefer a full frame DSLR, or if you are a sports photographer you would want an ultra fast smaller chip DSLR. On the other hand a photojournalist may prefer the convenience of a well featured prosumer digital camera, whilst someone interested in candid portraiture may want the inconspicuousness offered by a compact digital camera. A commercial advertising photographer may even be able to justify the price tag and require the power and quality of a medium format digital back.

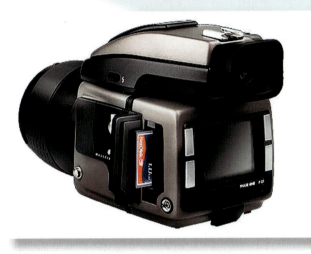

Phase One P25 medium format back

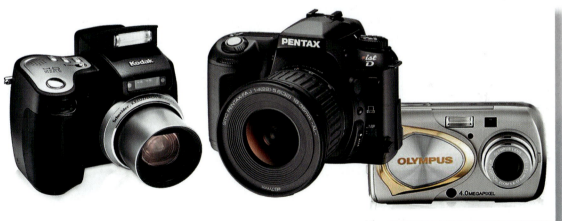

Choose a camera that best suits the purpose

Whatever the outcome, the overall package must suit your individual needs - and it must feel right! Ensure the specifications are appropriate for you, ensure the camera build quality is durable enough for the work you intend to put it through and make sure its size and weight suit your goals. The overall quality, suitability, weight, and bulk (or otherwise) of the package as a whole, all need to be considered as part of the equation - and they will remain long after the specific technical details have been forgotten.

Saville Coble

digital negatives

Sam Everton

essential skills

~ Capture high quality digital images as camera RAW files.

~ Process a camera RAW file to optimize color, tonality and sharpness.

~ Use camera RAW settings to batch process images for print and web viewing.

Introduction

One of the big topics of conversation since the release of Photoshop CS and Elements 3 has been the subject of 'RAW' files and 'Digital Negatives'. This chapter guides you through the advantages of choosing the RAW format and the steps you need to take to process a RAW file from your camera in order to optimize it for final editing in Adobe Elements 3 or Photoshop CS/CS2.

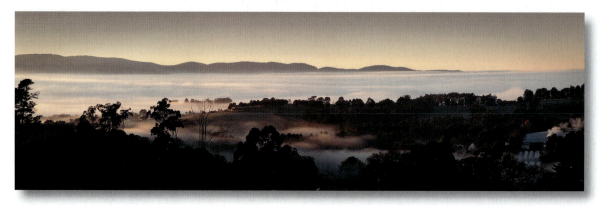

All digital cameras capture in RAW but only Digital SLRs and the medium to high end 'Prosumer' cameras offer the user the option of saving the images in this RAW format. Selecting the RAW format in the camera instead of JPEG or TIFF stops the camera from processing the color data collected from the sensor. Digital cameras typically process the data collected by the sensor by applying the white balance, sharpening and contrast settings set by the user in the camera's menus. The camera then compresses the bit depth of the color data from 12 to 8 bits per channel before saving the file as a JPEG or TIFF file. Selecting the RAW format prevents this image processing taking place. The RAW data is what the sensor 'saw' before the camera processed the image, and many photographers have started to refer to this file as the 'digital negative'.

Camera Raw

The sceptical amongst us would now start to juggle with the concept of paying for a 'state-of-the-art' camera to collect and process the data from the image sensor, only to stop the high-tech image processor from completing its 'raison d'être'. If you have to process the data some time to create a digital image why not do it in the camera? The idea of delaying certain decisions until they can be handled in the image-editing software is appealing to many photographers, but the real reason for choosing to shoot in camera RAW is QUALITY.

Processing RAW data

The unprocessed RAW data can be converted into a usable image file format by the latest image-editing software from Adobe. Variables such as bit depth, white balance, brightness, contrast, saturation and sharpness can all be assigned as part of the conversion process. Performing these image-editing tasks on the full high-bit RAW data (rather than making these changes after the file has been processed by the camera) enables the user to achieve a higher quality end-result. Double-clicking a RAW file opens the camera RAW dialog box where the user can prepare and optimize the file for final processing in the normal image-editing interface. If the user selects the 16 Bits/Channel option, the 12 bits per channel data from the image sensor is rounded up - each channel now capable of supporting 32,769 levels instead of the 256 we are used to working with in 8 bits per channel. Choosing the 16 Bits/Channel option enables even more manipulation in the main editing space without the risk of degrading the image quality. When the file is opened into the image-editing workspace of your Adobe software the RAW file closes and remains in its RAW state, i.e. unaffected by the processing procedure.

Processing activity - images on supporting CD

Although the camera RAW dialog box appears a little daunting at first sight, it is reasonably intuitive and easy to master, and then RAW image processing is a quick and relatively painless procedure. The dialog box has been cleverly organized by Adobe so the user starts with the top slider and works their way down to the bottom control slider. If the image you are processing is one of a group of images shot in the same location, and with the same lighting, the settings used can be applied to the rest of the images as an automated procedure.

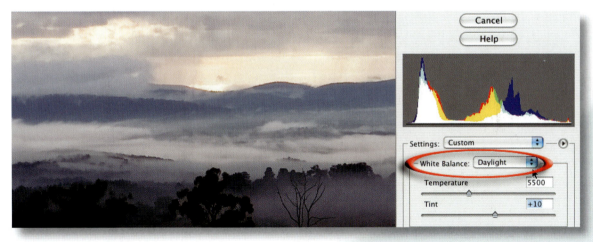

White balance - *Step 1*

The first task is to set the white balance by choosing one of the presets from the drop-down menu. If a white balance was performed in the camera the 'As Shot' option can be selected. If none of the presets adjust the color to your satisfaction you can manually adjust the 'Temperature' and 'Tint' sliders to remove any color cast present in the image. The 'Temperature' slider controls the blue/yellow color balance whilst the 'Tint' slider controls the green/magenta balance. Moving both the sliders in the same direction controls the red/cyan balance.

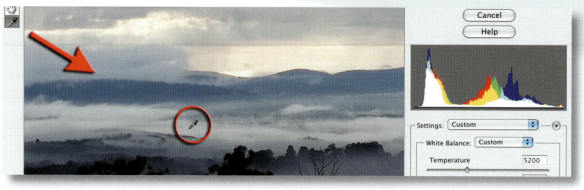

Alternatively you can simply click on the 'White Balance' eyedropper in the small tools palette (top left-hand corner of the dialog box) and then click on any neutral tone you can find in the image.

Note > Although it is a 'White Balance' you actually need to click on a tone that is not too bright. Clicking on a light or mid gray is preferable. A photographer looking to save a little time later may introduce a 'gray card' in the first frame of a shoot to simplify this task.

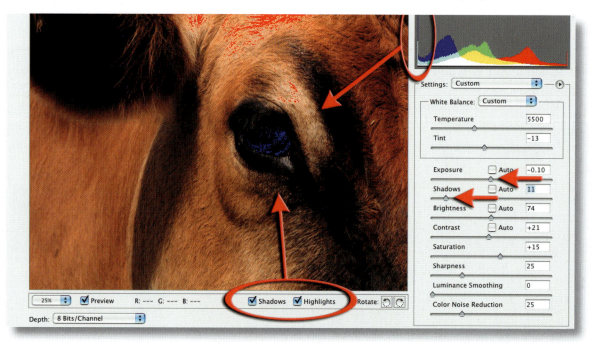

Tonal adjustments - *Step 2*

Set the tonal range of the image using the 'Exposure', 'Shadows' and 'Brightness' sliders. These sliders behave like the input sliders in the 'Levels' dialog box and will set the black and white points within the image. The 'Brightness' slider adjusts the midtone values in a similar way to the 'Gamma' slider when using 'Levels' dialog. When tall peaks appear at either end of the histogram you will lose shadow, highlight or color detail when you export the file to the main editing software. Careful adjustment of these sliders will allow you to get the best out of the dynamic range of your imaging sensor, thereby creating a tonally rich image with full detail.

Clipping information

Hold down the 'Alt/Option' key when adjusting either the 'Exposure' or 'Shadows' slider to view the point at which highlight or shadow clipping begins to occur (the point at which pixels lose detail in one or more channels). In Elements 3 you can check the 'Shadows' and 'Highlights' boxes underneath the main image window instead of holding down the Alt or Option key.

Note > If you hold down the 'Alt' or 'Option' key to view the clipping, the color that appears in the image window indicates the channel or channels where clipping is occurring (this only applies to the Alt/Option key technique). Color Saturation as well as overly dark shadows and overly bright highlights will also influence the amount of clipping that occurs. Clipping in a single channel (indicated by the red, green or blue warning colors) will not always lead to a loss of detail in the final image. When the secondary colors appear, however (cyan, magenta and yellow), you need to take note, as loss of information in two channels starts to get a little more serious. Loss of information in all three channels (indicated by black when adjusting the shadows and white when adjusting the exposure) should be avoided at all costs.

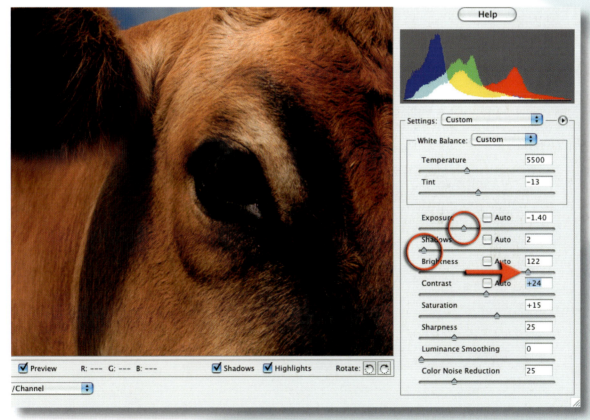

By moving the Exposure and Shadow sliders to the left, information is restored to the blue and red channels. The image is then made brighter using the Brightness slider.

Note > Large adjustments to the 'Brightness', 'Contrast' or 'Saturation' sliders may necessitate further 'tweaking' of the 'Exposure' and 'Shadows'.

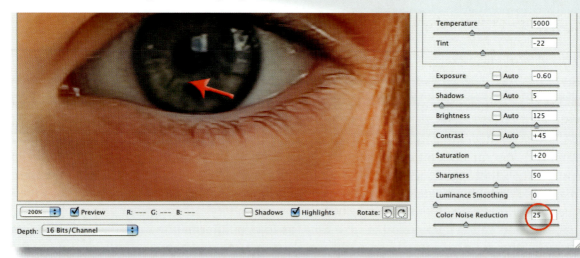

Noise reduction and sharpening - *Step 3*

If you intend to carry on enhancing or manipulating the image in the main editing space of your Adobe software it is recommended that you only perform a gentle amount of sharpening in the RAW dialog box (less than 25). The Luminance Smoothing and Color Noise Reduction sliders (designed to tackle the camera noise that occurs when the image sensors' ISO is high) should only be raised from 0 if you notice image artifacts such as noise appearing in the image window.

Note > The Luminance Smoothing and Color Noise reduction sliders are featured directly below the Contrast and Saturation sliders in Elements 3. In Photoshop they are organized in a separate tab behind the color and tone sliders.

WARNING > The current default setting of 25 for the 'Color Noise Reduction' slider can remove important color detail that may go unnoticed if the photographer is not careful to pay attention to the effects of these sliders. Zoom in to take a closer look, and unless you can see either little white speckles or color artifacts set these sliders to 0.

Choosing a bit depth - *Step 4*

The only step that remains is to select the 'Depth' in the lower left-hand corner of the dialog box and then click 'OK'. If the user selects the 16 Bits/Channel option, the 12 bits per channel data from the image sensor is rounded up – each channel is now capable of supporting 32,769 levels. In order to produce the best quality digital image, it is essential to preserve as much information about the tonality and color of the subject as possible. If the digital image is edited further in 8 bits per channel the final quality will be compromised. If the digital image has been corrected sufficiently for the requirements of the output device in the RAW dialog box the file can be edited in 8-bit mode with no apparent loss in quality. Sixteen-bit editing, however, is invaluable if maximum quality is required from an original image file that requires further or localized editing of tonality and color after leaving the camera RAW dialog box.

The problem with 8-bit editing

As an image file is edited extensively in 8 bits per channel mode (24-bit RGB) the histogram starts to 'break up', or become weaker. 'Spikes' or 'comb lines' may become evident in the resulting histogram after the file has been flattened.

Note > The least destructive 8-bit editing techniques make use of adjustment layers so that pixel values are altered only once, when the layers are flattened prior to printing.

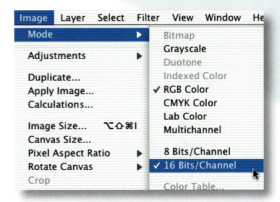

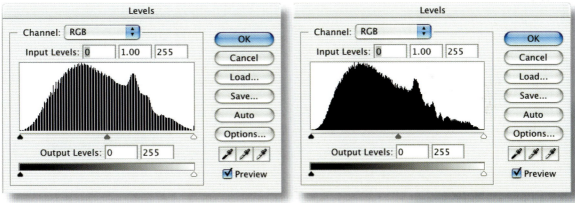

Final histograms after editing the same image in 8 and 16 bits per channel mode

The problem with editing extensively in 8-bit mode is that there are only 256 levels or tones per channel to describe the full color range of the image. This is usually sufficient if the histogram looks healthy (few gaps) when we begin the editing process and the amount of editing required is limited. If many gaps start to appear in the histogram as a result of extensive adjustment of pixel values this can result in 'banding'. The smooth change between dark and light, or one color and another, may no longer be possible with the data supplied from a weak histogram. The result is a transition between color or tone that is visible as a series of steps in the final image.

Advantages and disadvantages of 16-bit editing

When the highest quality images are required there are major advantages to be gained by using Photoshop or Elements 3 to edit an image file in '16 bits per channel' mode. In 16 bits per channel there are trillions, instead of millions, of possible values for each pixel. Spikes or comb lines, which are quick to occur whilst editing in 8 bits per channel, rarely occur when editing in 16 bits per channel mode. Photoshop CS/CS2 has the ability to edit an image in 16 bits per channel mode using layers and all of the editing tools whilst Elements 3 supports only a single layer when editing in 16 bits per channel. The disadvantages of editing in 16 bits per channel are:

- Not all digital cameras are capable of capturing in the RAW format.
- File sizes are doubled compared to 8-bit images with the same pixel dimensions.
- Many filters do not work in 16 bits per channel mode.
- Only a small selection of file formats support the use of 16 bits per channel.

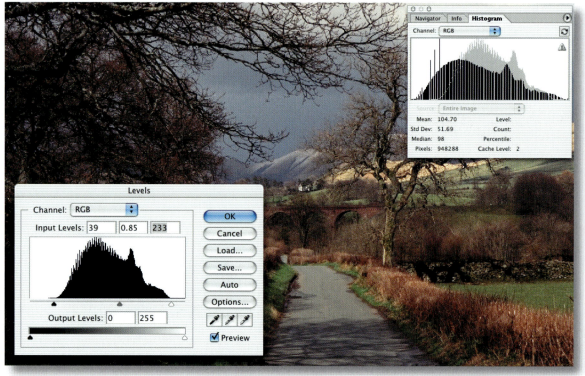

The comb lines that appear in the histogram palette (CS/CS2 and Elements 3) will disappear when the uncached view is selected when editing in 16 bits per channel

Editing in 16 bits per channel

It is still preferable to make major changes in tonality or color in the RAW dialog box or in 16-bit mode before converting the file to 8-bit mode. Most of the better scanners that are now available (flatbed and film) now support 16 bits per channel image capture. Remember, you need twice as many megabytes as the equivalent 8-bit image, e.g. if you are used to working with 13 megabytes for a full-page image (8in x 10in @ 240ppi) you will require 26 megabytes to work with the same pixel dimensions in 16 bits per channel.

Choosing a color space - *Step 5*

Elements users do not get a choice in the RAW dialog box as to the color space the image will be opened in when OK is selected. The color space of the resulting image is determined by the Color Settings in the software preferences. If full Color Management has been selected the image will have the Adobe RGB color space embedded. If No Color Management or Limited Color Management is selected the image will acquire the sRGB color space. For images destined for print the preferred option is Full Color Management.

Photoshop CS/CS2 users can choose the profile that suits their current workflow. A new addition to the list is ProPhoto. This is a wide gamut color space and is the default editing space used by the camera RAW plug-in.

The wide gamut ProPhoto space (white) compared to the Adobe RGB 1998 space (color)

Note > The ProPhoto color space should only be selected if you have access to a print output device with a broad color gamut. The profile is suitable for users who are intending to stay in 16 Bits/Channel for the entire editing process and who have access to a print output device with a broader color gamut than traditional CMYK devices are capable of offering.

Additional information

Distribution of data

Most digital imaging sensors capture images using 12 bits of memory dedicated to each of the three color channels, resulting in 4096 tones between black and white. Most of the imaging sensors in digital cameras record a subject brightness range of approximately five to eight stops (five to eight f-stops between the brightest highlights with detail and the deepest shadow tones with detail).

Tonal distribution in 12-bit capture

Darkest Shadows	- 4 stops	- 3 stops	- 2 stops	-1 stop	Brightest Highlights
128 Levels	256	512	1024	2048	4096 Levels

Distribution of levels

One would think that with all of this extra data the problem of banding or image posterization due to insufficient levels of data (a common problem with 8-bit image editing) would be consigned to history. Although this is the case with midtones and highlights, shadows can still be subject to this problem. The reason for this is that the distribution of levels assigned to recording the range of tones in the image is far from equitable. The brightest tones of the image (the highlights) use the lion's share of the 4096 levels available whilst the shadows are comparatively starved of information.

An example of posterization or banding

Shadow management

CCD and CMOS chips are, however, linear devices. This linear process means that when the amount of light is halved, the electrical stimulation to each photoreceptor on the sensor is also halved. Each f-stop reduction in light intensity halves the amount of light that falls onto the receptors compared to the previous f-stop. Fewer levels are allocated by this linear process to recording the darker tones. Shadows are 'level starved' in comparison to the highlights that have a wealth of information dedicated to the brighter end of the tonal spectrum. So rather than an equal amount of tonal values distributed evenly across the dynamic range, we actually have the effect as shown above. The deepest shadows rendered within the scene often have fewer than 128 allocated levels, and when these tones are manipulated in post-production Photoshop editing there is still the possibility of banding or posterization.

Expose right and adjust left

'Expose right' and multiple exposures

This inequitable distribution of levels has given rise to the idea of 'exposing right'. This work practice encourages the user seeking maximum quality to increase the exposure of the shadows (without clipping the highlights) so that more levels are afforded to the shadow tones. This approach to make the shadows 'information rich' involves increasing the amount of fill light or lighting with less contrast in a studio environment. If the camera RAW file is then opened in the camera RAW dialog box the shadow values can then be reassigned their darker values to expand the contrast before opening it as a 16 Bit/Channel file. When the resulting shadow tones are edited and printed, the risk of visible banding in the shadow tones is greatly reduced.

Separate exposures can be combined in image-editing in Photoshop or Elements

This approach is not possible when working with a subject with a fixed subject brightness range, e.g. a landscape, but in these instances there is often the option of bracketing the exposure and merging the highlights of one digital file with the shadows of a second. The example above shows the use of a layer mask used to hide the darker shadows in order to access the bit-rich shadows of the underlying layer and regain the full tonal range of the scene. See *Essential Skills: Photoshop CS2* for detailed post-production editing techniques.

Batch processing

The settings you have used in the camera RAW dialog box can then be used for all the images captured in the same lighting using the automate option in the 'File Browser' (Elements and CS) or from the Edit menu in Bridge (CS2). Hold down the Control key (Command key on a Mac) and click on each image you wish to adjust using these settings and then select 'Apply Camera Raw Settings' from the 'Automate' menu.

Archiving digital negatives

Working with camera RAW files is going to create some extra strain on the storage capacity found on a typical computer's hard drive. What to do with all of the extra gigabytes of RAW data is a subject that people are divided about. You can burn them to CD or DVD discs - but are the discs truly archival? You can back them up to a remote FireWire drive - but what if the hard drive fails? Some believe that digital tape offers the best track record for longevity and security. Why archive at all you may ask? Who can really tell what the image-editing software of the future will be capable of - who can say what information is locked up in the RAW data that future editions of the RAW editors will be able to access. Adobe has now created a universal RAW file format called DNG (Digital Negative) in an attempt to ensure that all camera RAW files (whichever camera they originate from) will be accessible in the future.

The Adobe DNG converter is available from the Adobe web site or from the supporting CD. The converter will ensure that your files are archived in a format that will be understood in the future. Expect to see future models of many digital cameras using this DNG format as standard. One thing is for sure - RAW files are a valuable source of the rich visual data that many of us value - and so the format will be around for many years to come.

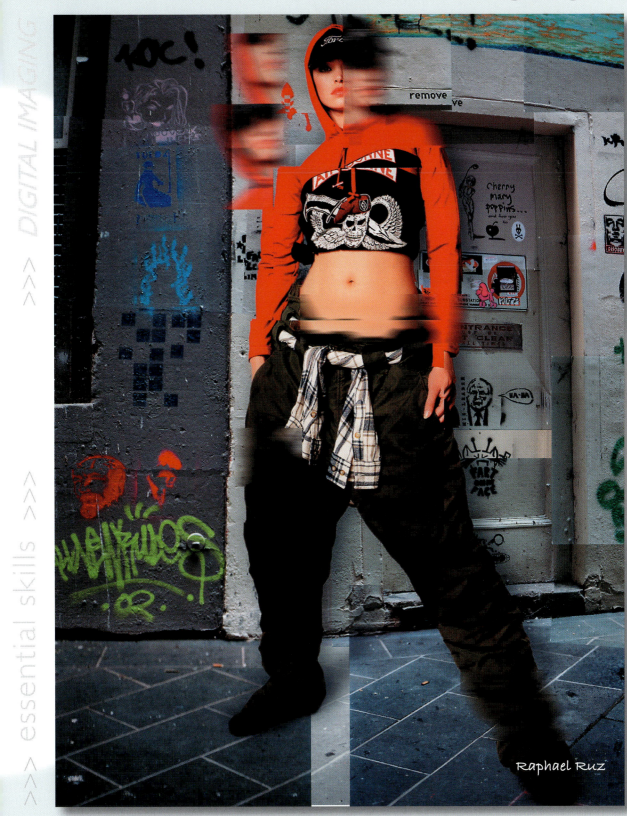

Raphael Ruz

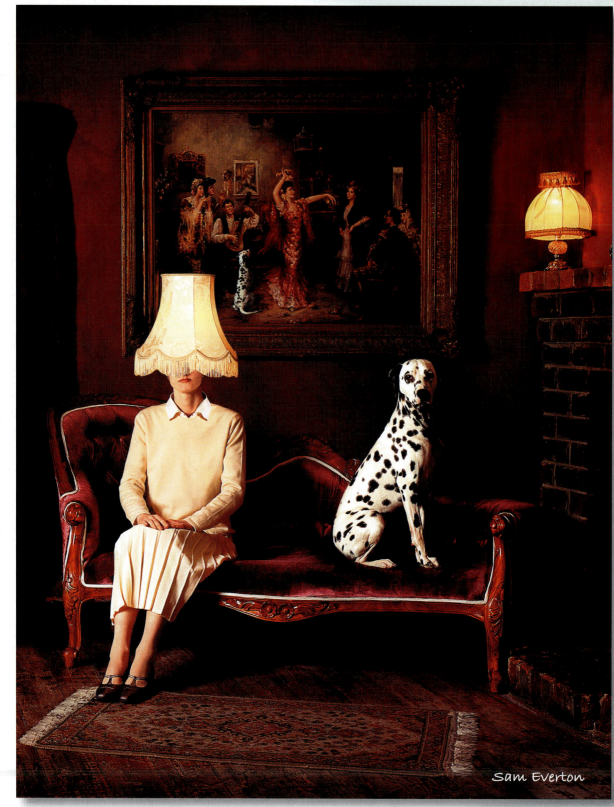

Sam Everton

Les Horvat

essential skills

~ Understand the hardware options available within digital imaging.

~ Make decisions about the most appropriate form of digital output.

~ Know the available options for scanning images.

~ Be able to research and evaluate the various hardware devices available for digital imaging, including:

 - monitors

 - scanners

 - storage devices

Introduction

Today, the selection of computer platform does not itself define the choice of imaging software. It is true to say that some software is written specifically for PC or Mac, but the accepted benchmark, Adobe Photoshop, works equally well on both. Although most imaging professionals prefer the Mac platform, the main difference between the two systems these days is in color management. Because of this it is best to use Windows 98 or later, rather than earlier operating systems if using the PC platform (see '**Color management**', page 83).

System requirements

Any computer system is only as good as the individual parts that comprise it, so let us consider each major component in some detail.

Monitor

In many ways this can be considered as the heart of any imaging system. Unless the image can be previewed accurately, any further adjustments may not be as intended. Important aspects to consider are the size, the quality and the reliability of color that the screen can display. '**Screen real estate**', an often used term, refers to the amount of **usable** space within the viewing area. This is influenced not only by the physical size of the monitor itself but also by the space taken up with palettes and other software controls. For this reason, many professionals actually use two monitors - one for palettes and tools and the other exclusively for the image. This may sound unusual, but in fact as long as a second video card is able to be connected to the '**motherboard**' of the computer, it is often a cost effective option - especially as the second monitor does not have to be of such high quality as the main unit and the alternative of a large single monitor can be extremely expensive in its own right.

A flat screen CRT monitor

Choosing a monitor

A flat screen monitor is preferable to one with a noticeable curve, as reflections are easier to control on a flat screen. However, with the price of LCD monitors coming down in price and at the same time the quality going up, today's digital image creators are tending to choose LCD screens - which by their nature are completetly flat. Today's LCD screens are extremely bright, clear and sharp unlike earlier incarnations, and are very suitable for high end use. They are also not as heavy and considerably smaller in 'footprint'. An added advantage is that they maintain their color settings far better than a CRT monitor. It is true to say though, that some professionals still feel that a high quality CRT monitor will provide a more accurate rendition of the image.

LCD monitors take up less space and are becoming extremely popular

In addition to the monitor itself, the choice of '**video card**' and the amount of '**video memory**' will also determine the quality and speed of '**screen re-draws**'. This can have a significant effect on the speed at which large files can be worked on within the system. A great source of frustration can be having to constantly wait for the screen image to refresh itself when a new view of the image is chosen - a problem which can result from too little video memory. In general, it is fair to say that in the area of displays, you get what you pay for - in the long run, your budget will determine the best options for your needs.

Samsung Syncmaster LCD monitor

Processor

The speed of software such as Photoshop and how it functions on a system will depend on many considerations - not merely the amount of RAM available. The speed at which the computer processor can perform calculations, the number of calculations it can perform at once, the speed of data transfer as well as the number of processors within the system will all have a profound effect on performance. In most cases the fastest processor speeds will be much more expensive than those just a little slower, so unless you are a high end digital professional who will be using your computer to earn income, it is not advisable to purchase a machine with the absolute fastest processor available.

Memory

Editing and manipulating images makes great demands on the computer's RAM (random access memory). Software such as Photoshop routinely uses 3 to 5 times the file size in RAM to function efficiently. In other words, a 30MB image will require up to 150MB of RAM or it will slow down considerably as it substitutes '**scratch disk memory**' from the hard drive instead.

Note > Adding more RAM to a system is a very cost effective means of increasing overall speed for image processing.

Hard disk

The price of hard disk storage has tumbled in recent years, almost as fast as the capacity has increased. This is important for digital imaging as the hard drive performs three main functions, all of which can consume large amounts of its available volume:

~ **Scratch disk space:** As previously mentioned, the overflow 'working space' that the software uses which does not fit into the available RAM (3 to 5 times the file size) is created on the hard drive. If the file is very large this can be considerable.

~ **Storage space:** Downloading files from your camera, scanning film originals or simply storing manipulated images - even if only temporarily - will consume vast amounts of disk space. In addition, during the image editing and manipulation process, it is a sensible idea to save multiple versions of the image file itself (see 'Save, save and save', page 100).

~ **Software:** The days of 'lean and mean' software are well and truly over. In today's computer environment, not only are the operating systems bigger than ever, but most applications are also quite large and take up considerable space in their own right.

All of this suggests that a large hard disk drive is important, especially in terms of choosing a system that will meet future requirements. However, just as with processor speed, the largest and fastest hard drives are significantly more expensive than those just a little smaller. Choose a drive that is appropriate for requirements, but also remember that a second hard disk can be added at a later time. In fact some users set up their system with two hard disk drives, so that one can be kept reasonably free for use exclusively as a scratch disk. This option reduces '**crashes**' which tend to occur when the computer software runs low on memory or scratch disk space!

External storage

Various methods exist for both increasing overall storage capacity and at the same time offering maximum user flexibility. Working with digital images requires the ability to transfer files easily - from input, to computer, to output - as well as ultimately archiving the completed images. Being able to create conveniently stored '**galleries**' may also be an important requirement. There are many different options for external storage, each having their own advantages and disadvantages, so it is worth examining them.

External disk array

Otherwise known as '**RAID**' (Redundant Array of Independent Disks), this type of external hard disk storage is made up of an array or 'stack' of disks and is most often found in high end systems. A RAID disk enables a large amount of information to be broken up into smaller segments each being stored onto a separate disk. So for example if five disks make up the array, the data file is broken up into five chunks. The advantage is that this multiple storage occurs simultaneously, hence the original file takes much less time to be written to the disk. This is of obvious value for the very large files used in professional work environments where multi-layered files can be of the order of many hundreds of megabytes. An alternative type of RAID disk can store multiple sets of the same file onto different disks - all at the same time. This creates a much more secure storage system, which is of importance in data critical systems - if one version becomes corrupted or the hard disk crashes, then another saved version can be used.

Removable hard drives

These are another category of devices that are particularly useful as a backup solution for important data. Manufacturers such as LaCie, Iomega and Maxtor have removable drives that plug into either the USB port or to a Firewire connection with storage capacities of up to 300GB. All drives in this category boast a simple user interface - some with 'One Touch' operation - that makes them ideal for transferring or backing up large volumes of data.

Maxtor OneTouch and 5000 DV drives

Removable media

This type of storage has come in many different formats - none of which unfortunately is compatible. However, since they all require their own dedicated drive mechanism, compatibility is not an issue. These units come in the form of small, removable hard disks inside a plastic cartridge that slots into a drive unit. The latest version of the Zip drive, comes in 750Mb capacity although other types of removable media such as 100MB and 250MB '**Iomega Zip**' disks, 2GB '**Iomega Jaz**' disks, 120MB '**Imation Super**' disks and 2.2GB '**Castlewood Orb**' disks were also available. However, with the advent of newer, smaller and less expensive memory devices these disks are becoming somewhat obsolete - although they are still a flexible storage media that can be used if frequent backups to a portable device are required, but they are not recommended for archival storage.

750MB Iomega Zip drive

External storage media

External USB flash memory drives can readily store up to 512MB in a device small enough to slip into a pocket or attach to a key-chain and are rapidly taking over from other removable media. Despite their miniature size and light weight, more expensive variants can store as much as 2Gb of data. These devices plug straight into the USB slot of the computer and require no cables, software and are suitable for both Mac and PC, making them extremely useful and convenient for transferring and copying files.

USB memory comes in various shapes and sizes

Magnetic tape

Originally created as a form of audio tape, this type of storage known as '**DAT**' (Digital Audio Tape) comes in the form of a small cassette tape. It has become popular as a storage or backup medium mainly due to its low cost. Some units can accommodate up to 80GB of information (with compression) onto a single cassette. The only disadvantage with this type of device is the length of time it can take to find particular files, as the tape has to be wound and rewound in a sequential fashion.

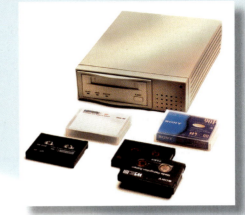

External DAT drive with tapes

CD and DVD writers

Writable CDs and DVDs are fast becoming one of the cheapest storage mediums available, particularly with the rapidly reducing prices of burners as well as of blank media. Although re-writeable forms are also available, the most common usage is with data written only once onto a CD or DVD, with the 'session' then closed off. As a result they are best suited for archiving images that are finalized and do not require any further adjustment or manipulation. Burning speeds have continued to increase, with most recent DVD burners capable of 16X write speed, whilst CD burners can write at 48X. Dual layer DVDs are fast becoming available and are capable of storing up to 8.5GB of data.

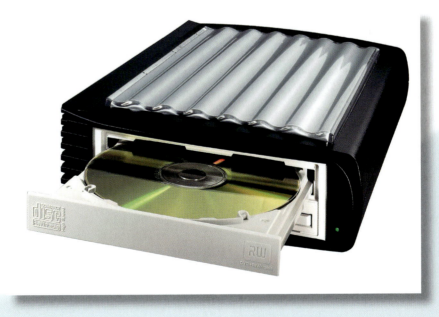

Buslink DVD burner with USB interface will burn CDs as well as DVDs

Mobile storage devices

One of the problems for digital photographers on location has been the restrictions of storage. Multiple memory cards have been the solution for those who were not able to download onto a laptop or computer back at the studio - until relatively recently. A new breed of mobile, high capacity storage has developed, especially for the photographer on the move. This has taken the form of a hard drive mounted in an external case with a memory card reader built in, thereby enabling efficient download of digital storage cards. An extra important feature is that most units will work on battery as well as mains power.

Innoplus Phototainer

Transcend Digital Album

As these units have developed, a feature has been added to many of them that was much needed by photographers - a small LCD screen which allows review of the images after they have been downloaded. This not only gives added confidence with the knowledge that the captured images have been actually stored properly in the drive after transfer from the card, but it also allows for review, editing and updating of the data whilst still on location. These units typically vary in capacity from 10GB to 40GB and are USB 2 compatible. Some even come with remote control devices that can be used when connected to a TV for the playback of images.

ACTIVITY 1

Storage units vary in price, speed and flexibility depending on their overall design.
1. Make a list of devices available in your area - include tape, removable disks, CDs and DVDs. Find out the prices of the units for each type of storage and also the cost of the blank media itself - remember to make a note of how much information can fit onto each.
2. Create a table that compares the cost per MB of each type of system. Be sure to include the overall cost of initial setting up as well.
3. Include in the table the speed of transfer of data with each system. Make a recommendation for the best device for your purposes.

Scanners as input devices

If film is used as the method of capture, to be able to perform further manipulations or even transmissions of that image electronically it is necessary for that film to be scanned. There are different types of scanner to choose from - the choice depends on the quality required and the budget available.

Drum scanners

The traditional high-end scanner used by pre-press houses and printers for the production of color separations. These scanners use a **PMT** (PhotoMultiplier Tube) to achieve the greatest possible dynamic range and sharpness. Very high in cost, these scanners are still considered to be the benchmark for scanning quality.

Film scanners

These scanners are dedicated to scanning film formats from 35mm to 5 x 4 inches, although some like the Flextight can also scan reflection art. These scanners can vary in price quite considerably, depending on quality and at their best they can rival drum scanners in terms of output, although not in terms of speed. They are able to scan at up to 48 bit and can therefore be a good compromise when used under circumstances that do not require rapid throughput or efficiency.

Imacon Flextight 848

Flatbed scanners

The most commonly available type of scanner, it is suitable for scanning both reflection art and film. The quality of these scanners varies from entry level, low cost (but extremely good value), to high end flatbeds that are positioned as alternatives to drum scanners, particularly for use with reflection art. Since flatbed scanners use a moving array of sensors to digitize the image, considerations of noise, dynamic range and consistency of light need to be addressed in their design - in a similar way to that of digital cameras.

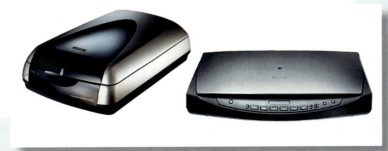

Epson Perfection Series and HP Scanjet Scanner

Workings of a flatbed scanner

Flatbed scanners are the most common desktop units and can be utilized in a variety of situations. Until recently, most flatbed scanners used '**CCD**' sensors, but '**CIS**' or '**Contact Image Sensors**' are now also used, replacing the larger optical pathways of earlier units. Illumination is provided by a row of tightly packed LEDs very close to the glass plate, enabling flatbed scanners to become as slim as notebook computers. Price points for this family of scanners vary enormously, depending on their construction and the purpose for which they are designed. In general, the quality is rapidly improving for all flatbed scanners whilst price is falling dramatically. However, it is worth discussing a number of the criteria by which scanners can be assessed and compared.

Microtek ScanMaker 4700

Sampling depth

The sampling rate or bit depth is a figure that can be dubious when examining scanners. Whilst 8 bits (or 256 steps for each channel of RGB) is all that is needed to produce a full color image, many scanners boast bit depth figures of 10, 12, 14 or even 16. So instead of rating the scanner as being capable of 24 bits (8 x 8 x 8) of color, some are rated as offering up to 48 bits (16 x 16 x 16). However, it is doubtful that prints or reflection art actually have the subtlety of tone that can be measured or discerned with these extra steps.

What value is high bit depth?

If all that is required for full color is 24 bits, then what happens to the extra - is it simply lost? The answer unfortunately is not clear cut. Common engineering practice utilizes over-sampling, i.e. creating more data than is actually required, in the interests of avoiding noise. This is part of the internal workings of a scanner and applies simply to gain a result as free of noise as possible. However, aside from this over-sampling, the extra tonal separation that a high bit depth can determine is potentially useful to differentiate particularly subtle tones - mainly in the deep shadows and extreme highlights. However, it has to be said that this extra information is extremely subtle, perhaps not even noticeable at all and certainly not of as much consequence as the overall sharpness of the scan or as important as the consistency of the scanning mechanism itself. So whilst a high bit depth can be of value, the visible benefit may often not be very significant.

Note > If the editing software is able to work with the 16-bit scanned image, then the extra information is quite valuable as it is a way of avoiding data loss resulting from the editing process.

The benefit then is found not in the tonal depth of the scan, but in the ability to manipulate the file at a later stage with minimal loss of quality. If further manipulation is not anticipated, then scanning at higher bit depths is only really of marginal value.

Resolution

Scanner manufacturers sometimes quote a resolution figure that is actually an interpolated resolution rather than an optical resolution. Interpolation is a means whereby the software associated with the scanner attempts to invent values between the actual pixels scanned. Although this software interpolation is often quite sophisticated in its application, the outcome is usually a slight softening of the scan. Consequently it is rather misleading - only the optical resolution is of any real value when making comparisons between scanners.

Optimum scanning area

Most flatbed scanners have minor inconsistencies in their scanner mechanism which result in uneven scanning areas across the scanner window. These can particularly affect large areas of smooth tone and show up as dark or light bands or 'blotches'. Sometimes the edges of the scanner window are particularly affected.

ACTIVITY 2

Since most often the original to be scanned is smaller than the window size, it makes sense to determine where the optimum area of the window actually is located, i.e. where is the best place to situate the original?

1. Take a clean white piece of paper cut to the exact dimension of the scanner window. If the scanner is of the type which has a calibrating slit over which originals must not be placed, then be sure to leave this blank.
2. Setting the resolution to 100ppi, magnification to 100%, scan a sheet of white paper.
3. Open the file in Photoshop and select Image > Adjust > Equalize to exaggerate the subtle differences in the scan tonality. Examine the 'cleanest' area of even tone - this is the best region to situate original when scanning.
4. Make a black cardboard template with a window that corresponds with this region and use it when scanning.

Scan of white paper

>>> DIGITAL IMAGING

>>> essential skills >>>

Printers as output devices

It is probably true to say that the most commonly required output for all types of photography is still the printed image. Whether the original is taken digitally or via film (and not withstanding the new areas of electronic reproduction such as the web) most photographers still want to hold a print in their hands for viewing. Technology has moved very rapidly in the area of digital printers and there are quite a few options available - the choice, as always, is dependent on purpose and price.

Dye-sublimation printers

Sublimation is a process where a solid is converted to a gas and bypasses the liquid stage - for example 'dry ice'. In printing, sublimation describes inks that when heated turn into a gas and bond with a surface. Dye-sublimation printers use a sheet of ribbon made of plastic impregnated with cyan, magenta, yellow (and with some systems black dye) which is heated by thousands of elements capable of temperature variations, moving across the ribbon.

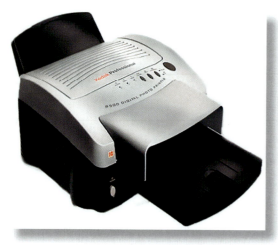

The dyes vaporize when heated and bond with the underlying coated paper. In the Kodak printer the paper passes through the unit four times - one for each of yellow, magenta and cyan plus a final clear UV resistant gloss coat. The exact nature of the surface finish, gloss or semi-matt, is governed by this coat. The advantage of this process is the high image quality due to the richness of tone and the lack of any grain. In addition images can be transferred to other surfaces such as fabric, ceramics etc., by re-heating and reactivating the sublimation dyes. However, due to the nature of the large ribbon, the cost per print is usually quite high.

Kodak 8500 Dye-Sub printer

Thermo-Autochrome (TA) printers

Thermo-autochrome printing is to some extent like traditional analog color photographic printing. The system only requires a special paper with yellow, magenta and cyan layers imbedded within it which are activated at a certain temperature. As the paper passes through the printer, the printer's thermal head heats up tiny areas of the paper, activating the hidden layers one by one, thereby creating up to 256 yellow, magenta and cyan gradations to produce up to 16.7 million colors! An ultraviolet light then passes across the paper, 'fixing' the colors and preventing the inactivated ink from developing. The Thermo-Autochrome system has the added convenience of requiring only paper, thereby eliminating the environmental effects of using ink or ribbons. This makes the TA system very economical as well as environmentally friendly. The system has been championed by Fuji with it's Pictography and NX500/70 series printers and although not capturing a large share of the market, is able to produce exceptional quality prints very simply, and is especially suited to commercial kiosk type operations where particular expertise is not required.

Digital photographic printers

Rather than inks, this family of printers uses light to expose directly onto photographic paper. Units such as the Durst Lambda, Kodak Pegasus and Ilford Lightjet use a beam of light created by LEDs or lasers to expose onto light sensitive paper or backlit film. The result is an archivally stable, ultra-sharp, continuous tone enlargement without any inherent grain or visible dot. Although these printers are extremely expensive, their accuracy, sharpness and speed mean that they are rapidly being introduced into commercial laboratories where the savings in labour costs make the high capital outlay worthwhile.

Durst Lamda 130 printer

Thermal wax printers

This process is rather similar to dye sublimation as it relies on heat. The difference is that in this case the dye is suspended in a wax impregnated ribbon which is applied to a specially coated paper after application of quite low heat, which causes the wax to melt. The final image is composed of very small dots of colored wax. The advantages of this printer are the bright colors possible and the relatively high speed at which the print can be produced. The disadvantages are the need for specially coated paper and the dot pattern produced throughout the image.

Color laser printers

Laser printers, using a technology similar to copiers, apply colored toner to a drum via a finely focussed laser beam. This drum is electrostatically charged to accept the toners and is then rolled onto the receiving paper and heat fused. The advantages of this method are that the printers can be extremely fast and do not require special paper. Unfortunately the quality of the output is not as high as other forms of printing, but these printers are very useful for preliminary output.

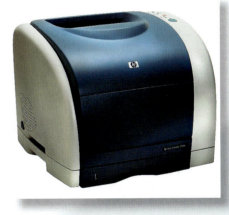

Hpcolor Laserjet 2500

Film recorders

Although the output from a film recorder is a transparency or negative film, it is nonetheless a printer. Rather than expose light directly onto paper this device exposes onto film. The photographic film is then developed in the normal manner. The original role of these devices was for the purpose of creating slides for presentations. However, the technology has been adapted so that large format film output is also possible. The costs for this type of output are quite high and with improvements in digital printing, the reason for outputting to a film based photographic print is not easily justified.

Inkjet printers

This category of printers has benefited from technological improvements in the last few years and has become one of the most common types of printer available. Although a number of different techniques exist to deliver the ink to the paper surface, the most common is the '**piezoelectric**' method. This approach uses certain types of crystals that can be made to expand or contract when different voltages are applied. This vibration of the crystal causes precise volumes of ink to be sprayed onto the paper. Different 'families' of inkjet printer are in common usage today - each designed for a particular purpose.

Desktop inkjet printers

This group of printers has revolutionized the accessibility and quality of digital output. At a modest cost, printers from manufacturers such as Epson, Hewlett Packard and Canon are able to produce photo-quality printouts on various paper stocks. Although the units themselves are quite modestly priced, it is via the consumables - the ink and paper - that the cost per print can become high. Some printers use six inks rather than the usual four, with the addition of a Light Magenta and a Light Cyan ink, resulting in purer highlights and smoother gradations. Although these printers are not extremely fast, the convenience and quality of the prints has meant that the desktop inkjet has found a place within many of today's digital imaging systems.

Epson Stylus Pro 4000

Printer inks

The inks used in inkjet technology have mostly been water-based, which poses certain problems. Whilst the results from some of early inkjet printers were prone to smudging, there have been enormous improvements in ink chemistry since then. The major problem however has been the archival permanence of the print. Most manufacturers initially used dyes for colored inks, making use of their wide color gamut, and pigment-based black ink - because of its better waterproof and fade-resistance characteristics. The trend in the development of inkjet ink was however towards pigment inks, as they have been seen to offer an answer to the impermanence of inkjet output. Pigment molecules are much larger and more complex than dye molecules and tend to break down more slowly, and as a result, dyes are more susceptible to UV radiation and pollution. As a result, pigments are more fade-resistant than dyes - but at a cost. The color gamut of pigments is much smaller than for dyes and pigments tend not to have the same brightness as dye based inks. Of late however, much development has gone into producing archival pigment based inks, which are able to almost match the output of dye based inks.

Wide-carriage inkjet printers

A group of inkjet printers that specialize in the production of large banner style outputs. These printers are becoming extremely popular for commercial purposes where one-off banners or posters are required for advertising or display. Although not usually of as high resolution as their smaller desktop cousins, in most instances the prints would be viewed from a greater distance so that the inherent dot pattern is not apparent. The outputs are not intended for long term display so the lack of archival permanence of the images is not usually an issue

Epson Sylus Pro 9600

Giclée inkjet printers

This type of inkjet printer (pronounced zhee-clay) is named after the French term meaning 'spray of ink'. Derived from the Iris inkjet printer, which was initially used in the production of proofs for four colur printing, this style of printer is able to output onto watercolor papers, thereby making it suitable for high quality, original art works, multiple originals or extremely accurate reproductions. Printed onto specially coated watercolor papers or canvas with specifically developed inks, these prints have all the continuous tone characteristics and color saturation of the original artworks. In fact, with further unique embellishment by the artist, they can become individual works of art in their own right. The printer comprises a large rotating drum upon which a stream of ink is directed through a series of nozzles slowly traversing the surface. Each nozzle delivers either cyan, magenta, yellow or black ink droplets smaller in size than a human red blood cell. Although taking considerable time to produce a single print, the quality and accuracy of the results are such that Giclée prints are being accepted by galleries and museums around the world. Advances in archival inks and paper combinations mean that this method of printing is rapidly gaining a respected place within art circles.

Les Horvat

color management

Les Horvat

essential skills

~ Have an awareness and understanding of color management issues.

~ Understand how color is formed and defined in the digital medium.

~ Know how to implement a color managed workflow.

~ Create a personal target file for output and testing to facilitate further color control.

Introduction

As noted in 'Foundations', the three fundamental aspects of color are hue, saturation and brightness. However, as we are only too well aware, perceptions of color vary from person to person and are also affected by the history of color experience of the individual. To add further complexity to an already subjective issue, the different ways that we reproduce color, through the mechanical and electronic devices at our disposal, have significant limitations that may ultimately alter the actual color produced.

What is color management?

This is a question that often leads to confusion and misunderstanding, so let's begin with a definition of three important terms:

~ **Color management** - is the adoption of a system whereby all '**devices**' within a chain used to create a color image are referenced and linked together to produce predictable, consistent color.

~ **A Color Management System (CMS)** - is the calibration and profiling of both input and output devices, so that the color image printed is an accurate interpretation of the image and is consistent with what is viewed on the monitor. Examples of input devices are scanners and digital cameras, whilst output devices include your monitor, desktop printer and the press that has printed this book.

~ **A Color Management Module (CMM)** - is the software that defines the mathematical manipulations by which color conversions are made. Some of the manufacturers who make CMMs are Kodak, Apple, Agfa and Adobe.

The degree of sophistication of the particular CMS chosen for any given work environment will depend on many factors, such as cost, portability and complexity of implementation. In this chapter we will examine a number of options that result in satisfactory solutions for predictable color '**work flows**'.

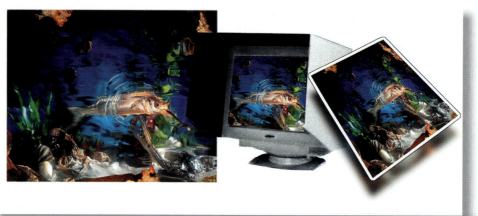

From vision to print

What is a color space?

There are two distinct ways we can create a range of colors. The first is by using light and the second is with pigments, dyes or inks. A '**color space**' is a map of all the colors we can observe when we use a particular method to create that color in the first place. This color space is often represented graphically to try to indicate which colors can be 'seen' and which fall outside that particular space. It is possible in fact to create a greater range of colors by mixing light than we can by mixing dyes or inks. To complicate matters further, different inks, different ways of applying that ink as well as different papers upon which it is printed, all have an effect on the final colors.

RGB color

Although our perception of all color is through the reflectance and absorption of different parts of the spectrum by various objects, we can in fact mix different colored light beams directly to produce new colors. This method of producing color is known as RGB color and is made up of the primary colors **red, green and blue**. In fact, red, green and blue light can be added together in various combinations and amounts to theoretically produce all possible colors - hence the term '**additive color**'. Looked at another way, white light itself is merely a combination of equal amounts of red, green and blue and indeed can be broken up into its respective components via prisms. This additive color space is therefore known as RGB color.

Red , **green** and **blue** light mixed in equal proportions forms **white** light.

ACTIVITY 1

1. Collect three torches of the same type and size, making sure that the batteries are new in each and that the bulbs are of the same type and wattage.
2. Using the '**tri-color**' filters red, green and blue, place one onto each of the torches. (Tri-color filters are merely accurate hues of the selected color and are available through camera suppliers. If it is not possible to obtain these filters, then any filter gels will suffice although the results will not be as clear.)
3. In a darkened room fix each torch onto a stand and point the red and green side by side onto a screen or white wall, adjusting the beams so that they overlap by approximately one half. Make a note of the color that appears in the middle.
4. Turn the green torch off, and point the blue torch beam underneath the red beam, overlapping by about a half. Note the color that appears in the overlapped area.
5. Now turn the green torch back on. (The beams should be positioned so that the blue intersects across both the red and green beams and all three cross each other in the middle.) What is the color of the area in the middle where all three beams intersect?
6. Discuss what factors may influence the accuracy of this experiment.

Note > This additive method of color creation, using three projectors, was the first way that the earliest color images were produced.

CMYK color

As mentioned earlier the alternative to mixing light to create color is the mixing of dyes or inks. It needs to be understood however, that colored dyes and inks appear colorful due to the action of light upon them. In other words, without light there can be no color. (You might care to contemplate the question: in a darkened room does color not exist or is it merely invisible to the viewer?) Each ink or dye absorbs (or subtracts) a portion of the white light illuminating it, but reflects the components of its own color back to the viewer - hence the term '**subtractive color**'. It is because of this reflection that the viewer can see the color. The three primary subtractive colors are **cyan**, **magenta** and **yellow**.

cyan ink:	absorbs/subtracts	red light,	but reflects blue and green
magenta ink:	absorbs/subtracts	green light,	but reflects blue and red
yellow ink:	absorbs/subtracts	blue light,	but reflects red and green

When cyan, magenta and yellow inks are mixed in equal proportions on a white page, theoretically all light is absorbed, so the page appears black. In practice however, when we print colored images, rather than relying on the mixing of inks to produce black, a black ink is also commonly used. This is due to the fact that:

~ Black ink is less expensive than colored inks.
~ The ink formulations of the primary subtractive colors (cyan, magenta and yellow) are not perfectly accurate in reflecting only one third of the spectrum, so the 'black' they produce when mixed is often a 'muddy' brown color.
~ The paper dries faster because there has been less quantity of ink applied.

Note > With the addition of black as a fourth ink, this subtractive color space is known as CMYK, where to avoid confusion with B for Blue (in RGB) the K comes from the last letter of the word Black.

Additionally, an equal layering of cyan, magenta and yellow inks (resulting in a dark greyish color on paper) can be replaced instead with a lesser amount of black ink. This ink replacement technique has two variants - '**UCR**' or Under Color Removal and '**GCR**' or Gray Component Replacement. Either can be utilized depending on the exact printing process used. It should be noted however, that not all of the colors in an RGB color space can be reproduced in a CMYK space. In fact, the colors produced by using inks are far less than those that can be created by mixing light - for example in a monitor where the colors are made by firing phosphors of red, green and blue at the screen. Notably, neither method is able to produce the range of colors our eyes can perceive, nor can our eyes perceive the complete spectrum of light. For example, the infra-red and ultraviolet ends of the spectrum are not visible to the eye.

We live in a colorful world, but not only is our perception of that color restricted, but when we try to represent that color in a printed environment, it is at best merely an approximation!

Painters and subtractive color

It is worth taking a little detour here to examine an area of common confusion regarding color. We have just established that an additive color system - which uses light - has as its primary colors red, green and blue. In addition, a subtractive color system - which uses inks and dyes - has as its primary colors cyan, magenta and yellow. How then is it that in art class at school we are often told that the primary colors for painting are red, blue and yellow! Is not paint a subtractive system? The answer to this question lies in the fact that what is actually used as red paint is often a very dark magenta/red and the blue paint is actually most often a dark cyan. If we were able to use pure paints, then in theory a much larger range of color could be created. The lack of accuracy of these paints is clearly demonstrated by the chocolate brown color achieved when they are mixed together - as any pre-school teacher cleaning up after an enthusiastic art class will attest!

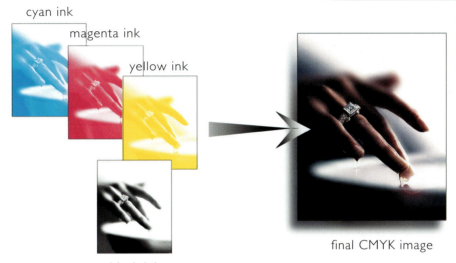

cyan ink

magenta ink

yellow ink

black ink

final CMYK image

ACTIVITY 2

The inks used in the printing process are often applied at high speed and with very large printing roller presses. It is important that as part of this process, as the inks are applied to the paper they exactly register with each other, otherwise a double image would result. To assist in this step, registration marks are often printed in areas of the paper surface to be later trimmed or folded. In addition, as each color is applied a color swatch of the ink is also usually printed.

1. Take a box of breakfast cereal and open the bottom flaps. Examine to see if any color shapes are printed in any folded flaps. How many colors can you find?
2. Find a box with a prominent logo or particular color scheme on it as part of its overall design. (A pack with gold or silver colors would be ideal.) Open the flaps and look for any color swatches. Are there more than might be expected? Knowing the deficiencies of the four color printing process, can you offer an explanation for the extra colors?
3. Examine the areas around the colors. Do any of the swatches have numbers associated with them? To what do you think these refer?

Color gamuts

Whilst each color space depends on the device used to create it, some spaces are inherently able to represent more colors than others. As discussed previously however, none is able to match the colors perceived by our eyes - or in fact that exist in our world.

The range of colors possible within a particular color space is known as the '**color gamut**' of that space. In the diagram below, the color gamut is reducing as we travel down from the original scene to the printed representation of that scene.

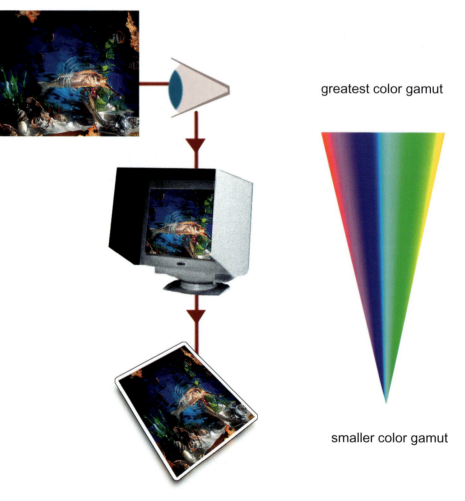

greatest color gamut

smaller color gamut

The printed representation of a scene has a much smaller color gamut

There are sections of the electromagnetic spectrum emitted by the sun, that even the human eye cannot perceive. When a particular space - in this case the color space of our eye - is unable to define a particular color it is said to be '**out of gamut**'. The CMYK, subtractive, ink/dye based color space has the largest number (or greatest amount) of 'out of gamut' colors. For that reason, any printed color image will only ever be an approximation of both the image as displayed on a monitor and as it exists in our known world.

How does RGB relate to CMYK?

The visible portion of the spectrum of light can be reproduced by combinations of additive primaries red, green and blue in varying amounts. It would stand to reason that the subtractive primary colors - cyan, magenta, and yellow - created by the absorption and reflection of sections of the spectrum can also be created by directly mixing together combinations of red, green and blue light. This is indeed the case, as demonstrated by the following table which indicates the relationship between the two sets of primary colors.

Red and **Green**	make **Yellow**	the opposite of **Yellow** is	**Blue**
Red and **Blue**	make **Magenta**	the opposite of **Magenta** is	**Green**
Green and **Blue**	make **Cyan**	the opposite of **Cyan** is	**Red**

The subtractive and additive primaries and their relationship together are shown above - a color's opposite is sometimes referred to as its 'complementary' color

Device independence

Whilst both the RGB and CMYK color spaces depend on the physical attributes of the devices used to create them, the spectral composition of light can be measured accurately and consistently. It is therefore also possible to measure the color wavelengths produced by light emissions in a pre-defined and accurate manner. As a consequence, various smaller RGB color spaces can be defined as a subset of the RGB space itself.

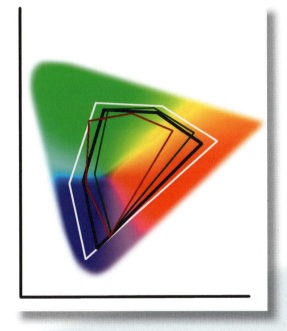

This means that these color spaces contain most, but not all, of the theoretically possible colors of the RGB color space - which in turn contain some but not all the colors possible as defined by the CIELab model. Some of the more common ones in use are sRGB, Adobe RGB, Colormatch RGB and Bruce RGB.These color spaces are **'device independent'** since they can be defined and measured completely independently of any hardware that may utilize, or have even initially defined and created them. It is this capacity to replicate colors independently of any device that is the basis of a color management system - a system based on the mapping of colors from one space to another in a known and predictabe manner. Without such an independent definition of color we would always be at the mercy of the particular device that is representing the color.

A diagram showing the theoretical color space of light based on the CIE model (Commission Internationale de l'Eclairage). Within this diagram is the RGB color space (shown as a white line) and inside that area are a number of actual RGB color spaces

Device dependence

Unlike RGB color spaces based on light, those that rely on the application of inks are not as easy to measure and control. Some of the variables that may affect the reproduction of color when using inks and dyes and may impact upon the color of the finished piece are:

~ Ink absorption characteristics of the paper stock
~ Ink texture and viscosity
~ Amount of ink applied to the surface
~ Ink formulations
~ Application methods used to place the ink onto the surface
~ Paper color and formulation
~ Paper surface texture.

As a result, CMYK color spaces are said to be **device dependent**, since each printing device will produce a color space (or a map of possible colors) that is to a greater or lesser extent different from another device.

Note > A CMYK color space is defined in terms of a unique printing device and is not necessarily applicable to a different printer.

Because of this close relationship to the particular printer, for the colors to be accurate any file converted to CMYK will need to be printed on the exact printer defined by the chosen CMYK space. For this reason it is important not to archive digital files in CMYK format unless they will be outputed via a known device - and even then a 'master' RGB version should always be saved.

What is a profile?

Since all hardware devices reproduce color slightly differently, for any CMS to be useful, hardware must be calibrated and an accurate profile created. A profile is a set of mathematical measurements that defines the reproduction of color for a particular device. With a properly calibrated system, the various profiles interact to ensure each bit of data matches with the particular device to give the expected result. This is often termed WYSIWYG or 'what-you-see-is-what-you-get', an outcome that is the ideal requirement for all digital imaging outputs. A profile therefore is a little like a set of translation rules that determine the basis for giving meaning to a sentence. In this analogy, the sentence is the image and the meaning is the color within that image. Utilizing this understanding of color spaces and profiles, we can examine what is meant by color management in a more sophisticated way. The following sentence gives a more accurate definition.

Color management or 'color workflow' can be defined as the translation of an image from one color space to another, using the profiles associated with devices within that workflow.

Color concepts in practice

So far we have examined various aspects of color and how they relate to the construction and representation of images. Whilst this topic in itself can become quite complicated and confusing, it is essential that a sound grasp of the fundamentals is achieved. The following activity is designed to reinforce those fundamentals in a practical manner.

ACTIVITY 3

1. Click in the foreground palette at the bottom of the toolbox and open the Color Picker.

2. Slide the color slider to the top of the range, which should be showing red. Move the selection circle to the top right of the picker window, thereby creating a bright red color in the main window. Make sure that Hue is selected in the radio buttons at the right of the window and has a value of zero.

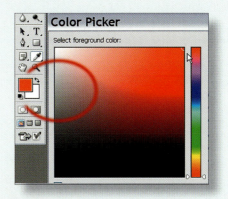

Note > Remember, the monitor is an RGB device, i.e. it produces the image by mixing light, therefore a wide range of colors is available.

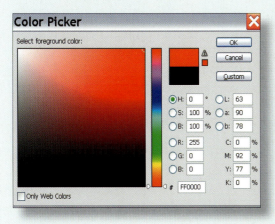

3. Examine the detail on the right side of the Color Picker. The columns of numbers refer to the values of the chosen color, each in different ways. In other words the color is being described in alternative color spaces. The first is HSB, or Hue, Saturation and Brightness. In Adobe Elements, there is also RGB, whilst Photoshop has CMYK and Lab as well. This color space (also known as CIELab) is the space that describes all the colors theoretically possible, as a graphical representation on a three dimensional color wheel - it is the largest space we can define.

4. Take a note of the values in the RGB and CMYK boxes. The amount of black is zero, indicating that the color is pure - no grey has been added. In addition, the cyan is also zero - as expected, because red is made up of yellow and magenta. In the RGB domain, we see that pure red contains no additional green or blue, again as one would expect.

5. Click on the selection circle and move it around the picker window. Notice how the red becomes darker as more black is added. Likewise, it becomes less pure in hue as it is defined by additional amounts of green and blue (in RGB), or cyan (in CMYK). Move the selection circle about and note the values in both RGB and CMYK as the color changes.

ACTIVITY 4 (Photoshop only)

1. Go to File > New and create a new file of 75 pixels/inch resolution and 295 x 295 pixels in dimension. Using the red color chosen in the previous activity, fill the file with this color by going to the menu command Edit > Fill.

2. Now choose the elliptical marquee selection tool and draw a circular selection within the image area. Then choose the gradient tool in the toolbox and click on the gradient window under the menu bar - the gradient editor should now appear.

3. Pick a rainbow style gradient and apply it within the selected area by dragging a line from the top to the bottom of the circle. The circle should now be filled with a rainbow of colors.

Note > The end result should be a vivid circle of colors within a red background.

4. Save this file and repeat step 2, this time using a pure green and a pure blue color in turn as the background. Save each file.

5. Draw a circular selection in each file and fill with a rainbow gradient, making sure there is a good selection of colors in each.

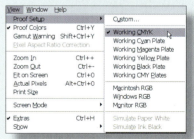

6. Taking each file in turn, create a new window for the file by selecting View > New View and choosing View > Proof Setup > Working CMYK. Preview each of the files in turn with both the CMYK and RGB versions on screen at the same time and compare the two. What do you notice about the colors in the CMYK previews? Which colors are most affected? What does this indicate about CMYK as a color space?

Applying color management

Any environment where color management is to be applied will as a first priority require calibration of the devices that are being used. Of these devices, the monitor is perhaps the most critical as any subjective judgements relating to an image will depend on the monitor and how it displays the image. If the monitor is totally uncalibrated, it is akin to looking at an image with tinted glasses - and not even knowing what color the tint is!

Calibrating the monitor

Whilst all monitors function in an RGB space, each monitor behaves a little differently depending on its mechanical and electronic design. In addition, monitor color changes over time - over short periods as the unit heats up and stabilizes, as well as over longer periods as it ages. For this reason, to maintain accurate color a monitor should be calibrated frequently, but only after it has been on for at least half an hour. Before calibration, the viewing environment should be examined and a number of simple steps taken.

- ~ Reduce glare and reflections from nearby walls or windows.
- ~ Construct a viewing hood out of black cardboard and drape it over the monitor to minimize glare. This hood should protrude at least 30cm over the top of the monitor.
- ~ Reduce the room light so that it does not 'overpower' the monitor.
- ~ Make sure the room lighting is consistent. If necessary, remove some bulbs or connect all lights to the one switch.
- ~ Use lighting that is as neutral as possible. This is equally important for the viewing of printed outputs.
- ~ Remove any colored and heavily patterned wallpaper on the monitor desktop as this may interfere with the visual perception of colors.

How computer systems vary

Unfortunately, there are differences in the way that Macs and PCs use color management. With a Macintosh the CMS is known as '**ColorSync**' and is built into the operating system and available for applications which are designed to use it. This system level software is one of the reasons that the Mac is favoured by imaging professionals. On a Windows platform the CMS is known as '**ICM**' (Image Color Management) and uses the same basis as ColorSync to manage color reproduction. In its latest incarnation - ICM 2.0 - it is at last also available to be used at system level as well as applying to color spaces other than RGB. The recognition by Microsoft that the CMYK and Lab spaces, as well as support for additional processes such as HiFi Color, are important for reproduction accuracy should lead to fewer differences in the way color is reproduced on a PC than in the past. ICM 2.0 has been incorporated into Windows operating systems since Windows 98 - anything earlier is problematic in this regard.

ACTIVITY 5

Calibration using 'Adobe Gamma'. This method is the least complex to implement and involves the use of software available with Photoshop. Accessed via a control panel, the software calibrates the white point, contrast, brightness and 'gamma' of the monitor. The resulting profile is saved as an 'International Color Consortium' (ICC) file, the industry standard for profile description. Although the 'Adobe Gamma Wizard' takes the user through the process step by step, it can take a little practice to be accurate with the settings as they rely on subjective assessments. Also, ensure that any CRT monitor has been on for at least 30 minutes so that the display has stabilized.

1. Open 'Adobe Gamma' via the Control Panel. Win 95 and Win NT users cannot incorporate the resulting profile at system level, so Win 98, Win XP or above is recommended for PC users. (Mac users with OS 9 or before can also use Adobe Gamma.)

2. Upon opening the Gamma control panel, you will be asked if you wish to use the 'Step By Step' method or simply the control panel itself. Next, choose the ICC profile that relates to your monitor from the available list. The profile initially offered is the standard profile that shipped with the monitor and this default is usually a good starting point.

3. Next, we need to make changes to the brightness and contrast. Using the monitor controls, adjust the contrast to the highest value, then adjust the brightness so that the inner square is only just visible. (Due to factory settings which vary from monitor to monitor, this step may be difficult to achieve - simply choose the closest possible adjustment.)

4. We now need to select the phosphors used by your monitor. Either consult the monitor handbook or choose between the two most common types - Trinitron or P22-EBU. Any tube manufactured by Sony (of which there are many including Apple) uses Trinitron, whilst Mitsubishi, Hitachi and Radius all use a Diamondtron tube which uses P22-EBU phosphors. Remember that all tubes age and alter their characteristics over time, so that the actual settings may not exactly match these settings anyway. (For an LCD screen choose custom and then click OK on the figures offered.)

5. To adjust the gamma of the monitor, ensure the View Single Gamma checkbox is **not** ticked. Select either 2.2 or 1.8 depending on whether your system is Windows or Mac OS, then adjust the sliders under each box to fine tune the result. To perform this rather tricky step, sit back a little from the monitor and squint your eyes until the lines on the outer boxes begin to disappear - this will enable a better blend with the inner tone.

6. Next, the white point of the monitor needs to be determined. Ensure step 5 has been completed accurately or this step will also be affected. Since monitor phosphors change with age, the actual white point will need to be chosen - so select the Measure option for Hardware White Point.

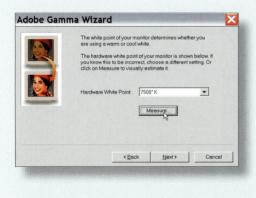

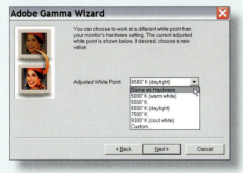

7. The Adjusted White Point is the setting you want the monitor to use when displaying images. This can be settings such as paper white (5000°K), or daylight (6500°K). However, in practice it is advisable to choose the Same as Hardware option which selects the setting you determined in step 6, as this avoids any truncation of the monitor's dynamic range.

8. Finish and save after viewing the 'before' and 'after' options to determine how the display has changed. (If necessary go back to adjust any settings again.) Make sure the profile is saved to a new name such as MonitorDateSetting - this will now be the profile used by the system and defines the Monitor Space.

Note > Do not touch any brightness or contrast buttons on the monitor after calibration, as any alterations will interfere with the created profile.

DIGITAL IMAGING >>>

ACTIVITY 6

Calibration using 'Diplay Calibrator'. (Mac users of OSX will not have Adobe Gamma available and should use '**Apple Display Calibrator**' instead.)

This software is accessed via the '**Display Control Panel**'. Choose a display that best matches your own and then press '**Calibrate**'. Ensure that the 'Expert Mode' check box is ticked so that all settings are available.

1. Make adjustments by moving the two sliders for each of the five screens offered by the '**Calibrator Assistant**'. In each screen, the left slider adjusts the brightness and the right slider adjusts the overall hue. This process is quite similar to that used in '**Adobe Gamma**' although the five stages of this process relate to smaller sections of the Gamma curve, therefore making it potentially more accurate.

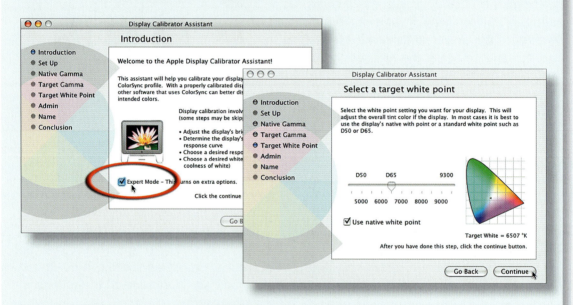

2. Set the '**Target Gamma**' by moving the slider to either 1.8 or 2.2. Although Macs are usually set to a Gamma of 1.8, if a work environment exists where PCs are also used, it should be set to 2.2 so that display consistency is retained.

3. Choose a desired '**White Point**' setting, most commonly set to daylight, or simply tick the '**Use Native White Point**' check box.

4. Provide a unique name for the profile and save. The calibrator displays a summary which can be checked to ensure the details are correct. By returning to the Display Control Panel, this profile (or any other profile created in the past) can be selected. As CRT monitor settings in particular will 'drift' over time, it is a good idea to incorporate the date in the name of the profile, thereby being able to determine its age at a glance.

>>> essential skills >>>

Hardware calibration

Without doubt the most accurate means of calibrating a monitor is through the use of a hardware device, known as a 'colorimeter', which sits on the face of the screen via a suction cup and actually measures the red, green and blue light being emitted. The associated software then builds a profile based on any variations from the expected values. This approach eliminates any individual color bias which could affect a subjective method such as using Adobe Gamma. Whilst the use of a colorimeter is more complicated and expensive than simple software calibration, prices have come down radically over the last few years and the applications themselves are becoming easier to use. Some very sophisticated monitors even have built-in calibration capabilities. These special monitors are more expensive than most entry level displays, but are capable of re-calibrating themselves throughout their life and thereby offer unparalleled performance.

X-Rite and Colorvision colorimeters, used to calibrate the monitor via screen attachment

Note > If a monitor is not calibrated there can be no confidence in the on-screen colors displayed being a true representation of the image.

How is this monitor profile used?

The aim of color management is to produce consistent and expected outputs, but the type of system we need to implement depends on our particular requirements. The least complex solution is where we have a 'closed' system - the computer being connected to an input device such as a scanner or digital camera and an output device such as an inkjet printer. In such a system, the image files will only ever move from one of these devices to another, so it does not really matter if our profiles are not accurate (in terms of an accepted industry standard), as long as they operate successfully within the loop. This type of arrangement is extremely easy to set up and if the need to use outside printing or scanning services is not an issue, is a very functional means of achieving consistent results. This was the only type of color management possible before software able to work with ICC profiles was introduced.

The alternative to the above system is based on ICC compliant profiles. These profiles are tagged onto images, which then results in adjustments being made to image data as it moves from one device to another - an open, universal color management system.

Justin Ridler

image adjustments

Sam Everton

essential skills

~ Capture appropriate pixel dimensions for your required output needs.

~ Resize and crop images to optimum.

~ Adjust color, tonality and sharpness of digital images.

~ Duplicate, optimize and save image files for print and for web.

Introduction

Every digital image that has been captured can be enhanced further so that it may be viewed in its optimum state for the intended output device. Whether images are destined to be viewed in print or via a monitor screen, the image usually needs to be re-sized, cropped, retouched, color-corrected, sharpened and saved in an appropriate file format. The original capture will usually possess pixel dimensions that do not exactly match the requirements of the output device. In order for this to be corrected the user must address the issues of '**Image Size**', '**Resampling**' and '**Cropping**'.

Optimizing image quality

This chapter focuses its attentions on the standard adjustments made to all images when optimum quality is required. Standard image adjustments usually include the process of optimizing the color, tonality and sharpness of the image. With the exception of dust removal these adjustments are applied globally (to all the pixels) whereas the 'Image Enhancements' chapter looks at global and localized adjustments (selecting groups of pixels). Most of the adjustments in this chapter are 'objective' rather than 'subjective' adjustments and are tackled as a logical progression of tasks. Automated features are available for some of these tasks but these do not ensure optimum quality is achieved for all images. The chapter introduces many features that are dealt with in greater depth in 'Image Enhancements'.

Save, save and save

Good working habits will prevent the frustration and the heartache that are often associated with inevitable '**crash**' (all computers crash or '**freeze**' periodically). As you work on an image file you should get into the habit of saving the work in progress and not wait until the image editing is complete. It is recommended that you use the 'Save As' command and continually rename the file as an updated version. Unless computer storage space is an issue the Photoshop (PSD) file format should be used for work in progress. Before the computer is shut down, the files should be saved to a removable storage device or burnt to a CD/DVD. In short, save often, save different versions and save back-ups.

First steps

Follow the seven steps over the following pages in order to create one image optimized for print and one file optimized for web viewing.

Image capture - *Step 1*

Select or create a softly lit color portrait image (diffused sunlight or window lighting would be ideal). The image selected should have detail in both the highlights and shadows and should have a range of colors and tones. An image with high contrast and missing detail in the highlights or shadows is not suitable for testing the effectiveness of the capture or output device.

Digital capture via a digital camera

Images can be transferred directly to the computer from a digital camera or from a card reader if the card has been removed from the camera. Images are usually saved on the camera's storage media as JPEG, RAW or TIFF files. If using the JPEG file format to capture images you should choose the high or maximum quality setting whenever possible. If using the TIFF or JPEG file formats, it is important to select low levels of image sharpening, saturation and contrast in the camera's settings to ensure optimum quality and editing flexibility in the image-editing software. If the camera has the option to choose Adobe RGB instead of sRGB as the color space this should also be selected.

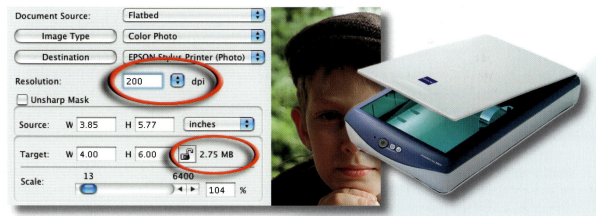

Digital capture via a scanning device

Ensure the media to be scanned is free from dust and grease marks. Gloss photographic paper offers the best surface for flatbed scanning. The scanning device can usually be accessed directly from the Adobe software via the 'Import' command. Ensure that you scan the image at an appropriate resolution for your image-editing needs (see 'Foundations > Calculating file size and scanning resolution').

Cropping an image - *Step 2*

When sizing an image for the intended output it is important to select the width and height in pixels for screen or web viewing and in centimeters or inches for printing. Typing in 'px', 'in' or 'cm' after each measurement will tell Elements or Photoshop to crop using these units. If no measurement is entered in the field then Adobe will choose the default unit measurement entered in the Preferences ('Preferences > Units & Rulers'). The preference can be quickly changed by Control-clicking on either ruler (select 'View > Rulers' if they are not currently selected).

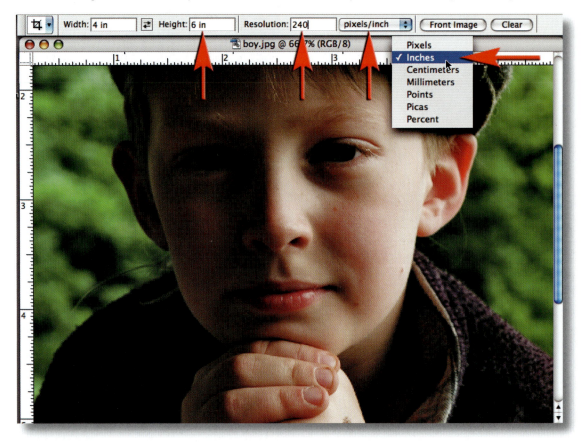

Select the 'Front Image' option to select the current measurements of a selected image. This option is useful when you are matching the size of a new image to an existing one that has already been prepared. Select the 'Clear' option to quickly delete all of the existing units that may already be entered in the fields from a previous crop. The action of entering measurements and resolution at the time of cropping ensures that the image is sized and cropped or 'shaped' as one action. Entering the size at the time of cropping ensures the format of the final image will match the printing paper, photo frame or screen where the image will finally be output.

Note > If both a width and a height measurement are entered into the fields the proportions of the final crop will be locked and may prevent you from selecting parts of the image if the capture and output formats are different, e.g. if you have entered the same measurement in both the width and height fields the final crop proportions are constrained to a square.

Perfecting the crop

If the image is crooked you can rotate the cropping marquee by moving the mouse cursor to a position just outside a corner handle of the cropping marquee. A curved arrow should appear, allowing you to drag the image straight.

Click and drag the corner handle to extend the image window to check if there are any remaining border pixels that are not part of the image. Press the 'Return/Enter' key on the keyboard to complete the cropping action. Alternatively press the 'esc' key on the keyboard to cancel the crop.

The marquee tool is programmed to snap to the edges of the document as if they were magnetized. This can make it difficult to remove a narrow border of unwanted pixels. To overcome this problem you will need to go to the 'View' menu and switch off the 'Snap To' option.

Note > See Image Enhancements - Project 1 for more information on cropping images.

Tonal adjustments - *Step 3*

The starting point to adjust the tonal qualities of EVERY image is the 'Levels' dialog box (go to 'Enhance > Adjust Lighting > Levels' in Adobe Elements and 'Image > Adjustments > Levels' in Photoshop CS/CS2). Do NOT use the 'Brightness/Contrast' adjustment feature as this can be destructive to the quality of your image. The horizontal axis of the histogram in the levels dialog box displays the brightness values from left (darkest) to right (lightest). The vertical axis of the histogram shows how much of the image is found at any particular brightness level. If the subject contrast or 'brightness range' exceeds the latitude of the capture device or the exposure is either too high or too low, then tonality will be 'clipped' (shadow or highlight detail will be lost).

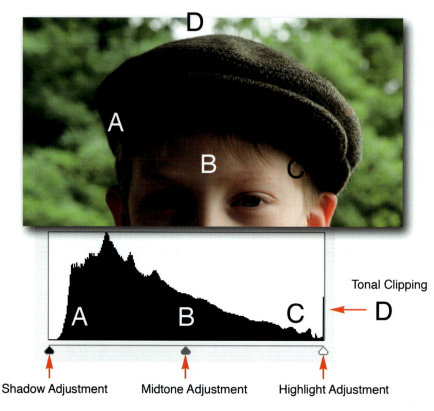

Histograms

During the capture stage it is often possible to check how the capture device is handling or interpreting the tonality and color of the subject. This useful information can often be displayed as a 'histogram' on the LCD screen of high quality digital cameras or in the scanning software during the scanning process. The histogram displayed shows the brightness range of the subject in relation to the latitude or 'dynamic range' of your capture device's image sensor. Most digital camera sensors have a dynamic range similar to color transparency film (around five stops) when capturing in JPEG or TIFF. This may be expanded beyond seven stops when the RAW data is processed manually.

Note > You should attempt to modify the brightness, contrast and color balance at the capture stage to obtain the best possible histogram before editing begins in the software.

Optimizing tonality

In a good histogram, one where a broad tonal range with full detail in the shadows and highlights is present, the information will extend all the way from the left to the right side of the histogram. The histogram below indicates missing information in the highlights (on the right) and a small amount of 'clipping' or loss of information in the shadows (on the left).

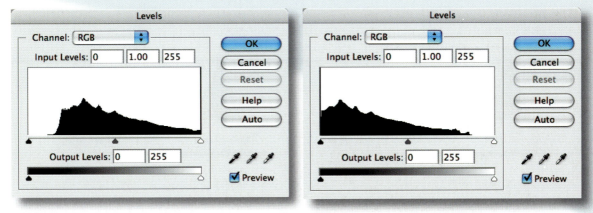

Histograms indicating image is either too light or too dark

Brightness

If the digital file is too light a tall peak will be seen to rise on the right side (level 255) of the histogram. If the digital file is too dark a tall peak will be seen to rise on the left side (level 0) of the histogram.

Solution: Decrease or increase the exposure/brightness in the capture device.

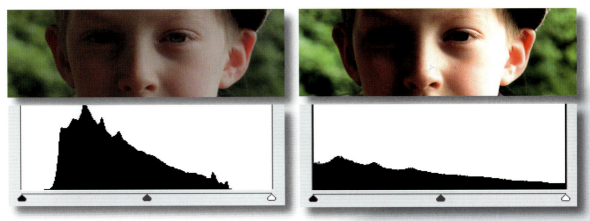

Histograms indicating image either has too much contrast or not enough

Contrast

If the contrast is too low the histogram will not extend to meet the sliders at either end.
If the contrast is too high a tall peak will be evident at both extremes of the histogram.

Solution: Increase or decrease the contrast of the light source used to light the subject or the contrast setting of the capture device. Using diffused lighting rather than direct sunlight or using fill-flash and/or reflectors will ensure that you start with an image with full detail.

Optimizing a histogram after capture

The final histogram should show that pixels have been allocated to most, if not all, of the 256 levels. If the histogram indicates large gaps between the ends of the histogram and the sliders (indicating either a low-contrast scan or low-contrast subject photographed in flat lighting) the subject or original image should usually be recaptured a second time.

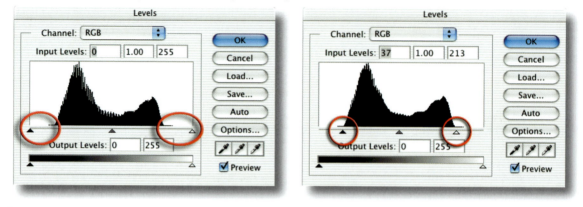

Small gaps at either end of the histogram can, however, be corrected by dragging the sliders to the start of the tonal information. Holding down the Alt/Option key when dragging these sliders will indicate what, if any, information is being clipped. Note how the sliders have been moved beyond the short thin horizontal line at either end of the histogram. These low levels of pixel data are often not representative of the broader areas of shadows and highlights within the image and can usually be clipped (moved to 0 or 255).

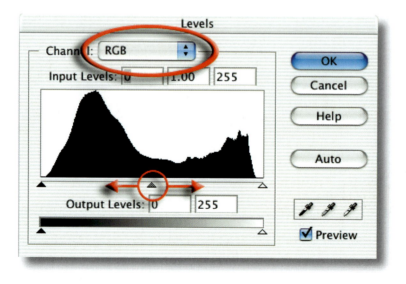

Moving the 'Gamma' slider can modify the brightness of the mid-tones. After correcting the tonal range using the sliders, click 'OK' in the top right-hand corner of the Levels dialog box.

Note > Use the Levels for all initial brightness and contrast adjustments. The Brightness/Contrast adjustment feature in both Photoshop CS and Elements should be avoided as this will upset the work performed using Levels and can result in a loss of information.

Shadows and highlights

When the tonality has been optimized using the Levels dialog box the shadow and highlight values may require further work. One of the limitations of the Levels adjustment feature is that it cannot focus its attention on only the shadows or the highlights, e.g. when the slider is moved to the left both the highlights and the shadows are made brighter.

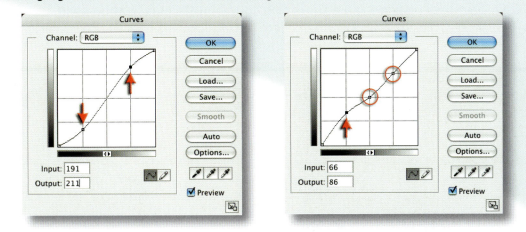

For Photoshop CS users this can be achieved using the Curves adjustment feature. Curves allows the user to target tones within the image and move them independently of other tones within the image, e.g. the user can decide to make only the darker tones lighter whilst preserving the value of both the mid-tones and the highlights. It is also possible with a powerful editing feature such as Curves to move the shadows in one direction and the highlights in another. In this way the contrast of the image could be increased without losing valuable detail in either the shadows or the highlights.

An adjustment feature that is common to both Elements and Photoshop CS is the Shadows/ Highlights adjustment feature. This targets and adjusts tonality in a non-destructive way and in many ways offers superior control than the curves adjustment feature (Midtone Contrast) in a user friendly interface. See 'Image Enhancements > Shadows and Highlights' for more information.

Note > See Image Enhancements - Project 4 for more information on shadow and highlight control.

Color adjustments - *Step 4*

Neutral tones in the image should appear desaturated on the monitor. If a color cast is present try to remove it at the time of capture or scanning if at all possible.

Solution: Control color casts by using either the white balance on the camera (digital), shoot using the RAW file format or by using an 80A or 80B color conversion filter when using tungsten light with daylight film. Use the available color controls on the scanning device to correct the color cast and/or saturation.

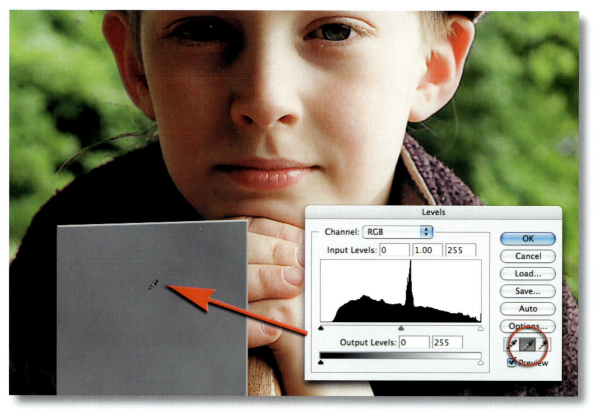

Color correction using Levels

If you select a Red, Green or Blue channel (from the channel's pull-down menu) prior to moving the Gamma slider you can remove a color cast present in the image. For those unfamiliar with color correction the adjustment feature 'Variations' in Photoshop or 'Color Variations' in Elements gives a quick and easy solution to the problem.

Setting a Gray Point

Click on the 'Set Gray Point' eyedropper in the Levels dialog box and then click on any neutral tone present in the image to remove a color cast. Introducing a near white card or gray card into the first image of a shoot can aid in subsequent color corrections for all images shot using the same light source.

Note > See Image Enhancements - Projects 2 and 3 for more information regarding levels.

Variations (not available when editing 16-bit files)

The 'Variations' command allows the adjustment of color balance, contrast and saturation to the whole image or just those pixels that are part of a selection. For individuals that find correcting color by using the more professional color correction adjustment features intimidating, Variations offers a comparatively user friendly interface. By simply clicking on the alternative thumbnail that looks better the changes are applied automatically. The adjustments can be concentrated on the highlights, mid-tones or shadows by checking the appropriate box. The degree of change can be controlled by the Fine/Coarse slider.

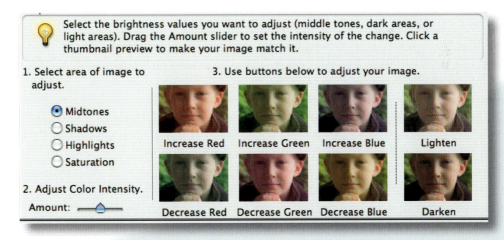

Variations can be accessed from the Adjustments submenu in the Image menu. Elements users should go to the 'Enhance' menu and choose 'Color Variations' from the 'Adjust Color' menu. Elements users can follow the numbers they see in the box whilst CS users have to figure the clicking order out for themselves. Start by selecting the 'Midtones' radio button and then adjust the intensity until you can see a thumbnail that looks about right, and then click on the one you like. Then click 'OK'.

Note > Editing with the highlights, shadows or saturation button checked can lead to a loss of information in one or more of the channels. If the 'Show Clipping' is checked a neon warning shows areas in the image that have been adjusted to 255 or 0. Clipping does not, however, occur when the adjustment is restricted to the mid-tones only.

Cleaning an image - *Step 5*

The primary tools for removing blemishes, dust and scratches are the 'Clone Stamp Tool', the 'Healing Brush Tool' and the new 'Spot Healing Brush Tool'. The Clone Stamp is able to paint with pixels selected or 'sampled' from another part of the image. The Healing Brush is a sophisticated version of the Clone Stamp Tool that not only paints with the sampled pixels but then 'sucks in' the color and tonal characteristics of the pixels surrounding the damage. The Spot Healing Brush Tool requires no prior sampling and is usually the first port of call for most repairs. The following procedures should be taken when working with the Spot Healing Brush Tool or Healing Brush Tool.

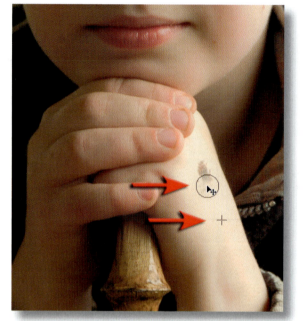 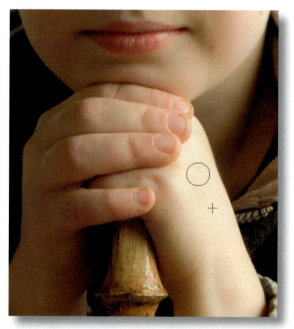

- Select the Spot Healing Brush Tool from the Tools palette.
- Zoom in to take a close look at the damage that needs to be repaired.
- Choose an appropriate size brush from the brushes palette that just covers the width of the blemish, dust or scratch to be repaired.
- Move the mouse cursor to the area of damage.
- Click and drag the tool over the area that requires repair.
- Increase the hardness of the brush if the repair area becomes contaminated with adjacent tones, colors or detail that does not match the repair area.
- For areas proving difficult for the Spot Healing Brush to repair switch to either the Healing Brush Tool or the Clone Stamp Tool. Select a sampling point by pressing the Alt or Option key and then clicking on an undamaged area of the image (similar in tone and color to the damaged area). Click and drag the tool over the area to paint with the sampled pixels to conceal the damaged area (a cross hair marks the sampling point and will move as you paint).

Note > If a large area is to be repaired with the Clone Stamp Tool it is advisable to take samples from a number of different points with a reduced opacity brush to prevent the repairs becoming obvious.

Sharpening an image - *Step 6*

Sharpening the image is the last step of the editing process. Many images benefit from some sharpening even if they were captured with sharp focus. The 'Unsharp Mask' filter from the 'Sharpen' group of filters is the most sophisticated and controllable of the sharpening filters. It is used to sharpen the edges by increasing the contrast where different tones meet.

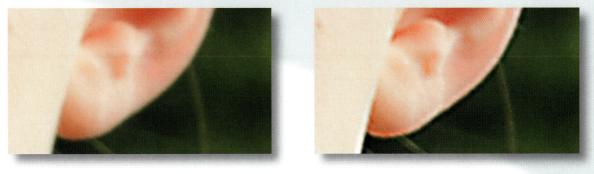

The pixels along the edge on the lighter side are made lighter and the pixels along the edge on the darker side are made darker. Before you use the Unsharp Mask go to 'View > Actual Pixels' to adjust the screen view to 100%. To access the Unsharp Mask go to 'Filter > Sharpen > Unsharp Mask'. Start with an average setting of 100% for 'Amount', a 1 to 1.5 pixel 'Radius' and a 'Threshold' of 3. The effects of the Unsharp Mask filter are more noticeable on-screen than in print. For final evaluation always check the final print and adjust if necessary by returning to the saved version from the previous stage. The three sliders control:

Amount - This controls how much darker or lighter the pixels are adjusted. Eighty to 180% is normal.

Radius - Controls the width of the adjustment occurring at the edges. There is usually no need to exceed 1 pixel if the image is to be printed no larger than A4/US letter. A rule of thumb is to divide the image resolution by 200 to determine the radius amount, e.g. 200ppi ÷ 200 = 1.00.

Threshold - Controls where the effect takes place. A zero threshold affects all pixels whereas a high threshold affects only edges with a high tonal difference. The threshold is usually kept very low (0 to 2) for images from digital cameras and medium or large format film. The threshold is usually set at 3 for images from 35mm. Threshold is increased to avoid accentuating noise, especially in skin tones.

Unsharp Mask

OK

Cancel

☑ Preview

50%

Amount: 120 %

Radius: 1.5 pixels

Threshold: 2 levels

Note > See 'Image Enhancements – Project 5' for more information on sharpening images.

Saving a modified file - *Step 7*

Go to the 'File' menu and select 'Save As'. Name the file, select 'TIFF' or 'Photoshop' as the file format and the destination 'Where' the file is being saved. Check the 'Embed Color Profile' box and click 'Save'. Keep the file name short using only the standard characters from the alphabet. Use a dash or underscore to separate words rather than leaving a space and always add or 'append' your file name after a full stop with the appropriate three- or four-letter file extension (.psd or .tif). This will ensure your files can be read by all and can be safely uploaded to web servers if required. Always keep a back-up of your work on a remote storage device if possible.

Resize for screen viewing

Duplicate your file by going to 'Image > Duplicate Image' (CS) or File > Duplicate (Elements). Rename the file and select OK. Go to 'Image > Image Size'. Check the 'Constrain Proportions' and 'Resample Image' boxes. Type in approximately 600 pixels in the 'Height' box (anything larger may not fully display in a browser window of a monitor set to 1024 x 768 pixels without the viewer having to use the scroll or navigation bars). Use the Bicubic Sharper option when reducing the file size for optimum quality.

Using the Crop Tool (typing in the dimensions in pixels, e.g. 600px and 450px) will also resize the image quickly and effectively. This technique does not, however, make use of Bicubic Sharper and images may require sharpening a second time using the Unsharp Mask.

Note > Internet browsers do not respect the resolution and document size assigned to the image by image-editing software - image size is dictated by the resolution of the individual viewer's monitor. Two images that have the same pixel dimensions but different resolutions will appear the same size when displayed in a web browser. A typical screen resolution is often stated as being 72ppi but actual monitor resolutions vary enormously.

JPEG format options

After resizing the duplicate image you should set the image size on screen to 100% or 'Actual Pixels' from the View menu (this is the size of the image as it will appear in a web browser on a monitor of the same resolution). Go to 'File' menu and select 'Save As'. Select JPEG from the Format menu. Label the file with a short name with no gaps or punctuation marks (use an underscore if you have to separate two words) and finally ensure the file carries the extension .jpg (e.g. portrait_one.jpg). Click 'OK' and select a compression/quality setting from the 'JPEG Options' dialog box. With the Preview box checked you can check to see if there is excessive or minimal loss of quality at different compression/quality settings in the main image window.

Note > Double-clicking the Zoom Tool in the Tools palette will set the image to actual pixels or 100% magnification.

Choose a compression setting that will balance quality with file size (download time). High compression (low quality) leads to image artifacts, lowering the overall quality of the image. There is usually no need to zoom in to see the image artifacts as most browsers and screen presentation software do not allow this option.

Image Options: The quality difference on screen at 100% between the High and Maximum quality settings may not be easily discernible. The savings in file size can, however, be enormous, thereby enabling much faster uploading and downloading via the Internet.

Format Options: Selecting the 'Progressive' option from the Format Options enables the image to be displayed in increasing degrees of sharpness as it is downloading to a web page, rather than waiting to be fully downloaded before being displayed by the web browser.

Size: The open file size is not changed by saving the file in the JPEG file format as this is dictated by the total number of pixels in the file. The closed file size is of interest when using the JPEG Options dialog box as it is this size that dictates the speed at which the file can be uploaded and downloaded via the Internet. The quality and size of the file is a balancing act if speed is an issue due to slow modem speeds.

Save for Web

The save for the web offers a single command centre for duplicating, resizing and saving using the JPEG file format. It also offers a preview option so that you can view how your image will appear if it is displayed in software that does not read the ICC profile.

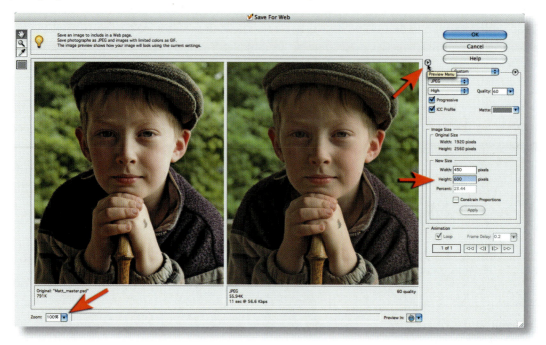

Photoshop CS/CS2 and Elements users can use the Save for Web option when previewing and saving images destined for a screen presentation. Photoshop CS/CS2 users can also go to View > Proof Setup and then choose either Macintosh RGB or Windows RGB depending on the intended monitor that the image will be viewed on. With the Proof Setup switched on, adjustments will usually be required to both image brightness and saturation in order to return the appearance of the image to 'normal'. Brightness should be controlled via the 'Gamma' slider in the 'Levels' adjustment feature and color saturation via the 'Hue/Saturation' adjustment feature. The adjustments required to the first image can usually be replicated on subsequent images using the same settings.

Image adjustments overview

1. Capture an image with sufficient pixels for the intended output device.
2. Resize and crop the image to the intended output size.
3. Optimize the histogram using the Levels dialog box.
4. Adjust the tonality and color.
5. Clean the image using the Clone Stamp Tool or the Healing Brush Tool.
6. Apply the Unsharp Mask.
7. Save the adjusted image as a Photoshop file (PSD).
8. Duplicate the file and resize for uploading to the web if required.
9. Save the file as a JPEG with a suitable compression/quality setting.

Experimenting with levels

It is possible using levels and curves to control the tonal and color characteristics (contrast and brightness of selected tones and their relative hue) within an image. In this way it is possible to optimize or manipulate the image viewed on the monitor and in print.

ACTIVITY 1

What follows is a simple practical experiment using Photoshop or Elements to help you understand the control over tonal characteristics that the levels command affords.

1. Create an RGB file 450 pixels high and 600 pixels wide. From the File menu choose New (Command or Ctrl + N).

2. Set the default foreground and background colors in the tools palette to black and white.

3. Select the 'Gradient Tool' icon in the Tools palette and the Linear gradient in the options bar. Ensure that 100% opacity and the Foreground to Background gradient are selected.
Starting from the far left of the image, drag the cursor to the extreme right side of the image area. This will create a gradient from black to white (0 to 255).

4. Select the top half of the image using the Rectangular Marquee Tool. If using Photoshop choose Adjustments > Posterize From the 'Image' menu. If using Elements go to Filter > Adjustments > Posterize. Type 9 in the 'Levels' box with the 'Preview' left on (try typing different numbers in the levels box to observe different effects). Click OK to apply nine tones to the selected area.

5. The tonal range of the top section of the gradient is reduced from 256 levels to just nine. When we adjust the tonal characteristics using levels and curves it will be easier to identify and measure the changes than with the portion of the image that has retained 256 levels.

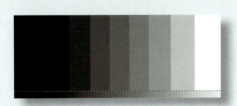

1	2	3	4	5	6	7	8	9
0	31	63	95	127	159	191	223	255

Level values

18%K (CMYK)

The specific levels of these nine tones are indicated in the illustration. The tones in this digital step-wedge are reminiscent of the tonal values used by photographers in the 'zone system'.

The levels palette

6. From the Image or Enhance menu select Levels. The levels indicate nine very high peaks to show the large number of pixels present in the nine tones created for the step wedge. Drag the input highlight and shadow sliders towards the centre to see the effect on the highlight and shadow tones of the step wedge.

Slide the middle slider to various positions. Observe the effects on the mid-tones, shadows and highlights.

Now drag the output sliders and observe the effects on the highlight and shadow tones. These output sliders reduce the contrast of the image whilst the input sliders increase the contrast.

7. From the Window menu choose Info. Move the cursor to the centre mid-tone and note the levels in the RGB info (127). This is the digital mid-tone if all three channels are 127. A tone sampled in a grayscale file will give only a percentage black reading in the information palette and no specific information regarding its precise level.

Note > A photographic 'gray card' scanned accurately will register a level of 110 in each of the three channels.

8. Select cancel to close palette or hold the Alt/ Option key and click 'reset' to return the levels to their original setting.

The levels is similar to a bar graph and shows the relative number of pixels for each of the 256 levels. The sliders beneath the levels can be used to modify the shadow, mid-tone (gamma) and highlight tones.

The white and black eyedropper tools can be used to set white and black points within the image, e.g. click on the darkest tone within the image with the black eyedropper to move it to level 0.

The Set Gray Point eyedropper tool in the centre can be used to remove color casts from selected tones in color images.

The information palette

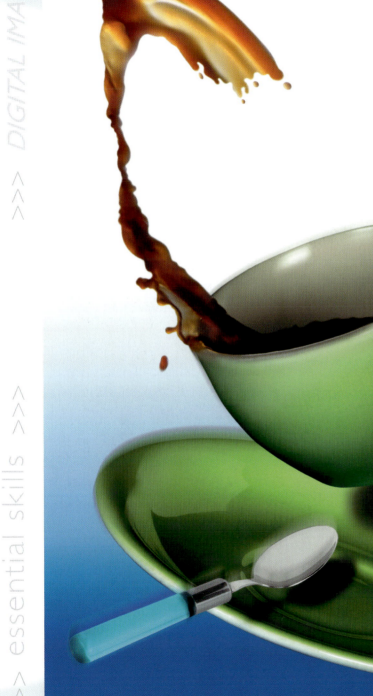

Seok-Jin Lee

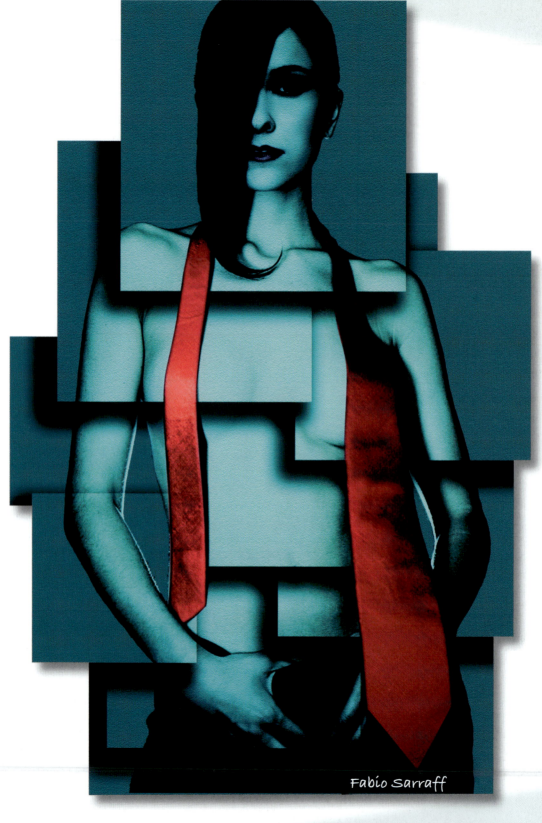

Fabio Sarraff

digital

image enhancements

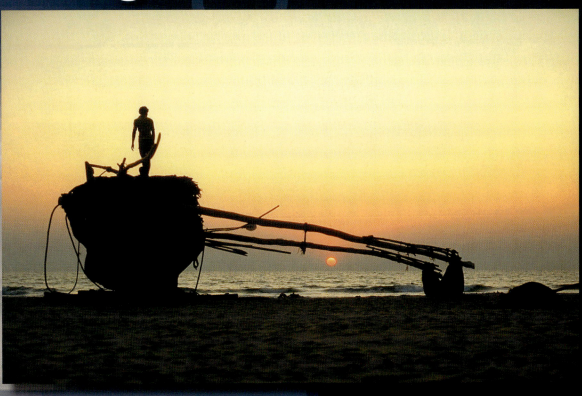

Mark Galer

essential skills

~ Develop creative techniques to enhance and optimize images.

~ Develop skills using selection tools, adjustment layers, layer masks and blend modes.

~ Target image tonality for the intended output device and remove color casts.

~ Control shadow and highlight tonality whilst preserving midtone contrast.

~ Use advanced techniques for localized sharpening.

Introduction

To end up with high quality output you must start with the optimum levels of information that the capture device is capable of providing. The factors that greatly enhance the final quality of the image are:

- A 'subject brightness range' that does not exceed the exposure latitude of the capture medium (the contrast is not too high for the image sensor or film).
- Using a low ISO setting or fine grain film to capture the original image.
- The availability of RAW camera file import or 16 bits per channel scanning.

With a healthy histogram the retouching process can begin. The digital file can then be enhanced or manipulated to create a specific aesthetic objective and be targeted to meet the output characteristics of a specific output device. In this way maximum quality can be achieved and maintained.

Project overview

The projects that follow are designed to provide the skills for controlled and non-destructive image editing. The first four projects should be tackled first and sequentially as the skills can be applied to every subsequent project you intend to tackle. The Projects are supported by QuickTime movies that give an audio visual demonstration of the sequence and techniques required to complete each project. The information in the text offers a more comprehensive understanding of the skills and techniques involved in the projects and will help to place the skills in context with all future image-editing projects that you undertake. The projects are illustrated with screen grabs from Adobe Elements 3 but all of the techniques and tools are also available in the full version of Photoshop. The differences between Photoshop CS/CS2 and Elements 3 sometimes requires a slightly different approach to arrive at the same outcome. Each of the approaches will be clearly labelled as belonging to CS/CS2 or Elements. Differences between PC and Apple Macintosh keyboard layouts should also be observed when reading the actions required to complete each step successfully.

Advanced cropping and sizing techniques - *Project 1*

This simple project may unmask some of the crop tool's hidden features to enable you to fine-tune your image for print or screen viewing.

1. When we size an image we should select the width and height in pixels for screen or web viewing and in centimeters or inches for printing. Typing in 'px', 'in' or 'cm' after each measurement will tell Elements or Photoshop to crop using these units. If no measurement is entered in the field then Adobe will choose the default unit measurement entered in the preferences ('Preferences > Units & Rulers'). The preference can be quickly changed by control clicking on either ruler (select 'View > Rulers' if they are not currently selected).

2. Select the 'Front Image' option to select the current measurements of a selected image. This option is useful when you are matching the size of a new image to an existing one that has already been prepared. Select the 'Clear' option to quickly delete all of the existing units that may already be entered in the fields from a previous crop. The action of entering measurements and resolution at the time of cropping ensures that the image is sized and cropped or 'shaped' as one action. Entering the size at the time of cropping ensures the format of the final image will match the printing paper, photo frame or screen where the image will finally be output.

Note > If both a width and a height measurement are entered into the fields the proportions of the final crop will be locked and may prevent you from selecting parts of the image if the capture and output formats are different, e.g. if you have entered the same measurement in both the width and height fields the final crop proportions are constrained to a square.

3. If only a small amount of the image is being removed it is important to cancel the 'Snap to Grid' option in the 'View' menu of Elements or deselect the 'Document Bounds' option in the 'Snap To' submenu of Photoshop CS/CS2. If these options are selected it is difficult to move the cropping selection close to the edge of the image without it 'snapping' to the edge (as if the crop bounding box had a magnetic attraction to the edges of the document).

4. Drag the cropping marquee over the image to create the best composition (selecting the shield option will aid in this process by masking the portion of the image that will be discarded by the cropping action). If however you notice your image is crooked, the edge of the crop marquee can first be aligned with either a vertical or horizontal line within the image. In the example the lower edge of the crop marquee is moved to a position alongside the horizon line in the image.

5. Move the cursor to a position just outside one of the corner handles of the cropping marquee. When the double-headed curved arrow appears you can rotate the cropping marquee to align it with a horizontal or vertical within the image. When aligned the crop marquee can be extended by moving the cursor back to the crop handle to achieve the final composition. Photoshop CS/CS2 users can also reposition the axis of rotation to a corner to help in the alignment process.

6. The first time you drag the cropping marquee you are prevented from extending the marquee beyond the image area. Dragging the cropping marquee a second time however, allows the user to extend the canvas area and is useful for creating a border around the image. The additional canvas is filled with the foreground color selected in the tools palette. Click on the 'tick' in the options bar to 'Commit' the current crop operation. Hitting the 'enter' key (return key on a Mac) will also commit the crop. Hitting the 'cross' in the option bar or the 'escape' key will cancel the crop operation.

7. When a camera is tilted up or down with a short focal length lens (wide angle) the verticals within the image can lean excessively inwards or outwards (converging verticals). Professional architectural photographers use cameras with movements or special lenses to remove this excessive distortion. Photoshop CS/CS2 has a perspective cropping option linked to the crop marquee to correct the distortion as part of the post-production processing of the image. The correction can be also achieved in 'CS/CS2' or 'Elements' using the 'Transform' command. Switch on the 'Grid' in the 'View' menu to start this process.

8. Duplicate the background layer by dragging it to the 'Create a new layer' icon in the 'Layers' palette. Extend the image window so that all of the image edges can be clearly viewed (zoom out if necessary). Select the 'Free Transform' command from the Edit menu in CS/CS2 or from the 'Transform' submenu located in the 'Image' menu in Elements.

DIGITAL IMAGING >>>

9. Click and drag the corner handles of the Free Transform bounding box whilst holding down the Control key (Command key on a Mac). Use the grid lines to align the verticals within the image.

>>> essential skills >>>

10. Use the keyboard shortcuts to access the zoom tool (Control/Command + Spacebar and Alt/Opt + Spacebar) if you need to zoom in on a vertical to check the accuracy of the correction. Clicking on the zoom tool in the tools palette will commit the transformation.

Note > You may need to raise the centre handle of the 'Free Transform' bounding box to prevent the image looking too 'squat' after the verticals have been corrected.

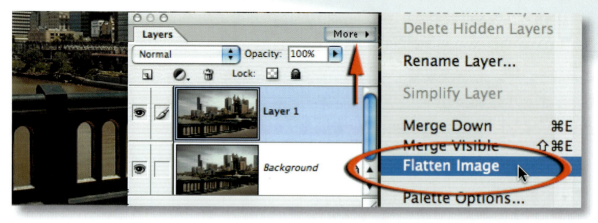

11. Commit the transformation by clicking on the tick in the options bar and then flatten the image if required by selecting the option in the 'More' menu of the layers palette.

12. The before and after perspective correction reveals the effectiveness that can be achieved by using this simple technique to obtain a more professional result.

This project demonstrates how the Crop and Transform tools can be used to size and shape your images so that they appear tailor-made every time.

Advanced levels control - *Project 2*

This project will guide the novice safely through the tricky mountain passes of the primary and essential technique to achieving quality digital images. The adjustment feature is called 'Levels', but when you are presented with the virtual mountain range on opening the Levels dialog box, you begin to wonder what the clever people at Adobe were thinking of when they gave this indispensable adjustment feature its wonderful name (I think its called irony).

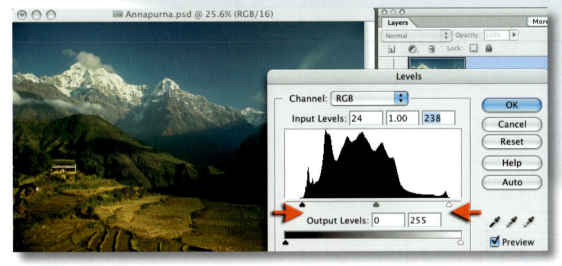

1. In the illustration above one might be forgiven for thinking that the black peaks in the dialog box are an indication of how high the mountains are in the image, but no, it is really an indicator of how many pixels of each tone are present in the image. If the image is dark then the mountains will be higher on the left side. If the image is very light, the mountains will be taller on the right side. The first step in nearly all image-editing tasks is the need to optimize the tonality or 'contrast' of the image by adjusting the 'Levels'.

> **Finding your levels > In 'Elements' go to the 'Enhance' menu and select 'Levels' from the 'Adjust Lighting' submenu. In 'Photoshop CS/CS2' go to the 'Image' menu and select 'Levels' from the 'Adjustments' submenu.**

If you are a newcomer to this dialog box you may simply want to click on the 'Auto' button and then click 'OK'. This simple procedure ensures the tonality of the digital image starts with a deep black and finishes with a bright white for optimum contrast and visual impact. If you want to perform the task manually click on the black slider underneath the mountain range (the pointy triangle) and drag it to where the mountains start. If you are now looking for the little triangle at the foot of the photographic mountains instead of the virtual ones, then I suggest go and lie down for a moment and come back refreshed. Do the same with the white slider and you are almost finished. Click and drag the gray slider in the middle to make the image brighter or darker (depending on which way you drag the slider). If you want to start impressing the neighbors then you may like to start calling the gray triangle the 'gamma slider'.

Warning > **The user should avoid using the destructive Brightness/Contrast adjustment from the same submenu as the image will often look far from enhanced if used.**

DIGITAL IMAGING >>>

essential skills >>> >>> >>>

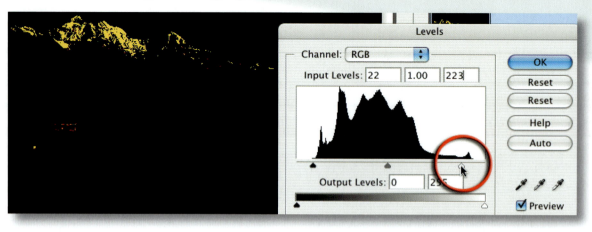

2. If you drag the sliders too far you will lose or 'clip' information from the image file. Shadows will become black and highlights will become white. Your detail will have sunk without a trace into the black holes of our virtual valleys (called level 0) or have been pushed off the top of the virtual peaks (called level 255). If you fear the numbers 0 and 255 (which every self respecting photographer should) you could try the following top tip. Hold down the 'Alt' key (Option key on a Mac) and drag the shadow or highlight slider towards the mountains (your image will disappear momentarily but fear not). Colors will start to appear in your main image window when information is being lost. Move the sliders back until these colors disappear. If colors are still appearing in the image window with the sliders all the way back to the edge of the histogram then your image was either underexposed or overexposed in your camera. If you are really unlucky you will have lost detail both in the shadows and in the highlights as result of the photographers worst enemy - 'Excessive Contrast'. Not even the magic called 'Adobe Elements' can dig you out of this hole my friend if you failed to 'bracket' your exposures (take several images using different exposure settings).

3. Elements and Photoshop CS/CS2 who have acquired images at a higher bit depth using camera RAW or a scanner set to 48-bit scanning should now drop their images to 8 Bits/Channel (Image > Mode > 8 Bits/Channel). The secret to intelligent color adjustment is that the grass may 'really' be greener on the other side. Until you have seen the other side how will you know? With this in mind Adobe has given us 'Color Variations'. It is a simple case of 'if you see something else you like - you can have it'.

DIGITAL IMAGING >>>

essential skills >>>

16-bit editing

16-bit editing is now a reality for Adobe Elements 3 and Photoshop CS/CS2 users. If you have acquired your image from the Camera RAW dialog box or a 48-bit scanner using Adobe Elements 3, then you will need to drop the bit depth to 8 bits to complete the following steps because although Elements 3 supports 16-bit editing it does not support the use of adjustment layers with which to edit the bit rich pictures. Photoshop CS/CS2 users can now edit their images with layers in 16 bits per channel but this places an enormous demand on the available RAM and processor speed of the computer as the file sizes begin to blow out. Adjusting the levels of your image in 16 bits per channel and then dropping to the more time-efficient 8 bits per channel mode gets you 95% the way there on the path to maximum quality. If you have invested in the latest state of the art computer hardware, 2 Gigabytes of RAM and Photoshop CS/CS2 you may continue in 16 bits per channel with the exception of step 4 - which is still unavailable in 16-bit editing mode.

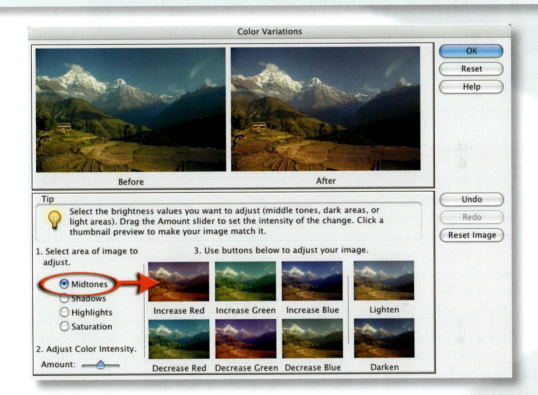

4. From the 'Enhance' menu choose 'Variations' from the 'Adjust Color' menu. Yes I know it's a big box. It needs to be this size so they can get all of the lovely colors in. Elements users can follow the numbers they see in the box whilst CS/CS2 users have to figure the clicking order out for themselves. Start by selecting the 'Midtones' radio button and then adjust the intensity until you can see the flavoured thumbnails look about right (not too loud please), and then click on the one you like (color blind males may need a woman's touch just about now). Then click 'OK'. For those that have found bliss you can stop this project now - or for those who still want to take another look at that grass - press on to step 5.

Warning > Clicking on anything other than 'Midtones' in this dialog box may be harmful to the health of your pixels that you so lovingly looked after in the 'Levels' dialog box.

5. We have just completed our global adjustments (all of the pixels in the image have changed in brightness and color). We will now set about changing just a select few. To isolate pixels for a 'localized adjustment' we have to select them with (yes - you guessed it) a 'selection tool'. We will start with the very wobbly 'Lasso Tool' (there are three in the stack so make sure you get the right one - click, and hold you clicker down, on the little black arrow in the corner of the lasso tool to see your options). Now draw (yes I know drawing isn't everybody's strong point) along the terraced fields in the foreground of the image (don't let go of the mouse clicker - not even when you get to the end of the field) and then circle (what else would you expect to do with a lasso) beneath the image and around until you get back to the point where you started - now let go. Those things that have appeared are called 'marching ants'. Don't worry about how wobbly your drawing is at this stage.

Note > If you did happen to let go (even though I told you not to) before you had finished the selection, go to the 'Select' menu, choose 'Deselect', and then start again (this time paying closer attention to not letting go of your clicker).

6. Now if your drawing (like mine) leaves a lot to be desired, we can fix it up by painting it better (my painting isn't much better than my drawing either, but at least with the brush we can let go of the clicker without unleashing the mad ants and take a breather for a while).

Photoshop CS/CS2 users can select the 'Brush Tool' in the tools palette and then switch to 'Quick Mask Mode'. This Quick Mask icon is just below the 'Background Color Swatch' in the tools palette or you can simply hit the letter 'Q' on your keyboard. Quick mask is a way of viewing your selection as a color overlay instead of the marching ants. It is possible to modify this selection with the painting tools instead of the selection tools. CS/CS2 users should ensure the foreground and background colors are set to their default setting (hit the letter 'D' on the keyboard).

Elements users do not have a Quick Mask Mode. They must use the 'Selection Brush Tool' to fix up the very disturbing attempts with the lasso or the not-so-magic 'Magic Wand Tool'. The Selection Brush Tool icon in the tools palette has a circle of ants emanating from the tip of the brush (wow - a brush that paints ants - how wonderful). Now painting ants is too weird for me so I usually choose 'Mask' from the 'Mode' menu in the 'Options Bar' (positioned above the image window) to replicate the Quick Mask mode found in Photoshop CS/CS2.

Set the brush hardness to 100% and start painting your mask better. If you are using Elements, and your paint has strayed over the line, you will need to hold down the Alt key (Option key on a Mac) and paint to remove the paint (strange but true). If you are using Photoshop CS/CS2 you need to switch the foreground and background colors. Black adds to the mask, whilst white takes away. Take your time - no rush - zoom in if you can't see what you are doing and paint on the bigger picture.

7. Just trust me on the next step OK. I want you to 'feather your selection'. Elements users should choose 'Feather' from the 'Select' menu and then enter a Value of 2 in the 'Feather Radius' field. CS/CS2 users should choose 'Gaussian Blur' from the 'Blur' submenu in the 'Filters' menu and then enter a radius of 2 pixels.

When you click 'OK' watch the edge of your brushwork - it goes sort of soft. If you missed it go to the 'Edit' menu and choose 'Undo' and then 'Redo'. Zoom in if you still didn't see it change. I need you to see it change so you don't think I am messing with your head on this one. So why is soft better than hard you ask? Soft is good (in this instance) because it is hard to pick a soft transition between pixels that have been adjusted and those that missed the boat, i.e. no one will be able to pick that you have been 'tweaking' (A.K.A. enhancing) your image. At the moment however you have not tweaked anything, merely isolated it for tweaking.

Note > If the terminology 'Feather Selection', when you are in fact looking at a mask, is troubling you as an Elements user, you have my permission to select 'Selection' in the options bar instead of 'Mask' before feathering. The advantage to feathering or blurring the selection, when it is being viewed as a mask, is that you can see whether the amount of feather is appropriate, and adjust the pixel radius according to the softness of the edge that looks right for your image. Bigger images (more 'Megapixels') require more feathering as a rule.

Warning > Too much feathering is as bad as none at all, i.e. now the color corrections will bleed into the adjacent image and make it look like your colors are running.

8. Because making a selection can be the most time-consuming part of the process, and because computers crash (no really they do), Adobe allows you to save your artwork (the selection). Go to the 'Select' menu and choose 'Save Selection' - give it a name, choose 'OK' and then save your image file by going to the 'File' menu and choosing 'Save As'. This will allow you to choose a different name and save it as a different file to the one you originally opened. In this way you will have one original and one enhanced/stuffed file just for good measure. You can now lie down for five minutes to rest the gray matter and then return to your enhanced/stuffed file - go to the 'Select' menu and choose 'Load Selection'.

9. With the marching ants running rampant all around your selected pixels I now want you to find the Layers palette. If it is hiding then you can summon it up from the depths of oblivion by going to the 'Window' menu and selecting - yes you guessed it again - 'Layers'. Click on the little round icon that is half black and half white. It is at the bottom of the layers palette for Elements 2 and Photoshop CS/CS2 but has migrated (it probably fancied a change of scenery) to the top of the palette for Elements 3. Click on the icon and choose 'Levels' from this submenu.

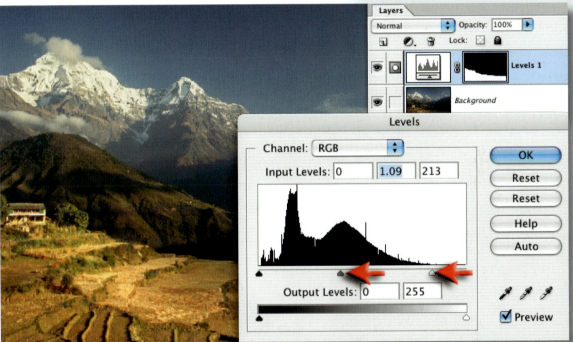

10. Now a couple of really interesting things have happened (well mildly interesting for a computer geek anyway), first, and not surprisingly, the virtual mountains have reappeared - but this time they represent only the foreground pixels and not the pixels of the entire image (hence the different shape). Second - the ants have mysteriously disappeared, only to be replaced by a new layer in the layers palette. This layer is called an 'adjustment layer' and it will play host to the adjustments we are about to make in this Levels dialog box. Third - the mask has reappeared in a little thumbnail image to the right of the adjustment icon in the layers palette. This is called a layer mask and it will hide any adjustments we make in the upper portion of the image (the pixels we did not select).

Move the highlight slider (the white triangle) in towards the slopes of the histogram and move the gray triangle (the gamma slider) to the left to brighten the foreground.

Note > The adjustment layer icon changes with the preferences set for this palette - so don't worry if yours doesn't look the same as mine.

NON-DESTRUCTIVE EDITING

Now we could have picked up the 'Levels' command from the 'Enhance' menu, as in step one of this very exciting project. The difference is that adjustments made using an adjustment layer are infinitely editable. Infinite editing is great for people who are indecisive about color, want to make frequent changes and don't want to degrade the quality of their image by doing so. The changes you make when you use an adjustment layer are not actually applied to the pixels at this point in time. The adjustment layer acts like a filter showing us a view of how the pixels will look when the adjustments are applied. If you make frequent changes to the actual pixels themselves you will eventually degrade the image quality. Using adjustment layers you can make changes 'til the 'cows come home' and never degrade the quality of the image. Your adjustments are only applied once - when your editing is complete and your image is either saved for screen viewing or printed.

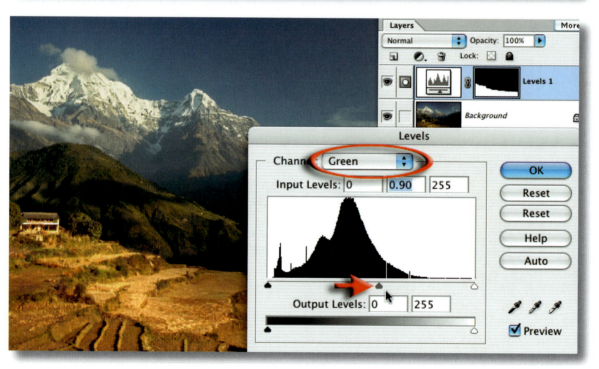

11. Because the grass is sometimes too green on the other side we can go to the 'Green' channel in the 'Channel' menu, positioned near the top of the Levels dialog box, and move the gray triangle to the right. This will make the grass less green. These adjustments will have the effect of making the foreground look sunnier (brighter, more contrasty and warmer usually does the trick). Select 'OK' and sit back and admire a job well done. Zoom in to look for bleeding color or areas that should have been in the selection that were left out.

DIGITAL IMAGING >>>

12. If you have found any errors they can usually be attributed to the mask. To work on the mask you can click on its thumbnail in the Layers palette and paint with either white or black. This time Elements users need to select the real paintbrush and not the one that paints ants. Pressing the letter 'D' on the keyboard will make sure the colors in the Tools palette are set to their default settings of white and black. Black will remove the adjustments and white will allow the adjustments to affect the pixels below. Use a slightly soft brush to match the softening you have done to your mask. If you want to see the mask during this operation you will need to hold down the 'Alt' ('Option' key on a Mac) and the 'Shift' key at the same time whilst clicking on the layer mask thumbnail. Repeat this action to return to the normal view.

essential skills >>>

13. Don't forget the final step of any editing procedure is the Unsharp Mask. I always prefer to create a separate layer for the sharpening process - especially if I am intending to make a print. My procedure is to choose 'Select All' from the 'Select' menu, 'Copy Merged' and then 'Paste' both from the 'Edit' menu. Set the view to 'Actual Pixels' from the 'View' menu before going to the 'Filter' menu to choose the 'Unsharp Mask' option from the 'Sharpen' submenu. Standard settings are around 100% for the amount, 1.5 for the Radius when sharpening a 5 or 6 Megapixel image with a threshold of around 3. Slightly more if your image is slightly noisy or has already been sharpened in-camera.

A print has a habit of looking less sharp than the screen image so a little bit of over-sharpening is usually required to get things looking perfect. If you can't see any sharpening then you need to check that you do not have the adjustment layer selected. You cannot sharpen invisible pixels, i.e. there are no pixels on an adjustment layer to be sharpened. Project five will look at advanced skills for sharpening localized areas of the image.

LAYER ORDER

If this sharpening layer is beneath the adjustment layer, the adjustments will be applied twice, and then your image will look like it has had a tussle with the ugly stick. If this happens you should drag the new layer to the top of the layers stack. Remember that when you choose 'Paste' from the 'Edit' menu the pixels are always pasted into a new layer above the active layer.

Target values - *Project 3*

After effecting global and local changes to enhance the digital image it is important to optimize the image for the intended output device. To achieve optimum tonal quality in your digital images it is important to target both the highlight and shadow tones within each image. When using Photoshop CS/CS2 or Elements the eyedropper tool is a key to unlock the quality that lies dormant in any one of your images that has been correctly exposed.

Ansel Adams was responsible for creating the famous/infamous 'Zone System' in order to precisely control the tonal range of each of his masterpieces. If you look carefully at one of his beautiful landscape photographs you will notice that only the light source (or its reflection - something termed a 'specular highlight') appears as paper white. All the rest of the bright highlights reveal tone or texture. Likewise, the shadows may appear very dark, but they are not devoid of detail. Ansel was careful only to render black holes as black. Any surface, even those in shadow, would render glorious amounts of detail

To make sure the highlight detail does not 'blow out' (become white) and the shadow detail is not lost in a sea of black ink it is possible to target, or set specific tonal values to these important tones. The tones that should be targeted are the lightest and darkest areas in the image that contain detail. The default settings of the eyedroppers to be found in the levels dialog box are set to 0 (black) and 255 (white). These settings are only useful for targeting the white overexposed areas or black underexposed areas. These tools can however be recalibrated to something much more useful, i.e. tones with detail. A typical photo quality inkjet printer printing on premium grade photo paper will usually render detail between the levels 15 and 250. Precise values can be gained by printing a 'step wedge' of specific tones to evaluate the darkest tone that is not black and the brightest tone that is not paper white.

COMMERCIAL TARGETS

The precise target values for images destined for the commercial printing industry are dependent on the inks, papers and processes in use. Images are sometimes optimized for press by skilled operatives during the conversion to CMYK. Sometimes they are not. If in doubt you should check with the publication to get an idea of what you are expected to do and what you should be aiming for if the responsibility is yours.

1. Open your potential masterpiece and select the 'Eyedropper Tool' in the tools palette. Set the sample size of the eyedropper to a 5 by 5 average in the options bar to ensure general tonal values are sampled rather than individual pixel values.

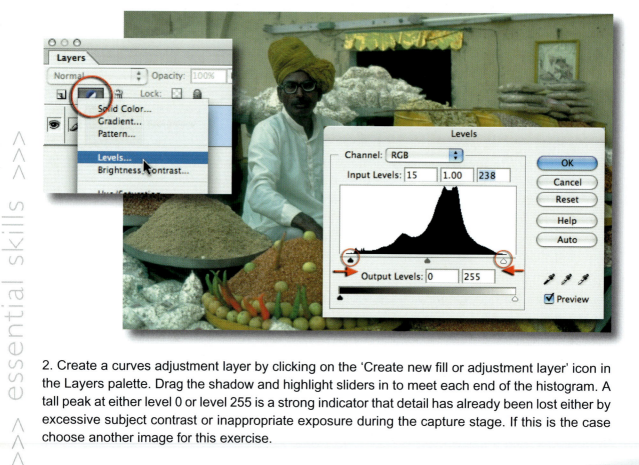

2. Create a curves adjustment layer by clicking on the 'Create new fill or adjustment layer' icon in the Layers palette. Drag the shadow and highlight sliders in to meet each end of the histogram. A tall peak at either level 0 or level 255 is a strong indicator that detail has already been lost either by excessive subject contrast or inappropriate exposure during the capture stage. If this is the case choose another image for this exercise.

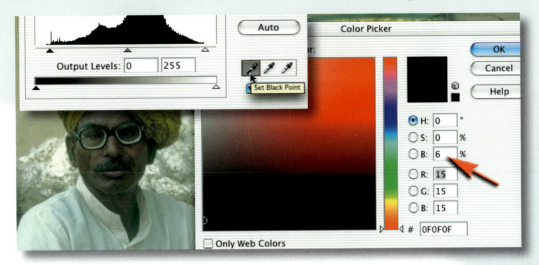

3. Double-click the 'Set Black Point' eyedropper in the levels dialog box to display the Color Picker. Enter a value of 6 in the 'Brightness' field (part of the hue, saturation and brightness or 'HSB' controls) and select OK.

Note > You can experiment with alternative values later as these adjustments will be placed on an adjustment layer that is editable.

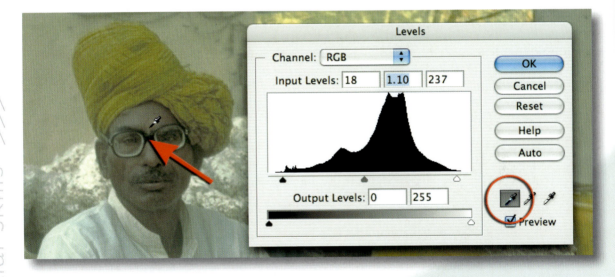

4. Carefully view the image to locate the darkest shadow or surface within the image. Be careful to select representative tone, e.g. a dark surface rather than a black hole. With the 'Set Black Point' eyedropper still selected move into the image window and click on this area to target this as the deepest shadow tone within your image. In the example illustration the rim of the man's glasses or spectacles are selected.

Note > Hold down the 'Alt' key ('Option' key on a Mac) as you move the sliders to gain an idea of where the darkest shadows and brightest highlights are residing in the image.

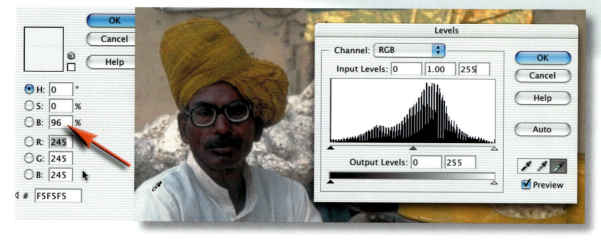

5. Double-click the 'Set White Point' eyedropper to display the Color Picker again. This time enter a value of 96 in the 'Brightness' field and select OK. Locate the brightest highlight within the image. Do not select a specular highlight such as a light source or a reflection of the light source that should be 255. With the 'Set White Point' eyedropper still selected move into the image window and click on this area to target this as the brightest highlight tone within your image.

Note > When targeting highlights and shadows of a color image a color cast may be introduced into the image if the tones to be targeted are not neutral or desaturated. This can be rectified using the Gray eyedropper to correct any cast introduced.

6. Select the 'Set Gray Point' eyedropper (between the black and white point eyedroppers). Click on a suitable tone you wish to desaturate in an attempt to remove the color cast present in the image (the metal tray holding produce to the left of the man's shoulder was ideal in the example illustration). The neutral tone selected to be the 'Gray Point' can be a dark or light tone within the image. If the tone selected is not representative of a neutral tone the color cast cannot be rectified effectively.

DIGITAL IMAGING

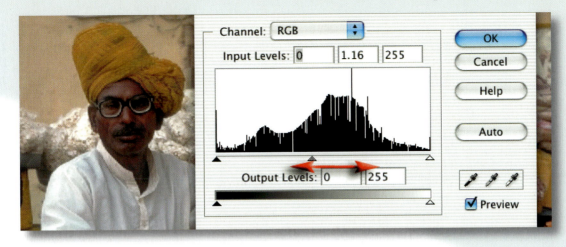

7. Move the Gamma slider to fine-tune the overall brightness of the mid-tones. Excessive movement of the Gamma slider however will upset the targeted tones set previously.

Note > Use the information palette and set the second reading in the palette options to HSB to gain an accurate idea of the precise mid-tone values being created.

8. Click 'OK' to apply the tonality changes to the image. When presented with the dialog box that reads 'Save the new target colors as defaults?' you can select 'Yes'. This will ensure that when you use the eyedroppers on your next image you will not have to select the target values from the 'Color Picker' as they will have been stored by Elements. This will allow you to fine-tune image color and tonality with just a few clicks of the mouse.

9. After a global color change using the Set Gray point eyedropper it may be necessary to carry out a localized tonal or color adjustment for fine-tuning or for effect. To create a localized adjustment it is useful to first make a rough selection to isolate the section of the image to be modified. Accuracy at this stage is not required as it can be perfected later.

>>> essential skills >>>

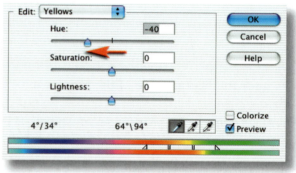

10. For a localized color adjustment create a 'Hue/Saturation' adjustment layer. Select the 'Yellows' from the 'Edit' drop-down menu. Choosing a specific color from this menu will limit the effects of the hue change to an isolated portion of the color spectrum.

11. The 'Hue' slider is moved until all the yellows' are shifted to orange/red hue. The color range affected can be further limited or expanded by using the eyedroppers in the dialog box. Click on the first eyedropper to fine-tune the particular hue of yellows to be adjusted. Alter the range of colors to be adjusted by clicking on the 'Add to Sample' or 'Subtract from Sample' eyedroppers.

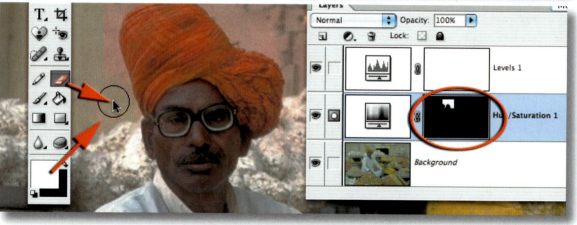

12. Select the 'Eraser Tool' and make the foreground color white. In the options bar set the opacity to between 80 and 100% and choose a soft edge eraser for increased subtlety. Select an appropriate brush size and paint to remove any unwanted color. Switch the foreground color to black to paint back the color if you accidentally remove too much. Add additional adjustment layers for further modifications. Apply the Unsharp Mask to a merged layer before printing.

Note > If the default colors are set in the tools palette the keyboard shortcuts 'Ctrl + Delete' and 'Alt + Delete' can be used to fill or clear a layer mask quickly (use the Command key or Option key when using a Mac).

Shadows and highlights - *Project 4*

Perhaps one of the most impressive new features to arrive with Photoshop CS and Elements 3 is the Shadow/Highlight adjustment. For Elements users it replaces the Fill-Flash and Adjust Backlighting adjustments that were part of the Enhance > Lighting collection of adjustments. These adjustment features, although working on the shadows and highlights, did little to 'enhance' the image, with mid-tone contrast suffering at the hands of these tools. Elements users have previously been unable to work on the shadows or highlights in isolation to the rest of the tones in the image without knowledge of some advanced techniques and workarounds. With the introduction of Shadow/Highlight, Elements users should no longer feel frustrated with the shortcomings of the levels adjustment feature, which does an excellent job of managing the overall spread of tones but is unable to focus or limit its attention without resorting to time-consuming selections.

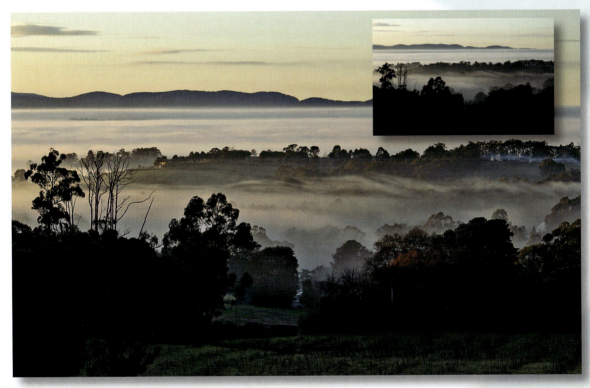

A new kid on the block

The Shadow/Highlight adjustment feature first appeared in Photoshop CS in 2003 and was almost overlooked by many experienced image editors who were used to manipulating tonality through the advanced adjustment feature called 'Curves'. The strength of the new adjustment feature for Elements 3 and Photoshop CS/CS2 users (even for users of Curves), is its handling of mid-tone contrast and saturation and its user-friendly interface (its even kind to the histograms of bit impoverished 8-bit files). The only downside to this adjustment feature is that it is not available as an Adjustment Layer.

143

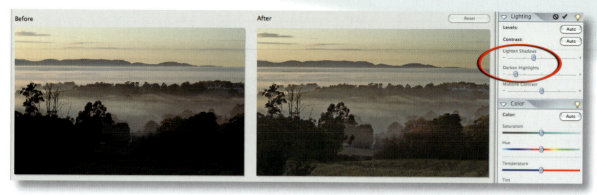

1. **Locating the adjustment feature** - The Shadow/Highlight adjustment feature is available in the Quick Fix working space in Elements 3 or from Image > Adjustments in Photoshop CS/CS2 and Enhance > Adjust Lighting in Elements 3. Elements users are advised to access this from the Quick Fix workspace to make use of the zoom, 'before' and 'after' and saturation options.

2. Modifying the tonality - The Shadow/Highlight dialog box in CS/CS2 has a 'Show More Options' feature to allow the meticulous control freak to tweak the adjustment to their own liking (heaps more sliders). For most users however this is where the 'Quick and Easy' becomes the 'Slow and slightly complex'. For most images with overly dark shadows, moving the Lighten Shadow slider or the Amount slider up to 30% or so, will reveal the detail in the dark areas of the image that was previously hiding. Use higher amounts (up to 50%) in Elements 3 if you have raised the Midtone Contrast. Using higher values in CS/CS2 without resorting to the extra options will often start to degrade rather than enhance the overall quality of the image.

Warning > Do not use this adjustment feature to compensate for a poorly calibrated monitor. There is not much value in optimizing the images for your own screen when they will look entirely different in print or on a correctly calibrated monitor.

144

3. Comparing the technique - Photoshop users who may have previously resorted to curves to fix a shadow problem (raising the shadow values and lowering the mid-tone and highlight values) should be aware of the plateau that this creates in the mid-tone section which often leads to low contrast in this area of the image. Note how the same adjustment using Shadow/Highlight gives you independent control over this value. There are advanced workarounds for CS/CS2 users but all involve a great deal more time and energy than Shadow/Highlight demands.

Note > Elements users who have upgraded to version 3 (and who have nothing to compare it to) can rest assured that what they previously had on offer in version 2 was inferior to the Photoshop example used in this illustration.

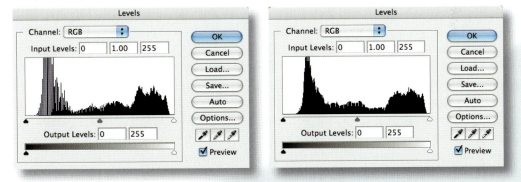

Perhaps the icing on the cake for CS/CS2 users considering whether to use the Shadow/ Highlight in preference to other, more traditional techniques is to observe the histograms of files that have been modified. The illustration shows the sacrifices that have been made using curves to open up the shadow tones (more experienced CS/CS2 users will however be aware that spikes in histograms can mysteriously disappear when a file is resampled).

145

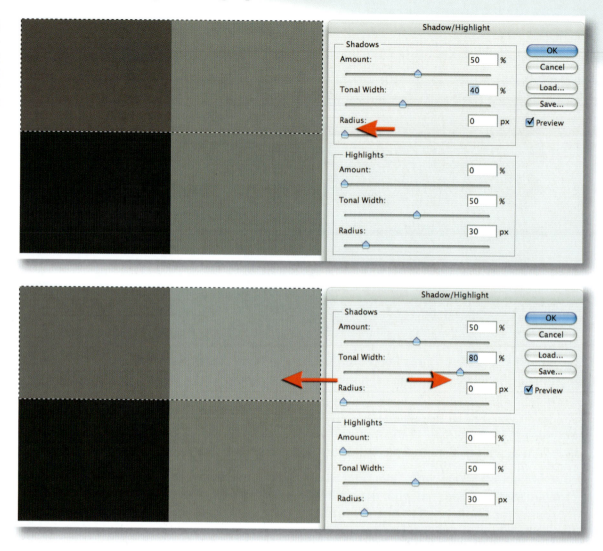

Photoshop CS/CS2

Options, options and more options

For CS/CS2 users many of the 'Option' sliders such as Color Correction and Midtone Contrast make perfect sense - but what about Tonal Width and Radius? Let me illuminate - the Tonal Width slider controls which tones get affected by the Amount slider. Raise the Tonal Width slider and mid-tones start to come under the influence of the Amount slider. Take the radius to 0 to experiment with the relationship of the top two sliders. The illustration uses two tones placed side by side. The top half of these tones have been selected, so the bottom section remains unaffected by the Shadow/Highlights adjustments. With the Tonal Width slider set low, the lighter of the two tones remains unaffected by the adjustment. As the Tonal Width slider is raised the lighter tone is also affected by the adjustment.

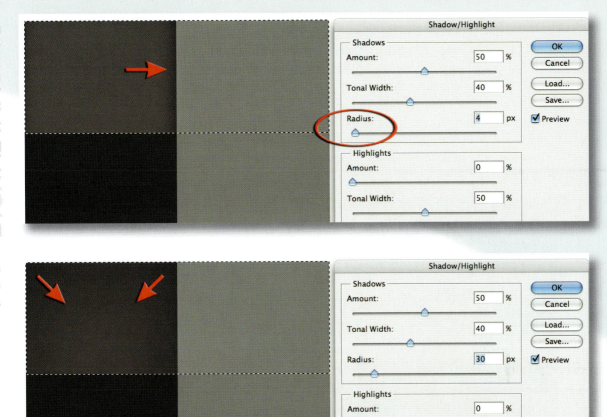

Raising the Radius amount will create localized contrast in the shadow areas. This is a very useful feature, but is perhaps the most difficult to come to terms with. The optimum value is dependent on both the resolution of the image and the size of the shadow areas in the image. I recommend obtaining an appropriate setting for the top two sliders and then zoom into the shadows to gain an idea of the optimum setting required for the Radius slider. The demonstration file shows the effects of raising the Radius slider by only a few pixels (magnified view). This sets up an edge contrast effect similar to the effects of the Unsharp mask. Raising the slider softens the effect on smaller tonal differences within the shadow areas and pushes, or limits, the effect to the boundaries of the larger shadow areas. There is no right or wrong with this slider, just different visual outcomes. If you understand the principles of the Shadow adjustment then the Highlights adjustment won't come as any surprise. The adjustment capability of this Shadow/Highlight feature is so powerful that an image can be rendered either entirely flat or appear as if it has become a negative version of itself!

With this knowledge firmly in place open the project image and begin to massage the tonality and color into a shape that pleases your own subjective eye. The tonal manipulations on offer are not new, but the speed and ease of access is a breath of fresh air. This truly is Adobe's best Quick Fix to date.

Advanced sharpening techniques - *Project 5*

Most if not all digital images require sharpening - even if shot on a state of the art digital mega-resolution SLR with pin-sharp focussing. Most cameras or scanners can sharpen as the image is captured but the highest quality sharpening is to be found in the image-editing software. Sharpening in the image-editing software will allow you to select the precise amount of sharpening and the areas of the image that require sharpening most. If sharpening for screen it is very much a case of 'what you see is what you get'. For images destined for print however, the monitor preview is just that - a preview. The actual amount of sharpening required for optimum image quality is usually a little more than looks comfortable on screen - especially when using a TFT monitor (flat panel).

The basic concept of sharpening is to send the Unsharp Mask filter on a 'seek and manipulate' mission. The filter is programmed to make the pixels on the lighter side of any edge it finds lighter still, and the pixels on the darker side of the edge darker. Think of it as a localized contrast control. Too much and people in your images start to look radioactive (they glow), not enough and the viewers of your images start reaching for the reading glasses they don't own. The best sharpening techniques are those that prioritize the important areas for sharpening and leave the smoother areas of the image well alone, e.g. sharpening the eyes of a portrait but avoiding the skin texture. These advanced techniques are essential when sharpening images that have been scanned from film or have excessive noise, neither of which needs accentuating by the Unsharp Mask. So let the project begin.

Note > If you have any sharpening options in your capture device it is important to switch them off or set them to minimum or low. The sharpening features found in most capture devices are often very crude when compared to the following technique. It is also not advisable to sharpen images that have been saved as JPEG files using high compression/ low quality settings. The sharpening process that follows should also come at the end of the editing process, i.e. adjust the color and tonality of the image before starting this advanced sharpening technique.

DIGITAL IMAGING >>>

essential skills >>>

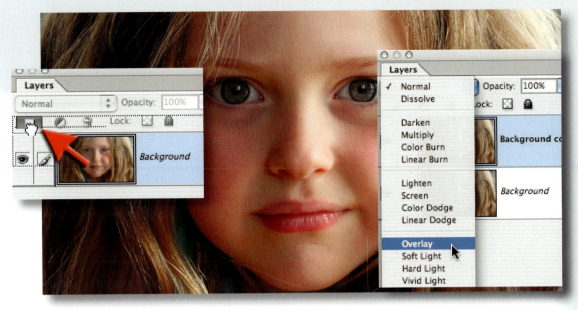

TECHNIQUE ONE - HIGH PASS

1. Duplicate the background layer and set the blend mode to Overlay. Select 'Overlay' from the blend modes menu in the Layers palette.

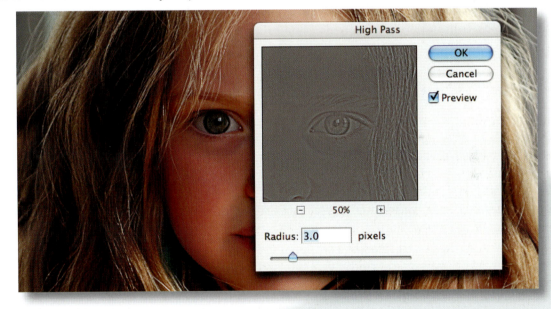

2. Go to 'Filter > Other > High Pass'. Increase the pixel radius until you achieve the correct amount of sharpening. A pixel radius of 1.0 if printing to Gloss paper and 3.0 if printing to Matt paper would be about normal.

Note > To adjust the level of sharpening later you can either adjust the opacity of the High Pass layer or set the blend mode of the 'High Pass' layer to 'Soft Light' or 'Hard Light' to increase or decrease the level of sharpening.

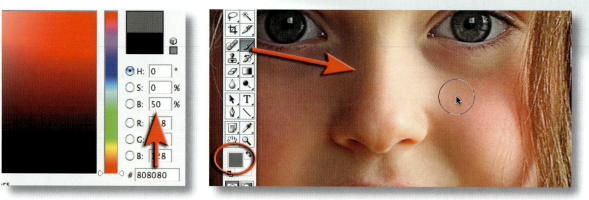

3. Click on the Foreground color swatch in the tools palette to open the Color Picker. Enter 0 in the Hue and Saturation fields and 50% in the Brightness field to choose a mid-tone gray. Select OK. Paint the High Pass layer to remove any sharpening that is not required, e.g. skin tones, skies etc. This technique is especially useful for limiting the visual appearance of noise or film grain.

Note > You may like to temporarily switch the blend mode of the High Pass layer back to Normal mode during the painting process.

Detail from a portrait captured on a Nikon D I x. The RAW image was processed with 15% sharpening. First test has no subsequent sharpening. Second test uses a High Pass layer (3 pixel radius) in Soft Light mode. Third test has had the blend mode of the High Pass layer changed to Overlay mode. Fourth test has sharpening via a localized Unsharp Mask (100%) in Luminosity mode. The opacity slider could be used to fine-tune the preferred sharpening routine

4. Remember at this point the settings you have selected are being viewed on a monitor as a preview of the actual print. To complete the process it is important to print the image and then decide whether the image could stand additional sharpening or whether the amount used was excessive. If the settings are excessive you can choose to lower the opacity of the 'High Pass' layer. You can alternatively switch the blend mode of the 'High Pass' layer to 'Soft Light' to reduce the sharpness or 'Hard Light' to increase the sharpness.

DIGITAL IMAGING >>>

SATURATION AND SHARPENING

Most techniques to increase the contrast of an image will also have a knock-on effect of increasing color saturation. As the High Pass and Unsharp Mask filters both increase local contrast there is an extended technique if this increased color saturation becomes problematic. You may not notice this in general image-editing but if you become aware of color fringing after applying the High Pass technique you should consider the following technique to limit its effects.

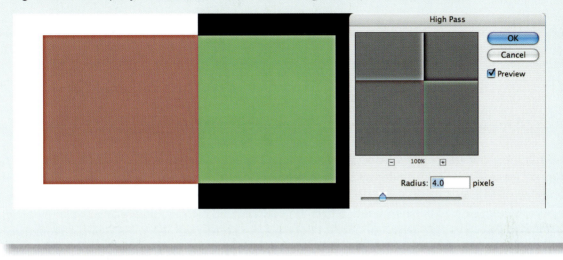

TECHNIQUE TWO - UNSHARP MASK

The second technique is a continuation of the first technique and is intended to address the issues of increased saturation leading to the effect of color fringing. If a merged layer is used as the sharpening layer (as in project 2) and this layer is then changed to Luminosity blend mode the effects of saturation are removed from the contrast equation. This second technique looks at how the benefits of localized sharpening and Luminosity sharpening can be combined.

essential skills >>>

5. Change the Blend mode of the High Pass layer back to Normal mode. Then apply a Threshold filter to the High Pass layer. Elements users can find the threshold filter in the Filter > Adjustments submenu whilst Photoshop users will find the Adjustments submenu in the Image menu.

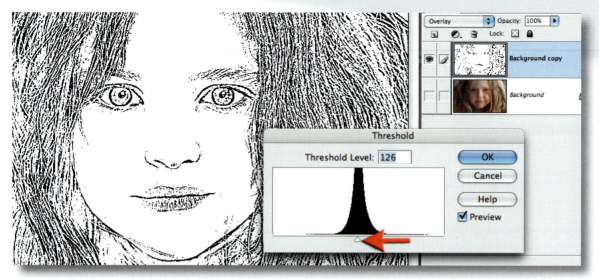

6. Drag the slider just below the histogram to isolate the edges that require sharpening. The aim of moving these sliders is to render all of those areas you do not want to sharpen white. Select 'OK' when you are done. Paint out any areas that were not rendered white by the Threshold adjustment that you do not want to be sharpened, e.g. in the portrait used in this example any pixels remaining in the skin away from the eyes, mouth and nose were painted over using the paintbrush tool with white selected as the foreground color. Switch off the background layer visibility after cleaning this layer of unwanted detail.

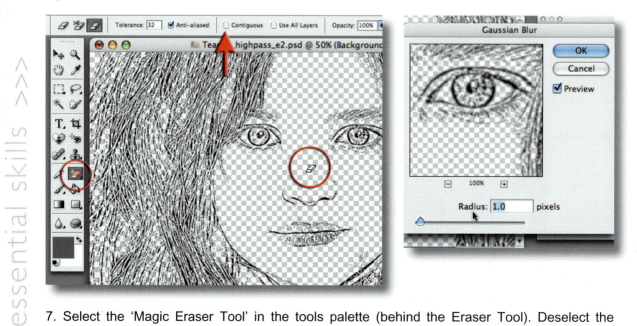

7. Select the 'Magic Eraser Tool' in the tools palette (behind the Eraser Tool). Deselect the 'Contiguous' option in the options bar and then click on any white area within the image. You should be left with only the edge detail and none of the white areas. Go to Filter > Blur > Gaussian Blur and apply a 1 pixel radius blur to this layer.

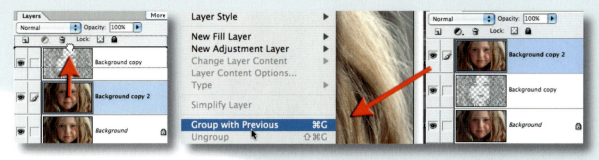

8. Switch on the visibility of the background layer and duplicate the background once again. Drag this duplicate layer to the top of the layers stack. Ensure the image is zoomed in to 100% for a small image or 50% for a larger print resolution image (200ppi-300ppi). From the Layer menu select Group with Previous (Elements) or Create Clipping Mask (Photoshop CS/CS2). This clips or groups the layers together. The transparent areas on the 'Threshold layer act as a mask so only the important areas of the image appear sharpened.

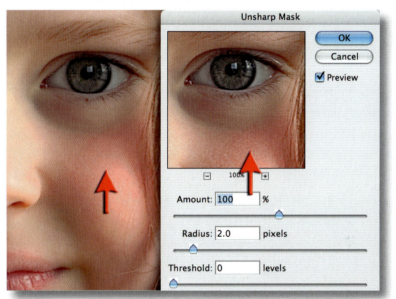

9. Go to 'Filter > Sharpen > Unsharp Mask'. Adjust the 'Amount' slider to between 80 and 150%. This controls how much darker or lighter the pixels at the edges are rendered. Choose an amount slightly more than looks comfortable on screen if the image is destined for print rather than screen. The 'Radius' slider should be set to 0.5 for screen images and between 1 and 2 pixels for print resolution images. The Radius slider controls the width of the edge that is affected by the amount slider. The 'Threshold' slider helps the Unsharp Mask decide where the edges are. If the threshold slider is raised the Unsharp Mask progressively ignores edges of lower contrast. Set the slider between 0 and 3 for images from digital cameras and between 3 and 7 for images scanned from 35mm film.

Note > If you are sharpening an excessively 'noisy' or 'grainy' image the Threshold slider is moved progressively higher to avoid sharpening non-image data. The exact threshold setting is not so critical for this advanced technique.

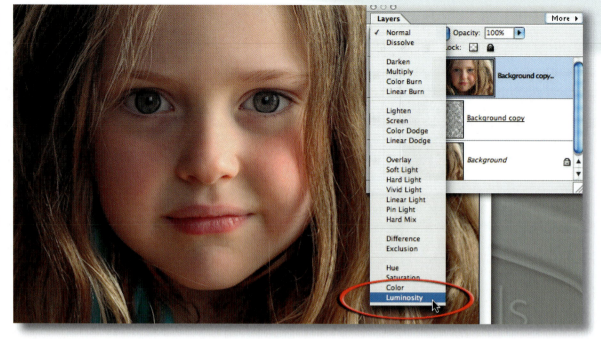

10. Change the blend mode of the sharpening layer (the uppermost layer) to Luminosity mode. Luminosity mode will restrict the contrast changes to brightness only, and will remove any changes in saturation that have occurred due to the use of the Unsharp Mask. The changes are often very subtle so this technique is only recommended when you become aware of the problems of color fringing due to increased saturation.

Before and after the luminosity mode change

The illustration above is a maginified view of the effects of changing the blend to Luminosity. These two cutting edge techniques are capable of producing razor sharp images that will really put the finishing touches to a folio quality image.

Andrew Elliot

Paul Allister

digital post-production

Mark Galer

essential skills

- ~ Explore the creative potential of post-production image editing.
- ~ Selectively convert RGB images into black and white.
- ~ Tone images using the Gradient Map technique.
- ~ Control apparent depth of field using Gaussian Blur and Lens Blur techniques.
- ~ Expand the dynamic range of the capture medium by applying advanced blending techniques to multiple exposures.
- ~ Create a seamless digital montage using advanced masking techniques.

Black and white - *Project 6*

When color film arrived over half a century ago the pundits who presumed that black and white film would die a quick death were surprisingly mistaken. Color is all very nice but sometimes the rich tonal qualities that we can see in the work of the photographic artists are something certainly to be savoured. Can you imagine an Ansel Adams masterpiece in color? If you can - read no further.

Creating fabulous black and white photographs from your color images is a little more complicated than hitting the 'Convert to Grayscale mode' or 'Desaturate' buttons in your image editing software (or worse still, your camera). Ask any professional photographer who has been raised on the medium and you will discover that crafting tonally rich images requires both a carefully chosen color filter during the capture stage and some dodging and burning in the darkroom.

Color filters for black and white? Now there is an interesting concept! Well as strange as it may seem screwing on a color filter for capturing images on black and white film has traditionally been an essential ingredient to the recipe for success. The most popular color filter in the black and white photographer's kit bag, that is used for the most dramatic effect, is the 'red filter'. The effect of the red filter is to lighten all things that are red and darken all things that are not red in the original scene. The result is a print with considerable tonal differences compared to an image shot without a filter. Is this a big deal? Well yes it is - blue skies are darkened and skin blemishes are lightened. That's a winning combination for most landscape and portrait photographers wanting to create black and white masterpieces.

Note > The more conservative photographers of old (those not big on drama) would typically invest in a yellow or orange filter rather than the 'full-on' effects that the red filter offers.

DIGITAL IMAGING >>>

essential skills >>>

Now just before you run out to purchase your red filter and 'Grayscale image sensor' you should be reminded that neither is required by the digital shooter with access to image editing software. Shooting digitally in RGB (red, green, blue) means that you have already shot the same image using the three different filters. If you were to selectively favor the goodies in the red channel, above those to be found in the mundane green and the notoriously noisy blue channels, when you convert your RGB image to Grayscale, you would, in effect, be creating a Grayscale image that would appear as if it had been shot using the red filter from the 'good old days'. Owners of Photoshop CS/CS2 can see the different information in the individual channels by using the 'Channels Palette', and can then selectively combine the information using the 'Channel Mixer'. For owners of Adobe Elements you are two cans short of a six-pack for this procedure - but take heart. Yes there is no Channels Palette, and no, you don't have a Channel Mixer (but then your bank account probably looks healthier for it). As luck would have it the famous digital Guru 'Russel Preston Brown' has come up with a work-around that is both easier to use than the Channel Mixer and is also available to the software impoverished.

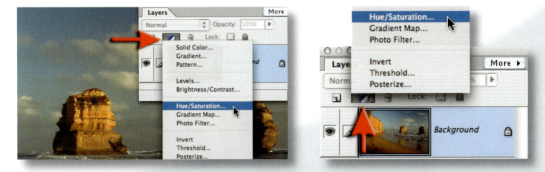

1. Drag the Layers palette from the palette bin (this will be your command centre for this technique). Click on the Adjustment Layer icon in the Layers palette and scroll down the list to select and create a 'Hue/Saturation' adjustment layer. You will make no adjustments for the time being but simply select OK to close the dialog box. Set the blend mode of this adjustment layer to 'Color'.

159

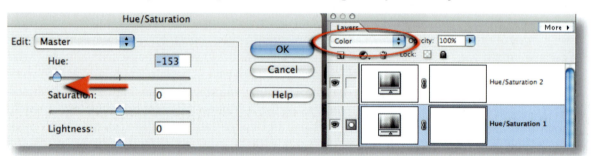

2. Create a second Hue/Saturation adjustment layer. Slide the Saturation slider all the way to the left (-100) to desaturate the image. Select OK. The image will now appear as if you had performed a simple Convert to Grayscale or desaturate (remove color) command.

Note > This second adjustment layer should be sitting on top of the layers stack.

3. Select the first Hue Saturation layer that you created and double-click the layer thumbnail to reopen the Hue/Saturation dialog box. Move the 'Hue' slider in this dialog box to the left. Observe the changes to the tonality of the image as you move the slider. Blues will be darkest when the slider is moved to a position around −150. Select OK. The drama of the image will probably have been improved quite dramatically already but we can take this further with some dodging and burning.

4. Click on the 'New Layer' icon in the Layers palette. Set the blend mode of the layer to 'Overlay'. Set the default 'Foreground and Background' colors in the tools palette and then select the 'Gradient' tool. In the options bar select the 'Foreground (black) to Transparent' and 'Linear' gradient options and then lower the opacity to 50%.

DIGITAL IMAGING >>> >>> essential skills >>> >>>

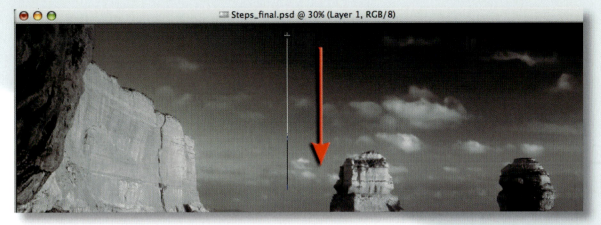

5. Drag one gradient from the base of the image to the horizon line, and a second from the top of the image window to the horizon line. This will have the effect of drawing the viewer into the image and create an increased sense of drama. Lowering the opacity of the layer if the effect is too strong.

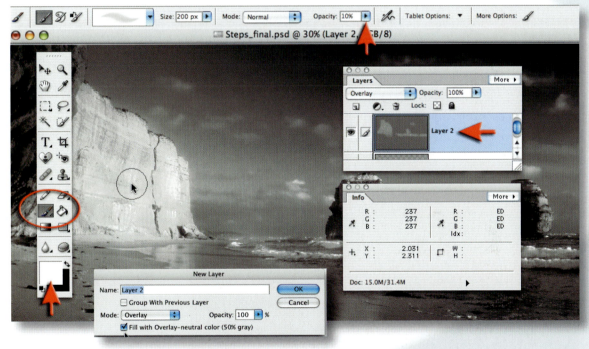

6. Press the 'Alt/Option' key and click on the 'New Layer' icon. In the New Layer dialog box set the blend mode to 'Overlay' and select the 'Fill with Overlay-neutral color' option. Select the Paintbrush Tool and select a soft edged brush from the options bar and lower the opacity to 10%. A layer that is 50% Gray in Overlay mode is invisible. This gray layer will be used to dodge and burn your image non-destructively, i.e. you are not working on the actual pixels of your image. If any mistakes are made they can either be corrected or the layer can be discarded. Paint onto the gray layer with black selected as the foreground color to burn (darken) the image in localized areas or switch to white to dodge (lighten) localized areas. In the project image the cliffs and the surf were dodged to highlight them.

DIGITAL IMAGING >>>

essential skills >>>

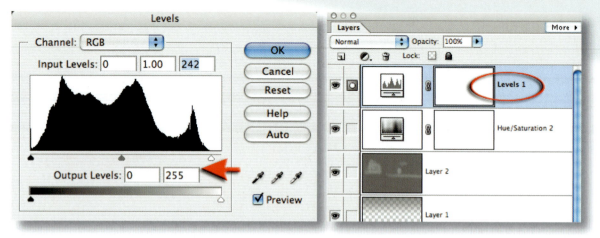

7. Select the top layer and then create a 'Levels' adjustment layer (one adjustment layer to rule them all) to sit above all of the other layers. Make sure the histogram extends all the way between the black and white sliders. Move the sliders in to meet the histogram if this is not the case.

8. Try experimenting with the introduction of some of the original color. Duplicate the background layer by dragging it to the new layer icon. Then drag the background copy further up the layers stack to a position just below the Levels adjustment layer. Reduce the opacity of this layer to let the black and white version introduce the drama once more.

Toning - *Project 7*

Burning, toning, split-grade printing and printing through your mother's silk stockings are just some of the wonderful, weird and positively wacky techniques used by the traditional masters of the darkroom waiting to be exposed (or ripped off) in this tantalizing digital project designed to pump up the mood and ambience of the flat and downright dull.

Seeing red and feeling blue

It probably comes as no small surprise that 'color' injects images with mood and emotional impact. Photographers, however, frequently work on images that are devoid of color because of the tonal control they are able to achieve in traditional processing and printing techniques. Toning the resulting 'black and white' images keeps the emphasis on the play of light and shade but lets the introduced colors influence the final mood. With the increased sophistication and control that digital image editing software affords us, we can now explore the 'twilight zone' between color and black and white as never before. The original image has the potential to be more dramatic and carry greater emotional impact through the controlled use of tone and color.

The tonality of the project image destined for the toning table will be given a split personality. The shadows will be gently blurred to add depth and character whilst the highlights will be lifted and left with full detail for emphasis and focus. Selected colors will then be mapped to the new tonality to establish the final mood.

1. For the best results choose an image where the directional lighting (low sunlight or window light) has created interesting highlights and shadows that gently model the three-dimensional form within the image. Adjust the levels if necessary so that the tonal range extends between the shadow and highlight sliders. In the Layers palette drag the background layer to the New Layer icon to create a background copy (a safety-net feature).

2. Bright areas of tone within the image can be distracting if they are not part of the main subject matter. It is common practice when working in a black and white darkroom to 'burn' the sky darker so that it does not detract the viewer's attention from the main focal point of the image. In the project image the overly bright sky detracts from the beautiful sweep of the dominant sand dune.

To darken the sky start by clicking on the foreground color swatch in the tools palette to open the 'Color Picker'. Select a deep blue and select 'OK'. In the Options bar select the 'Foreground to Transparent', 'Linear Gradient' and 'Multiply' options. Drag a gradient from the top of the image to just below the horizon line to darken the sky. Holding down the Shift key as you drag constrains the gradient keeping it absolutely vertical.

Note > You may need to make an initial selection of the sky if the gradient interferes with any subject matter that is not part of the sky.

3. Duplicate the 'Background' layer (the one without the gradient) and then drag it to the top of the layers stack. Select 'Desaturate' from the 'Image > Adjustments' menu (CS/CS2) or 'Remove Color' from the 'Enhance > Adjust Color' menu (Elements).

4. Hold down the Alt/Option key on the keyboard and click on the 'Create adjustment layer' icon. In the 'New Layer' dialog box check the 'Group With Previous Layer' option. Click 'OK' to open the 'Levels' dialog box.

5. Drag the highlight slider to the left until the highlights disappear. Move the 'Gamma' slider (the one in the middle) until you achieve good contrast in the shadows of the image. Select 'OK' to apply the levels adjustment.

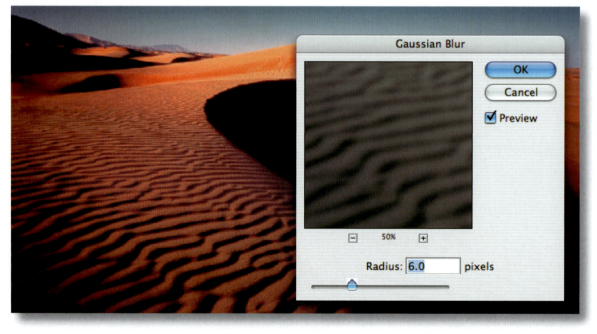

6. In the Layers palette switch the 'Mode' of this Grayscale layer to 'Multiply' to blend these modified shadow tones back into the color image.

7. Go to 'Filter > Blur > Gaussian Blur' and increase the 'Radius' to spread and soften the shadow tones. With the preview on you will be able to see the effect as you raise the amount of blur. Go to 'View > Zoom In' to take a closer look at the effect you are creating.

Note > This effect emulates the silk-stocking technique when it is applied to only the high contrast part of the split-grade printing technique made famous by Max Ferguson and digitally remastered in his book Digital Darkroom Masterclass *(Focal Press)*.

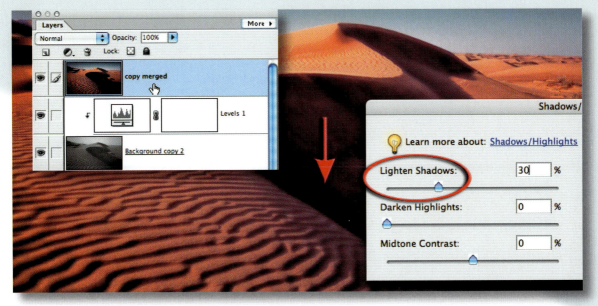

8. Create a 'copy merged' layer by going to the Layer menu and choosing 'Select All'. Then from the Edit menu choose 'Copy Merged'. Again from the Edit menu choose 'Paste'. This copies all of the information from the visible layers and pastes it to a new layer. Drag this to the top of the layers stack if it is not already there. Use the Highlight/Shadow adjustment feature to lighten the overly dark shadows (a result of the Multiply blend mode).

9. Select black as the foreground color in the tools palette. Click on the 'Create adjustment layer' icon in the Layers palette and choose 'Gradient Map' from the menu. Click on the gradient in the Gradient Map dialog box to open the 'Gradient Editor' dialog box.

10. The Gradient Editor dialog box allows you to assign colors to shadows, mid-tones and highlights. Click underneath the gradient to create a new color stop. Slide it to a location that reads approximately 25% at the bottom of the dialog box. Click on the 'Color' swatch to open the 'Color Picker' dialog box. Cool colors such as blue are often chosen to give character to shadow tones. Create another stop and move it to a location that reads approximately 75%. This time try choosing a bright warm color to contrast with the blue chosen previously.

Drag these color sliders and observe the changes that occur in your image. Create bright highlights with detail and deep shadows with detail for maximum tonal impact. Be careful not to move the color stops too close together as banding or 'posterization' will occur in the image. Choose desaturated colors from the Color Picker (less than 40%) to keep the effects reasonably subtle. Once you have created the perfect gradient you can give it a name and save it by clicking on the 'New' button. This gradient will now appear in the gradient presets for quick access.

Note > The gradient map used in this toning activity can be downloaded from the supporting CD and loaded into the 'presets' by going to Edit > Preset Manager > Gradients > Load. Then browse to the Digital_Imaging.grd preset and select OK.

DIGITAL IMAGING >>>

essential skills >>> >>>

Creative depth of field - *Project 8*

The Gaussian Blur filter or Lens Blur filter in Photoshop CS/CS2 can be used creatively to blur distracting backgrounds. Most digital cameras achieve greater depth of field (more in focus) at the same aperture when compared to their 35mm film cousins due to their comparatively small sensor size. This is great in some instances but introduces unwelcome detail and distractions when the attention needs to be firmly fixed on the subject - and not the woman in the background picking her nose!

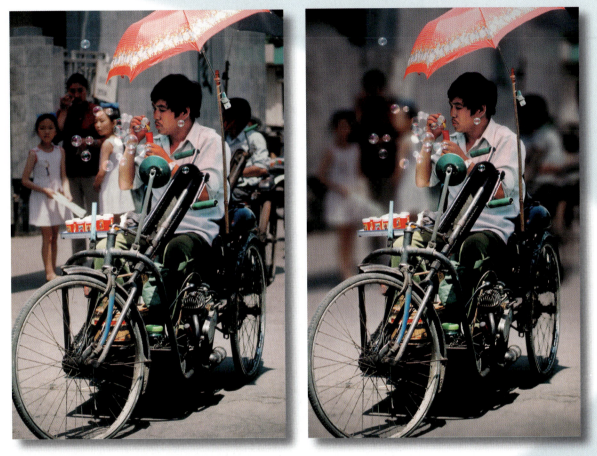

There is often a lot to think about during the capture of an image and the time required to consider the appropriate aperture and shutter speed combination for the desired visual outcome often gets the elbow. Photoshop or Elements can, however, come to the rescue and drop a distracting background into a murky sea of out-of-focus oblivion. A careful selection to isolate the subject from the background and the application of either the 'Gaussian Blur' filter or 'Lens Blur' filter in Photoshop CS/CS2 usually does the trick. Problems with this technique arise when the resulting image, all to often, looks manipulated rather than realistic. A straight application of the Gaussian Blur filter will have a tendency to 'bleed' strong tonal differences and saturated colors into the background fog, making the background in the image look more like a watercolor painting rather than a photograph. The Gaussian Blur filter will usually require some additional work if the post-production technique is not to become too obvious.

DIGITAL IMAGING

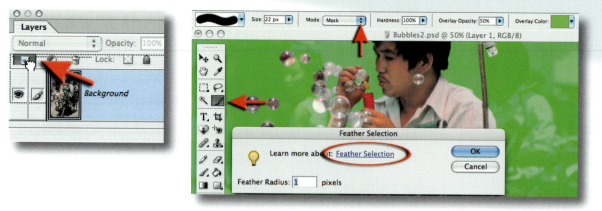

1. Start the project by duplicating the background layer and then creating a selection of the foreground subject matter (or alternatively load the saved selection in the project image on the supporting CD). This selection will isolate the foreground subject from the blurring technique that will follow. If you intend to use a mixture of selection tools, adjust the feather setting in the options bar to 0. Perfect the selection using a hard-edged brush in 'Quick Mask Mode' or the 'Selection Brush' with the 'Mask' option selected when using Elements. Apply a Gaussian Blur filter (Filter > Blur > Gaussian Blur) to the Mask (CS/CS2) or Feather the selection (Elements) to replicate the edge quality of the main subject. Exit Mask mode when the selection is finished.

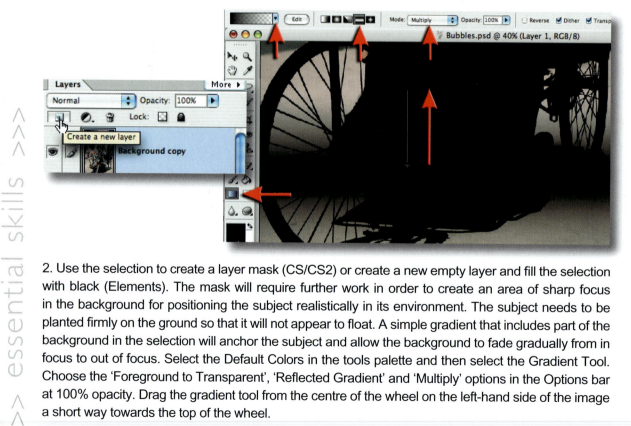

essential skills >>>

2. Use the selection to create a layer mask (CS/CS2) or create a new empty layer and fill the selection with black (Elements). The mask will require further work in order to create an area of sharp focus in the background for positioning the subject realistically in its environment. The subject needs to be planted firmly on the ground so that it will not appear to float. A simple gradient that includes part of the background in the selection will anchor the subject and allow the background to fade gradually from in focus to out of focus. Select the Default Colors in the tools palette and then select the Gradient Tool. Choose the 'Foreground to Transparent', 'Reflected Gradient' and 'Multiply' options in the Options bar at 100% opacity. Drag the gradient tool from the centre of the wheel on the left-hand side of the image a short way towards the top of the wheel.

Note > The following technique for blurring differs between Photoshop CS/CS2 and Elements.

Lens Blur filter - *PHOTOSHOP CS/CS2 ONLY*

The Lens Blur filter was new to Photoshop CS. The filter is extremely sophisticated, allowing you to choose different styles of aperture and control over the specular highlights to create a more realistic camera effect. The filter introduces none of the bleed that is associated with the Gaussian Blur technique.

Click on the image thumbnail in the Layers palette to make sure this is the active part of the layer rather than the layer mask. From the 'Blur' submenu in the 'Filter' menu, select the Lens Blur filter. From the 'Depth Map' section of this dialog box choose 'Layer Mask'.

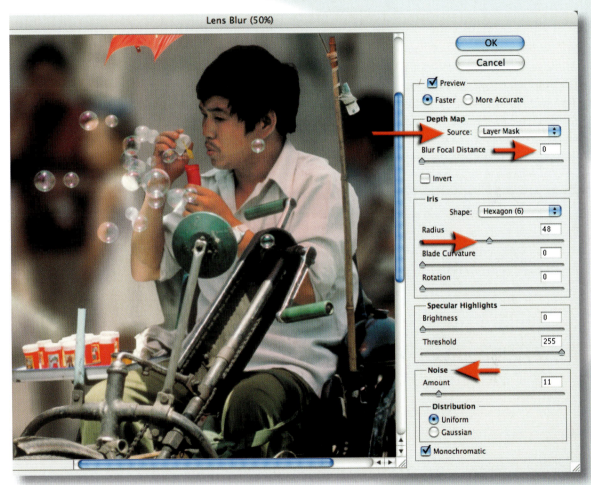

Set the focal point (region of sharp focus) if the foreground subject is not already sharp. This can be set using the Blur Focal Distance slider or by simply clicking on the foreground subject in the preview window. Choose the depth of field required by moving the Radius slider. The Blade Curvature, Rotation, Brightness and Threshold sliders fine-tune the effect. Finally apply a small amount of noise to replicate the textural quality (noise or film grain) of the rest of the image that will remain in focus. Click OK when the blur quality has been achieved. Steps 5 and 6 in this project may also help the CS/CS2 user fine-tune the layer mask after the Lens Blur filter has been applied.

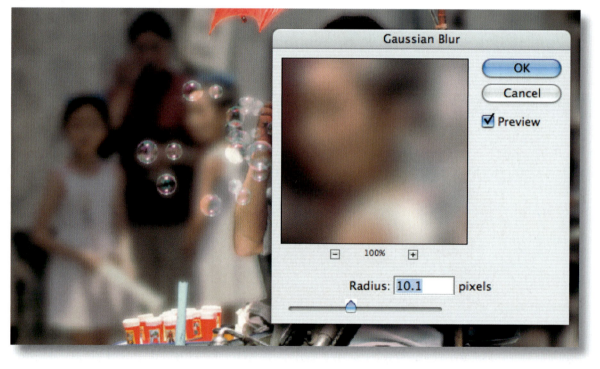

ELEMENTS

3. Move the Background copy layer to the top of the layer stack in the Layers palette. Group the Background copy layer with the mask layer you created in step 2 (go to Layer > Group with Previous). This technique will mask the pixels on the top layer that correspond with the transparent pixels on the mask layer. At this stage no difference will be observed as the Background and Background Copy layers are identical.

4. Select the background layer and apply the Gaussian Blur filter (go to Filter > Blur > Gaussian Blur). Choose a pixel radius that renders the background less distracting to the main subject matter. Click OK and inspect the edges of the subject to observe the transition between the sharp subject and blurred background. Any inaccuracies in the mask may be observed as halos.

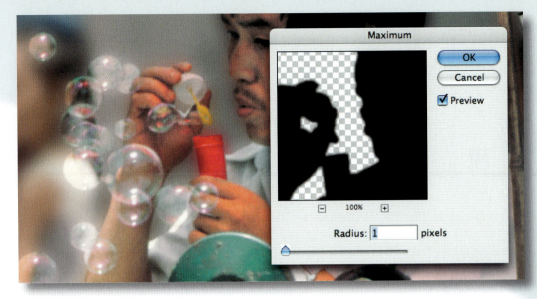

5. Move the edge of the mask to align with your subject using the Maximum or Minimum filters from the 'Filter > Other' submenu. A one or two pixel radius is often sufficient to remove any tell-tale halo. If a halo is present around a localized area of the subject only, you can first make a selection with the lasso tool prior to using the Maximum or Minimum filter.

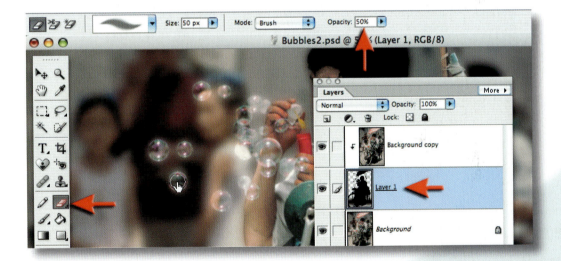

6. Select the eraser tool to soften the focus in localized areas (Photoshop CS/CS2 users who have used a layer mask should select white as the foreground color and a soft edged paintbrush). From the options bar use a soft edged brush with an opacity of 50%. Select the mask layer and paint any areas of the subject that appear too sharp to reduce the detail present. Several passes of the brush set at 50% opacity will gradually reduce the detail and leave a subtle edge.

Note > CS/CS2 users who have used the Lens Blur filter instead of the Gaussian Blur filter will be able to paint with black to restore detail but will be unable to paint with white to reduce detail.

7. When the Gaussian Blur filter is used to blur the background saturated colors or contrasting tones may bleed into the background from the edge of the subject. This can be removed by using the Clone Tool or Healing Brush Tool. If you use the Healing Brush Tool you must first load the selection from the mask layer to prevent further bleeding. This is achieved by holding down the Control key (Command key on a Mac) and clicking on the thumbnail of the mask layer in the Layers palette. You will then need to Inverse the selection (Select > Inverse). Select a large soft-edged brush at a reduced opacity. Press the 'Alt' key (Option key on a Mac) to sample an area that is free from the color or tonal bleed and paint these pixels to mask the unwelcome effect. If using the Clone Stamp tool use a brush at a reduced opacity and make several passes (choosing a different source for each subsequent pass).

8. Use this selection to create a localized 'Levels' adjustment layer to lower the overall brightness of the background to further draw attention to the foreground subject matter.

Future developments - shifting focus

If digital cameras are eventually able to record distance information at the time of capture this could be used in the creation of an automatic depth map for the CS/CS2 Lens Blur filter. Choosing the most appropriate depth of field could be relegated to post-production image editing in a similar way to how the white balance is set in camera RAW.

Tonal contraction - *Project 9*

Contrary to popular opinion - what you see is not what you always get. You may be able to see the detail in those dark shadows and bright highlights when the sun is shining - but can your CCD or CMOS sensor? Contrast in a scene is often a photographer's worst enemy. Contrast is a sneak thief that steals away the detail in the highlights or shadows (sometimes both). A wedding photographer will deal with the problem by using fill-flash to lower the subject contrast; commercial photographers diffuse their own light source or use additional fill lighting and check for missing detail using the 'Histogram' or a 'Polaroid'.

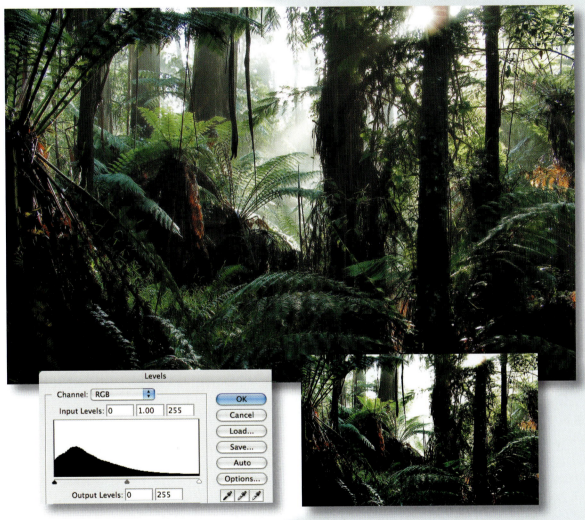

Landscape photographers however, have drawn the short straw when it comes to solving the contrast problem. For the landscape photographer there is no 'quick fix'. A reflector that can fill the shadows of the Grand Canyon has yet to be made and diffusing the sun's light is only going to happen if the clouds are prepared to play ball.

DIGITAL IMAGING >>>

>>> essential skills >>>

Ansel Adams (the famous landscape photographer) developed 'The Zone System' to deal with the high contrast vistas he encountered in California. By careful exposure and processing he found he could extend the film's ability to record high contrast landscapes and create a black-and-white print with full detail. Unlike film however the latitude of a digital imaging sensor (its ability to record a subject brightness range) is fixed. In this respect the sensor is a straight jacket for our aims to create tonally rich images when the sun is shining ... or is it? Here is a post-production 'tone system' that will enrich you and your images.

Note > It is recommended to capture in RAW mode to exploit the full dynamic range that your image sensor is capable of as JPEG or TIFF processing in-camera may clip the shadow and highlight detail (see Digital Negatives, page 53).

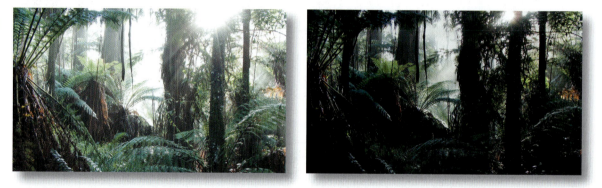

1. The first step to tonal riches is all in-camera. If we can't fit all the goodies in one exposure - then we'll just have to take two. The idea is to montage, or blend, the best of both worlds (the light and dark side of the camera's, not quite, all seeing eye). To make the post-production easier we need to take a little care in the pre-production, i.e. mount the camera securely on a sturdy tripod. Take two exposures, one overexposing from the auto reading, and the other underexposing from the auto reading. One or two stops either side of the meter indicated exposure should cover most high contrast situations.

BRACKETING EXPOSURES

Setting your camera to 'auto bracket exposure mode' means that you don't have to touch the camera between the two exposures, thereby ensuring the first and second exposures can be exactly aligned with the minimum of fuss. Unfortunately for me, the little Fuji FinePix s7000 I was using for this image has auto bracket exposure but it is not operational in RAW capture mode - the only respectable format for self-respecting landscape photographers. This is where you dig out your trusty cable release, and, if you are really lucky - have somewhere to screw it into! The only other movement to be aware of is something beyond your control. If there is a gale blowing (or even a moderate gust) you are not going to get the leaves on the trees to align perfectly in post-production. This also goes for fast moving clouds and anything else that is likely to be zooming around in the fraction of a second between the first and second exposures.

2. Select the Move Tool in the tools palette and drag the dark underexposed image into the window of the lighter overexposed image (alternatively just drag the thumbnail from the Layers palette with any tool selected). Holding down the 'Shift' key as you let go of the image will align the two layers (but not necessarily the two images).

3. In the Layers palette set the blend mode of the top layer to 'Difference' to check the alignment of the two images. If they align - no white edges will be apparent (usually the case If the tripod was sturdy and the two exposures were made via an auto feature or cable release). If you had to resort to a friend's right shoulder you will now spend the time you thought you had saved earlier. To make a perfect alignment you need to select 'Free Transform' from the 'Edit' menu and either nudge the underexposed layer into position using the arrow keys on the keyboard and/or rotate the layer into position. This is achieved by moving the mouse cursor to a position just outside the corner handle of the 'Free Transform' bounding box and then rotating the layer into position. It may help if the axis of rotation is moved before rotating the layer in order to get a precise match (CS/CS2 only).

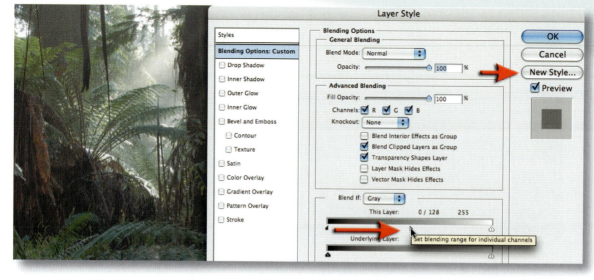

Advanced blending

4. Using the advanced blending options it is possible to reduce the opacity of the shadow tones on the top layer to reveal the shadow tones beneath. The effect can be faded in gradually creating a blend of the optimum highlights from the top layer and the optimum shadow tones of the background layer. The advanced blending options are only available to users of Photoshop CS/CS2 but the same results can be achieved using a layer style preset loaded into the presets folder in Elements.

Transparent shadows created using the advanced blending options

Photoshop CS/CS2

Photoshop users can access the advanced blending options by clicking on the 'Add a layer style' icon in the Layers palette and then choosing Blending Options or by simply double-clicking the layer in the Layers palette (be sure to click the layer and not the layer thumbnail or layer name). In the 'Blend if' section of this dialog box go to the 'This Layer' gray ramp. Split the black slider by holding down the Alt or Option key and dragging the right-hand side of the slider towards the higher levels. Observe the changes in the image when the slider is moved to 64, 128, 196 and all the way to 256. Click OK to exit this dialog box and apply the effect. Alternatively you can click on the 'New Style' button and save this setting in the Layer Styles palette for use on subsequent projects.

Photoshop Elements 3 Presets Styles Shadow_Transparency.asl

Elements

Elements users can access the same effect but must first load the preset that is available on the supporting CD into the styles folder of the application software. The preset was created in Photoshop CS/CS2 but can be read by Elements. The software must be restarted after loading the preset into the folder before Elements can find it.

Select the top layer in the Layers palette and then click on each of the four presets in turn (now located in the Styles and Effects palette) and choose the one that renders the best tonality.

5. Create an adjustment layer by clicking on the 'Create new fill or adjustment layer' icon and choose 'Levels' from the submenu. The final step in the process is to target the deepest shadows and brightest highlights to the values best suited to your chosen output device. My own Epson inkjet paper handles the highlights really well and tones of 250 are easily distinguishable from the paper white (255). The precise targeting of the shadow tones is dependent on the inks and paper being used and can be anywhere between 10 and 20. Do not rely on your monitor at this stage if your final output is print - if in doubt print a test strip and readjust the target points if required. To target a tone refer to Project 3 in the 'Image Enhancements' chapter. Select OK when you are satisfied your image is looking fabulous.

Note > Finding the optimum values for your printer and media can be achieved by printing a tonal step wedge with known values to plot what your printer is capable of.

Digital Montage - *Project 10*

Masks are used to control which pixels are concealed or revealed on any image layer except the background layer. If the mask layer that has been used to conceal pixels is then discarded the original pixels reappear. This approach to montage work is termed 'non-destructive'. In the full version of Photoshop the mask is applied to the image layer whilst in Elements the mask is applied to a separate layer. The following technique adopts the latter approach and works in either version of the Adobe software.

1. Drag the layer thumbnail of one image into the image window of another to create a file with two layers. Use the 'Move tool' to position the second layer. Select 'Free Transform' to make minor changes in size of any new item being included in the montage.

2. Select the majority of the background using a combination of the magic wand and lasso tools. Keep the Shift key depressed to build on, or add to, each successive selection or use the 'Add to selection' and 'Subtract from selection' icons in the Options bar.

DIGITAL IMAGING >>>

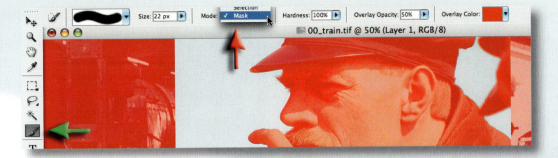

3. Use Quick Mask mode (CS/CS2) or the 'Selection Brush Tool' in 'Mask' mode to fine tune the selection work. Pressing the Alt key (Option key on a Mac) when painting with the selection brush tool will remove rather than add to the selection or mask. Keep the feather set to 0 and the hardness of the Selection Brush Tool set to maximum to match the quality of the Magic Wand.

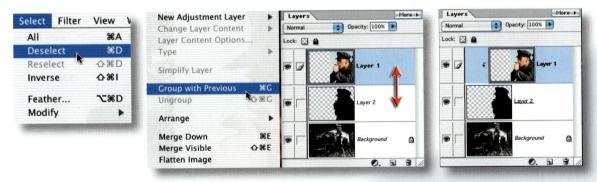

4. Choose the command 'Select > Inverse' so that only the subject is selected. Select the background layer in the Layers palette and create a new empty layer by clicking on the 'Create a new layer' icon. Go to 'Edit > Fill' and select black as the content color.

5. Go to 'Select > Deselect' to remove the selection. This layer will act as your mask. In the full version of Photoshop it can sit on the same layer as the image you are masking. In Elements there is no option to add a layer mask to an image layer.

6. Click on the top layer and select 'Group with Previous' from the 'Layers' menu. The base layer of a layer group acts as a mask to the other layers. The pixels are concealed rather than being deleted and can be retrieved if required to create the perfect edge.

>> essential skills >>>

7. The mask will require some modifications before the edge is subtle and believable. From the 'Filters' menu select 'Blur > Gaussian Blur'. Select a pixel 'Radius' that softens the edge of the subject by an appropriate amount (one or two pixels is usually sufficient). If the subject has one edge that is softer than the rest, first make a selection to isolate that edge for individual attention. To remove the small halo or fringe pixels of the old background from around the subject go to the 'Filter' menu and select 'Other > Maximum'. Select a pixel radius amount that is just enough to shrink the mask so that the fringe of old background pixels disappears.

Note > Any small traces of old background (especially in corners or areas of fine detail) can be removed with the 'Eraser Tool'. Select a small brush with a hard edge at a reduced opacity (approximately 50%) and erase some of the mask in the localized area that is causing the problem.

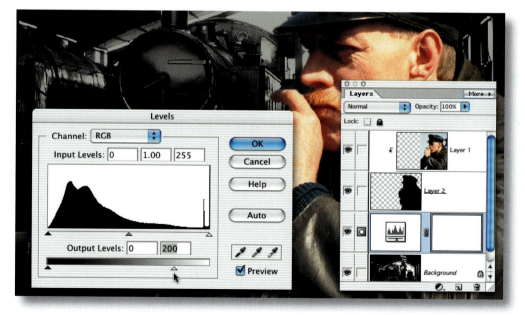

8. Select the background layer and create a 'Levels adjustment layer'. Drag the Output Level slider to a value of 200 to reduce the brightness of the distracting highlights in the background.

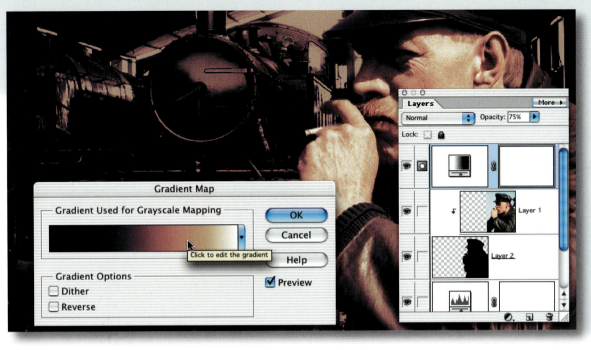

9. Select the driver layer and from the Layers palette select 'Gradient Map'. Click on the gradient to either choose or edit an existing gradient map. See 'Project 6' for more information on this technique.

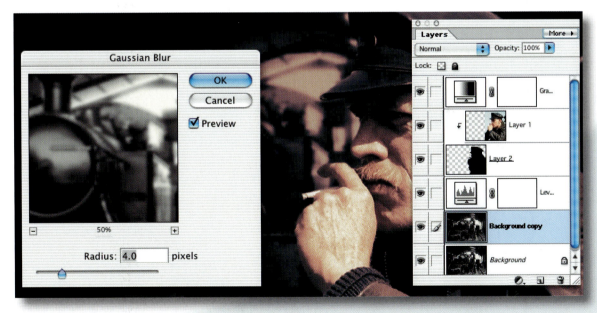

10. Duplicate the background layer, and from the 'Filters' menu choose 'Blur > Gaussian Blur'. Select a pixel 'Radius' that reduces the focus sufficiently to separate the portrait from the background layer. CS users may explore the Lens Blur filter for this technique (see Project 8).

11. Create an empty layer above the background layer and group the background copy with it as you did previously with the driver and the driver mask. Select the gradient tool with the 'foreground (black) to transparent' and 'linear' options. Drag the gradient tool to follow the perspective line of the train. This gradient mask will conceal the front of the blurred train layer to create a simple depth of field effect.

Note > more elaborate 'depth masks' can be created using the selection tools.

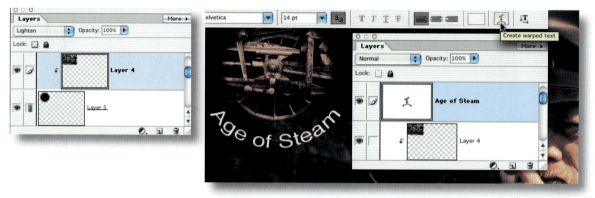

12. Use the clone stamp set to 50% opacity to 'tone down' the distracting highlights on the left side of the image. This action makes way for the insertion of the wheels image in the top left-hand corner. Select the Circular Marquee Tool and draw a circle around the wheel. Create a new layer and fill the selection with black. Apply the Gaussian Blur filter to soften the edge of this mask. Use the 'Type tool' to create a line of text and click on the 'Create warped text' icon in the Options bar and then select the 'Arc' option in the drop-down menu. For more advanced montage techniques see *Photoshop CS: Essential Skills*.

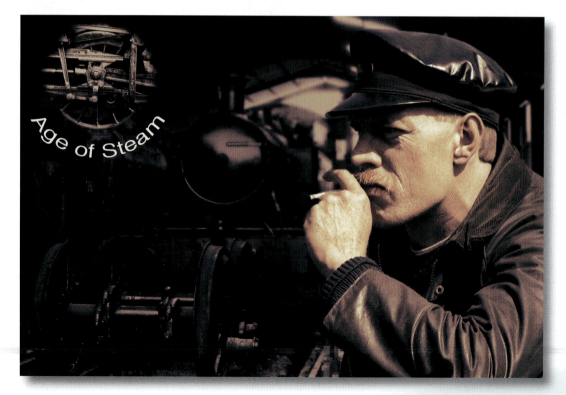

Tamas Elliot

Amber Williams

digital

presentations

Stuart Wilson

essential skills

- ~ Batch process multiple files.
- ~ Create contact sheets for reference and CD archive covers.
- ~ Create a Picture Package.
- ~ Create a slideshow presentation using custom backgrounds and transitions.
- ~ Create an automated Web Photo Gallery.
- ~ Create a panoramic image.

Introduction

The process of creating presentations for screen and print are now a common aspect of the typical photographer's workflow. Many of the automated procedures for handling image files and creating presentations are shared between Photoshop CS/CS2 and Elements 3. They can be accessed via the Automate menu in the File Browser, The Tools > Photoshop menu in Bridge (CS2) or from the File menu in the main image editing workspace of the software. By holding down the Shift key the user can click on the first and last image to select a range of files from an image folder. By holding down the Ctrl or Command key the user can click on a non-sequential number of images to select multiple files from the same folder.

The Batch command (CS/CS2) or Process Multiple Files (Elements 3) takes the repetitive nature out of duplicating, renaming, sizing and formatting multiple files destined for a screen or web presentation. CS/CS2 users have the option to add a custom action to this process whilst Elements users can access Quick Fix adjustments as part of the process together with the option to watermark the images.

Contact sheet

Several labor intensive operations that image-makers frequently find themselves performing are handled quickly and easily by the automated features available in Photoshop. The 'Contact Sheet II' automated feature prepares all the images within a folder as thumbnails at either screen resolution or print resolution.

The creation of a CD cover size contact sheet allows the image-maker to create inserts for CDs containing archived images. The option of including 'Subfolders' allows the user to create file sheets for large cataloged image collections that are kept by cataloging software packages such as the Organizer in Elements 3 for PC or 'iPhoto' for Mac. When the first contact sheet is full Photoshop automatically creates additional pages until all of the images in the folder are represented.

Picture Package - *Project 11*

On the surface Picture Package appears to offer little more than the ability to group multiple versions of the same image into a single document in a fairly uninspiring way. The updated feature for Elements 3 and Photoshop CS/CS2 does however have the option to create and use custom layouts, and can be pushed to behave like a simple desktop publishing package to create simple promotional flyers for the photographer in a hurry. Picture Package can be accessed from the File Browser or from the File menu (tucked away in the Automate menu in CS/CS2).

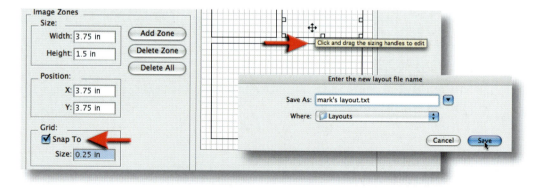

1. If you intend to create a custom layout choose only the Paper Size, Resolution and Label information. As the same label is applied to each image you could use this for copyright information. Holding down the Alt or Option key and pressing the letter G on the keyboard will give you the copyright icon in this text field. Removing the check from the Flatten All Layers box will allow you to edit the layout further as the layout will be exported as a multi-layered document. Click the Edit Layout button to proceed.

2. In the Layout Editor you are able to add or delete zones, adjust the position and size of these zones and align them precisely using the Snap To Grid option. Saving the completed layout takes you back to the main Picture Package dialog box.

DIGITAL IMAGING >>>

3. Once back in the main dialog box you simply click on each of the custom zones to allocate a picture by browsing to its source. Although Picture Package will scale the image to fit the zone, if the proportions of the image do not match that of the zone, a space will be left on two sides. It should be possible to import multiple images directly into Picture Package from either the File Browser or from the Source Images menu and then edit the zones to fit the images but this feature has proved unreliable in the recent versions of the Adobe software for both Elements 3 and Photoshop CS/CS2.

Note > In the example used a logo identifying the photographer or organization is used as a banner above the other images. Although the default background color is white, if the Flatten All Layers option is not checked, this can be modified later.

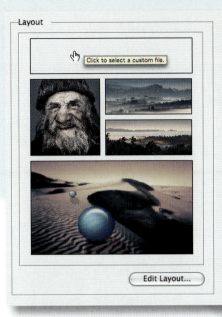

essential skills >>>

4. Use the eyedropper tool to sample the background color of your banner image and then use the Fill command from the Edit menu to fill the background layer with this sampled color. Keeping the layers intact enables the user to add layer styles such as drop shadows to each of the image and text layers.

DIGITAL IMAGING >>>

Screen presentations

It seems everywhere you look these days there is a piece of software offering to present your images as a slideshow. Apple Macintosh seems to be particularly keen on the idea of presenting a multi-media face with their iPhoto, iMovie and iDVD offerings. Adobe Photoshop CS/CS2 and Adobe Elements also give us the opportunity to present selected images as PDF presentations. Adobe Elements 3 for PC can also export slideshows in the Windows Media Player format (WMP). The discerning slideshow enthusiast is however, a difficult animal to please. Simplicity, speed, sophistication, limitless options, cinematic quality slide transitions and sound are the features that are in demand. Not content with these, the discerning user also demands that the show play on any computer and be small enough to fit on an old floppy disk or to be emailed to your Paraguayan penfriend with a 28K modem. PC users with Elements 3 need to look no further than the excellent new Custom Slide Show feature. Mac owners will need to explore a variety of options at present.

Apples iFamily

iFamily is Apples multi-media solution to the digital user who wants to share their life. The four pieces of software are bundled together for DVD burning owners as the iFamily package and comes shipped free with every new Mac computer sporting their 'Superdrive' (iDVD is deleted from the package for CD burning owners). iPhoto is the fastest share solution in the iFamily collection with the ability to export your show as a QuickTime movie in a variety of sizes and compression settings - from email to full DVD quality. iPhoto takes selected photos or 'albums' from your 'Pictures' archive and presents them with a music file that you nominate from your iTunes collection. All the software interacts with each other pretty intelligently, working together to create a variety of presentation formats to share with your family and friends. For a Mac user who doesn't require small file sizes but requires increased cinematic sophistication they can select a folder of images or 'album' and the click on the iDVD option.

Presentations from image banks and digital cameras
Some consumer digital cameras and many of the portable image banks (an external hard drive with image capability) also offer the user the facility to hook up to a monitor or TV and present a stored sequence of images as a slideshow.

essential skills >>>

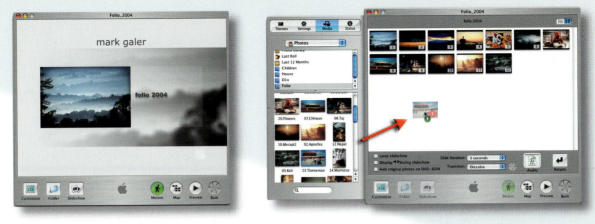

iDVD allows the user to add the interactive splash screen that we have all come to love with DVD movies. The ability to simply drag and drop additional images from your iPhoto archive and add your favorite music file from your iTunes MP3 library makes the task relatively painless. The down sides are the relatively high price of DVD blanks, slow DVD write speeds and the 'Regional Codes' that are attached to the discs that may exclude people overseas from seeing your show. Meticulous Mac media freaks wanting precise control over timing and transitions can use iMovie to fine-tune the multi-media experience before choosing either QuickTime or iDVD as the sharing media.

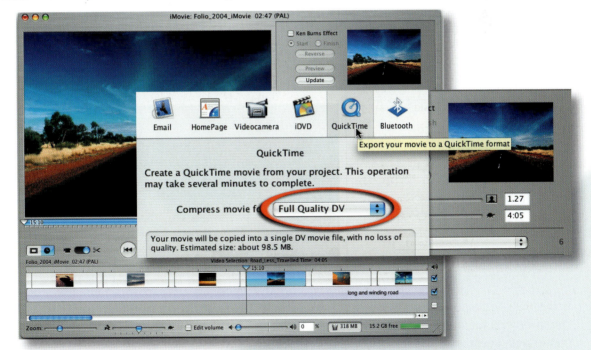

If the user would like a little more control over the presentation, iMovie offers most of the features that the budding movie producers amongst us would require. The creation of precise timings and transitions for sound, music and image files are easy to manage via iMovie's elegantly simple interface. iMovie also offers us the 'Ken Burns' effect that allows us to zoom or pan across a still image to breathe a little more interest into the presentation.

Creating a simple PDF slideshow

The PDF Slideshow option is part of the automated features in both Elements and Photoshop CS/CS2. The option can also be accessed directly from either the File Browser or the Organizer in Elements 3 for PC. PDF Slideshows are viewed in Adobe's own Acrobat Reader software (freeware) that is usually found on most computers. The advantage of the PDF slideshow is that Adobe Acrobat reads the image profiles used by Photoshop and Elements, thereby ensuring the images will not vary in hue, saturation or brightness.

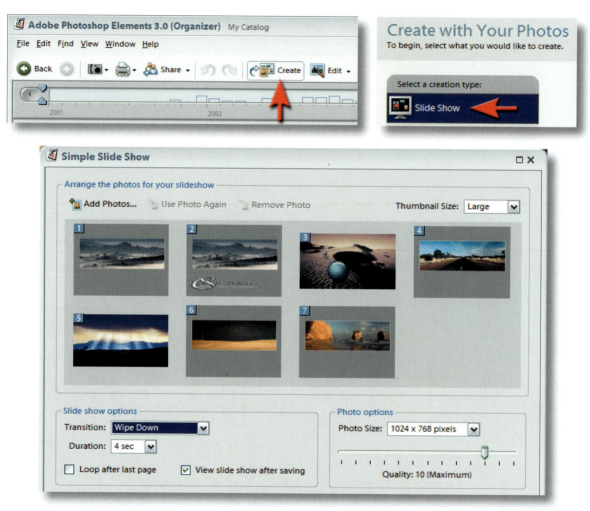

In the PDF Slideshow dialog box it is possible to select the duration of time that the slides will be displayed and the transition effect (a fairly limited selection) between each slide. Thumbnails, and control over image size and quality are also available for PC users using Elements 3. The slide show can be 'looped' to start again after the last slide has been displayed. The greatest limitations of the PDF slideshow are the limited transitions available, the lack of support for attaching a music file and the standard duration for each slide that must be applied to every slide. If you require narration or music you will need to use the Custom Slide Show feature in Elements 3 for PC or one of the iFamily options when working on a Mac. PowerPoint is yet another option for both Mac and PC users.

DIGITAL IMAGING

>>> essential skills >>>

The PDF slideshow plays automatically when the file is launched. After the last slide is displayed the user can exit the slideshow by pressing the 'esc' key. The slideshow is then visible as a multi-paged pdf document. The slideshow can be returned to the first page using the Adobe Acrobat page controls and viewed again by using the 'Full Screen View' option from the 'Window' menu. Using the page up, page down or the arrow keys on the keyboard will advance the slides manually if the show has been created without a time allocated to the 'Advance Every' option.

If you require the images to be displayed full-screen you will need to crop the images to the aspect ratio of the monitor you intend to use for the display. A typical 15 or 17-inch monitor may be running a 1024 × 768 pixel resolution. If the images are to be borderless in the slideshow the images should be cropped to these dimensions prior to loading them into the PDF presentation. No control over background color or size is possible with the PDF slideshows so specific borders or backgrounds must be added to the images as part of the editing process of each image. If the aspect ratio of an image displayed in the slideshow differs from the aspect ratio of the monitor (and no background has been added in the image-editing software) the PDF slide will use a black border on two sides of the image.

Custom Slide Show - Elements 3 (PC only)

One of the best solutions for the creation of high quality slide presentations is the Custom Slide Show feature that is now part of Elements 3 for PC. The Custom Slide Show saves the resulting show as a Windows Media Video that is viewed through the Windows Media Player. The resulting slideshow includes both smooth fades and an embedded sound file and keeps the resulting file size reasonably small.

Images destined for the slideshow can be first selected in the Photo Browser before clicking on the 'Create' button in the Options bar. Choose 'Custom Slide Show' and then from the Edit menu choose 'Preferences'. The default background color, slide duration and slide transition can be selected from the preferences.

Individual transitions or timings can be selected by clicking on the icons beneath the preview window. This allows the slideshow to be extensively customized. Additional photos can be added by clicking on the 'Add Photos' icon in the Options bar. Clicking on the Add Audio icon allows a sound file to be added to the slideshow.

The 'Edit Audio' option allows for multiple soundtracks to be linked to the presentation. The duration of each sound file can be controlled along with the start and stop times. In the main editing space the option 'Fit Slides to Audio' will reorganize the timings so that the music and images end at the same time. Prior to saving the slideshow choose the 'High-quality Output' profile by clicking on the 'Change WMV output quality' button in the Custom Slide Show preferences.

Note > The Windows Media Player required to play the slideshows is available to Mac owners but is not commonly found on Macs as QuickTime is the default media player.

New

Name: Slide Master

OK Cancel

Image Size: 2.25M
Preset Sizes: 1024 x 768
Width: 1024 pixels
Height: 768 pixels
Resolution: 100 pixels/inch
Mode: RGB Color

Contents
○ White
● Background Color
○ Transparent

Fill

Contents
Use: 50% Gray
Custom Pattern:

OK Cancel Help

Blending
Mode: Normal
Opacity: 100 %
☐ Preserve Transparency

Creating a slide background - *Project 12*

1. Create a new document or 'Slide Master' by going to File > New. Enter the width and height of your monitor in pixels. Fill the Background layer with the color you will use for your slideshow presentation by going to 'Edit > Fill'.

Note > The Recommended minimum resolution for Photoshop is now listed as 1024 × 768 pixels. This size may be available in the preset sizes menu.

Stroke

Stroke
Width: 2 px
Color:

OK Cancel Help

Location
○ Inside ○ Center ● Outside

Blending
Mode: Normal
Opacity: 100 %
☐ Preserve Transparency

2. Add background graphics or text to a separate layer to act as a title slide or closing slide to your presentation. Cut and paste one of your presentation images as a new layer (alternatively you can drag the thumbnail of your presentation image into your new document or 'Slide Master' image). Go to 'Edit > Stroke' to apply a thin stroke or border to frame the image.

Note > Create a new layer and load a selection of the image layer before applying the stroke if you want the stroke to be on a separate layer to the image. Ctrl + Click (Command + Click on a Mac) to load the contents of a layer as a selection.

3. It is possible to create a clipping group in your Adobe software that will act as a mask to align or 'register' subsequent slides to the same size and position as the first slide. To create the base layer of this clipping group fill a selection with black on a layer sitting above the background layer. Then drag in a new image from a different file. To reduce the size of an image that is too big, go to the 'Edit' menu (Photoshop) or 'Image' menu (Elements) and select the 'Free Transform' command. Hold down the Shift key as you drag a corner handle to constrain the proportions as you resize the image.

4. Select the image layer and position it above the black mask layer in the Layers palette. Go to the 'Layer' menu and select 'Create Clipping Mask' or 'Group with Previous' to clip and frame the image. Select the move tool and drag the image in the image window to fine-tune the composition. Save a maximum quality JPEG of each slide you create to a common folder that will be used as the slideshow image resource. Number each slide starting with 01, 02, 03 etc. if you want the slides to be sequenced automatically. Alternatively you can drag the image files to a new position in the list when the PDF presentation dialog box is open. When all the files are sequenced click OK in the PDF presentation dialog box and then sit back and wait for your Adobe software to complete the construction.

Microsoft PowerPoint

PowerPoint presentations are synonymous with pie-graphs, sales statistics and slumber inducing business meetings. Remove the cheesy background graphics however, and the software can be used to fuel a half decent folio slideshow. As half the planet now seems to own a copy of Microsoft Office (Word, Excel, PowerPoint and Entourage) Mac owners who do not have the luxury of the Custom Slide Show that is shipped with Elements 3 for PC have the option of increasing the level of sophistication over Adobe's PDF presentation without investing in additional software.

Advantages and disadvantages

The advantage of PowerPoint over the iFamily collection for sharing images is that a PowerPoint show scales the slideshow automatically to play full-screen. The size of the finished presentation is considerably smaller than a comparable QuickTime movie and the image quality is not compromised by any QuickTime compression setting used. PowerPoint also allows each slide to be timed independently and a soundtrack such as an MP3 file can be linked to the show. The down side to creating a slideshow in PowerPoint is that the software does not read the color profiles used by Adobe, and therefore the images are not color managed. The duration of the slide transitions are dictated by the speed of the computer's processor that is playing the show. As a result the duration of the slideshow varies considerably between different machines and attempts to time slides to the supporting music are fairly futile.

Photoshop CS/CS2 and Elements users should use the Save for Web option when previewing and saving images destined for a PowerPoint presentation. Photoshop CS/CS2 users can also go to View > Proof Setup and then choose either Macintosh RGB or Windows RGB depending on the intended monitor that the slideshow will be viewed on. With the Proof Setup switched on, adjustments will usually be required to both image brightness and saturation in order to return the appearance of the image to 'normal'. Brightness should be controlled via the 'Gamma' slider in the 'Levels' adjustment feature and color saturation via the 'Hue/Saturation' adjustment feature. The adjustments required to the first image can usually be replicated on subsequent images using the same settings.

When setting up a new PowerPoint presentation, choose the 'Blank' slide layout whenever you are given a choice and then make sure you choose the appropriate slide dimensions and image quality from the 'Preferences' menu. Before you even start loading the slides into the presentation it is a good idea to save the PowerPoint file into a folder holding the soundtrack file you intend to use (MP3 files currently offer great sound with a relatively small file size).

Important > To avoid ugly artwork, all graphics and text destined for the slide presentation should be created in Elements or Photoshop and saved as a JPEG image file as there is no anti-aliasing option (the technique of removing the jagged edges) in PowerPoint.

Large music files are, by default, linked rather than embedded to the PowerPoint presentation. Before inserting the music file it is wise to place the music file in the same folder as the work-in-progress PowerPoint file. This will ensure the PowerPoint presentation will always be able to find the music to play. When the PowerPoint file is moved to a new platform or burnt to a CD the folder of files should be moved as one item to ensure this link is never broken.

Important > Images are embedded into a PowerPoint document but they should not be inserted into the presentation from an external drive or disc that is connected to the computer as this can cause a few annoying dialog boxes popping up advising the user to insert disc or connect to drive.

Playing a sound file for the duration of the slideshow rather than the duration of the slide is perhaps the most obscure task to perform in an otherwise simple software package. The first step in the process is simple enough. Go to Insert > Movies and Sounds > Sound from File and then browse to the folder where the PowerPoint file has been saved and choose the Music file from the same folder. If the music file is not in this folder move it to this location before inserting the file using this command. Select 'Yes' to start the music playing automatically when the slideshow is launched.

It is also a good idea to click and drag the music file icon off the edge of the slide to hide it from view in the presentation. Alternatively you could insert the music file first and then place the image over the music file icon to hide it. The next step to ensuring the music file plays for the duration of the slide show rather than the duration of the slide is not obvious, as the menu command comes under the 'Slide Show > Animations > Custom' submenu.

Select the 'Options' menu in the 'Custom Animation' dialog box. Select the 'Continue Slide Show' and 'After' radio buttons. Specify the number of slides in the slideshow and click on the 'Loop until stopped' option to ensure the soundtrack does not end before the slides have finished playing.

DIGITAL IMAGING >>>

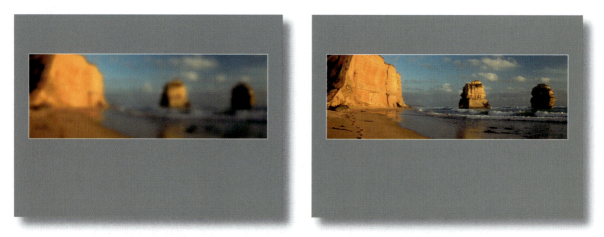

JPEG images can be dragged from your image resource folder directly onto the PowerPoint slides and edited in situ using the formatting palette. Images can be sized in the Adobe image-editing software to 25.4cm x 19.05cm whilst retaining the 1024 x 768 pixel dimensions (uncheck the resample option in the 'Image Size' dialog box so that the pixel dimensions are unaffected). This action will ensure that no further resizing is required when the images are dragged into the PowerPoint presentation.

Note > The precise slide dimensions for an 'On-screen Show' are listed in the PowerPoint 'Page Setup' options.

Creative ideas

A simple fade or wipe is often the best choice for a transition. This will ensure the effects don't upstage the images you have so lovingly crafted. You can create your own slide transitions with a little imagination by applying a Gaussian Blur to a duplicate slide in Adobe. This duplicate slide can then be assigned a short duration in PowerPoint so that the final effect is one of fading into focus. Using a duplicate slide that has been desaturated can create another interesting transition effect. Interleaving the slides that have been prepared with backgrounds with the occasional full-frame image can also create an element of visual surprise.

DIGITAL IMAGING

>>> essential skills >>>

Effect

Fade Through Black

○ Slow
○ Medium
● Fast

Sound

[No Sound] ☐ Loop until next

Advance slide

☑ On mouse click

☑ Automatically after 3 seconds

Save As: Folio_2004.pps

Format: PowerPoint Show

Where: 📁 Folio Show

☑ Append file extension (Options...)

(Cancel) (Save)

Completing the project

The timing and transition for each slide can be controlled via the 'Slide Transition' dialog box that can be accessed from the 'Slide Show' menu or from the options bar in the 'Slide Sorter' view. PowerPoint offers an option to time the slides to the music track selected (Rehearse Timings). The timings however will often vary significantly if the presentation is played on a different computer. When saving the completed project select the PowerPoint Show option from the Format pull-down menu and save the file to the folder containing the music file. When the user opens a PowerPoint Show file (PPS) instead of PowerPoint Presentation file (PPT) the user is transferred directly to the show rather than the construction interface. Later versions of PowerPoint have the option to save the presentation as a 'PowerPoint Package'. This will ensure that any files that were linked instead of being embedded in the document (namely the sound file) will be saved to the same folder. Any option to export the PowerPoint Presentation as a QuickTime movie should be avoided, as even the highest quality setting available in PowerPoint will cause considerable degradation of image quality when viewed in the final movie.

Creating a web photo gallery - *Project 13*

Photoshop CS/CS2 and Elements 3 can create a 'web photo gallery' of your images quickly and easily. All the additional software you may need to get your gallery online is available for free from the Internet. Apart from being exposed to a little jargon on the way the procedure is a remarkably painless process.

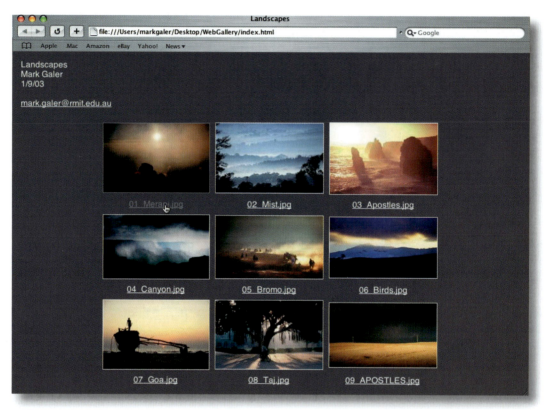

The Web Photo Gallery feature prepares all of your images and generates a homepage called an '**Index**' page, on which is displayed a sequence of thumbnails (small versions of your images). These thumbnails are linked to the larger images that are displayed individually on their own pages. When a thumbnail is clicked, the web browser (Explorer, Navigator, etc.) loads the full sized version of the image. Photoshop CS/CS2 and Elements allows control over the size of the thumbnails, the size of the images, the amount of JPEG compression used and the appearance of the page itself. The resulting web gallery is quick and a very efficient use of valuable time.

Uploading to the web

To place the gallery on the '**World Wide Web**' (www) you must either send (upload) the files to your own 'Internet Service Provider' (ISP), or use an Internet Service Provider that offers free hosting of your site, e.g. Netfirms.com or Tripod.com. The activity that follows uses a '**simple**' gallery style that does not require the more sophisticated use of '**frames**' that partition the page into separate sections.

1. Place a collection of your own images into a new folder (multiples of 3, 4 or 5 will make a neat arrangement). Web Photo Gallery will make copies of these images and resize them for the web gallery. Ensure the images look good with the color management switched off (use the Save for Web feature or the Proof Setup in CS/CS2). Ensure that the largest dimension of each image is at least 500 pixels. Images prepared by Adobe for a web gallery will be stripped of their embedded profiles and should therefore be prepared with this in mind. These master images can be in any file format. Adobe handles the conversion to JPEG and will sequence the images in the web gallery according to the numerical or alphabetical beginning of the file names. Files starting with numbers are placed before files starting with letters in the sequence. Images should be numbered with a zero preceding the first nine numbers, i.e. 01 to 09 to sequence them in a preferred order in the gallery, e.g. 01.Stone.jpg, 02.Slate.jpg, etc. Image 11 will come after 1 if the zero is not included.

Note > Use short single-word file names with no spaces to avoid linking problems.

2. Choose 'File > Automate > Web Photo Gallery'. Choose 'Simple' from the 'Styles' menu and enter your email address if you would like to provide visitors with a useful point of contact.

3. From the 'Source Images' section of the dialog box click on the 'Choose' button to select the image directory or folder in which you have placed the images you would like to be featured in your gallery. Click on the 'Destination' button to select the folder the finished gallery will be saved to.

Note > Do not open the image folder – 'choose' it (locate the folder, select it, and then click on the 'Choose' button).

4. From the 'Options' menu select 'Banner'. Enter the gallery details that you would like to appear at the top of your gallery page. This will become your web page banner. You can enter alternative text in these boxes. Select a 'Font' and 'Font Size' to set the appearance of the text.

5. Select 'Large Images' from the 'Options' menu. Select 'Resize Images' and choose 'Custom' from the menu and enter a size of 500 pixels in the box. Choose 'Constrain: Both' and 'High' from the JPEG quality menu. Choose whether your images will be displayed with or without a border (a 1-pixel border was used in the example) and the source for the image title.

6. Choose 'Thumbnails' from the Options menu. If you think most of the people visiting your site will be using a high-resolution monitor (1024 x 768 or greater) you can choose quite large thumbnails, e.g. select 'Custom' from the 'Size' menu and enter 150 in the box. The gallery used in the example uses 3 columns and 3 rows. Avoid creating a gallery which leads to excessive scrolling which many web designers try to avoid. Finally select a border if required. One-pixel borders if selected are enough to separate the images from the background.

7. Choose 'Custom Colors' from the Options menu and click on the color swatches to change the colors. White text was used on a dark gray background. The same color was chosen for the banner to avoid the appearance of a box at the top of the page. As the thumbnails will be links, the link color will also become the border color for the gallery thumbnails. The link colors in the example gallery were selected from a limited palette of grays to avoid the gallery becoming too colorful and distracting from the imagery.

8. Click OK to create the web gallery. The web pages and images for the web gallery are placed in the destination folder. Once finished, your web browser is automatically launched and your Web Photo Gallery is displayed. If the browser does not launch, simply open the destination folder and double-click the 'index' file.

Upload your web gallery to the 'World Wide Web'

To upload your files to the World Wide Web you may need to acquire 'FTP' (file transfer protocol) software that can be downloaded for free from the web, e.g. Fetch (http://fetchsoftworks.com) for the Macintosh, and CuteFTP for Windows (http://cuteftp.com).

Using your own 'Internet Service Provider'

If you choose to use your own Internet Service Provider you will need to obtain some information from them in order to gain access to their server on which your files will be placed. You will need the address where your files will be uploaded, your user name and password, which will ensure that you can gain access to this server, and the directory your images will be placed in. You will also require the URL of your account with the ISP as it will be different to the ISP address you uploaded the site to.

The web gallery should be placed in a folder (called a 'directory' on the web) and so the URL may be as follows: http://www.esp8.netfirms.com/portraits/index.html. The advantage of placing the web gallery in its own directory on the server is that it allows the file name 'index.html' to be used again in a different folder or directory. This will allow you to have multiple galleries or link the gallery you have just created to a 'homepage', or master index.html, that you may create in a future activity.

Once you have entered the FTP location (Host), your User ID and Password you will be presented with the option of selecting files and folders to upload. Modern FTP software such as Fetch demands no more than simply to drag your folders and files into the FTP window. If your FTP software seems unhappy with this procedure simply look for the command 'Put folders and files'.

Using a free Internet host

There are many providers offering a free hosting service using advertising as their income revenue. If you pursue this route your gallery will be accompanied with a banner advertising somebody else's site that takes up some of your 'screen real estate'.

07_Goa.jpg

Your URL

As soon as you upload your files to the service provider the gallery will be 'live' on the Internet. If you want to invite people to view your gallery type your gallery's URL into an email and they should be able to click on this link to be transported to your images. Be careful to type in the exact address. URLs are sometimes 'case sensitive'. Once you have established the correct URL it is often safer to copy and paste the URL when notifying someone of your site address.

Getting found on the Net

To enable people to find your site (if you have not first given them your URL personally), you must first list your site with the 'search engines' (Google, Alta Vista, etc.). Search engines examine listed sites to check for compatibility with the keywords typed into the search field. The search engine then displays the most compatible sites in a 'ranked' order. Most search engines focus their attention on your 'index' or homepage. Additional 'HTML' (hypertext markup language) can be inserted into your index page to increase the chances of it being found. You can start with free html editing software such as 'Netscape Composer'. If your page is currently open in Navigator simply go to 'File > Edit Page' (your page will be jumped into Composer). Go to 'Format > Page Title and Properties'. Choose a title and description for your site that uses 'key words' that accurately describe the contents of your site and that may be used by the individual searching.

Creating a panorama using Photomerge - *Project 14*

In recent years shooting multiple pictures of a scene and then stitching them to form a panoramic picture has become a popular activity with digital photographers. This is the first time that Photoshop has shipped with Photomerge. The stitching program that first found its feet in Photoshop Elements has been included as a standard feature in Photoshop. This tool combines a series of photographs into a single picture by ensuring that the edge details of each successive image are matched and blended so that the join is not detectable. Once all the individual photographs have been combined the result is a picture that shows a scene of any angle up to a full 360°.

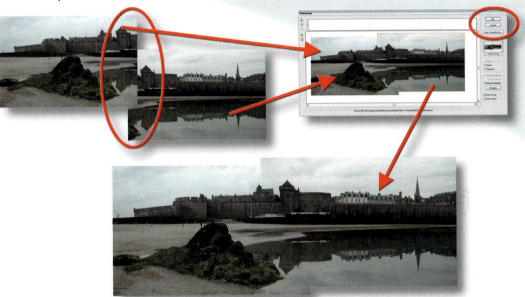

Images and project courtesy of Philip Andrews

The feature can be started from the File menu (File > Automate > Photomerge) or via the Automate > Photomerge setting in the file browser. The latter approach allows the user to select suitable source pictures from within the browser before activating the feature. At this point Photoshop attempts to automatically arrange and match the edge details of successive pictures.

In most circumstances Photomerge will easily position and stitch your pictures but there will be occasions where one or more images will not be stitched. These pictures are stored in the Light box area (top) of the Photomerge dialog where you can click-drag them to the correct position in the composition.

Individual pieces of the panorama can be moved or rotated at any time using the tools from the toolbar on the left-hand side of the dialog. Advanced Blending and Perspective options are set using the controls on the right. Photoshop constructs the panorama when the OK button is clicked.

Ensuring accurate stitching

To ensure accurate stitching successive images need to be shot with a consistent overlap of between 15 and 30%. The camera should be kept level throughout the shooting sequence and should be rotated around the nodal point of the lens wherever possible. The focal length, white balance, exposure and aperture need to remain constant whilst shooting all the source pictures.

1. Select Photomerge from the File menu (File > Automate > Photomerge) to start a new panorama. Click the Browse button in the dialog box. Search through the thumbnails of your files to locate the pictures for your panorama. Click the Open button to add files to the Source files section of the dialog.

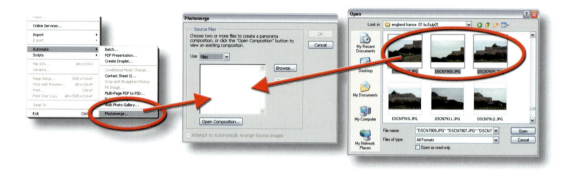

2. Select OK to open the Photomerge dialog box and start to edit the layout of your source images. To change the view of the images use the Move View tool or change the scale and the position of the whole composition with the Navigator. Images can be dragged to and from the light box to the work area with the Select Image tool.

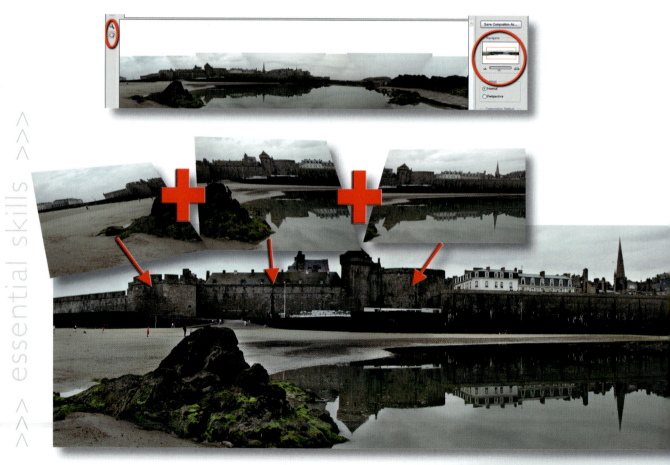

DIGITAL IMAGING >>> >>> ills >>>

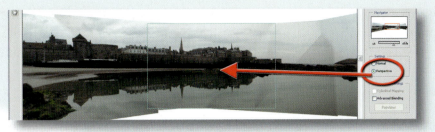

3. With the Snap to Image function turned on, Photomerge will match like details of different images when they are dragged over each other. Ticking the Use Perspective box will instruct Elements to use the first image placed into the layout area as the base for the composition of the whole panorama. Images placed into the composition later will be adjusted to fit the perspective of the base picture.

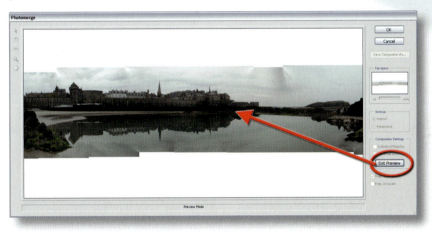

4. The Cylindrical Mapping option adjusts a perspective corrected image so that it is more rectangular in shape. The Advanced Blending option will try to smooth out uneven exposure or tonal differences between stitched pictures. The effects of Cylindrical Mapping as well as Advanced Blending can be viewed by clicking the Preview button. The final panorama file is produced by clicking the OK button.

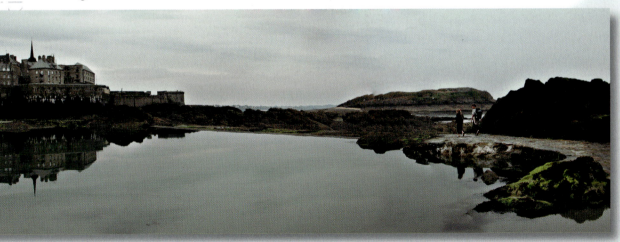

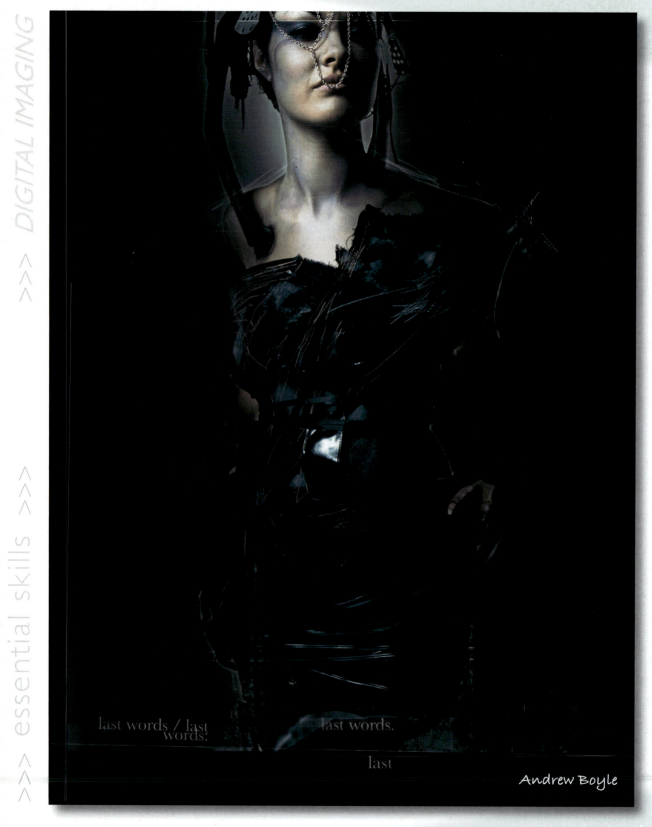

last words / last words:

last words.

last

Andrew Boyle

Paul Allister

capture workflows

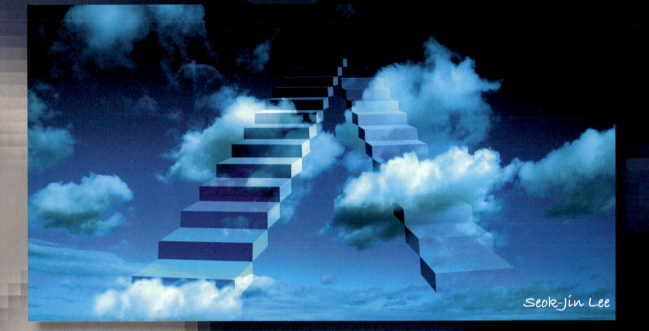

Seok-Jin Lee

essential skills

~ Understand the procedures involved in using a digital camera.

~ Know how an appropriate workflow will assist in the creation of the final image.

~ Know the workflow suitable for various types of photographic capture.

Introduction

Whether your background as a photographer comes from a long history of shooting film, or even if you have always embraced digital capture, one aspect of working within the digital domain becomes very clear all too rapidly. Whilst every form of technology involves new ways of working, no matter how experienced a photographer might be, to use digital methods most appropriately requires a new approach and a new type of workflow. Such a digital methodology not only draws from the accumulated history and operations of anolog based photography, but also embraces and harnesses the power and versatility of the digital domain. The five main stages of a digital capture workflow revolve around the following aspects:

~ Using the camera and its settings appropriately for the syle of photography being undertaken.
~ Storing the captured images in a manner that is both cost effective and flexible.
~ Organizing the resulting files so that they can be easily and effectively accessed.
~ Preparing the image files so that they suit the intended purpose.
~ Transmitting, delivering or outputting the final images.

All elements of any digital capture workflow need to integrate carefully to achieve the desired outcome

Digital camera controls

Whilst many of the camera controls and settings will be familiar to most people who have used film cameras, there are a number of extra menu driven functions that are unique to digital cameras. Of course each camera has it own way of operating, but there are similarities and it is worth discussing some important functions that work on almost all higher end digital cameras - certainly on most DSLRs and Prosumer models.

Card settings

Depending on the specific camera, the type of memory card that is suitable will be determined by the camera manufacturer, although some cameras will accept more than one type. (See 'Memory cards', page 45 for a discussion of the various memory cards available.) However it is important to format the card before capturing any images.

This may be required if the card has not previously been used, however it should also be repeated frequently to ensure that the card is set up correctly and will save those important images without problems. The particular camera will format in a fashion that may only apply to that particular model, so when a card is used on more than one camera it may be necessary to reformat before the camera will save images. Not formatting a memory card often enough is the single biggest cause of memory problems and can so easily be avoided - before it is too late! The camera's menu will allow you to select the format option and this should be incorporated into a regular schedule of use. If a 'Quickformat' option is available, this only removes the directory structure, so a full format is preferred to completely 'clean up' the card. (This can sometimes also be called a 'Secure Erase'.) Of course, formatting will delete all images stored on the card, so it is essential to have them first copied across to another storage device.

Color space

This function allows the user to select the color space into which the image file will be recorded by the camera. This may affect the range of colors that can be reproduced and can sometimes be set in the camera. The two most commonly used digital camera spaces are sRGB and Adobe RGB. If the intended use of the images is printed output of any type, or if the final usage is uncertain, then the Adobe RGB is recommended. The sRGB space is best only chosen if the images are to be used exclusively on the Internet.

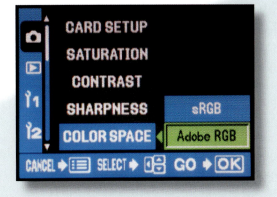

Menu for selecting color space on an Olympus E1

File format

A very important consideration with the use of digital cameras, is the choice of format used to record the image file. The most common options available are JPEG, RAW and TIFF. Often a camera may give varying levels of JPEG quality (or offer the option of different image file sizes), but this merely refers to the amount of compression applied to the image before it is saved in JPEG format. The important point to remember is that JPEG is a 'lossy' compression format, which simply means that the greater the compression the more lost or eliminated data, often resulting in 'artifacts' within the image. For this reason, if shooting JPEG then the highest quality should be chosen - however this will mean fewer images being able to be stored on the memory card.

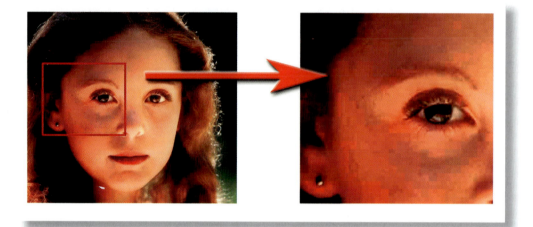

Section of an image saved in low quality JPEG format showing artifacts resulting from the compression

In some camera models, rather than listing the degree of compression applied to the JPEG file by the camera's algorithms, terms such as Best, PQ (Premium Quality), SHQ (Super High Quality), or similar are used to indicate compression levels. Some cameras don't even use these rather vague and extremely relative terms but simply advise how many images will fit onto a card. Although it can be tricky, it is important to be able to decipher exactly what these camera settings mean in practice - especially if SHQ actually translates to a rather high degree of compression!

Whilst there may in some cases be valid grounds for shooting in JPEG format - especially when file size is an issue - for serious, high quality digital capture, it is recommended that the camera's RAW format be used. A RAW format file contains information directly from the sensor which hasn't been processed by the camera software, thus allowing changes to be made to the processing parameters at a later stage. These changes even include choice of color space, so that an even larger space than the camera offers (such as 'ProPhoto RGB') can be selected for conversion of the file. This of course means more post-production time on the computer, but it also means more control and flexibility. Some manufacturers do actually apply some compression to their RAW files, but this type of compression is 'lossless' and will therefore not degrade the image. RAW files also capture the data in 12-bit form processed to 16-bit, rather than the lesser 8-bit for JPEG or TIFF. (A full discussion of the power of RAW files or 'digital negatives' as they are often referred to, is found in the 'Digital Negatives' chapter, page 53.)

Choosing a format

Apart from JPEG and RAW, some cameras may also offer TIFF format for image capture, making the choice even more broad. However, this fomat is rarely recommended as it takes about as much camera processing power (and time) as a JPEG, but since it does not involve compression, the file size is much greater - possibly as much as four times the file size of a maximum quality JPEG! This would mean that the memory card will be able to contain only a quarter the number of images possible if JPEG were used. In fact, in most cases even a RAW file is smaller than a TIFF, so there is little justification for choosing the TIFF option - indeed, many later model cameras no longer even offer it. The exception to this situation is the Fuji range of high end digital cameras that use two sets of sensors to save greater information at the high and low end of the dynamic range. In RAW capture mode, it therefore ends up with a large file accommodating the unprocessed data from the two sets of sensors.

The Fuji s20 Digital camera with 'Super CCD' sensor for increased dynamic range

Some manufacturers do offer a RAW + JPEG option, meaning that the image is captured in both RAW and JPEG formats. Even though this uses extra storage space, it means that a digital negative is retained for archival puposes or to be used as the basis at a later stage for the final image, but an already processed JPEG version is also available for immediate use. This JPEG is also available for faster preview or navigation of the image, as the RAW file is often only available after opening.

> **RAW** format for best quality, digital negative style archiving and being able to adjust the image later in post processing, but lag time - particularly in cheaper cameras - will increase due to limited buffer capacity.
>
> **High quality JPEG** for a shorter workflow, smaller file size and maximum efficiency, but lesser quality.
>
> **RAW + JPEG** for the best of both worlds, but at a size premium.

Resolution

The number of pixels in an image is clearly one of the most important determinants for image quality. Depending on the particular camera, you may not only be able to choose the compression level of the JPEG file, but also specify the pixel count. A 1600 x 1200 image for example contains four times the pixels of an 800 x 600 version, and even though a compression of 4:1 on the 16700 x 1200 image will result in approximately the same file size as an uncompressed 800 x 600 file, it will always be superior in quality. Shooting RAW usually captures the entire pixel count of the sensor, but with JPEGs (and TIFFs) and even with some cameras in RAW format, the resolution can be selected. For most circumstances, it is recommended that images be recorded at the camera's maximum resolution, even though this will mean that fewer images can be stored - that way an unexpected need for a larger image file will not be an issue and post-production interpolation will not be necessary.

Note > It is important to select resolution via your camera menu before shooting - as the default setting may not be the highest resolution the camera is capable of taking.

ISO setting

The ISO setting determines the sensitivity with which the image sensor responds to light, just like with its film equivalent. Being able to alter this sensitivity at will, rather than having to change film stock, is one of the great benefits of digital capture. Whilst the ISO sensitivity scale will be familiar to photographers, the numbers are actually only approximations to those generated via the physical characteristics of film.

Exact equivalence with film is therefore not guaranteed, but manufacturers do work very hard to ensure that the amount of light required to correctly expose a scene will be approximately the same as that required on film. Any slight discrepancy would only be an issue to those photographers using external light meters, although even for those users, the ability to check exposure with the use of histograms makes it easy to make any necessary adjustments or compensations.

Menu driven ISO adjustments on a Fuji digital camera

Note > Whilst some camera models allow the ISO to be set via the menu system, many cameras also have physical buttons on the camera body itself, in a familar fashion to film based cameras. Either method can be used depending on user preference, although be careful if one method has an override feature which can 'lock' the ISO.

Camera noise

If our digital camera can select any ISO within its range, the question that could be asked is why don't we always choose the highest ISO possible? That way we would always have the greatest sensitivity and thus be able to take pictures in low light situations. The simple answer is noise. As the ISO increases so does the associated camera noise. This notion is similar to the increased grain associated with increased film speed, but it is not entirely the same. Whilst both noise and grain increase with speed, and although noise can at times appear to look like grain, it generally is regarded as more of a flaw than the aesthetic associated with grain.

The two shots above were taken at the same time, with the same digital camera. The one on the left was taken with an ISO of 400 and a long shutter speed, whilst the image on the right was taken at an ISO of 80 and a much shorter exposure time. The enlargement of the version on the left clearly exhibits significant noise compared to the version on the right.

Note > The natural sensitivity of a sensor is the lowest ISO offered by the camera. All higher ISOs involve some level of electronic amplification, which in turn increases noise within the image.

Video photographers may be familiar with the concept of 'gain' when shooting in low light, where the signal is amplified to compensate for the lack of illumination. This is essentially the same as increasing the ISO of a digital camera and the associated noise is similar. Fortunately, noise can also be adjusted and manipulated in ways that film grain cannot.

What causes digital noise?

There are essentially two different types of noise associated with digital sensors. One tends to be random and the other more consistent, but both are related to charge or electron 'leakage' within the sensor sites. In fact, certain sensor sites can sometimes give 'hot pixels' where this leakage is great enough to create the appearance of pixel sized bright points of light - a concern for astro-photographers and those shooting often at night or dusk, but usually manageable for general photography. The resulting small, bright, pixels can be easily dealt with through just a little careful retouching.

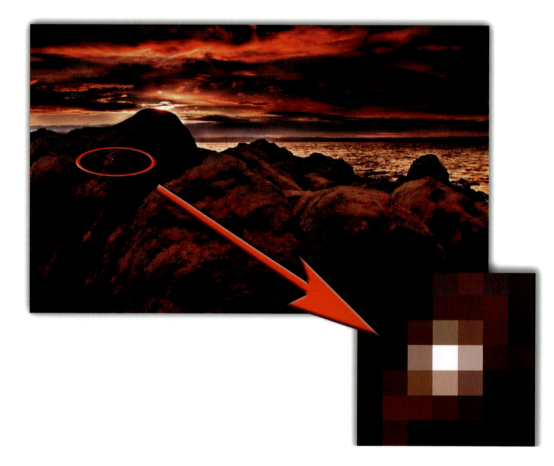

A dusk shot showing the white fleck associated with a hot pixel

However, the main factor that causes noise is the statistical effect resulting from the small size of each sensor site. The actual number of electrons liberated by the low levels of light photons hitting each site is small in number and prone to statistical deviations - in other words there isn't necessarily a totally consistent effect between the light hitting a sensor site and the electrical activity that is produced. This means, that each site will have slight statistical variations in the number of electrons activated as a direct result of the action of the light. And although sensor response to light is linear (unlike film which exibits an 'S' curve), the lower the volume of light, the greater the relative variation - therefore the greater the noise.

>>> DIGITAL IMAGING

>>> essential skills >>>

Minimizing noise

A number of factors will infuence the amount of noise that a digital camera produces and it is worth looking at these so that good photographic practices can be used to minimize this unwanted effect.

~ **High ISO:** The greater the ISO the greater the noise directly resulting from the amplification process itself. As the signal is amplified, the noise (both random and fixed) together with the imaging current produced by the sensor, will all be amplified equally - making the noise much more apparent.

~ **Long exposure times:** As the exposure time continues, the electron leakage from the sensor sites will also continue. In addition, the statistical deviations that give rise to inconsistencies will also become more pronounced, as relatively fewer imaging photons strike the sensor.

~ **High temperatures:** As the sensor warms, the leakage of electrons increases due to the extra energy gained through heat by each potentially 'wandering' electron. Even a ten degree increase can sometimes be visible.

With the above in mind, certain work practices become immediately apparent. Always choose the lowest possible ISO the image scene will allow - bearing in mind aesthetic judgements that may rely on shutter speed or aperture. Also, do not allow the camera to heat up - especially if high ISOs are required to be used.

On the other hand there is no evidence that cold temperatures cause any increase in noise levels. In fact, logically it would appear that the likelihood of fixed noise leakage could be minimized at low temperatures. Of course at low extremes, other factors such as battery performance may conspire to adversely affect a digital camera.

At times a higher ISO needs to be selected to avoid camera shake, but as a general rule, choose the lowest ISO possible to minimize noise

WARNING:

Be careful of using the auto setting on some digital cameras as it may automatically choose higher ISOs than is actually preferable. In some cases an increased aperture or decreased shutter speed may be a better solution to compensate for the lack of available light. This is an example where some individual decision making is preferable, and the loss of control in the name of convenience may have a detrimental effect on image quality.

Noise reduction software

There are three different ways that software can be used to reduce noise in an image. It can be incorporated into the camera settings, which although can be helpful, does not offer much control and can sometimes even soften the image a little. Alternatively, noise reduction can also be utilized as an adjustment within the RAW editor if shooting in RAW mode. This offers more control over the extent of the sharpening and has the advantage of not affecting the 'digital negative', but of course this increases the number of stages in the workflow - which may not always be desirable. The third and usually the most effective solution is the use of noise reduction filters in Photoshop CS2 and Elements or even third party software. The new 'Reduce Noise' filter in Photoshop CS2 and Elements 3 offers particularly good control in reducing noise and if available, is recommended over any noise reduction applied in Camera RAW.

*'Reduce Noise' filter in Photoshop
CS2 and Elements 3*

The most common of the third party programs are Neat Image, Grain Surgery and Noise Ninja, which can be used with most common file formats. (Demonstration copies can be downloaded freely from the internet.) This type of software relies upon pixel mapping and predictable patterns of noise - for best results these maps are even determined for specific cameras. Post imaging adjustments can shift pixel values and distort the noise in unpredictable ways, which then makes it more difficult for the software to operate optimally. Therefore if possible, noise reduction software should be applied early within the workflow - usually before other editing operations such as color and tonal adjustments, sharpening, or even resizing.

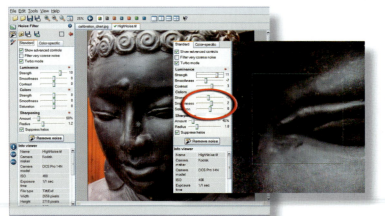

Noise Ninja uses sliders to adjust the removal of noise in both luminance and color channels. The Luminance channel affects filtering of noise in the brightness component of an image. The Colors channel controls filtering of color noise, which is often the most prominent

White balance

One of the most important determinants of image color is the 'White Balance' setting. The representation of color will vary depending on the light conditions - even the most common 'white' light sources such as sunshine, flash and incandescent light differ significantly in their color composition. Daylight itself will vary from bluish in a shady overcast environment, to yellowish as the last rays of the sun rake across a landscape at sunset, whilst candlelight is quite orange in its color. With a film based camera, our choice was to select either a daylight balanced film or artificial light balanced film to broadly compensate for these differences. Serious photographers would also use color compensation filters to make more subtle color corrections, in an attempt to either reach neutrality of color, or to aesthetically alter the color of the scene to enhance its atmosphere.

With a digital camera on the other hand, white balance color control is achieved extremely easily by simply making adjustments on a menu. In fact, this facility is one of the great conveniences of digital photography, as white balance changes can be carried out before each shot, rather than wait until the completion of an entire roll of film. This is achieved on most cameras through the use of a white balance sensor, which measures the infrared and visible rays to determine the color of the light - somewhat like a hand held color temperature meter.

White balance sensor on an Olympus E1

There are up to four diferent ways that white balance can be adjusted, three with the camera itself and one using software at a later stage:

Auto white balance: This function allows the camera to automatically set the white balance. In many circumstances works remarkably well, however is prone to slight changes as the light fluctuates in an otherwise consistent series of images. Especially dangerous for wedding photographers.

Manual white balance pre-sets: Via the camera's menu system it is possible to select a particular color temperature to be used for the image capture.

One touch white balance: This is achieved by pointing the camera at a white object in the scene, activating the white balance and storing the result as a custom pre-set.

Using a RAW editor: If shooting RAW format rather than JPEG, the white balance is not required to be set until later, at the post processing stage and is controlled by slider adjustments. These adjustments can also be used creatively to change the overall color of the image prior to the processing of the file, without destroying any pixel data.

DIGITAL IMAGING >>>

>> essential skills >>>

Setting up the camera - *Project 15*

For the following project you will need a 'Prosumer' or DSLR style digital camera (a consumer level model will most likely not offer enough control). The purpose of this exercise is to ensure that you are familiar with the important adjustments and choices that will affect your workflow.

1. Insert a memory card into the appropriate slot of your camera.

2. Looking at the back of the camera, activate the menu system. Choose 'Format' (or 'All Erase' or 'Secure Erase' as it may be termed) to completely eliminate any image files that may be on the card. This will ready the card for a new capture session. (It may also be necessary to set up a capture folder on the card depending on the camera model.)

Note > It is recommended that the memory card NOT be erased via computer formatting, as this can add extra uneccessary data onto the card. Some people believe a computer erase is more 'complete', however this is incorrect. It is best to always use the camera for formatting or erasing.

3. Set up a suitable static test scene with as many colors and tones as possible and place the camera onto a tripod. A target image as made in the 'Managed Workflows' chapter is useful as part of this scene, but any broad ranged selection of items will do.

4. Assuming the final shots are required for printed output (if your camera offers this choice) select the Adobe RGB color space, otherwise go with the default setting.

5. Placing either a Macbeth (or similar) color chart, a special 'WhiBal' neutral plastic white balance sample (or if not available use a white sheet of paper) into the scene, fill the frame with the white section and complete a white balance setting.

6. Zoom out from the color chart and add a descripter tag with all camera settings written upon it. An erasable white board marker is useful for this purpose, which can be used to write the details onto a white backed plastic CD cover.

7. Set the ISO to the lowest possible value and make sure that sharpening is not activated.

8. Setting the exposure mode, ensure that a relatively fast shutter speed is chosen and take the same picture using all formats available with your particular model camera ie. JPEG, RAW (and TIFF if available).

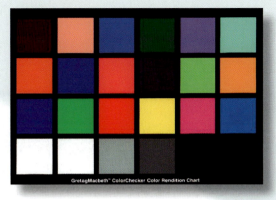

With the JPEG option make sure you take the same image with all the different compression settings that may be available. For this exercise set the resolution for these files at a medium setting. Change the descripter tag each time the details change. (In the following chapter we will look at the EXIF data the camera itself will save, which will make these tags unnecessary.)

9. Repeat this exercise at the highest possible ISO, closing the aperture down to the smallest available f-stop, to ensure the use of a long shutter speed. Make sure the lighting is consistent for all the shots.

10. You should now have a range of reference images, each taken with a different camera setting that can be used for evaluation purposes.

ACTIVITY 1

When shooting in RAW format, it is not necessary to set the white balance in the camera. The benefits of not having to perform this operation, when faced with rapidly changing lighting situations, is very attractive to photographers - particularly those having to deal with variable situations over which they have little control. To set white balance in Camera RAW, the most appropriate workflow is to use the White Balance tool (on the top left of the Camera RAW interface) together with a known target sample.

1. In Camera RAW, open a RAW version of the test image created in Project 1.

2. Select the White Balance Tool, drag it to a slightly gray area of your image and click. Note this tool is designed to set white balance from a non-specular bright tone, not a mid-gray. A standard 18% reflectance gray card is too dark and may include enough noise to actually distort the reading.

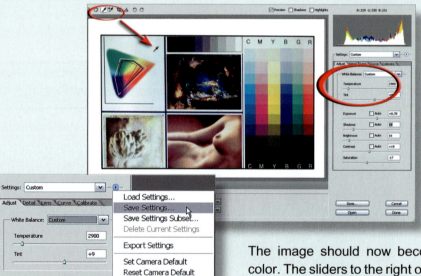

The image should now become neutral in color. The sliders to the right of the dialog box indicate the settings that are being applied.

3. Save these settings as a 'Custom White Balance' which can be used for any other shots taken under the same lighting situation.

With this technique, shooting a test target with a known light gray sample at the beginning of each shoot, is all that is required to achieve fast, accurate, color balance. The 'Temperature' and 'Tint' sliders are also a great way to creatively adjust the color balance of an image, without having to change pixel values. Doing so merely alters the transformation parameters of the processed file, resulting in a file that has not lost any information in the process of the color adjustment.

Sharpening

There is no doubt that all digital images require sharpening, however the two important considerations that need to be addressed in any workflow is **how** to sharpen and **when** to sharpen. The whole sharpening issue is one of the most controversial aspects of digital photography, but most experienced photographers will recommend against sharpening at the camera taking stage. This is because there is not enough control with in-camera sharpening, and it can also slow down the image processing. Also, if post-processing is anticipated on the file it is usually recommended that since sharpening is inherently a destructive process, it should be the final step in the workflow. In recent times however, a number of leading digital photographers (Bruce Fraser for example, has written extensively about this issue - see www.pixelgenius.com) have put forward the proposition that sharpening should be a three stage process within a workflow, each with a different purpose:

~ **Capture sharpening:** Restores sharpness lost during the image capture process, applied at a minimal level with as little damage as possible to image detail.

~ **Selective sharpening:** Applies local sharpening or sharpening related effects to the image. This is the area where aesthetic rather than technical considerations are to the fore and personal creativity is applied to the image via localized sharpening effects.

~ **Output sharpening:** Adjusts the image for the specific output required, whether off-set printing, inkjet printing or the Web. This is applied to the image after all other post production and adjustments, with the image sized for final reproduction.

The 'Automate' function in Photoshop enables the PhotoKit Sharpener plug-in

Various actual methods of sharpening can be employed, including the new **'Smart Sharpen'** filter in Photoshop CS2 to achieve a non-destructive, but controlled approach to the sharpening of an image file. To even simplify the process further, third party software is also available as a plug-in for Photoshop (such as 'PhotoKit Sharpener') where these three stages of sharpening can be applied as part of the overall workflow.

Capture sharpening

The notion of applying sharpening at different stages of the imaging process means that we need to examine how this is best achieved. As mentioned in the previous section, it is not usually recommended that sharpening be applied in-camera. The exception to this rule is where images are required quickly, with the shortest possible workflow, and a trade-off in image quality is acceptable. For this type of situation, it is preferable to apply any sharpening before the camera uses its algorithms to convert the image to JPEG, as sharpening an already compressed JPEG file will exaggerate the artifacts associated with this lossy compression format. An example of when this type of workflow may be necessary, is if shooting for news - especially if tight deadlines have to be met.

Since sharpening is essentially a destructive process where contrast is increased locally around borders of tonal change, when shooting in RAW format, it would be assumed that in-camera sharpening is undesirable. In practice, the sharpening settings selected in-camera, have no effect on the RAW file anyway and could be left on as a means of sharpening the JPEG file version, if that format is also being used.

Note > RAW format has no sharpening applied to the file, which means we begin with a 'digital negative' that has total integrity and all captured tonal values are intact.

If using Elements or earlier versions of Photoshop, a modest degree of sharpening at the capture stage can be applied via the RAW editor. This step is recommended as it is useful to apply some sharpening prior to adjusting overall contrast and color, as the tonal balance of an image can be affected by the sharpening process. Working with a slightly sharpened image at this point helps to avoid unexpected tonal changes later, and also gives a sound starting point for any subsequent 'creative' sharpening choices.

If using Photoshop CS2 however, the initial capture sharpening should be carried out on the TIFF file created from the original RAW digital negative. In this case, the sharpening slider in the RAW editor should be set to zero and sharpening carried out on the processed TIFF file, using 'Smart Sharpen'. This particular option allows for the most control and the greatest degree of flexibility in the capture sharpening applied to the image, as shadows and highlights can be dealt with independently.

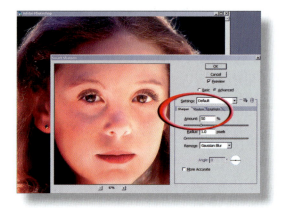

Smart Sharpen also allows the user to save settings, which is useful if applying the same sharpening regime to folders of images. In addition, the targeting of the sharpening effect to either reflect Gaussian Blur (similar to using Unsharp Mask), Lens Blur (the preferred setting for most uses) and Motion Blur (if correcting for camera shake) allows for much greater flexibility and control.

Creative use of sharpening - *Project 16*

This type of sharpening, applied in a selective manner, is where creative decisions rather than technical considerations are the most important. It is the second stage in the sharpening workflow - although of course it need not be used in all situations. (Elements users will not be able to complete this project due to the use of 'Layer Masks' although other methods of creative sharpening are still possible.)

Selective sharpening

Essentially in this step, the 'Unsharp Mask' or 'Smart Sharpen' tool is used to either emphasize certain areas of an image, or applied at an extreme level as an over-sharpening effect. Whereas in most cases, unwanted artifacts, haloes and increased color saturation are the scurge of digital images, applied selectively and creatively these effects can actually become visually interesting and useful tools.

1. Open the file Buddha.tif on the accompanying CD. This image has been shot against a rather distracting background, in that both the focus and the color of the panelling detract from the serene visage of the statue.

2. The first step in this project is to make a soft edged copy of the background area. This can be easily achieved by either using the lasso tool with a large feather setting (approximately 30 pixels) or working in 'Quick Mask' mode with a soft brush. Save the selection,then duplicate the entire layer, select 'Inverse' and create a layer mask blocking out the statue.

3. Apply an overall blur to the background on this layer, either by using 'Gaussian Blur' or 'Lens Blur' from the filter menu. 'Lens Blur' will give a more photographic look as it also allows for the use of 'depth maps' resulting in a more realistic effect.

4. Click 'Select' and 'Load Selection' from the drop down menu and copy the statue from the Background layer to a new layer. Now apply sharpening via 'Filter > Sharpen > Unsharp Mask' or 'Filter > Sharpen > Smart Sharpen' in Photosop CS2. Experiment with different levels remembering that the aim is to create an exaggerated effect. Don't be too concerned if the overall image looks overblown, as this layer will now become the basis for applying the effect selectively by brush. When the desired sharpening amount is achieved, create a layer mask to remove all visibility by clicking the add layer mask icon at the bottom of the palette whilst holding down the 'Alt/Option' key.

5. Now proceed to paint the effect back by painting with white, using a soft brush - making sure that the mask is active in the layer. This ensures that you are painting the mask and not the image itself. Experiment with the opacity and size of the brush to achieve the desired effect. Pay particular attention to the depth of shadows and detail in the highlights, as these can become too heavy. Remember that sharpening is actually a localized contrast adjustment, so when taken to extremes, it tends to deliver solid blacks and whites.

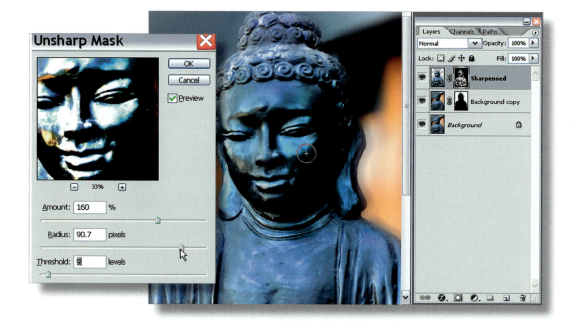

Another common by-product of oversharpening is an increase in color saturation. Usually this would be seen as undesirable, however if applied carefully in selective areas, it can sometimes add to the appearance of an image. As you paint, pay careful attention to the 'feel' of the lighting and endeavor to accentuate, rather than hinder the natural play of light on the statue.

6. If it becomes necessary to paint out some of the effect, simply change to painting black onto the layer - this will mask out the sharpening. It is quite possible to toggle from painting black to painting white, as often as is necessary to achieve the desired final result. Remember, this selective sharpening relies on creative input and decision making, rather than following the technically correct approach.

DIGITAL IMAGING >>>

7. As a final step in this project, make the background more in keeping with the feel of the shot by changing its color. By bringing the background into a similar tonal range as the statue, it ensures that the main visual attention is held at the face.

This is achieved by loading the selection of the statue, clicking 'Select > Inverse' to select the background and then clicking 'Layer > New Adjustment Layer > Hue/Saturation'. This will create an adjustment layer that will only act on the out of focus bacground. Make sure that the 'Colorize' check box is ticked, and then move the 'Hue' slider until the desired color is achieved. A small movement in the 'Lightness' slider can also darken the background a little, helping it to recede.

Note > Whilst this step of selective sharpening will not always become part of a workflow, it can be used in many forms to subtly enhance important aspects of any image.

>>> essential skills >>>

233

Output sharpening

This stage of the sharpening workflow should only occur at the very end - after any other manipulation, re-sizing or conversions have taken place. Its purpose is to ready the file for the type of output that it will undergo, a consideration that will require varying amounts of sharpening depending whether it is to be shown electronically, printed on an inkjet printer, laser exposed printer, or printed as a CMYK file on an offset press. The image file should always be archived prior to this stage, so that if any further re-sizing or preparation is required for a different output, the image can be resharpened appropriately for that purpose. In fact, just as a CMYK conversion is considered to be device specific (that is, the details of the printing device need to be known to accurately adjust the conversion parameters) this stage of the sharpening process should also be considered device specific and tailored to the particular printer or electronic display.

In broad terms, the quantity of sharpening applied at this stage will be:

~ **Minimal** for electronic output - judge the image on how it appears on the screen at the magnification that it will be displayed, remembering that increasing the sharpening excessively for electronic display often has no real benefit, it merely creates artifacts.

~ **Slight** for inkjet or laser exposed printed output, as this type of printing gives sharp results that can readily display unwanted artifacts if the image is over sharpened. This type of output greatly benefits from the advanced sharpening techniques covered in the 'Image enhancements' chapter.

~ **Strong** for halftone, press output where the paper bleed and inkspread require a greater level of sharpening than would otherwise be considered appropriate.

Artifacts and excess noise clearly visible at the pixel level are sometimes acceptable for press output

In fact, depending on the exact device (for example newsprint images require more sharpening than do glossy brochures) the image may look rather 'spotty' when viewed at 100% magnification with occasional pixels looking out of place tonally. (The term 'crunchy' is sometimes used as the effect on tones is somewhat like the difference between crunchy and smooth peanut butter.) This is quite normal and will not show in the final output - but it is obvious that this level of sharpening is not appropriate for all conditions.

Note > Careful use of the 'Unsharp Mask' or 'Smart Sharpen' tool via the use of luminosity and edge masks, will prepare the file beautifully for output.

Camera image review

One of the great advantages of digital capture is the ability to 'see' the image immediately after having taken it. This is very powerful if checking for a particular expression or action and of course this reviewing can be a whole lot of fun as well! It is not however, very useful for checking the quality of the image - particularly the exposure and tonality, as the LCD screen of the camera itself is of rather variable quality and may only give a passing resemblance to the recorded image.

Overexposed highlights indicated by the gray tone

Many cameras have a setting however, that indicates those highlights which are being clipped, as a solid (sometimes flashing) tone. This is a useful overexposure indicator although it still does not give very much overall information.

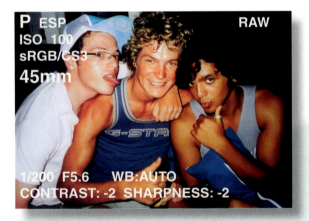

Further settings may be available that give information about many aspects of the image capture - such as exposure mode, metering mode, ISO, color space, focal length and other technical considerations. It is important to familiarize yourself with these settings and check them regularly during a shoot, so that inadvertent changes have not been made accidentally.

Histograms

Sensors do not behave exactly like film and so the rules of exposure that have served photographers well in the past do not necessarily apply. Clearly, too much exposure will cause dramatic problems, but underexposure may result in 'banding' within shadows and an overall increase in noise. Possibly one of the most useful tools available to digital photographers, is the histogram that can be called up on the camera's LCD screen. This histogram is a graph showing the distribution of tones within the captured image. The horizontal axis is a scale depicting all the possible tones from shadows to highlights moving across to the right, whilst the vertical axis indicates the actual numbers of each brightness value - the higher the bar, the more of those particular tones are present.

The histogram shape is determined by the scene itself - if skewed to the left, this indicates that the shot is low key, or if bunched to the right, it suggests a very bright scene. However, the actual position of the histogram shape is determined by the exposure. If the exposure is too high, then the graph will migrate to the right and may lose highlight tone through 'clipping'. If the exposure is too low, then the graph will sit to the left, with tones clipped at the shadow end.

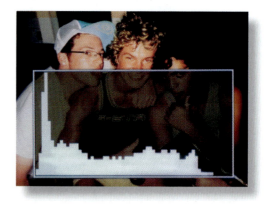

In effect, the histogram gives a digital reading of tones rather like a digital light meter. As such it is a very powerful tool that allows for the checking of exposure, specific to each image. A technique first suggested by Thomas Knoll (of Photoshop fame) and rapidly gaining acceptance, is the notion of '**expose right**'. This work practice encourages an increase in exposure to give more levels for the shadows, until the point is reached when highlights begin to 'clip' or lose detail. Where a RAW workflow is used, exposing with a histogram balanced to the right, and then correcting the shadows in the RAW editor is the preferred method. The use of the histogram to judge exposure, rather than looking at the camera's LCD, becomes even more critical when a JPEG workflow is used. This is because the exposure cannot be adjusted later (as in a RAW editor) and the clipping of tones means they are lost forever.

ACTIVITY 2

1. Shoot a series of images using RAW + JPEG format under constant lighting conditions, bracketing the exposure in half stop intervals to 2 stops either side of your expected exposure.
2. Examine the histogram of each frame on the back of the camera.
3. Open the JPEGs in Photoshop/Elements and the RAW files in a suitable editor. Adjust the shadows as required to achieve a correct 'look'.
4. Examine the resulting histograms in Photoshop/Elements to determine which frames have the most solid range of tones.

DIGITAL IMAGING >>>

Remote camera software

When working in a studio environment, especially if shooting still-life, the ability to control the camera from the computer is extremely useful. In fact, if you have a computer with wireless transmission it is also possible to remotely control the camera out in the field via a laptop. This can enable the camera to be set up in a difficult situation (for example along a horse race finishing line) and then activate and control the camera at will. Software that can control a digital camera remotely, such as 'Kodak DCS Camera Manager', or 'Breeze DSLR Remote' is however most suitable for studio use - particularly for the still-life photographer working tethered to a computer. This enables image capture to occur directly on the computer hard drive (bypassing the camera memory card) and gives an instant monitor sized preview - great for clients or models, in the same way that Polaroids were used in the past with film.

In this type of environment, the camera is usually sitting on a tripod and rather than looking through the viewfinder, it is triggered via the computer and the result displayed directly on the monitor.

essential skills >>> >>>

The camera is fully controllable via the software, so any changes to exposure etc. can be handled remotely. A grid overlay is often also available to assist with any critical perspective work. This type of working situation facilitates easy collaboration and consultation with clients, whilst at the same time being able to closely examine the image that has just been captured, ensures consistency.

237

Capture workflow decisions

The diagram below shows the key issues that must be addressed to set up a digital camera.

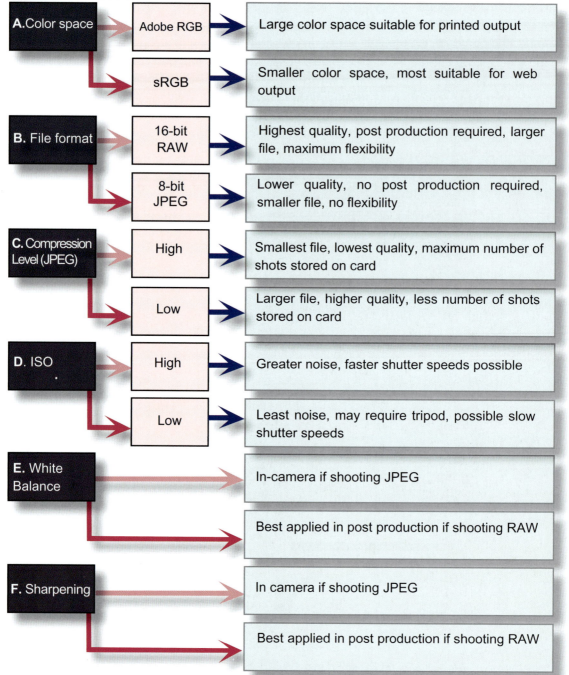

A. Color space	Adobe RGB	Large color space suitable for printed output
	sRGB	Smaller color space, most suitable for web output
B. File format	16-bit RAW	Highest quality, post production required, larger file, maximum flexibility
	8-bit JPEG	Lower quality, no post production required, smaller file, no flexibility
C. Compression Level (JPEG)	High	Smallest file, lowest quality, maximum number of shots stored on card
	Low	Larger file, higher quality, less number of shots stored on card
D. ISO	High	Greater noise, faster shutter speeds possible
	Low	Least noise, may require tripod, possible slow shutter speeds
E. White Balance		In-camera if shooting JPEG
		Best applied in post production if shooting RAW
F. Sharpening		In camera if shooting JPEG
		Best applied in post production if shooting RAW

These decisions will vary depending on the type of photography. At one end of the scale are news photographers who require a fast workflow that enables small files to be transmitted to the picture desk. At the other end are commercial photographers who require highest quality images with the flexibility to be able to make image adjustments well after the shoot.

Les Horvat

Les Horvat

file handling workflows

Les Horvat

essential skills

~ Understand the importance of file management.

~ Know how to batch process a collection of image files.

~ Understand the power and importance of meta-data.

DIGITAL IMAGING >>>

Introduction

In the previous chapter, the five main stages of a digital workflow were identified. Having then considered the camera, its settings and how these settings may influence workflow, the remaining four stages - which all occur outside the camera - need to be looked at in some detail as well. The next step in any workflow however must depend on the successful transfer of the images from the camera. The safe download (and storage) of precious shots currently stored on the memory card of the camera, is one of the most important, and sometimes nerve wracking, aspects of digital photography. Just as in the past it was imperative that film was not accidentally exposed to light after the shoot, if the file transfer does not proceed as planned, in a worst case scenario all images can potentially be lost! There are many options for this transfer, but essentially they rely on either direct connection to a computer via a cable, or removal of the memory card and insertion into a card reader - a USB 2 or Firewire card reader is usually the most convenient option. Alternatively, the data can be 'decanted' to a portable hard drive and stored temporarily until a further transfer to computer, or perhaps archived to CD or DVD.

A 12V LCD screen such as above can easily be adapted to connect to a digital camera.

Especially out in the field, the desire to view the images during the shoot itself, either for peace of mind, checking critical focus or to show a client, can sometimes lead to novel set-ups with equipment. One trend which is gaining popularity is the coupling of the camera, or a portable hard drive with 'video out' port, to an LCD screen designed originally for the automotive market. These large and relatively low priced TV screens are designed to operate with DC voltage, can be easily connected to battery power, are high resolution, and can provide a very simple way of viewing a large preview of the captured image. This type of output can make checking focus with the zoom feature of the camera much easier, and speed up the reviewing of duplicates or those images that simply 'don't make the grade' as part of the first stage editing process.

essential skills >>>

Image browsing

To achieve efficiency when working with the large volume of files produced as an inevitable consequence of digital capture, the use of a suitable program to browse the images is essential. Whilst there are a number of third party software options that will do this job extremely well, (such as 'Breeze Browser Pro') the 'File Browser' in Elements 3 and Photoshop CS, or 'Adobe Bridge' as it is called in the latest version of Photoshop CS2 is extremely powerful and integrates seamlessly with the RAW editor in both software packages.

ACTIVITY 1

1. Open the 'Bridge/File Browser' by either selecting 'File > Browse', clicking on the icon next to the dock, or 'File > Browse Folders' in Elements 3. The look of the browser will vary only slightly between the various versions and Adobe software packages, with the functionality being quite similar. Note: In 'File Browser' preferences, make sure 'Allow Background Processing' is not checked as this will consume processing power and slow down your computer functionality. Select the image folder required and allow Photoshop/ Elements to cache the images within the folder. Once this has occurred, the images will be available for viewing. Background processing is not an issue with the newer 'Adobe Bridge', as it is a stand alone program that does not slow down Photoshop.

Bridge screen display in Photoshop CS2

2. Choose the required folder from the cascading menu system in the top left of the window, which will allow the selected image to appear in a preview on the left. The meta data information (which will be discusseed later in the chapter) appears in the lower left-hand section of the window. An entire folder of images can be viewed at a glance, making this an extremely important tool in the file management workflow.

Browser display options

In 'Adobe Bridge', various display options can be selected. For example, 'Film Strip' will show all the files in a band at the bottom of the screen and display a large version of the file in the main window, whilst the 'Slide Show' option enables full screen sequenced display of an entire folder.

In 'File Browser', which was part of the previous version of Photoshop, and is also part of Elements 3, the preview size can be manipulated by selecting 'View > Custom Thumbnail Size' or by dragging the edges of the preview box. This results in an effect similar to the 'Film Strip' option although the thumbnails are down the side.

ACTIVITY 2

Open the preferences of Bridge/File Browser and explore the settings. Various levels of information can be displayed with each thumbnail and metadata setting (as well as even the background tone) which can then be saved by clicking 'Window > Workspace' to save your workspace views. This way each time you open the browser, it will appear as your preferred workspace was configured. If there are a number of different settings required for different stages of the production process, then each workspace can be saved with a relevant name and called up as needed.

Naming and saving files

One of the first steps in a file handling workflow is to create a backup. This is particularly important when using RAW capture, as this file is the totally unprocessed source data and should be saved before any further manipulation or processing. (A little like sleeving and storing unprinted negatives.) The 'File Browser' and 'Bridge' allow for a rather sophisticated method of storing and cataloging files, as various files can be tagged and stored in different folders. Such a feature is essential for the digital photographer as it is extremely easy to become swamped with the digital files created over even a short period of time!

Renaming can be carried out automatically for an entire folder using the 'Batch Rename' function. With 'Batch Rename' in the 'File Browser' (or 'Bridge' in Photoshop 9), setting the 'rules' for the new names, will result in an entire folder of files numbered and saved to a new folder

The first aspect to consider however is an appropriate naming convention. Ideally this naming system should contain the date and it should be somewhat descriptive. For example, in RAW mode a digital camera will name images sequentially together with a file extension - such as C210217. ORF, which whilst functional, is not very informative. This could be renamed as NumberSeries/Client/Date.ORF which would be more descriptive and far more helpful for future retrieval.

Metadata

Over the recent period many photographers have realized that management of files is an organizational skill that can define an efficient or inefficient workflow, and the term metadata has been increasingly used over the last few years - but what does metadata actually mean? At its simplest, metadata is data about data. In practice it is information (often embedded in the file) about the file itself, such as who took it, when, how etc. A number of different organizational systems (or 'schema') exist that collate this data through a defined set of properties:

~ File Info: is non image data that has been available in Photoshop as well as Elements and other Adobe products for a number of years. Data can be typed into simple pre-determined fields.

~ EXIF (Exchangeable Image File Format): is a schema set up by a group of major camera manufacturers, designed to embed particular technical settings and other image parameters at the time of capture. This data is automatically embedded.

~ XMP: an open source standard framework championed by Adobe, which aims to bring convergent standards to the creation of metadata.

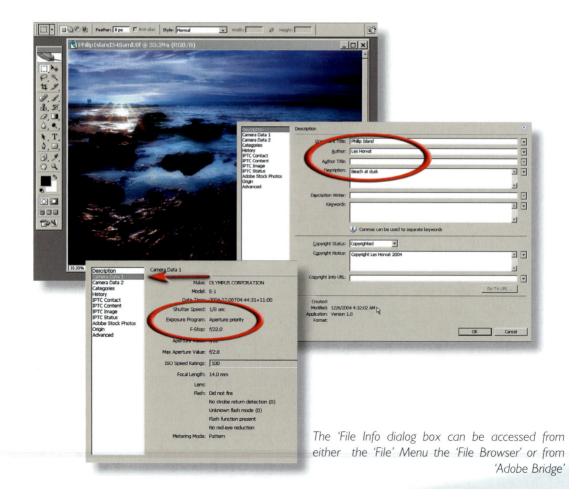

The 'File Info dialog box can be accessed from either the 'File' Menu the 'File Browser' or from 'Adobe Bridge'

Adding keywords within metadata

One of the major uses of metadata, apart from the technical and situational information that is able to be embedded into an image file, is the ability to add keywords that can assist in the definition and description of the image. This enables the image to be searched via the use of sophisticated databases, and called up in response to certain selected criteria. Of course such keywording and databases do not have to be restricted to the static image, and much work is being done in this area to construct rich 'warehouses' of photography and other image based creative assets. To add keywords to an image file, using the 'File Browser' or 'Bridge' select a JPEG or TIFF image taken by a digital camera.

ACTIVITY 3

1. Click 'File Info' from within the 'File' menu to open the File Info dialog box.

2. In the available fields add as much relevant data as possible e.g. description, author etc. Also add some descriptive keywords. Click OK and close the window.

Document Title:	Phillip Island
Author:	Les Horvat
Author Title:	
Description:	Beach at dusk
Description Writer:	
Keywords:	island; beach; ocean; sand; rocks

used to separate keywords

Copyright Status:	Copyrighted
Copyright Notice:	Copyright Les Horvat 2004
Copyright Info URL:	

Go To URL...

3. The metadata palette is located in the lower left portion of the 'Browser/Bridge' window (in its default configuration). The first section of the palette is 'File Data' which will have fields populated by Photoshop. Scroll down to the second section entitled IPTC. This stands for the '**International Press and Telecommunications Council**' which is a consortium of the world's major news agencies and news industry. Its role is to develop and maintain technical standards for news exchange and is the metadata standard for images submitted to any newspaper or magazine throughout the world. Observe the data already in these fields.

The data within this section will have been populated by the information entered via the 'File Info' window. It can also be changed or added to by simply clicking in the individual field and typing text. Each field has a defined meaning and classification, so it is important to put the correct data in the correct field - otherwise the information will be misinterpreted.

4. The 'Keyword' tab opens the keyword palette, which is an alternative way that Keywords can be entered. With this window, sets of keywords can be created specific to the workflow and as these are tagged they appear in the Metadata palette automatically. The small black arrow to the right of the palette gives the option of either adding a new Keyword or a New Keyword Set. To apply the same keyword to multiple files within a folder, simply tag each image by pressing 'Cmd/Cntrl Shift' and click the keyword in the 'Keyword' palette.

5. The 'Camera Data' section displays the EXIF data that is automatically inserted into the file by the digital camera at the time of shooting. Unlike the IPTC fields, these cannot be changed or altered - as indicated by the lack of pencil icon - as they constitute a secure data set.

Notice that in changing and adding metadata via the 'File Browser' or 'Bridge' we have not actually had to open the file. This is not only a huge potential time saver, but if shooting compressed JPEGs, this means that unnecessary opening and saving of the file can be avoided - one of the causes of JPEG image degradation.

Archiving captured images - *Project 17*

Shooting digitally means ending up with huge numbers of image files. The low immediate cost of this digital capture compared to film, is indeed one of the advantages of this style of photography. However, the time spent sorting, preparing and backing up files can be immense - and a significant cost in itself. Automating this process using the 'File Browser' or 'Bridge' is an important part of any digital workflow as it liberates much of the tedium involved in such repetitive processes. In this project, a memory card of RAW digital files will be archived and made ready for further uses.

1. Download the contents of a memory card with a series of images taken in RAW format, at approximately the same time (or the same session), onto the hard drive of your computer.

2. Rename this folder using 'Batch Rename" as described on page 245, using the Number/Client/Date.Extension format by opening the 'File Browser' in Elements and Photoshop or 'Bridge' in Photoshop CS2. Select all the files in the folder by clicking on the first image and Shift >clicking on the last. Choose 'Automate>Batch Rename' or 'Tools>Batch Rename' in 'Bridge' and select the naming rules that you wish to use. (Elements users only have two fields for setting this naming template and may have to simplify the name a little.) Save the images back to the same folder.

3. Next, we will add some extra metadata to all of the images in the folder. To achieve this we will create a metadata template by selecting the first image, going to 'File' and clicking 'File Info' to bring up the 'File Info' window. Change 'Copyright Status' to 'Copyrighted', but since at this stage we wish to add data that is common to all the images, only add keywords that would suit all images in the folder. Click 'IPTC Contact' on the left of the window to add contact information as appropriate - for example 'Creator', 'Address', 'Website'.

4. Then choose 'IPTC Status' to add a 'Copyright Notice'. Click the arrow at the top right of the window and select 'Save Metadata Template', give it a suitable name, 'Save' and click 'OK' to exit the dialog box.

5. To add this metadata to the other files in the folder, select all files and go to 'Edit > Append Metadata' in Elements and the 'File Browser' or 'Tools > Append Metadata' in 'Bridge' and select the metadata template you have created. All data in this template will be added to each file. This folder of RAW files now forms the set of 'originals' which are the basis for any further adjustment and processing. Duplicate this folder onto a CD/DVD, or onto a hard drive specifically used for back-up purposes (or both if total security is essential).

These archived files should not be altered in any way, as they form the storage archive of your captured images. All further work on the images should be performed only on a copy set, and saved appropriately to new folders with descriptive names.

If images are to be adjusted and processed for printed output, then a folder of TIFF format images will be required and processed from the RAW originals. On the other hand, if the images will be used for publishing onto the net, then a folder of JPEGs is more appropriate. Of course, in addition to the file format, the actual size and resolution of the JPEGs would be quite different to the TIFFs. However, as a practical workflow, if the possibility of both printed and web published images is likely, then it is advisable to create the TIFF files with all adjustments first, and then use those as a basis for conversion into JPEGs.

Applying workflow actions to folders - *Project 18*

After having archived the captured images from the memory card, commonly the next step is to convert these 16-bit RAW files into TIFF files, ready for output or further manipulation. Photoshop users can do this to the entire folder automatically by using 'Photoshop Actions' but Elements does not support 'Actions', so the images will need to be processed individually.

1. To achieve this we first need to set up the Photoshop action. Actions are a set of commands that can be recorded and then applied as required to one or more files. Click on the 'Actions' tab to open the 'Actions' palette, click the right-hand arrow and choose 'New Set'. (It is advisable to store any actions that are made in their own set for easy reference.) Then click on the right-hand arrow and select 'New Action'. Give it a suitable name such as RAW to TIFF, and click 'Record'. We can now begin to record the steps that will make up the action.

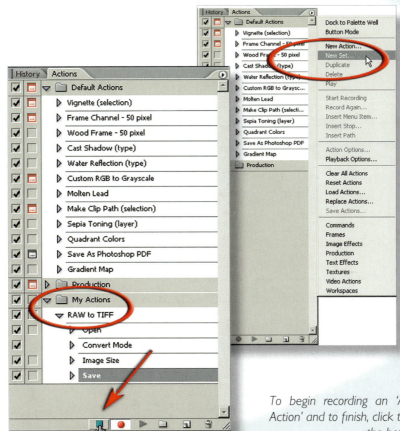

To begin recording an 'Action' click 'New Action' and to finish, click the small square at the bottom of the palette

2. Open a RAW file in the folder by double clicking in the 'File Browser' or 'Bridge'. Under 'Settings' choose 'Previous Conversion' and click OK. Then go to 'Image > Image Size' and ensure the size and resolution settings are as you require. It may be necessary to change to 300dpi as many printing devices require this resolution as standard, and/or slightly downsize the overall file size for your purposes.

3. If you do not wish the file to remain in 16-bit mode for subsequent editing, go to 'Image > Mode' and change to 8-bit mode. Then click 'File > Save As' and save as TIFF format in a new folder. Now click the square 'stop recording' button on the bottom of the palette. The action will now be available for future use.

4. Select all the images within your folder, and go to 'File > Automate > Batch', or 'Tools > Photoshop > Batch' in 'Bridge, to bring up the 'Batch' dialog box. Select your action, and make sure the 'Source' is set to 'File Browser' or 'Bridge'. Ensure 'Override Action "Open" Commands', is selected, then choose the destination folder. Similarly select 'Override Action "Save As" Commands' and click OK.

This batch process (for Photoshop users) will automatically convert each file into a TIFF, saved into its own folder, using the same conversion set-up as the first file that was converted. Although 'Adobe Elements' users are not able to automate using 'Actions', each image can be converted manually using the 'Previous Conversion' setting and saved in a similar fashion. Using these types of labor saving techniques are essential workflow processes for digital photographers.

Les Horvat

DIGITAL IMAGING >>>

essential skills >>>

Les Horvat

managed workflows

Les Horvat

essential skills

~ Understand the procedures involved in producing printed outputs that match color expectations.

~ Know the ways that managed workflows can influence color.

~ Produce a series of digital ouputs that demonstrate the outcomes of the workflows investigated.

Introduction

The purpose of a color managed workflow is to endeavor to get one device to represent accurately the colors depicted on another device - or perhaps even the colors of the 'original'. As previously discussed, there are many reasons for inconsistencies in color reproduction. Different devices will represent color differently depending on whether they are based on RGB or CMYK; that is, whether they use dyes or incident light to create their color. In addition, each particular output device has its own range of colors it is capable of producing, some having a large color gamut, others possessing a quite restricted one (see 'Color gamuts', page 88).

Predictability is at the heart of color management

Implementing a workflow

Setting up a workable system of color management which will deliver consistent results - in effect creating a managed workflow - requires at least the first or even both of the following:

~ **Calibration of devices.** This needs to be addressed at regular intervals as all device capabilities and performances will change over time (see 'Calibrating the monitor', page 93). Calibration ensures that all devices conform to an established state or condition. Note that this is **not** the same as the '**default**' or 'out of the box' state.

~ **Creation of device profiles.** A profile is a 'signature' for a particular device that describes the color capabilities of that device. This enables software (either ColorSync on a Mac or ICM on a PC) together with a CMM to convert color between device dependent and device independent color spaces. This implementation of a profile based workflow enables consistency, even if a file is moved from one chain of devices to another - as long as the new device chain also uses ICC based profiles.

Setting up a closed-loop workflow - *Project 19*

This is the simplest implementation of a color workflow - relying entirely on being able to match all of the devices within a specific hardware loop. This method is most suitable for those users who operate with software that does not include options for color management or within a completely controlled environment where input and output are regulated to the hardware that forms the workflow loop. For this system to be totally effective, files will not originate from sources other than from the loop input devices themselves - such as a scanner or digital camera.

A closed loop system

1. Go to Edit > Color Settings and select one of the pre-press default options under Settings. This will result in Adobe RGB being set as the working space.

2. Choose an RGB file that has a large range of colors and tones as your target image, making sure to include subtle shades of gray and skin color. See Assignment at the end of this chapter for production of such an image. (Similar files are sometimes supplied with scanners or printers.)

3. Output the file via the printer attached to the system and do not make any color or tonal adjustments through the printer driver software. Hold the print under neutral lighting conditions as close as possible to your monitor and using Adobe Gamma, fine tune the settings for the gamma of the monitor (as for Activity 5, page 94) so that the monitor display matches the printed output as closely as possible. Make sure the 'View Single Gamma Only' check box is **not** ticked so that individual color adjustments can be made.

Matching monitor display to print

4. Save the created profile under an appropriate name, such as 'myMonitorPrint'. This profile has now adjusted the monitor so that it displays the file to match as closely as possible the target print. (Use this monitor profile as a preview of how an image will appear when using the system's printer for output, see 'Using soft proofs', page 277).

5. Now take the print and scan it with the scanner attached to the system. Alter the scanner settings via the supplied scanner software until the displayed, scanned file on the monitor looks as much like the original file, as well as the print. Save this setting for the scanner under an appropriate name and make sure it is used for all scans.

In the above, the set-up requires calibration of devices to achieve predictable color but does not rely on the use of profiles. The system has now been calibrated so that a WYSIWYG outcome is achievable. However, it does not mean that the colors are 'correct', in fact the quality will depend largely on the quality of the devices - particularly as both the monitor and scanner have really been set to match the printer's limitations.

Print output used to calibrate a closed loop system

Using profiles in a managed workflow

In a closed-loop system of color management, since all the variables of input, display and output are dealt with by a limited and known series of devices, the end result can be controlled and predictable. However, if at any stage another device external to the loop is used, e.g. a different scanner or printer, then the results can be impossible to predict. This is when a more formalized process of color management is necessary. Such a system, based on universally recognized ICC profiles, enables files to be moved from one system or device to another - with associated predictability. Software such as Photoshop can help in the creation of this universal approach, which relies not on visual, subjective adjustments to color outputs, but on ICC profiles which control the necessary changes to achieve consistency.

Note > As the image moves from one device to another, it is automatically adjusted via its associated profile, so that it displays consistently on all hardware within the chain.

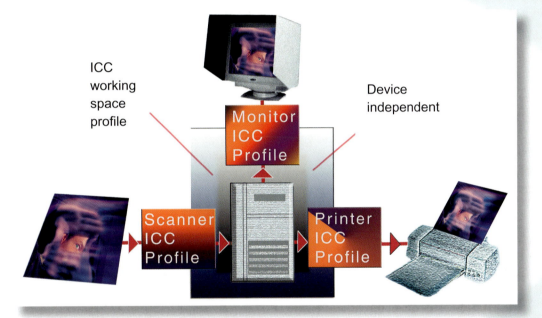

ICC working space profile

Device independent

Profiles as applied through the workflow

Tagging

Calibrating the monitor within a system (whether via software or hardware) results in the creation of a unique ICC profile. As each monitor has its own unique characteristics (and profile), identical RGB values are displayed somewhat differently on each system. Differently, that is, unless the particular profile is embedded into the image file itself. Then the system could adjust the RGB values so that they display identically on both monitors. This process is known as '**tagging**', and is supported as an automatic step in many versions of image editing software available today. However, tagging the image with the monitor profile would mean constant changes to the image data are required whenever the image is transferred from one system to another. This is where the '**working space**' becomes important.

What is meant by working color space?

As discussed in the previous section, every monitor will reproduce colors in its own way, within its unique RGB color space. Since each monitor is slightly different, this unique monitor color space (characterized by its profile) if tagged onto the image would result in changes to the image data **every** time the file is displayed on a different monitor. The more often the file travels backwards and forwards between different systems, the more the file is altered; resulting in greater potential for loss of information. It would therefore seem that tagging the monitor profile onto the image is not a total solution to achieving consistent color, since it could lead to image degradation as the file is moved from one system to another.

Note > The solution to this problem is not to embed into the image the actual monitor profile used by the system, but a pre-defined 'working space' RGB profile instead.

An image displayed on two monitors, with each display adjusted by its own profile

This 'working space' is precisely defined and even more significantly is device independent. Which means that any two systems running the same working space profile will not require changes to the **actual image data**, only to the **image display data**. This is a big advance in color management, as now whatever platform or hardware is used the device independence of the RGB image color is assured. In practice, the monitor profile determines how the image displays on the screen, whilst the working color space determines the actual RGB color data of the image. Monitor profiles are often included with software such as Photoshop, as well as with the operating system, but make sure that the chosen working space setting is an independent space such as Adobe RGB.

Set working space under 'color settings'

ACTIVITY 1 (Photoshop only)

1. Open any RGB image that has a wide range of colors.

2. Go to Image > Mode > Assign Profile. Make sure the preview box is ticked, click on Profile and choose any monitor profile from the drop down list. (The monitor profiles are usually found at the very top of the list within their own section.) Click OK.

3. Observe how the image color changes as each new profile is selected. The changes can be compared by simply toggling the tick on and off in the preview box. Notice how this change is not necessarily uniform in nature, but affects some colors more than others.

4. Now choose some of the profiles from the remainder of the list. The actual profiles that appear will vary depending on your system. These profiles are camera, printer as well as monitor profiles that you have either added over time or have been automatically included via the operating system or software such as Photoshop.

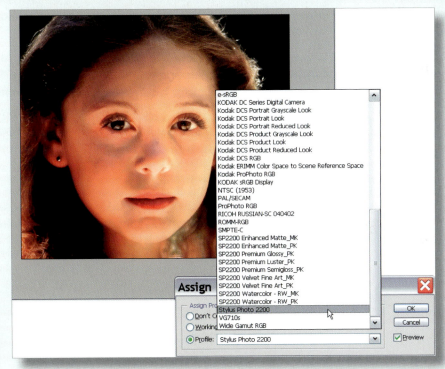

Profile available from list under assign profile

5. As you select different profiles in this list, notice how some of the changes are rather dramatic and affect not only the color but also the density of the image. This is particularly true for printer profiles, which are usually added to the list when the printer driver is installed and will vary depending on the paper surface. (Printer profiles are also available for download from most manufacturers on the Web.)

261

DIGITAL IMAGING >>>

>>> essential skills >>>

How to choose the working space

A number of RGB color spaces are often included in both application and system software. Aside from individual monitor spaces and device specific output spaces (which are not approporiate) most of these can be selected as a working color space. Each however, has certain characteristics and requires some further explanation:

~ **Apple RGB** is based on the Apple 13" monitor and is the old default space.
~ **sRGB** is a restricted monitor space most suitable for web based usage.
~ **CIE RGB** is based on the CIE color model.
~ **Adobe RGB,** previously known as **SMPTE-240M**, is wide enough for most RGB and CMYK
~ print work. It is the space of choice for many image professionals.
~ **Wide gamut RGB** is an extremely large space that will cover all RGB possibilities, but it includes many colors that are not printable.
~ **NTSC/PAL/SECAM** are TV standards.
~ **ColorMatch RGB** is a standard based on a commonly used pre-press monitor. It has a slightly smaller gamut than the AdobeRGB space.
~ **Monitor RGB** is the space associated with the profile made for your individual monitor. Only use this space if broader color management is not required, e.g. for closed-loop set-ups.

In Photoshop, the default color space for versions prior to CS is sRGB, which due to its restricted gamut is not suitable for print work. Therefore, it is important to change the working space to a wider one that is more appropriate for printed output - for example Adobe RGB. Photoshop will automatically set this as the default if you change Settings in the Color Settings window to any of the standard generic press defaults. (See step two in 'How to set up an ICC profile based system', page 264.)

A color space analogy

To be able to make sense of the theory behind a color managed workflow, it is essential to understand the difference between monitor space and working space and to be clear on how they are each utilized. To clarify this concept, consider the following analogy:

The working space can be thought of as a large box of colored pencils and the monitor space as a piece of paper.

As long as the box of pencils is large enough, we have no problem in reproducing most of the colors of a viewed scene. If the range of pencils in the box is too small however, then some colors cannot be reproduced. On the other hand, if the range of pencils is very large, we may even have some left over that are not being utilized! The paper we choose, or more precisely the color of the paper we choose, will determine exactly which pencils we need to reproduce each color. In this analogy, a large box of pencils equates with a large gamut working space, whilst the display vehicle of our image - the paper upon which we use the pencils - equates to our monitor space.

ACTIVITY 2

Imagine you are a graphic artist given the task of copying onto paper the logo of a particular company. This company, called Spectrum Enterprises, has a logo that contains a rainbow colored band with a white square. You are given a box of twenty colored pencils (your 'working space') and a sheet of white paper (your 'paper space').

1. Using a set of colored pencils, accurately copy the logo onto a white sheet of paper.

2. Now take a yellow piece of paper and with the same set of pencils copy the logo again. Notice this time you have to use a white pencil to create the centre square - but the yellow colored pencil is not required at all. In other words, to replicate the logo accurately, different pencils from the set need to be used when the paper color changes. If this were expressed in terms of a mathematical expression or profile, it could be said that a 'paper profile' needs to be applied, so that the right pencils are selected for the logo to be reproduced correctly onto the yellow paper. It then would follow that each time the paper color changes, a new 'paper profile' needs to be used - even though we are still using the same set of pencils!

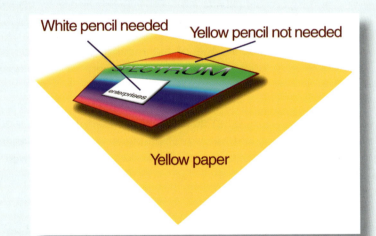

3. This time, try to draw the logo with only three pencils. Try again on the yellow paper. Observe how when the colored pencils are reduced in number, no matter what paper we use, the logo cannot be reproduced properly. It is clear that this small set of three pencils is a working space that is simply too small to draw the required logo. The relationship between the paper (display space) and the pencils (working space) becomes apparent.

Note > In digital imaging the 'display space' is the monitor space and the 'working space' is the selected RGB space assigned via the color set-up.

How to set up an ICC profile based system

Setting up a workflow that is compatible with universally accepted standards requires the use of ICC profiles. This enables color management that will give predictable results - no matter what devices are used in the process. To set up such a system requires a number of steps. Each step in the process needs to be followed carefully, and once implemented the system settings should not be arbitrarily altered. The biggest obstacle to proper color management is the lack of understanding of the process by some users who then alter one or more aspects of their system thereby breaking the process chain.

Step one: monitor calibration

As described in the earlier section, the monitor must be calibrated so that the representation of the image on the screen is accurate. Whilst it is possible to work purely using the actual values as indicated through the 'Info' palette, image creation is a subjective activity that relies on constant aesthetic judgements being made therefore viewing the image accurately on screen is important.

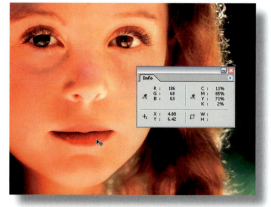

The Info palette can be used to read the values within an image

Step two: configure Photoshop

The process of configuring Photoshop is one of the most important steps towards creating predictable color. In this regard, significant changes have been made from early versions of Photoshop. Aside from fixing numerous aspects of functionality, there has been a fundamental change in the way working spaces were set up and applied. The most significant aspect was that unlike previous versions where all open documents required the same working space, the incorporation of document specific color (that is profiles tagged within the files themselves) now enabled the correct display of multiple documents at the same time **regardless of the working space set by the user**. This is important when two or more images are being merged together thereby avoiding unnecessary conversions from one space to another.

Choosing a working space

Whist the choice of RGB working space to ensure the correct display of images is not absolutely critical, the choice should be based on the needs and intentions of the user. For example if most image creation is for the web, then the sRGB space is recommended. On the other hand if images

Other
Monitor RGB - VG710s
Adobe RGB (1998)
Apple RGB
ColorMatch RGB
sRGB IEC61966-2.1

images are usually printed, then a space such as Adobe RBG or ColorMatch would be most appropriate as they are wider than sRGB. If the chosen color space is too large, e.g. Wide gamut RGB, many colors will not print and so images that look great on the monitor will look disappointing when printed.

Color settings for Photoshop

One of the most information rich dialogue boxes in Photoshop is Color Settings which can be found under Edit > Color Settings. Whilst at first glance it may appear a little daunting, the fact that most of the options available to the user are grouped together is in fact a real benefit. In addition, Adobe have created a number of pre-sets to help with the decision making. (Ticking the Advanced Mode box expands another two sections.)

>>> DIGITAL IMAGING

The first section is a pop-up menu entitled Settings, where various pre-installed configurations are stored, as well as any custom settings you may subsequently create. This menu actually controls the settings on the other areas of the dialog box, so it is possible simply to choose the required option from the menu and all the individual choices will be made automatically. It is also possible to choose from the drop down list for each separate working space and save those custom settings.

An important area in this dialog box is the 'Color Management Policies' section. The recommended settings here should be 'Preserve Embedded Profiles' and 'Ask When Opening'. This means that unless you convert when prompted by Photoshop, all image files will maintain their embedded profiles and display correctly in their own color space on your monitor, thereby avoiding any unnecessary conversions. Remember, it is possible to have several files in different color spaces all open at once.

>>> essential skills >>>

Color management for Elements

Photoshop Elements, a program that is fast becoming popular with those who do not need all the power and flexibility of the original Photoshop software, differs in its color management approach somewhat. This can be seen in both the settings that are possible and in the management policies of the software. In essence, it is similar in its approach except that the number of possibilities is a little more limited and directed to what is seen to be the most likely requirements for the average user. The main color settings dialog box has only three options:

~ '**No Color Management**'. With this option any existing embedded profiles are preserved, but new image files created in Elements will not have profiles embedded.

~ '**Limited Color Management**'. This option uses the sRGB color space as the working space and embedds this profile into any created images. The sRGB space is preferred for web applications and as such this option is ideal if images are to be viewed electronically or on the internet. If an image with a different profile is introduced into Elements, the profile is not converted.

~ '**Full Color Management**'. This option uses the Adobe RGB space, which as discussed earlier is the preferred space for printed output. Images with alternative tagged profiles are not converted and any new images are embedded with the Adobe RGB space.

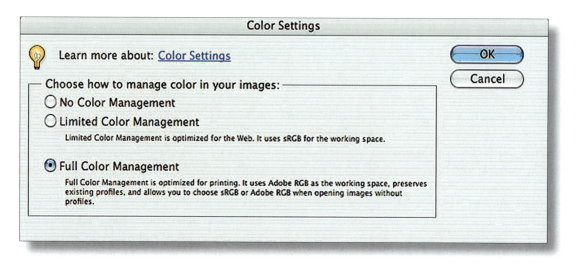

The above options still allow Elements users to engage with color management at a level that is sufficient for most purposes. The major diference is that CMYK spaces are not supported and as such, device dependent printing profiles are not able to be chosen. (However all is not lost if a CMYK file is encountered by Elements, it at least gives the user the option of converting it to RGB.) This is only an issue if images are to be sent to a press (see '**CMYK working space**' and '**Consumer inkjet printers**' in the following pages). Without doubt, for those who are using digital cameras and exporting files to the web or printing to RGB based printers, the color management offered in Elements is more than sufficient.

Color management policies for Photoshop

Photoshop will always check whether a profile is embedded when it opens a file. The 'Color Management Policies' section determines how Photoshop behaves when images are brought into the system from external sources or legacy files are opened that were created in previous versions. Three alternative 'Policies' are offered by Photoshop and it is important to understand what each will do:

'Preserve Embedded Profiles' This setting provides the most flexibility when dealing with files from various sources. An image with a tagged profile opens in its own working space regardless of the working space set on your machine. The display of the image will be adjusted by the monitor profile in use, so it will look as it was intended, and after editing it will be saved with its original profile.

These options can however be altered on a case by case basis if the 'Ask When Opening' and 'Ask When Pasting' checkboxes are ticked. This is highly recommended as it enables choices to be made where the default option set by the 'policy' chosen may not be appropriate. For example, if the original file does not have a profile embedded, it can be opened with the system working space profile tagged to the file.

'Convert to Working Space' This setting automatically gives preference to your selected working space and converts all incoming files to be tagged with that profile. This is not necessary to view the file correctly on your monitor and would only be the preferred workflow if you were part of a controlled work situation where your files rarely move to other systems. In particular, it is unlikely you would want an incoming CMYK file profile converted, as it would most likely be defined specifically for the device on which it is intended to be printed.

'Off' This option only applies if the intention is not to use any color management, and even then it only applies to newly created documents. This is not a recommended setting, unless you have a particular, closed-loop, 'by the numbers' workflow. Even then, if a file is moved to another system, the image will look different. The numerical values of the colors will remain unaltered, but they will mean different things within different set-ups.

CMYK working space

(Photoshop only)

Because CMYK is a device dependent color space (as defined by the printer's capabilities) it is this choice of space that will affect the way a CMYK file will print on a press or '**PostScript**' printer. Photoshop has a number of pre-sets under the 'Settings' section mentioned previously, which will take care of the appropriate CMYK choice for you. So if, for example, your output is for European, Japanese or U.S. printing presses, then choose the appropriate Settings default and the correct CMYK space will be automatically chosen. However it is also possible to make these choices individually, particularly if specific output for particular known printers is required.

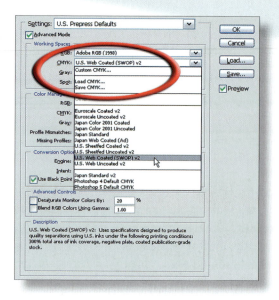

Consumer inkjet printers

As discussed earlier, an RGB defined space is created using light and a CMYK space is created using inks or dyes. Why is it then that many consumer inkjet printers label themselves as RGB devices and require RGB files for output to achieve the best results?

The answer to this question lies in the nature of the CMYK space. Since converting an RGB file to CMYK is device dependent and will depend on the set-up being used, to avoid complications, entry level, consumer inkjet printers - such as the Epson series - allow the inbuilt printer driver to convert the file to CMYK. That way, the printer is always using the greatest possible information (via the larger RGB space) to output the image. It also means that where the printer uses more than four inks (eight or even more is possible) to achieve the best results, the conversion is optimized by the printer driver. The result is that these relatively low cost desktop printers can produce extremely high quality 'photographic' output, without the user needing to have sophisticated color knowledge.

Epson 2200/2100 inkjet printer

Because most inkjet printers have this characteristic, the particular choice of CMYK working space selected is of no real consequence - since the printer uses RGB data files anyway. CMYK working spaces are only relevant when files are sent to a CMYK device, such as a printing press.

Step three: calibrate the scanner

As for any hardware device, a scanner will function within its own color space. Therefore, within a managed workflow it will be necessary to tag the scanner color space to the image, so that the image can display correctly on the system into which it is imported. When this occurs the image should appear on the monitor as close as possible to the original. If however the scanner is not properly calibrated, the profile tagged to the image will not provide accurate information to the system and the image will not appear correct. This is why it is essential to calibrate the scanner properly. Numerous third party software applications (e.g. EZColor, GretagMacbeth, X-Rite) are available to help with this task.

Usually supplied with the software or the scanner, a reference target (often called an IT8) is scanned with all settings set to their default. This reference target is available in both a print and a transparency version, each with a corresponding reference file of expected values. The scanned version is compared through the calibration software with this reference file and a profile is created.

Note > Ensure the profile has been saved in the correct folder so that Photoshop can make use of it. For Windows XP and 2000, it should be in WINDOWS\system32\spool\drivers\ Color and for Mac OS X in the Library/ColorSync/Profiles Folder.

Step four: calibrate the printer

The production of the printer profile is once again created by software specifically designed for the purpose, and can often be part of the calibration suite used for the scanner or monitor.

There are two methods that can be used:

1. Using a '**spectrophotometer**' - an instrument that will directly measure the printed colors - to determine the values of a known target, printed on the device to be calibrated. These values are then compared with the original expected values, similar to the scanner calibration, and a corresponding profile built.
2. Using the scanner to scan in the printed output of the target and then making the comparisons with the known values through the calibration software. **Remember to disable any printer color management during this procedure**.

The latter method, although less expensive - in that it does not use any expensive hardware - is not as accurate since it relies on the calibration of the scanner and its associated profile. Other limiting factors include the texture and reflectivity of the test target paper. Once again the profile is stored in the required folder for access by Photoshop, or other imaging software.

Creating a target image - *Project 20*

The aim of this activity is for you to create a test image for printing and viewing purposes. This image should be saved as a reference target for calibrating any devices within your workflow.

1. Choose four images that contain a good range of colors and tones. Highlights having detail as well as shadows with detail are essential in at least one image. In addition one image should contain skin tones. If these images are not already available as digital files scan them at 300ppi to about A5 size.

2. Create a step wedge by first making a file with a gradient from black to white. Then apply '**Pixelate>Mosaic**' from the Filter Menu, choosing an appropriate cell size so that a 12 step file is created.

3. Select the entire file (Select >All) and copy it to another layer five times. The end result will be six layers each containing the same gray step wedge.

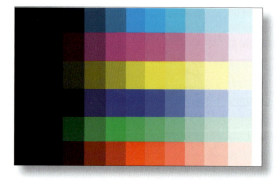

4. Go to Image > Adjust > Hue/Saturation and click the Colorize button. Then drag the saturation slider to approximately 75. The active layer should now be red.

5. Repeat this process for each layer. Making each layer active in turn, move the Hue slider until green, blue, yellow, magenta and cyan step wedges are created, in addition to the red. The Hue values to use are: green - 100, blue - 225, yellow - 55, magenta - 315, and cyan - 200. (For yellow, magenta and cyan a saturation value of 90 works best.)

6. Make each layer active in turn and using the Move tool, drag until the layer underneath is exposed. When all layers have a strip exposed the result should be a six color step wedge. Rotate the canvas if desired to fit better into your composite image, flatten the layers and save.

DIGITAL IMAGING >>>

7. Add this colored step wedge to the four images together with the black and white step wedge created earlier. Using the Type Tool add the letters 'CMYBGR' to the top and bottom of the step wedge for identification purposes onto the relevant bars. (Choose either black or white for the type color as required.)

8. Make sure the final composite image is scaled to fit onto an A4 size piece of paper and save after flattening the layers. Save the file onto a disk and record any color space and profile details. This should remain the master copy of the file.

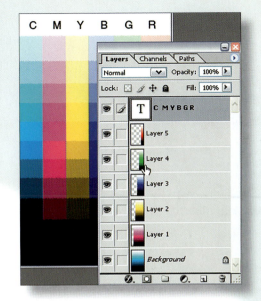

Note > This composite image can now be used for all future test outputs as a standard reference image having all necessary colors and tones.

essential skills >>> >>> >>>

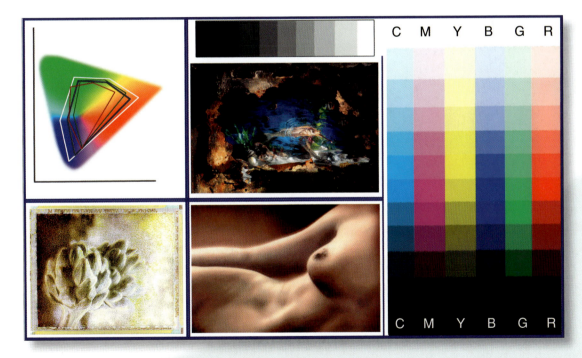

9. Create a folder to file each test printout using this target image. On the reverse of each print be sure to record all details of color space, profile, paper stock and workflow. This folder should become your color management work book and should build up over time with a library of test results.

Lizette Bell

printing and pre-press

Les Horvat

essential skills

~ Understand the procedures involved in printing a digital image.

~ Know how control can be exercised over an image when translated onto a paper surface.

~ Print digital image files using ICC profiles.

~ Know how to preview using soft proofing.

Introduction

For many purposes, even with today's electronic modes of displaying images gaining in prominence, the final output of the photographic image will still be printed onto paper or similar substrate. Whether this is achieved via the press using mechanical reproduction techniques, or using digital printing devices for short run or even single output, the final result should conform to expectations - which means a color managed workflow needs to be in place. Unless a closed-loop system is employed, the use of ICC profiles tagged within the image file, utilized by the CMS of the computer system and recognized by the editing and printing software, is necessary.

It is important to archive all image files in a device independent space i.e. RGB, even if a subsequent conversion for printing purposes takes place. This will ensure maximum flexibility for future uses.

Soft proofing in Photoshop

A feature available in Photoshop (although not in Elements) is the ability to 'soft proof' the output expected from a particular device. A 'soft proof' is a simulation displayed on the monitor of how the output would appear when printed. This feature can be used to get an indication of how the image will appear on various printers and print media.

Note > Soft proofing is only as good as the profile for that device and relies heavily on the accuracy of the monitor calibration.

When preparing an image for output, rather than actually printing the file, the soft proof option enables it to be displayed similarly to how it will look when printed. This feature is accessed via '**View > Proof Colors**' with the actual setting chosen via '**Proof Setup**' on the drop down menu. If changes need to be made it is more convenient, and less time consuming to determine this from the preview, rather than the print itself.

One aspect of this feature that is extremely useful is that it can also be used to see how an image will display on either a Mac or a Windows monitor.

Since each system uses different gamma settings, the image will appear with different densities and contrast if viewed on a Mac or PC. This facility is of particular use when creating images to be viewed on the web, which need to look right no matter what system is used for display.

Printing with preview

An important option in both Photoshop and Elements is the ability to 'Print with Preview'. Although the Photoshop and Elements dialog boxes for this feature look a little different, they both have the same functionality. The three main sections of this dialog box are:

A. The 'Position' section which allows the image to be scaled and moved within the paper area as defined with the 'Page Setup' window. Either click and move the bounding boxes or type in the numbers to indicate the required dimensions. The most powerful portion of this window however, occurs in the lower section. Make sure that the 'Show More Options' is checked to be able to view all of the functionality available.

Different versions of the 'Print with Preview' dialog box

B. The 'Color Managment' tab when selected gives two further options that we can adjust to suit the requirements of the output. The 'Source Space' allows us the option of either choosing the image file as we want it to print (in this case the final output is on our printer), or to choose a proof version. We would choose the latter only if we are trying to predict how the file may look on another output device through making this print e.g. on a printing press. In other words, we are using our printer as a proofing device.

Note > In Photoshop CS2 an attempt has been made to try and make this choice clearer by changing the labels - 'Source Space' is now termed 'Print', but it has the same effect.

C. 'Print Space' allows us to select the profile associated with the printer, whilst 'Intent' gives us options which may slightly vary the appearance of the print. (See '**Choosing a rendering intent**', on the following page.) In 'Photoshop CS2' this has been clarified under the 'Options' setting. Within this section, the 'Color Handling' allows the choice of software or printer to handle the color management, which then allows a choice of printer profile to be selected. This is effectively the same as the 'Print Space' section in earlier versions.

Choosing a rendering intent

Before we further discuss printing from a digital file, it is important to understand what is referred to as 'Rendering Intent'. Simply stated, when colors are changed from one space to another, certain adjustments have to be made to accommodate for the different gamuts of the spaces in question. Just how these adjustments are defined is the basis of the rendering intent.

~ **Perceptual** - often the choice for photographic images, this intent maintains the relationship between colors as perceived by the human eye, but compresses the entire color gamut so that it will fit into the target color space.

~ **Saturation** - this intent creates vivid colors at the expense of accuracy. It is most suitable for business graphics.

~ **Relative Colorimetric** - this intent shifts those colors within the color space that are out of gamut relative to the target color space. For example, when the paper white is compared against the monitor white. The result is that only those source colors that are out of gamut are clipped in the target space. This intent is sometimes preferred for images (and is the default setting in Photoshop) however, extreme RGB colors can be dramatically changed when converted to CMYK and may need to be adjusted manually.

~ **Absolute Colorimetric** - this intent maintains color accuracy, but does not change the relationship between colors if any fall outside the gamut of the destination space. Specific colors will map very precisely as long as they fall within the target gamut and therefore this intent is particularly useful where spot colors within a design are required to reproduce accurately.

'Black Point Compensation' ensures that the darkest shadow points on the source space are mapped to the darkest shadow points on the target space, thereby using the largest possible dynamic range. As a result, it is best left on.

Using soft proofs

Soft proofs can be useful as a way of predicting how an image will print. They can then give an indication of where any color problems may arise when outputting to that particular device. Suitable localized or even global adjustments can be made to the original file (via an adjustment layer), until the preview closely matches the original image.

ACTIVITY 1

1. Go to View > Proof Setup > Custom. From the Profile menu select the profile of the printer and paper you wish to use.

2. Check the 'Preview' and the 'Black Point Compensation' boxes. Do not however 'Preserve Color Numbers' as this will show how the image will look if the raw numbers were sent to the output device without the color space conversion - the exact opposite of what is required and would most likely give a very skewed result. The simulate 'Paper White' is an attempt to indicate how the paper surface will affect the print. This is at best a rough approximation, but does give an indication of what can be expected.

3. Choose either Perceptual or Relative Colorimetric from the 'Intent' options. As discussed in the previous section, the most common setting here is perceptual, but it is worth experimenting with the other options to determine which appears to give the most accurate result.

Two versions of the same file - one showing a soft proof

4. Save this setting to a suitable name and the next time the 'Proof Setup' box is opened it should appear in the 'Setup' tab.

5. Open the image file you wish to soft proof. Make a copy of the file. (It is best to include the word 'copy' in the file name to ensure that the two files do not become confused.) With both files on the desktop, and the copy version active, go to View > Proof Colors and the copy image should change to indicate how it will appear when printed. With the two images side by side, it is then possible to make changes to the copy file with an adjustment layer, so that it appears to match the original file when printed.

DIGITAL IMAGING >>>

essential skills >>>

Closed loop printing to an RGB device - *Project 21*

Note > This method of printing relies on the adapted monitor profile created in 'Setting up a closed loop workflow' page 257, being used as a preview of the print.

1. Open the image intended for printing. Go to View > Proof Setup and choose the adapted monitor profile that was created to best match the printed output of the target print in '**Managed Workflows**'. This profile should appear at the bottom of the list if it was saved previously, but if not, go to View > Proof Setup> Custom and select it from the drop down menu. (With some systems this monitor profile may not appear and so cannot be used as a soft proof. If that is the case then simply load the adjusted monitor profile manually from the display control panel and skip step 2.)

2. Go to View > Proof Colors to view the image (via a soft proof) as a replica of the printed result. This does not tag the file with a new profile, it merely changes the file display.

3. Now create an adjustment layer by selecting Layer > New Adjustment Layer. Choose any of the methods available (curves, levels, hue/saturation, etc.) depending on the changes that you require. Apply an appropriate adjustment to the file so that it matches as closely as possible the intended appearance of the print. Do not flatten this adjustment layer, rather save it with a name that suggests it is required just for the printed output. In fact you could have more than one adjustment layer - or layer set - relating to more than one printer.

4. Open the 'Print with Preview' dialog box, adjust the image position and size. Choose 'Document' as 'Source Space' and the 'Same as Source' for 'Print Source'. (This setting is chosen as we are not using profiles to color manage the printing.) Set 'Intent' and 'Black Point Compensation'.

5. Click 'Print' and choose your printer. Select the paper and print quality and importantly select 'No Color Adjustment' in the color management area.

6. Click OK to print, making sure the adjustment layer is active.

7. When printing is complete, ensure 'Proof Colors' is no longer checked so the adjusted monitor profile does not remain as the active monitor profile setting.

Managed printing to an RGB device - *Project 22*

Note > This method of printing relies on ICC profiles tagged onto the file to manage the printing process.

1. Select File > Print with Preview as in Step 4 in Project 21.

2. Choose 'Document' as 'Source Space'. The 'Source Space' gives us a choice between the profile tagged within the file or the ICC profile chosen in the CMYK set-up in 'Color Settings'. Since we are printing to a device which requires RGB data, we should use the RGB profile embedded within the document, so choose 'Document'.

3. Choose the printer profile from the list specific to your printer and paper surface. (Printer profiles are available for download from various sites and will be specific to the printer and the paper surface used.) The 'Print Space' profile allows us to choose how we actually apply color management from Photoshop to the printer. Three choices are available:

~ If '**Same as Source**' is chosen, the data is simply sent to the printer without change, effectively telling Photoshop **not** to color manage the document.

~ If '**Printer or Postscript Color Management**' is selected, the file along with the chosen 'Source Space' profile will be sent to the printer, allowing the printer to manage the color. It is best to choose this option only if you do not have a profile for the printer, as the results are dependent on the printer's color conversion capabilities.

~ If a **profile** is selected from the list that matches the printer, the file is sent with the printer's color space embedded, giving the most accurate result - as long as the printer profile is accurate. With this approach the file itself does not have any changes applied - the profile is applied '**on the fly**' by the printing set-up.

4. Click 'Print' and choose your printer. Select the paper and print quality and importantly select 'No Color Adjustment' in the color management area. **If this is not done then the printer will apply color controls to the image, which will conflict with the profile controlled printing.** Click OK to print.

279

Inkjet printing

One of the most common methods of print output for both the home and professional user is the inkjet printer. For the home user this technology offers fairly inexpensive, high quality, convenient output; whilst for the professional it offers the ability to proof and print images that may at a later stage be printed on a press or used on the Internet. Check prints of this type offer the working photographer a quick and effective presentation tool for clients, as well as a great opportunity for marketing. With the advances in inkjet technology, both the quality and consistency of inkjet prints have been improving, and with the use of color management systems even the predictability has become decidedly better. However, as this technology has become more widespread a number of aspects of inkjet printing need to be considered.

Archival permanence

The first inkjet printers used water soluble, organic dye based inks, which were bright, ultra fine in particle size and had a wide color gamut. There was a trade-off however - the inks were prone to fading and discoloration. Although improvements have been made over the years, this family of inks is still not considered very archival. Oil based dyes, which are much more colorfast, create problems when reduced to the ultra small particle sizes required for inkjet technology. A compromise solution that promises greater permanence is the use of pigment based inks. Pigment inks do not dissolve in water but have a reduced color space as well as a tendency to clump together, which poses problems for the inkjet head itself. However, manufacturers have been able to overcome some of these issues, with today's pigment based inks boasting fade resistance measured in years. These pigment inks print with practically no metamerism (where a color appears quite different under different light sources), and offer the best combination of longevity and wide color gamut available today.

Epson C64 printer with pigment inks

Paper media

One aspect that has long been recognized as being equally important with regard to archival permanence, is the paper stock itself. The chemical composition and the surface coating play an important role in the ability of the ink to remain fade resistant. The inkjet suitable papers of today are not only more archivally manufactured, but are also available in a myriad of surfaces and finishes. Legion, Hahnemuhle and Somerset are brands that offer high quality acid free, archival, textured and untextured papers. These, together with offerings from other better known inkjet and photographic brands, provide a choice far greater than has been traditionally available with normal 'wet process' photographic papers.

How many inks are enough?

Even though a CMYK printing space is effectively produced with four inks, unlike a press it is not so difficult to add more to an inkjet printer head. Commonly, a Light Magenta and a Light Cyan ink are added to the printer resulting in an effective six color system, although some manufacturers are also adding Orange and Red to give an eight color system! The purpose of these extra inks is to extend the smoothness of the tones, reduce the possibility of banding and widen the overall gamut. Since the files are sent to the printer in RGB format, the addition of extra inks is dealt with automatically via the conversion processes of the printer driver - an important reason why CMYK files should never be sent to an inkjet printer.

Quad ink printing

Printing a B&W image without a color cast is extremely difficult, as most color ink sets do rather a poor job of monochrome work, at least by the standards a photographer would set. Using color inks to reproduce a B&W image tends to produce a print in which the color is not quite neutral over the full tonal range from black to white, and there is a tendency for this color cast to shift with time. Such a color cast can be avoided by either using only black ink (as in a grayscale image) which tends to give a very grainy result, or by using cartridges containing several different shades of gray instead of the normal CMYK color inks - a process that is referred to as 'quadtone' printing. By using a simple color curve adjustment in PhotoShop associated with the relevant profile, high quality B&W images with tonal graduations to match traditional silver halide printing can be produced. One company producing these inks, Lyson, claims all their Quad Black inks have an extremely long life, without noticeable fade in average indoor display conditions. Their own testing indicates that Quad Black prints exceed the display life of most traditional silver halide images. Lysonic Quad Black inks are available in three different subtle hues to match the image style required: Cool, Neutral and Warm tone. The only major drawback to this approach is the need to either flush out the printer heads after each session (to allow color printing) or to have a dedicated printer exclusively printing Quad Tone B&W output.

Image by Regis Martin

Managed printing to a CMYK device

(This form of printing is only possible with Photoshop or other DTP software and is not available with Elements). Most of what has been discussed in the previous sections concerning an RGB printing set-up is equally valid for CMYK printing and press outputs. However, many of the settings chosen are even more critical and need to be addressed separately within the workflow. As the boundaries and demarcations become more and more fuzzy between what was once the role of a Pre-Press House or printer, and the role of the photographer, it is essential that photographers have a clearer understanding of decisions they may make which have a major effect on the final printed output.

A closed loop CMYK workflow

Printing to a CMYK printer requires a CMYK file, which as we know is device specific. For this reason it is recommended that the original RGB file should be retained as a 'master' file and the required CMYK version created from it as necessary. However, one way to avoid the entire conversion process is to work with a CMYK file supplied by the Pre-Press House or printer themselves. Even though all scanning devices are RGB in nature (as they work with light, not inks), most high end drum scanners convert the file 'on the fly' to CMYK. The settings used in this process have already been optimized for the printer and press that is to be used for output, so further adjustment is not required.

Note > Any editing to be done on the file should occur in the file's native CMYK format and not in RGB, so that it is not altered and compromised in its press optimization.

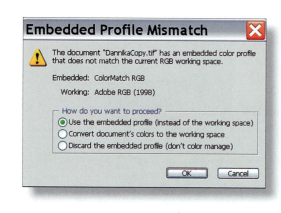

Therefore, it is essential that as the file is brought into the system, it is not converted to another color space, i.e. tagged with a new profile, as this will alter the color values. (Photoshop can happily work with the file in its own space and still represent it correctly on your monitor.) The safest way to ensure this is not happening is to tick the checkboxes in the 'Color Management Policies' window, so that 'Ask When Opening' occurs at all times. Make sure that you choose the option of using the embedded profile instead of the working space.

When the required editing and manipulation of this file is complete, it is automatically saved with its own original profile, ready for print output. At this point the file is most probably sent back to the printer who will then control that process, knowing that the device specific, optimized file that was sent out of their 'closed loop' environment has not been inadvertently altered.

Note > Remember that this file would be unsuitable for use in any other printing set-up or printing press.

CMYK workflows in Photoshop

In many cases, the image file a photographer will be working with has not been drum scanned, or indeed scanned at all in the case of files from digital cameras. As a result the file in its original form will be an RGB file, which will require conversion to CMYK for printing. This process can be carried out by choosing 'Image > Mode > CMYK Color' from the drop down menu. However, this simple menu step hides what is a very powerful and crucially important stage in the creation of a press ready image file. Although Photoshop performs this conversion very well, the nature of the information necessary for the result to be meaningful can often be difficult to obtain.

It may necessitate contact with the printer to determine the exact press conditions the image will be printed under and some printers may not be keen to provide this information as a misguided way of protecting their 'turf'. Perhaps the printer has not yet been chosen for the job, or maybe even the same CMYK file will be sent to many printers for insertion into multiple magazines. This difficulty in obtaining the particular press conditions that will determine the parameters of the conversion gives rise to problems that are difficult to deal with.

A growing view amongst many professionals within the reprographic industry is that for the above reasons, all files should be supplied in device independent RGB form, with the conversion being completed at pre-press stage by the printer.

Converting a file to CMYK

However, if you are required to create a CMYK file ready for printing, you need to revisit the 'Color Settings' dialog box and choose 'Custom CMYK'. This is the 'engine room' of your CMYK conversion and enables entry of all the parameters that need to be controlled for the specific printing device. Once all the detail has been entered, simply save the file with a suitable name and description - Photoshop will automatically save it in the 'Settings' folder. Next time the 'Color Settings' window is opened, the saved setting will appear in the 'Settings' menu.

Note > If the printing conditions are not available then choose from the pre-sets offered within Photoshop. For example, for European printing conditions choose 'Europe Pre Press Defaults'.

What press information is required?

To successfully customize the settings required for a high quality CMYK conversion, certain information is needed from the printer to determine the conditions under which the image file will be reproduced.

~ **Ink colors.** Inks will behave differently depending on the paper type they are to be applied upon - whether for example the stock is coated or uncoated will give different printed results and may require varying ink formulations. Find out which ink set is to be used on the presses and include that information by selecting 'Custom' from the 'Ink Colors' menu.

~ **Dot gain.** This is a measure of the amount of spread that occurs as the ink is applied to the paper. It is of course dependent on the particular paper stock to be used, so the choice of paper must also be considered.

~ **Separation options.** Included in this area is information about the limit to the total ink that will be applied, as well as how the black generation is to be controlled. Options to consider are whether GCR (Gray Component Replacement), UCR (Undercolor Removal), UCA (Undercolor Addition) or a combination of these is to be used. All of these techniques are methods employed by the printer to avoid too much ink being applied to the paper, which can result in muddy tones or smeared wet ink as it rolls through the high speed presses.

Proofing with inkjet printers

Desktop inkjet printers such as the Epson 2200/2100 use CMYK inks - or more accurately CMYK plus Light Cyan and Light Magenta. However, these printers are not ideal as proofing devices for press output - since translating the characteristics of a six color printer to preview or proof a four color printing process is somewhat problematic. Where these printers can be useful however, is in the production of a 'target' print - to help specify the final outcome required after CMYK separations have been created. **This print can be used as a guide to the 'pre-press house', when starting with an RGB file, to direct the operator as to how the final printed result should look.**

ACTIVITY 2

Displaying a soft proof of an RGB file (Photoshop only):

1. Open the image file 'onions.jpg'.

2. From the View menu select Proof Setup > Custom. Make sure the Preview box is ticked so that the result can be seen immediately. This is also useful as a method of toggling backwards and forwards between the soft proof and the original file.

3. From the Profile menu select an output device profile from the available list. You can choose any RGB or CMYK profile related to a printer, monitor or working space - although make sure you do not choose a digital camera or scanner, as these are not output spaces.

4. Check and uncheck the preview box to see how the conversion to your chosen space has affected the file. If you have chosen a space in the same color mode as the original (for example RGB to RGB), then the 'Preserve Color Numbers' checkbox will also be available. The purpose of this option is to indicate how the file would look if sent to the chosen device without any conversion - particularly useful to determine how a file with a particular CMYK conversion would print if sent unchanged to another CMYK set-up. Toggle this checkbox to observe the way the image alters.

5. Select a rendering intent (see 'Choosing a rendering intent', page 276) that gives the most pleasing result. This will usually be either Perceptual or Relative. By changing from one to the other you can immediately see how each affects the image.

6. The 'Simulate' checkboxes indicate how the output appears with the white of the paper and the blackness of the ink. Click 'Paper White' to preview how the paper shade itself will alter the appearance of the print. Select 'Save' and give the soft proof a suitable name.

ACTIVITY 3 (for Photoshop only)

The ability to soft proof allows easy comparisons between profiles - either created or supplied by the manufacturers of hardware devices. Using an image that has a wide gamut, it is easy to see which colors will not translate readily to certain CMYK device spaces.

1. Open the image file ColorTest.jpg.

2. Choose Proof > Setup > Custom from the View menu.

3. Select the Euroscale Coated profile from the drop down list, choose 'Relative Colorimetric' and make sure that the 'Preview' box is checked. Observe how the colors displayed on screen change, particularly with regard to the blue and deep orange hues. Toggle the 'Preview' checkbox.

4. Now select 'Paper White'. Observe how there is a general fading of all the colors as the paper tone is allowed for in the soft proof.

5. Uncheck 'Paper White' and select Euroscale Uncoated. This is simulating an uncoated paper stock which by its nature absorbs more ink and has a matt appearance. Notice how the colors change even further from the original.

6. Now select 'Paper White' once again. With an uncoated stock it is quite clear that the colors will not be reproduced with anything like the intensity of the original.

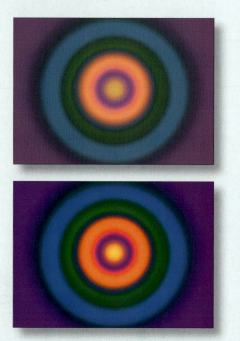

Original image (above) with soft proof on uncoated paper with 'Paper White' selected (top) and not selected (below)

7. Uncheck 'Paper White' once again. This time toggle between the various 'Intent' settings to observe how the representation of the original changes as it is mapped to the CMYK space with the different renderings. In particular, note how the 'Absolute' intent completely loses many of the dark colors.

Note > Soft proofing is a very powerful way to determine the accuracy of a particular color space associated with a device - or at least the profile created for that device.

ACTIVITY 4

The world of digital print output is vast and constantly changing. The various types of printing devices have been discussed in 'Platforms and output devices' - some of which are available to the home user and some available from commercial bureaus or labs.

1. Make a list of the relevant types of output that might be of value to your workflow.
2. Determine which of these are available to you either locally within your area or remotely via the Internet.
3. Contact your service provider and enquire as to the specifications they require for output ready files. Apart from determining the cost, pay special attention to the following:

 ~ Resolution for output (a higher than required resolution is usually discarded by the printer).
 ~ Maximum size of print (useful as sometimes it is more convenient and cheaper to 'gang' up a series of images onto one sheet of paper).
 ~ Color space used by the device.
 ~ Target points (some printers have a restricted density range).
 ~ Does the lab require/suggest match prints to ensure fidelity of print to expectations.
 ~ Scaling (should the image be supplied at 100% and are crop marks useful).
 ~ Color management system used by the lab.
 ~ Whether they will print a complementary test strip/target image for you.

4. Run a standard target image (See '**Creating a target image**' in '**Managed workflows**') as a test on each printer that you are identifying.
5. Collate a data file that indicates each output device with its associated details, so that it is available for any future printing output you may require. Ensure the printed target image is included in the file.

Les Horvat

Glossary

Additive color	A color system where the primaries of red, green and blue mix to form the other colors.
Adjustment layers	Image adjustment placed on a layer.
Adobe gamma	A calibration and profiling utility supplied with Photoshop.
Algorithms	A sequence of mathematical operations.
Aliasing	The display of a digital image where a curved line appears jagged due to the square pixels.
Alpha channel	Additional channel used for storing masks and selections.
Analyse/Analysis	To examine in detail.
Anti-aliasing	The process of smoothing the appearance of a curved line in a digital image.
Aperture	A circular opening in the lens that controls light reaching the film.
Area arrays	A rectangular pattern of light sensitive sensors alternately receptive to red, green or blue light.
Artifacts	Pixels that are significantly incorrect in their brightness or color values.
Aspect ratio	The ratio of height to width. Usually in reference to the light sensitive area or format of the camera.
Bit	Short for binary digit, the basic unit of the binary language.
Bit depth	Number of bits (memory) assigned to recording color or tonal information.
Bitmap	A one-bit image, i.e. black and white (no shades of gray).
Blend mode	The formula used for defining the mixing of a layer with those beneath it.
Brightness	The value assigned to a pixel in the HSB model to define the relative lightness of a pixel.
Buffer	RAM memory in a digital camera for temporarily holding image data before downloading to the memory card.
Byte	Eight bits. The standard unit of binary data storage containing a value between 0 and 255.
Captured	A record of an image.
CCD	Charge Coupled Device. A solid state image pick-up device used in digital image capture.
Channels	The divisions of color data within a digital image. Data is separated into primary or secondary colors.
Charge coupled device	See CCD.
CIS	Contact Image Sensor. A single row of sensors used in scanner mechanisms.
Clipboard	The temporary storage of data that has been cut or copied.

Clipping group	Two or more layers that have been linked. The base layer acts as a mask limiting the effect or visibility of those layers clipped to it.
Cloning tool	A tool used for replicating pixels in digital photography.
CMOS	Complementary Metal Oxide Semiconductor. A chip used widely within the computer industry, now also frequently used as an image sensor in digital cameras.
CMYK	Cyan, Magenta, Yellow and blacK. The inks used in four color printing.
Color Picker	Dialog box used for the selection of colors.
ColorSync	System level software developed by Apple, designed to work together with hardware devices to facilitate predictable color.
Color fringes	Bands of color on the edges of lines within an image.
Color fringing	See color fringes.
Color gamut	The range of colors provided by a hardware device, or a set of pigments.
Color space	An accurately defined set of colors that can be translated for use as a profile.
Complementary Metal Oxide Semiconductor	See CMOS.
Composition	The arrangement of shape, tone, line and color within the boundaries of the image area.
Compression	A method for reducing the file size of a digital image.
Constrain proportions	Retain the proportional dimensions of an image when changing the image size.
Contact Image Sensor	See CIS.
Context	The circumstances relevant to something under consideration.
Continuous tone	An image containing the illusion of smooth gradations between highlights and shadows.
Contrast	The difference in brightness between the darkest and lightest areas of the image or subject.
CPU	Central Processing Unit used to compute exposure.
Crash	The sudden operational failure of a computer.
Crop	Reduce image size to enhance composition or limit information.
Curves	Control for adjusting tonality and color in a digital image.
DAT	Digital Audio Tape. Tape format used to store computer data.
Default	The settings of a device as chosen by the manufacturer.
Defringe	The action of removing the edge pixels of a selection.
Density	The measure of opacity of tone on a negative.

Depth of field	The zone of sharpness variable by aperture, focal length or subject distance.
Descreen	The removal of half-tone lines or patterns during scanning.
Device dependent	Dependent on a particular item of hardware. For example, referring to a color result unique to a particular printer.
Device independent	Not dependent on a particular item of hardware. For example, a color result that can be replicated on any hardware device.
Device	An item of computer hardware.
Digital Audio Tape	See DAT.
Digital image	A computer-generated photograph composed of pixels (picture elements) rather than film grain.
Download	To copy digital files (usually from the Internet).
Dpi	Dots per inch. A measurement of resolution.
Dummy file	To go through the motions of creating a new file in Photoshop for the purpose of determining the file size required during the scanning process.
Dye sublimation print	A high quality print created using thermal dyes.
Dyes	A type of pigment.
EXIF	Camera settings data stored with the image file.
Edit	Select images from a larger collection to form a sequence or theme.
Editable text	Text that has not been rendered into pixels.
Eight/8-bit image	A single channel image capable of storing 256 different colors or levels.
Evaluate	Assess the value or quality of a piece of work.
Exposure	Combined effect of intensity and duration of light on a light sensitive material or device.
Exposure compensation	To increase or decrease the exposure from a meter-indicated exposure to obtain an appropriate exposure.
Feather	The action of softening the edge of a digital selection.
File format	The code used to store digital data, e.g. TIFF or JPEG.
File size	The memory required to store digital data in a file.
Film grain	See Grain.
Film speed	A precise number or ISO rating given to a film or device indicating its degree of light sensitivity.
F-numbers	A sequence of numbers given to the relative sizes of aperture opening. F-numbers are standard on all lenses. The largest number corresponds to the smallest aperture and vice versa.
Format	The size of the camera or the orientation/shape of the image.
Frame	The act of composing an image. See 'Composition'.
Freeze	Software that fails to interact with new information.

FTP software	File Transfer Protocol software is used for uploading and downloading files over the Internet.
Galleries	A managed collection of images displayed in a conveniently accessible form.
Gaussian Blur	A filter used for defocusing a digital image.
GIF	Graphics Interchange Format. An 8-bit format (256 colors) that supports animation and partial transparency.
Gigabyte	A unit of measurement for digital files, 1024 megabytes.
Grain	Tiny particles of silver metal or dye that make up the final image. Fast films give larger grain than slow films. Focus finders are used to magnify the projected image so that the grain can be seen and an accurate focus obtained.
Grayscale	An 8-bit image with a single channel used to describe monochrome (black and white) images.
Gray card	Card that reflects 18% of incident light. The resulting tone is used by light meters as a standardized mid-tone.
Half-tone	A system of reproducing the continuous tone of a photographic print by a pattern of dots printed by offset litho.
Hard copy	A print.
Hard drive	Memory facility that is capable of retaining information after the computer is switched off.
HDR	High Dynamic Range.
Highlight	Area of subject receiving highest exposure value.
Histogram	A graphical representation of a digital image indicating the pixels allocated to each level.
Histories	The memory of previous image states in Photoshop.
History brush	A tool in Photoshop with which a previous state or history can be painted.
HTML	Hyper Text Markup Language. The code that is used to describe the contents and appearance of a web page.
Hue	The name of a color, e.g. red, green or blue.
Hyperlink	A link that allows the viewer of a page to navigate or 'jump' to another location on the same page or on a different page.
ICC	International Color Consortium. A collection of manufacturers including Adobe who came together to create an open, cross platform standard for color management.
ICM	Image Color Management. Windows based software designed to work together with hardware devices to facilitate predictable color.

Image Color Management	See ICM.
Image setter	A device used to print CMYK film separations used in the printing industry.
Image size	The pixel dimensions, output dimensions and resolution used to define a digital image.
Infrared film	A film that is sensitive to the wavelengths of light longer than 720nm, which are invisible to the human eye.
Instant capture	An exposure that is fast enough to result in a relatively sharp image free of significant blur.
International Color Consortium	See ICC.
Interpolated resolution	Final resolution of an image arrived at by means of interpolation.
Interpolation	Increasing the pixel dimensions of an image by inserting new pixels between existing pixels within the image.
ISO	International Standards Organization. A numerical system for rating the speed or relative light sensitivity of a film or device.
ISP	Internet Service Provider allows individuals access to a web server.
Jaz	A storage disk capable of storing slightly less than 2GB manufactured by Iomega.
JPEG (.jpg)	Joint Photographic Experts Group. Popular image compression file format.
Jump	To open a file in another application.
Juxtapose	Placing objects or subjects within a frame to allow comparison.
Kilobyte	1024 bytes.
Lab mode	A device independent color model created in 1931 as an international standard for measuring color.
Lag time	The time delay between pressing the shutter release button and the time it takes for the camera to capture the image.
Lasso tool	Selection tool used in digital editing.
Latent image	An image created by exposure onto light sensitive silver halide ions, which until amplified by chemical development is invisible to the eye.
Latitude	Ability of the film or device to record the brightness range of the subject.
Layer mask	A mask attached to a layer that is used to define the visibility of pixels on that layer.

Layers	A feature in digital editing software that allows a composite digital image where each element is on a separate layer or level.
LCD	Liquid crystal display.
LED	Light-emitting diode. Used in the viewfinder to inform the photographer of exposure settings.
Lens	An optical device usually made from glass that focusses light rays to form an image on a surface.
Levels	Shades of lightness or brightness assigned to pixels.
Light cyan	A pale shade of the subtractive color cyan.
Light magenta	A pale shade of the subtractive color magenta.
LiOn	Lithium Ion. Rechargeable battery type.
Lithium Ion	See LiOn.
LZW compression	A lossless form of image compression used in the TIFF format.

Magic wand tool	Selection tool used in digital editing.
Magnesium Lithium	See MnLi.
Marching ants	A moving broken line indicating a digital selection of pixels.
Marquee tool	Selection tool used in digital editing.
Maximum aperture	Largest lens opening.
Megabyte	A unit of measurement for digital files, 1024 kilobytes.
Mega-pixels	More than a million pixels.
Memory card	A removable storage device about the size of a small card. Many technologies available resulting in various sizes and formats. Often found in digital cameras.
Metallic silver	Metal created during the development of film, giving rise to the appearance of grain. See grain.
Minimum aperture	Smallest lens opening.
MnLi	Magnesium Lithium. Rechargeable battery type.
Mode (digital image)	RGB, CMYK, etc. The mode describes the tonal and color range of the captured or scanned image.
Moiré	A repetitive pattern usually caused by interference of overlapping symmetrical dots or lines.
Motherboard	An electronic board containing the main functional elements of a computer upon which other components can be connected.
Multiple exposure	Several exposures made onto the same frame of film or piece of paper.
Negative	An image on film or paper where the tones are reversed, e.g. dark tones are recorded as light tones and vice versa.

NiCd	Nickel Cadmium. Rechargeable battery type.
Nickel Cadmium	See NiCd.
Nickel Metal Hydride	See NiMH.
NiMH	Nickel Metal Hydride. Rechargeable battery type.
Noise	Electronic interference producing white speckles in the image.
Non-imaging	To not assist in the formation of an image. When related to light it is often known as flare.
Objective	A factual and non-subjective analysis of information.
ODR	Output Device Resolution. The number of ink dots per inch of paper produced by the printer.
Opacity	The degree of non-transparency.
Opaque	Not transmitting light.
Optimize	The process of fine-tuning the file size and display quality of an image or image slice destined for the Web.
Out of gamut	Beyond the scope of colors that a particular device can create.
Output device resolution	See ODR.
Path	The outline of a vector shape.
PDF	Portable Document Format. Data format created using Adobe software.
Pegging	The action of fixing tonal or color values to prevent them from being altered when using curves image adjustment.
Photo Multiplier Tube	See PMT.
Piezoelectric	Crystal that will accurately change dimension with a change of applied voltage. Often used in inkjet printers to supply microscopic dots of ink.
Pixel	The smallest square picture element in a digital image.
Pixellated	An image where the pixels are visible to the human eye and curved lines appear jagged or stepped.
PMT	Photo Multiplier Tube. Light sensing device generally used in drum scanners.
Portable Document Format	See PDF.
Pre-press	Stage where digital information is translated into output suitable for the printing process.
Primary colors	The three colors of light (red, green and blue) from which all other colors can be created.
Processor speed	The capability of the computer's CPU measured in megahertz.
PSB	Large document format suitable for saving files between 2 and 4 Gigabytes in Photoshop CS/CS2.

Quick mask mode	Temporary alpha channel used for refining or making selections.
RAID	Redundant Array of Independent Disks. A type of hard disk assembly that allows data to be simultaneously written.
RAM	Random access memory. The computer's short-term or working memory.
RAW	Unprocessed data captured by a camera's image sensor.
Redundant Array of Independent Disks	See RAID.
Reflector	A surface used to reflect light in order to fill shadows.
Refraction	The change in direction of light as it passes through a transparent surface at an angle.
Resample	To alter the total number of pixels describing a digital image.
Resolution	A measure of the degree of definition, also called sharpness.
RGB	Red, green and blue. The three primary colors used to display images on a color monitor.
Rollover	A Web effect in which a different image state appears when the viewer performs a mouse action.
Rubber stamp	A tool used for replicating pixels in digital imaging.
Sample	To select a color value for analysis or use.
Saturation (color)	Intensity or richness of color hue.
Save a Copy	An option that allows the user to create a digital replica of an image file but without layers or additional channels.
Save As	An option that allows the user to create a duplicate of a digital file but with an alternative name, thereby protecting the original document from any changes that have been made since it was opened.
Scale	A ratio of size.
Scratch disk memory	Portion of hard disk allocated to software such as Photoshop to be used as a working space.
Screen real estate	Area of monitor available for image display that is not taken up by palettes and toolbars.
Screen re-draws	Time taken to render information being depicted on the monitor as changes are being made through the application software.
Secondary colors	The colors Cyan, Magenta and Yellow, created when two primary colors are mixed.
Sharp	In focus. Not blurred.
Silver halide	Compound of silver often used as a light sensitive speck on film.

Single Lens Reflex	See SLR camera.
Slice	Divide an image into rectangular areas for selective optimization or to create functional areas for a web page.
Sliders	A sliding control in digital editing software used to adjust color, tone, opacity, etc.
SLR camera	Single Lens Reflex camera. The image in the viewfinder is essentially the same image that the film will see. This image, prior to taking the shot, is viewed via a mirror that moves out of the way when the shutter release is pressed.
Snapshot	A record of a history state that is held until the file is closed.
Soft proof	The depiction of a digital image on a computer monitor used to check output accuracy.
Software	A computer program.
Subjective analysis	Personal opinions or views concerning the perceived communication and aesthetic value of an image.
Subtractive color	A color system where the primaries of Yellow, Magenta and Cyan mix to form all other colors.
System software	Computer operating program, e.g. Windows or Mac OS.
Tagging	System whereby a profile is included within the image data of a file for the purpose of helping describe its particular color characteristics.
Thematic images	A set of images with a unifying idea or concept.
TIFF	Tagged Image File Format. Popular image file format for desktop publishing applications.
Tone	A tint of color or shade of gray.
Transparent	Allowing light to pass through.
Tri-color	A filter taking the hue of either one of the additive primaries, Red, Green or Blue.
True resolution	The resolution of an image file created by the hardware device, either camera or scanner, without any interpolation.
TTL meter	Through-The-Lens reflective light meter. This is a convenient way to measure the brightness of a scene as the meter is behind the camera lens.
Tweening	Derived from the words 'in betweening' - an automated process of creating additional frames between two existing frames in an animation.
UCR	Under Color Removal. A method of replacing a portion of the yellow, magenta and cyan ink, within the shadows and neutral areas of an image, with black ink.
Under Color Removal	See UCR.

Unsharp mask filter	A filter for increasing apparent sharpness of a digital image.
Unsharp Mask	See USM.
URL	Uniform Resource Locator. The unique Web address given to every web page.
USM	Unsharp Mask. A process used to sharpen images.
Vector graphic	A resolution-independent image described by its geometric characteristics rather than by pixels.
Video card	A circuit board containing the hardware required to drive the monitor of a computer.
Video memory	Memory required for the monitor to be able to render an image.
Virtual memory	Hard drive memory allocated to function as RAM.
Visualize	To imagine how something will look once it has been completed.
Workflow	Series of repeatable steps required to achieve a particular result within a digital imaging environment.
Zip	A compression routine commonly used when saving files in the PDF file format. Also an older style storage disk manufactured by Iomega.
Zoom tool	A tool used for magnifying a digital image on the monitor.

Keyboard shortcuts

⌥ = Option ⇧ = Shift ⌘ = Command CS/CS2 = Photoshop CS/CS2 E = Elements

Action	Keyboard Short Cut
Navigate and view	
Fit image on screen	⌘/Ctrl + 0
View image at 100% (actual pixels)	⌥/Alt + ⌘/Ctrl + 0
Zoom tool (magnify)	⌘/Ctrl + Spacebar + click image
Zoom tool (reduce)	⌥/Alt + ⌘/Ctrl + click image
Full/standard screen mode (CS/CS2)	F
Show/hide Rulers	⌘/Ctrl + R
Show/hide guides (CS/CS2)	⌘/Ctrl + ;
Hide palettes	Tab key
File Commands	
Open	⌘/Ctrl + O
Close	⌘/Ctrl + W
Save	⌘/Ctrl + S
Save As	⇧ + ⌘/Ctrl + S
Undo/Redo (CS/CS2) - Step Backward (E)	⌘/Ctrl + Z
Step Backward (CS/CS2)	⌥/Alt + ⌘/Ctrl + Z
Redo (Elements)	⌘/Ctrl + Y
Selections	
Add to selection	Hold ⇧ key and select again
Subtract from selection	Hold ⌥/Alt key and select again
Copy	⌘/Ctrl + C
Cut	⌘/Ctrl + X
Paste	⌘/Ctrl + V
Paste Into	⌘/Ctrl ⇧ + V
Free Transform	⌘/Ctrl + T
Distort image in free transform	Hold ⌘/Ctrl Key + move handle
Feather	⌘/Ctrl ⌥/Alt + D
Select All	⌘/Ctrl + A
Deselect	⌘/Ctrl + D
Inverse selection	⌘/Ctrl + I
Edit in Quick Mask Mode (CS/CS2)	Q

Painting

Set default foreground and background colors	D
Switch between foreground and background color	X
Enlarge brush size (with paint tool selected)]
Reduce brush size (with paint tool selected)	[
Make brush softer	[+ Shift
Make brush harder] + Shift
Change opacity of brush in 10% increments (with paint tool selected)	Press number keys 0 - 9
Fill with foreground color	⌥/Alt ⌫
Fill with background color	⌘/Ctrl ⌫

Image adjustments

Levels	⌘/Ctrl + L
Curves (CS/CS2)	⌘/Ctrl + M
Group layer (E)	⌘/Ctrl + G
Create Clipping Mask (CS2)	⌘/Ctrl + ⌥/Alt + G
Select next adjustment point in curves (CS/CS2)	Ctrl + Tab

Layers and masks

Add new layer	⇧ + ⌘/Ctrl + N
Load selection from layer mask	⌘/Ctrl + click thumbnail
Change opacity of active layer in 10% increments	Press number keys 0 - 9
Add layer mask - Hide All	⌥/Alt + Click 'Add layer mask' icon
Move layer down/up	⌘/Ctrl + [or]
Copy and merge visible and paste to new layer	⌘/Ctrl + ⌥/Alt + ⇧ + N and then E
Disable/enable layer mask	⇧ + click layer mask thumbnail
View layer mask only	⌥/Alt + click layer mask thumbnail
View layer mask and image (CS/CS2)	⌥/Alt + ⇧ + click layer mask thumbnail
Blend Modes	⌥/Alt + ⇧ + (N, S, M, O, Y) Normal, Screen, Multiply, Overlay, Luminosity

Crop

Enter crop	Return key
Cancel crop	Esc key
Constrain proportions of crop marquee	Hold ⇧ key
Turn off magnetic guides when cropping	Hold ⌥/Alt + ⇧ keys + drag handle

Web links

Resources

Essential Skills	http://www.photographyessentialskills.com
RMIT Photography	http://www.rmit.edu.au/adc/photography
Adobe Digital Imaging	http://www.adobe.com/digitalimag/main.html
Martin Evening	http://www.martinevening.com
Digital Photography Review	http://www.dpreview.com
Luminous Landscape	http://www.luminous-landscape.com
Digital Dog	http://www.digitaldog.net
Epson	http://www.epson.com
Computer darkroom	http://www.computer_darkroom.com
Inkjet Mall	http://www.inkjetmall.com

Tutorials

Adobe	http://www.adobe.com/products/tips/photoshop.html
Phong	http://www.phong.com
Russell Brown	http://www.russellbrown.com
Think Dan	http://www.thinkdan.com/tutorials/photoshop.html
Planet Photoshop	http://www.planetphotoshop.com
Ultimate Photoshop	http://www.ultimate-photoshop.com
Scan tips	http://www.scantips.com

Photomedia Illustrators

Paul Allister	obscur@hotpop.com
Stuart Wilson	http://www.stuartwilson.com
Samantha Everton	http://www.samanthaeverton.com
Orien Harvey	orien_harvey@ekit.com
Fabio Sarraff	http://www.fabiosarraff.com
Amber Williams	http://www.amberwilliams.com
Raphael Ruz	http://endersan.com

Supporting CD

The CD is a veritable teasure trove of supporting files for the projects in this book. The CD uses a web browser interface to supply quick and easy access to many of the images. Each of the 10 projects in the 'Image Enhancement' and 'Post-production' chapters is supported by a QuickTime movie tutorial, allowing you to start, stop and rewind so that the skills can be quickly and easily acquired.

The 'Support Folder' on the CD contains multilayered image files of the completed projects and all of the camera RAW files and resource images for the 'Digital Negative' and 'Presentations' chapters.

Open the JPEG images and watch the supporting movies

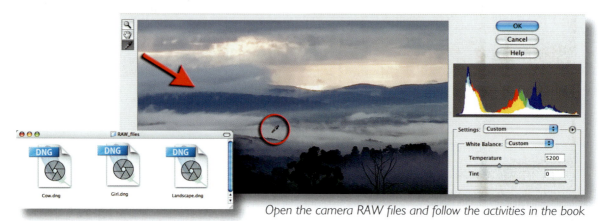

Open the camera RAW files and follow the activities in the book

>>> DIGITAL IMAGING

Photoshop Elements 3 > Presets > Styles ← Shadow_Transparency.asl

Load the Adobe Presets to enhance your Adobe software in line with Projects 7 and 9.

Open a multilayered PSD file from the CD to check the accuracy of your own technique

>>> essential skills >>>

Use the support files to create picture packages, slide shows, web galleries and panoramas

CD Content (see previous pages for overview)

THE CD PROVIDES EXTENSIVE SUPPORT IN THE FORM OF:

- Over one hour of movie tutorials.

- Over 40 high quality JPEG images to support imaging projects.

- 3 camera RAW files used in the chapter 'The Digital Negative'.

- 10 multilayered photoshop documents of completed projects.

- 2 Adobe presets to enhance performance capabilities of software.

- Printable PDF file of keyboard shortcuts to act as a quick and handy reference guide to speed up your image-editing tasks.

- A gallery of inspirational images.

- Quiz to test your digital imaging knowledge (answers at end of file).

- Links to useful web sites and contacts for digital illustrators and photographers used in the creation of this book.

- Links to the Focal Press, Essential Skills, Adobe and RMIT University web sites.

Essential Skills supporting web site

For all the latest support materials go to: http://www.photographyessentialskills.com

Index

8-bit depth, 10, 41
8-bit editing, 55, 59, 128
16-bit depth, 10
16-bit editing, 59, 60
 color adjustment, 129
 flatbed scanners, 76
 RAW dialog box, 55

Adams, Ansel, 137, 176
Additive color, 7, 85, 89
Adjustment layers, 133–5
 Black and White prints, 159–62
 localized color adjustment, 141–2
 printing to an RGB device in a closed loop,
 278
 selective sharpening, 233
 target values, 139
 toning, 165–8
Adobe Acrobat, 194
Adobe Bridge, 243–52
Adobe DNG format, 64
Adobe Elements 2 , 192, 194–5
Adobe Elements 3:
 16-bit editing, 60, 129
 advanced blending, 179
 Black and White prints, 159
 capture sharpening, 230
 clipping information, 57
 color management, 266
 Color Variations, 109
 Custom Slide Show, 194, 196–7
 Feather Selection, 132
 Gaussian Blur, 172–4
 image enhancements, 120
 image size, 19
 noise reduction software, 224
 presentations, 188, 201
 RAW dialog box, 54–61
 RGB color space, 91
 Save for Web, 114
 Selection Brush Tool, 131

 Shadows/Highlights adjustment, 107, 143–6
 tonal adjustment, 104, 115–16
Adobe Gamma, 94–6, 97, 258
Adobe Photoshop CS/CS2:
 16-bit editing, 60, 129
 advanced blending, 178
 Black and White prints, 159
 calibration of monitors, 94–6
 capture sharpening, 230
 CMYK workflows, 283
 Color Settings, 265
 color spaces, 91, 92
 Color Variations, 109
 computer platforms, 68
 Curves adjustment, 107
 ICC profile based system, 264
 image enhancements, 120
 image size, 19
 Lens Blur, 171–2
 noise reduction software, 224
 presentations, 188, 192, 194–5, 201
 Quick Mask Mode, 131
 RAM, 70
 RAW dialog box, 54–61
 resolution, 198
 Save for Web, 114
 Shadows/Highlights adjustment, 107, 143–7
 soft proofing, 274
 stitching, 211–13
 tonal adjustment, 104, 115–16
 working color space, 261–2, 262
Adobe RGB, 217, 226, 262, 264, 266
Advanced blending, 178–9
Anti-aliasing, 2, 201
Apples iFamily, 192–3, 200
Archives, 249–50
 CD and DVD, 73
 computer interface, 48
 digital negatives, 64
 digital versus traditional, 26
 file formats, 13

inkjet printers, 280
output sharpening, 234
printer inks, 80
removable media, 72
RGB versions, 90
Aspect ratio, 29, 41

Background, 169
Banding, 59, 62–3, 168
Batch processing:
 Photoshop Actions, 251–2
 presentations, 188
 RAW dialog box, 64
Batch Re-name, 245, 249
Batteries, 50
Bicubic Sharper, 20
 see also 8-bit depth; 16-bit depth
Bit depth, 10
 digital cameras, 41
 flatbed scanners, 76
 RAW dialog box, 59–60
Black:
 subtractive color, 86
Black and White, 158–62, 281
Blending:
 advanced, 178–9
Borders:
 cropping, 123
Bracketing exposures, 176–9
Bridge, 249–50, 251–2
Brightness, 5
 adjustment, 106
 calibration of monitors, 94–6
 Color Picker, 6
 histograms, 104, 105
 tonal adjustment, 104–7
 tonal distribution, 62
Browsers, 243–52
Burning, 160–2, 164

Calibration, 97
 ICC profile based system, 264
 managed workflows, 256
 monitors, 93–7, 144, 264, 274

printers, 269
scanners, 269
test images, 270–1
Camera buffer, 43, 44
Camera image review, 235
Camera noise, 221–4
Canon 1Ds Mark II, 35
Canon EOS 1D MkII, 36
Canon Powershot S1, 37
Capture, 24–51
 conventional cameras, 27
 histograms, 104–5, 236
 image adjustments, 101
 image preview, 242
 resolution, 14, 20
 sharpening, 148, 229–30
 speed, 36
 workflows, 216–38
 see also Digital cameras; Image sensors
Castlewood Orb disks, 72
CCDs see charge-coupled devices
CDs, 64, 73, 189
Channels, 3
 bit depths, 10
 RAW format, 59–60
Charge-coupled devices (CCDs), 30, 34, 76
CIELab color space, 89, 91
CIS see Contact Image Sensors
Cleaning an image, 110
Clipping:
 camera image review, 235
 color correction, 109
 histograms, 105, 106, 236
 Levels adjustment, 128
 RAW dialog box, 57
 tonal adjustment, 104
Clipping groups, 199
Clone Stamp Tool, 110, 174
Closed loop workflow, 97, 257–8, 282
CMM see Color Management Module
CMOS see complementary metal oxide
 semiconductor
CMS see Color Management System
CMYK, 3

color space, 86, 90, 91–2
Elements, 266
managed printing, 282–7
number of inks, 281
out of gamut, 88
printers, 268
relationship to RGB, 89
subtractive color, 7
target values, 138
working space, 268
Color, 7–9, 115–16
additive, 7, 85
adjustment, 108–9, 128–30, 141–2
adjustment layers, 133–6
bit depth, 10
capture, 27, 28
channels, 3
clipping information, 57
Color Picker, 6
conversion to Black and White, 158–62
gamut, 8, 88
Gaussian Blur, 174
Hue, Saturation and Brightness, 5
image sensors, 31
levels, 4
managed workflows, 256–71
management, 8
monitors, 68
noise reduction, 58
perception, 8
printers, 78–81
RGB relationship to CMYK, 89
sampling, 6
subtractive, 7
toning, 163–8
white balance, 55–6, 225
Color bleed, 174
Color casts, 108, 140
Color compensation, 26
Color correction, 108–9, 225
Color fringing, 151–4
Color gamuts, 8, 88
Color laser printers, 79
Color management, 8, 84–97

calibrating the monitor, 93–7
color space, 61
computer platforms, 68
Elements, 266
Photoshop, 267–8
profiles, 90–7
Web Photo Gallery, 207
workflows, 256–71
Color Management Module (CMM), 84–97,
 256
Color modes:
 file formats, 13
Color perception, 8
Color Picker, 6, 150, 164
Color Settings, 265, 279, 283
Color space, 85–7
 camera controls, 217
 closed loop workflows, 257
 color gamuts, 88
 device dependent, 90, 256
 device independent, 89, 256
 digital capture, 101
 RAW dialog box, 61
 scanners, 269
 working, 259–63
Color Variation, 128–9
Colorimeter, 97
ColorSync, 93
Comb lines, 59, 60
Commission Internationale de l'Eclairage
 (CIE), 89, 91
Compact digital cameras, 38
CompactFlash cards, 45, 46, 47
Complementary colors, 89
Complementary metal oxide semiconductor
 (CMOS), 30, 34
Compression, 11
 capture sharpening, 230
 digital capture, 44, 218
 file formats, 13
 see also JPEG; Lossless compression;
 Lossy compression
Computer interface, 48
Computers, 68–70

DIGITAL IMAGING >>> essential skills >>>

calibrating monitors, 93–7
card readers, 47
remote camera software, 237
Constrain Proportions, 19
Contact Image Sensors (CIS), 76
Contact Sheet, 189
Continuous tone, 4
Contrast:
 adjustment, 106
 calibration of monitors, 94–6
 digital capture, 101
 histograms, 105
 Levels adjustment, 127
 quality, 120
 Shadow/Highlight adjustment, 143–7
 sharpening, 111, 232
 tonal contraction, 175–9
Converging verticals, 124–6
Crashes, 70, 100
Creative depth of field, 169–74
Cropping, 102–3, 112, 121–6, 195
CS/CS2 see Adobe Photoshop CS/CS2
Curves, 107, 143
Custom Slide Show, 194, 196–7
Cylindrical Mapping, 213

DAT (Digital Audio Tape), 73
Depth of field, 169–74
Desktop inkjet printers, 80
Desktop publishing, 190–1
Device dependent color spaces, 90, 256
Device independent color spaces, 89, 256
Digital camera backs, 32
Digital cameras:
 aspect ratio, 41
 auto setting, 223
 bit depth, 41
 bracketing exposures, 176
 buffers, 43
 bundled software, 50
 camera noise, 221–4
 capture, 24, 25–6, 28, 101
 capture workflows, 216–38
 choosing, 40–51

color space, 217
compression, 44
computer interface, 48
control of color casts, 108
dynamic range, 25
file formats, 44, 218–20
histograms, 104–5
image size, 17
ISO range, 49
lenses, 42
memory cards, 45–7
pixel count, 40
power source, 50
presentations, 192
response times, 44
sensitivity, 48
sensor size, 41
setting up, 226–8
shutter lag, 44
size and weight, 51
types, 32–9
versus traditional, 26
viewfinders, 48, 49
white balance, 225
see also Digital SLR cameras; Image
 sensors; Prosumer cameras
Digital Negatives, 12, 54–64
see also RAW format
Digital SLR cameras (DSLRs), 35–6
 CompactFlash cards, 45
 image size, 17
 RAW format, 54
 setting up, 226–8
 viewfinders, 49
 zoom lenses, 42
Digital tape, 64
Digital video cameras, 39
Display Calibrator, 96
DNG format, 64
Docking stations, 47, 48
Dodging, 160–2
Dot gain, 284
Dots per inch (dpi), 16
Downsampling, 20

Dpi *see* dots per inch
Drawing, 130
Drum scanners, 75
DSLRs *see* Digital SLR cameras
DVDs (Digital Versatile Disks), 64, 73, 192–3
Dye-sublimation printers, 78
Dynamic range, 104

Elements *see* Adobe Elements 3
EXIF (Exchangeable Image File Format), 246, 248
Expose right, 63, 236
Exposure:
 bracketing, 176–9
 expose right, 63, 236
 histograms, 105, 236
 Levels adjustment, 128
 multiple exposures, 63
 noise, 223
 setting up the camera, 227
 target values, 138
External disk arrays, 71
External storage, 71–3
Eyedropper Tool, 137–42

Fades, 204
Feather Selection, 131–2
File Browsers, 243–52
File formats, 12–13
 digital cameras, 44
 digital capture, 218–20
File handling workflows, 242–52
File info, 246–8
File transfer protocol (FTP), 209
Files:
 metadata, 246–8
 naming, 112, 113, 245, 249
 saving, 245
 size, 10, 11, 16, 17, 18
 transfer, 48, 242
Film:
 capture, 24, 27
 dynamic range, 25
 scanners, 75

Film recorders, 79
Film scanners, 75
FireWire drives, 64
Flatbed scanners, 75–7
Focus, 169–74
Folders, 251–2
Formatting, 226
Foveon sensors, 30, 31
FTP *see* File transfer protocol
Fuji FinePix S3 Pro, 40
Fuji Finepix S20 Pro, 37

Gain, 221
Galleries, 71, 206–10
Gamma, 94–6
 see also Adobe Gamma
Gamma slider, 106, 127, 141
Gamut, 8, 88
Gaussian Blur:
 creative depth of field, 169–70, 172–4
 digital montage, 182, 183
 selective sharpening, 231
 slide transitions, 204
 toning, 166
GCR *see* Gray Component Replacement
Gicl‚e inkjet printers, 81
GIF (Graphics Interchange Format), 13
Gradient, 115, 167–8, 170
Gray Component Replacement (GCR), 86, 284
Gray Point, 108
Grayscale, 10, 159–62
Grey cards, 56

Hard disks, 70
Hard drives, 71
Healing Brush Tool, 110, 174
High Pass, 149–51
Highlights:
 capture, 236
 color correction, 109
 Curves adjustment, 107
 Levels adjustment, 127–8
 optimising histograms, 106

Shadow/Highlight adjustment, 107, 143–7
target values, 137–42
tonal contraction, 175–9
toning, 163–8
Histograms:
 8-bit editing, 59
 after capture, 106
 capture workflows, 236
 Digital SLR cameras, 35
 Layers, 133
 Levels adjustment, 127
 Shadow/Highlight adjustment, 145
 target values, 138
 tonal adjustment, 104–7
Hot pixels, 222
HSB see Hue, Saturation and Brightness
Hue, 5
 Black and White prints, 159–60
 color perception, 8
 Color Picker, 6
 localized color adjustment, 142
Hue, Saturation and Brightness (HSB), 5, 6, 7

ICC (International Color Consortium) profiles,
 94–6, 97, 259–63, 264, 279–81
iDVD, 192–3
Image adjustments, 100–16
Image banks, 192
Image browsing, 243–5
Image Color Management (ICM), 93
Image enhancements, 120–54
Image Modes, 3
Image quality, 100
Image review, 235
Image sensors, 29–32
 advances, 34
 capture, 28
 characteristics, 29
 creating an image, 31
 distribution of data, 62–3
 flatbed scanners, 76
 image size, 17
 ISO settings, 220
 noise, 221–4

resolution, 14
sensitivity, 49
size, 41
types, 30
Image size, 15, 17–20
 advanced techniques, 121–6
 JPEG formats, 113
 resizing for screen viewing, 112
 scaling, 19
Image stabilizers, 42
Imation Super disks, 72
iMovie, 193
Inkjet printers, 80–1
 color space, 268
 managed printing to an RGB device, 280–1
 output sharpening, 234
 proofing with, 284
Inks, 80
 color space, 85, 90
 inkjet printers, 280, 281
 press information, 284
 subtractive color, 86
International Press and Telecommunications
 Council (IPTC), 247, 249
Internet, 13, 112, 206–10
Internet Service Provider (ISP), 206, 209
Interpolated resolution, 40, 77
Interpolation, 20
Iomega Jaz disks, 72
Iomega Zip disks, 72
iPhoto, 192–3
ISO settings:
 digital cameras, 49, 220
 digital versus traditional, 26
 noise, 221, 223
 setting up the camera, 227

JPEG (Joint Photographic Experts Group)
 format, 12
 archiving, 250
 digital capture, 218, 219
 histograms, 236
 image adjustments, 101
 PowerPoint presentations, 201, 204

resolution, 220
Save for Web, 114
saving as, 113
setting up the camera, 227
sharpening, 148
Web Photo Gallery, 207
JPEG2000, 13

Keywords:
metadata, 247, 248, 249
Kodak Pro SLR/n, 36

Landscapes, 175–9
Large format camera systems, 33
Laser printers, 79, 234
Lasso Tool, 130, 180–1, 231
Layer Masks, 63
digital montage, 180–4
Gaussian Blur, 170, 172–4
Lens Blur, 171
selective sharpening, 231–2
Layers, 13, 133–6
LCD screens, 49, 69
Leaf Valeo 22 , 32
Lens Blur, 169, 231
Lenses, 33, 36, 42
Levels, 4
advanced control, 127–36
color correction, 108–9
digital image capture, 28
experimenting with, 115–16
target values, 137–42
tonal adjustment, 104
Lossless compression, 13, 44
Lossy compression, 12, 13, 44, 218
Luminosity sharpening, 151–4
LZW compression, 13

Mac computers:
iFamily, 192–3
PowerPoint, 200
slideshows, 197
Macintosh:
ColorSync, 93

Magic Eraser Tool, 152
Magnetic tape, 73
Magnification:
scanning resolution, 18
Managed workflows, 256–71
CMYK devices, 282–7
RGB devices, 279–81
'Marching ants', 130
Masks:
digital montage, 180–4
Layer Mask, 133–5
painting tools, 131–2
selection tools, 130
see also Layer Masks
Memory, 11
camera buffer, 43
computer platforms, 70
external storage, 71–3
hard disks, 70
Memory cards, 45–7
archiving, 249
camera buffer, 43
file transfer, 242
formatting, 217
setting up the camera, 226
Memory Stick, 46
Metadata, 246–8, 249–50, 259–60
MicroDrive cards, 46
Microsoft PowerPoint, 200–5
Minolta Dimage A2, 37
Mobile phones, 34
Mobile storage devices, 74
Modes, 3, 10
Monitor space, 263
Monitors, 68–9
calibration, 93–7, 144, 264, 274
closed loop workflows, 258, 278
profiles, 259, 278
resolution, 14
RGB color, 91
specifications, 17
working color space, 259–62
Montage, 180–4

MPG:
 digital cameras, 44
Multi-media:
 presentations, 192–3
MultiMedia memory cards, 46
Multiple exposures, 63

Names, 249
Noise:
 digital capture, 221–4
 flatbed scanners, 76
 image sensor types, 30
 ISO range, 49
 scanning film images, 24
 sharpening, 111, 148, 150
Noise Ninja, 224
Noise reduction, 58, 224
Non-destructive editing, 134, 180

Olympus C-8080 , 37
Optical resolution:
 flatbed scanners, 77
Optimum scanning area, 77
Out of gamut, 88
Output sharpening, 229, 234
Over-sampling, 76

Paint:
 subtractive color, 87
Painting tools, 131
Panorama, 211–13
Paper media, 79, 280
Parallax error, 49
PDF Slideshow, 194–5
Perspective, 124–6, 213
Photographic paper, 79
photographic printers, 79
Photographic quality, 4
Photomerge, 211–13
Photoshop Actions, 251–2
Photoshop Documents (PSD), 12, 13
Picture Package, 190–1
Pixels, 2
 bit depth, 41

cropping, 102
digital cameras, 40
hot, 222
image sensors, 28, 29, 31
image size, 19
resolution, 14–16
sharpening, 111
Pixels per inch (ppi), 15
Platforms, 68–81
PMT (PhotoMultiplier Tube), 75
Post-production, 158–84
Posterization, 168
PowerPoint, 200–5
Ppi see pixels per inch
Pre-press, 274–87
Pre-Press Houses, 282
Presentations, 188–213
Press:
 managed printing to CMYK devices, 282–7
 output sharpening, 234
 pre-press, 274–87
 target values, 138
Preview:
 printing with, 275, 278
Primary colors, 3, 7
Print with Preview, 275, 278
Printers, 78–81
 calibration, 269
 closed loop workflows, 258
 color space, 268
 device dependent color spaces, 90
 inks, 80, 85, 86, 90, 280, 281, 284
 managed printing to CMYK devices, 282–7
 output sharpening, 234
 profiles, 90
 target tones, 179
 working color space, 261
Printing, 274–87
 managed printing to an RGB device, 279–81
 resolution, 14
 sharpening, 148
 specifications, 17
 working color space, 262, 264, 268

Process Multiple Files, 188
Processors, 70
Profiles, 90–7
 closed loop workflows, 257–8
 Elements, 266
 ICC profiles, 94–6, 97, 259–63, 264, 279–81
 Photoshop, 267–8
 PowerPoint, 200
 printers, 269
 scanners, 269
 soft proofing, 274
 Web Photo Gallery, 207
 working color space, 259–63
ProPhoto color space, 61
Prosumer cameras, 37
 CompactFlash cards, 45
 RAW format, 54
 setting up, 226–8
 viewfinders, 49
PSD (Photoshop Document), 12, 13

Quad ink printing, 281
Quality:
 optimizing, 100
 RAW format, 54
 resolution, 16
Quick Fix, 144–7
Quick Mask, 131, 231–2
QuickTime, 200

Radius, 147, 153
RAID (Redundant Array of Independent
 Disks), 71
RAM, 70
RAW + JPEG format, 219
RAW dialog box, 55–64
 batch processing, 64
 bit depth, 59–60
 clipping information, 57
 color space, 61
 expose right, 63
 multiple exposures, 63
 noise reduction, 58
 sharpening, 58

 tonal range, 56
 white balance, 55–6
RAW format, 12, 54–64
 archiving, 64
 backups, 245
 bit depths, 10
 capture, 28, 218, 219
 capture sharpening, 230
 color adjustment, 128–9
 dialog box, 55–64
 digital cameras, 44
 expose right, 236
 file size, 11
 noise reduction software, 224
 resolution, 220
 setting up the camera, 228
 tonal contraction, 176
 white balance, 225, 228
Red filters, 158
Remote camera software, 237
Removable hard drives, 71
Removable media, 72
Rendering Intent, 276, 277
Resampling, 19
Resizing, 19, 112, 121–6, 204
Resolution, 14–16
 capture, 40, 220
 digital video cameras, 39
 flatbed scanners, 77
 image sensors, 29
 image size, 19
 Internet browsers, 112
 Photoshop, 198
 scanning, 18, 101
 setting up the camera, 227
RGB, 3
 additive color, 7
 bit depth, 10
 Black and White prints, 159–62
 closed loop workflows, 257
 color correction, 108
 color space, 85, 91–2, 259–63
 levels, 4
 managed printing, 279–81

printers, 268
printing in a closed loop, 278
relationship to CMYK, 89
Rotation, 122–3

Sampling, 6, 76
Sampling depth, 76
Saturation, 5
 Black and White prints, 159–60
 clipping information, 57
 color correction, 109
 Color Picker, 6
 digital capture, 101
 localized color adjustment, 142
 selective sharpening, 232
 sharpening, 151–4
Save for Web, 114, 201
Saving, 100
 backups, 245
 modified files, 112–14
 Save Selection, 132
Scanners, 75–7
 calibration, 269
 image adjustments, 101
Scanning:
 capture, 24
 control of color casts, 108
 dpi and ppi, 16
 resolution, 18
 sharpening, 148
Scratch disk memory, 70
Screen output, 234
Screen presentations, 188, 192–205
Screen real estate, 68
Search engines, 210
Secondary colors, 3
Secure Digital cards, 46
Security, 71
Selection Brush Tool, 131
Selective sharpening, 229, 231–3
Set Black Point, 139
Set Gray Point, 140–1
Set White Point, 140
Shadows:

capture, 236
color correction, 109
Curves adjustment, 107
distribution of data, 62–3
expose right, 63, 236
Levels adjustment, 127–8
optimising histograms, 106
Shadows/Highlights adjustment, 107, 143–7
target values, 137–42
tonal contraction, 175–9
toning, 163–8
Shadows/Highlight adjustment, 107, 143–7
Sharpening, 111, 135–6
 advanced techniques, 148–54
 capture workflows, 229–30, 231–4
 digital capture, 101
 output, 234
 RAW format, 54, 58
 resampling, 20
 selective, 231–3
Sharpness:
 lenses, 42
Shutter lag, 44
Sigma SD10, 40
Silk-stocking technique, 166
Sky:
 toning, 164
Slide Master, 198–205
Slideshows, 192–205
SLR style cameras, 35–6
Smart Sharpen, 230, 231–2, 234
SmartMedia, 47
Snap to Grid, 103, 122
Snap to Image, 213
Soft proofing, 274–6, 278, 284–6
Software:
 Color Management Module, 84
 digital cameras, 50
 disk space, 70
 noise reduction, 224
 remote camera, 237
Sony Cybershot DCS range, 39
Soundtracks, 200, 201–3, 205
Spectrophotometer, 269

Spikes, 59, 60
Spot Healing Brush Tool, 110
sRGB, 217, 262, 264, 266
Step wedges, 270–1
Stitching, 211–13
Storage, 11
 digital versus traditional, 26
 external, 71–3
 hard disks, 70
 JPEG compression, 12
 mobile, 74
 saving work in progress, 100
Subject brightness range, 120
Subject contrast, 138
Subtractive color, 7, 86, 87, 89

TA printers see thermo-autochrome printers
Tagging, 259–60
Target images:
 creating, 270–1
Target tones, 179
Target values, 137–42
Temperature:
 camera noise, 223
Test images, 226, 270–1
Thermal wax printers, 79
Thermo-autochrome (TA) printers, 78
TIFF (Tagged Image File Format), 12, 13
 archiving, 250
 capture sharpening, 230
 digital capture, 44, 218, 219
 image adjustments, 101
Tonal contraction, 175–9
Tonal distribution, 62–3
Tonal Width, 146
Tones:
 adjustment, 104–7
 bit depth, 10
 color perception, 8
 control using levels, 115–16
 flatbed scanners, 76
 Hue, Saturation and Brightness, 5
 levels, 4
 RAW dialog box, 56

target values, 137–42
 Zone System, 137
Toning, 163–8
Traditional cameras, 26, 27
Transform, 124–6
Transitions, 204–5
Transparencies, 13, 79
TV screens:
 viewing previews, 242

Under Color Removal (UCR), 86, 284
Unsharp Mask, 111, 135–6, 148, 151–4
 output sharpening, 234
 resampling, 20
 selective sharpening, 231
USB flash memory drives, 71

Video cameras, 39
Video card, 69
Video memory, 69
Viewfinders, 49

Web:
 Save for, 114
Web Photo Gallery, 188, 206–10
White:
 target values, 137
White balance, 225
 control of color casts, 108
 RAW format, 55–6, 228
 setting up the camera, 227
White point, 94–6
Wide-carriage inkjet printers, 81
Windows Media Player, 196–7, 197
Windows Media Video, 196–7
Wipes, 204
Workflows:
 capture, 216–38
 file handling, 242–52
 folders, 251–2
 managed, 256–71
Working color spaces, 259–63, 264
Working space, 267–8, 282
World Wide Web, 12, 114, 206–10

DIGITAL IMAGING >>>

essential skills >>>

WYSIWYG, 90, 258

XD Picture Card, 47
XMP, 246

Zip drives, 72
Zone System, 137, 176
Zoom, 35, 37, 38, 42